GREEK SCULPTURE

Greek Sculpture

An Exploration

Volume II: Plates

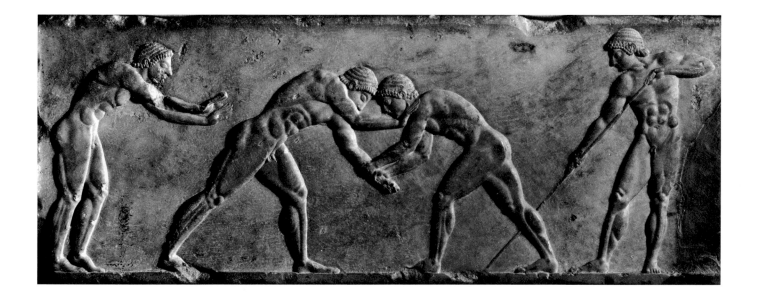

Andrew Stewart

Published with the assistance of the Getty Grant Program

Yale University Press New Haven & London

Publication of this book has been aided by a grant from The Millard Meiss Publication Fund of the College Art Association of America.

Designed by Ken Botnick
Set in Bembo type by Brevis Press.

Printed in the United States of America by Meriden-Stinehour Press.

Library of Congress Cataloging-in-Publication Data

Stewart, Andrew F.
 Greek sculpture: an exploration / Andrew Stewart.
 p. cm.
 Bibliography: v. 1, p.
 Includes index.
 Contents: v. 2. Plates.
 ISBN 0–300–04072–5 (v. 2: alk. paper) (set)
 1. Sculpture, Greek. I. Title.
NB90.S74 1990 89–9024
733′.3—dc20 CIP

10 9 8 7 6 5 4 3 2 1

Illustrations

The material is marble unless otherwise stated. The following abbreviations are used for dimensions: ht. = height; l. = length; w. = width; d. = diameter. Photographic sources cited in short bibliographic form here can be found in full in the bibliography of volume 1. Full details of locations, museum numbers, picture sources, polychromy, and so on, are given only in the list of illustrations.

The frontispiece is figure 145 in the list below; the illustration on the title page is figure 138.

54 Left hand of the kouros, fig. 49. Photo: MMA 94453B; Metropolitan Museum of Art, New York, Fletcher Fund, 1932 (32.11.1).

55 The New York kouros and the second Egyptian canon (after ca. 680). Drawing by Candace Smith.

56 Two kouroi, perhaps Kleobis and Biton, from Delphi, ca. 600–575. Delphi Museum 467 and 980 (A and plinth, to left), 1524 and 4672 (B and plinth, to right). Ht. 1.97 m. The feet of both figures and the left lower leg of B are restored. The plinth of A is inscribed "[Poly?]medes the Argive made [these]," and another inscription on that of B seems to name Kleobis and Biton. Photo: Emile Serafis.

57 Detail of the right-hand kouros (B) from fig. 56. Photo: Hirmer Fotoarchiv GP15.

58 Panoply from a tomb at Argos, ca. 725–700. Argos Museum. Bronze. Ht. of front plate of corselet, 47.4 cm. Photo: N. Stournaras.

59 Colossal head of a woman (Hera or a sphinx?) from Olympia, ca. 600–575. Olympia Museum. Limestone. Ht. 52 cm. Traces of red on the hairband, and yellowish-red on the hair. Photo: UCLA Classics Archive.

60 Kouros from Orchomenos in Boeotia, ca. 575. Athens NM 9. Ht. 1.27 m. Photo: DAI Athens, NM 4394.

61 Funerary monument of Dermys and Kittylos from Tanagra, Boeotia, ca. 600–575. Athens NM 56. Limestone. Ht. 1.47 m. Inscribed "Dermys" and "Kitylos" beside the figures, and "Amphalkes erected [this] for Kitylos and Dermys" on the base. Photo: Alison Frantz.

62 West pediment of the temple of Artemis at Corfu, ca. 600–575: in the wings, the gods (Zeus and perhaps Poseidon) fight the Titans; lion-leopards; and in the center, Medusa and her children Pegasos and Chrysaor. Corfu Museum. Limestone. Ht. 3.15 m, l. 22.16 m. Much of the background and the frame are restored. From Rodenwaldt 1939: pl. 2c.

63 Detail of the pediment, fig. 62: Medusa, Pegasos, and Chrysaor. Photo: DAI Athens, Korfu 559.

64 Detail of the pediment, fig. 62: Zeus and a Titan (presumably Kronos). Photo: DAI Athens.

65 Detail of the pediment, fig. 62: Poseidon(?) and a Titan (Rhea?). Photo: DAI Athens, Hege 2161.

66 Pediment from the Athenian Akropolis, ca. 575–550: Herakles fights the Hydra, with Iolaos and the crab sent by Hera to torment the hero on the left. Akropolis Museum 2. Limestone. Ht. 79 cm; l. 5.8 m; depth of relief, 3 cm. There are many traces of color: the crab is pink; the nearer horse dark blue (now green) with red mouth and nostrils, black bit and red mane; the further horse uncolored but with red harness; the chariot red; Iolaos's flesh pink, his cuirass, hair, beard and eyeballs blue-black; Herakles' flesh pink, his baldric red, his beard blue-black; and the Hydra's bodies plain and blue-black, with two green heads, black eyes and tongues, and red mouths. Photo: Alison Frantz AT 565.

67 "Olive-tree" pediment from the Athenian Akropolis, ca. 550. Unexplained subject: Achilles ambushes Troilos and Polyxena outside Troy, or an Attic myth involving Athena's olive-tree? Akropolis Museum 52. Limestone. Ht. 80 cm. There is much in-filling between the fragments. The inside of the building and its architectural details are black, the women wear red peploi and blue himatia. Photo: Alison Frantz AT 567.

68 Conjectural reconstruction of the pediments of the temple of Athena (figs. 69–75) on the Athenian Akropolis, by Immo Beyer. Akropolis Museum. Limestone. Restored ht. ca. 2.1 m, l. ca. 15.4 m. From Beyer 1974: 650, fig. 10.

69 Pedimental group of a lion and lioness savaging a bull (so-called lion group VIII), from the Athenian Akropolis, ca. 575–550: head of the bull. Akropolis Museum 3. Limestone. Ht. 97 cm. All the roughly textured areas are restorations. The (unpainted) background is also largely restored; the lion is plain, the lioness red, and both have blue tails; the bull is dark blue and the insides of its ears, nostrils, and mouth, together with the rims of its eyes, are red. Red blood pours from its wounds. Photo: Giraudon PF80; Giraudon/Art Resource, New York.

70 Pedimental group ("Bluebeard") from the Athenian Akropolis, ca. 575–550. Perhaps Okeanos, Pontos, and Aither. Akropolis Museum 35. Limestone. Ht. 90 cm. The background (unpainted) is largely restored, and there is some in-filling of details. The hair of the two outer figures is blue, of the center one white, and all three have blue beards; the left and central figures have red pupils, the right one blue; the lips are red, the flesh is pink, and the tails blue, red, and plain. Photo: Hirmer Fotoarchiv F654.1901.

71 Detail of fig. 70: heads of "Bluebeard." Photo: DAI Rome 43.227.

72 Pedimental group of a lioness savaging a bull (so-called lion group VII), from the Athenian Akropolis, ca. 575–550. Akropolis Museum 4. Limestone. Ht. 1.6 m. Most of the lioness's body is restored. The background is blue, the mane of the lioness red with one row of blue-green locks, and her teats are red, as are the bull's eyes. Photo: Alison Frantz AT 135.

73 Pedimental group from the Athenian Akropolis, ca. 575–550: the Introduction of Herakles to Olympos. Akropolis Museum 9. Limestone. Ht. 94 cm. Parts of Zeus's throne and other details have been restored, together with all the background adjoining the cornice, which probably does not belong with this pediment. The background is blue, Zeus's throne is decorated behind with a white, red, brown, and black chequer pattern, and is red inside; the footstool is red; the god sits on a red cushion and wears a blue-black himation with a red border, a plain chiton with a red tongue pattern, and red sandals. Hera's peplos is blue-black with a red meander neck-border, her himation red with a border of stars and crosses in blue. Herakles is uncolored, and Hermes wears a red fawn-skin with white spots over a sky-blue chiton. Photo: Alison Frantz AT 571.

74 Detail of fig. 70: head of "Bluebeard." Photo: G. Becatti.

75 Detail of fig. 73: Zeus. Photo: Alison Frantz AT 572.

76 Conjectural reconstruction of the frieze of a temple at Thermon in Aetolia (Northwest Greece), ca. 630. Athens NM 13410 and 13401. Wood with painted terracotta metopes. Ht. of metopes, 60 cm. From Antike Denkmäler 2: pl. 49.2.

77 Relief (part of a series) from Mycenae, ca. 625–600. Athens NM 2869. Limestone. Ht. 40 cm. Photo: Emile Serafis.

78 Conjectural restoration of a metope attributed to the Sikyonian treasury at Delphi (fig. 79) and its (fragmentary) neighbor, ca. 575–550: the ship Argo with Orpheus and another playing the kithara, with a Dioskouros on horseback to the left. Delphi Museum. Limestone. Ht. of metopes, 62 cm. Adapted by Candace Smith from de la Coste-Messelière 1936: 187, fig. 8.

79 Metope attributed to the Sikyonian treasury at Delphi, ca. 575–550: the ship Argo (cf. fig. 78). Delphi Museum. Limestone. Ht. 62 cm. The names of Orpheus and his companion . . el . . are painted on the background. Traces of wine-red color on the drapery, the shields, and the ship's hull. Photo: Alinari 24747; Alinari/Art Resource, New York.

80 Metope attributed to the Sikyonian treasury at Delphi, ca. 575–550: the Dioskouroi (named), Idas (named), and Lynkeus (name missing) raiding cattle. Delphi Museum. Limestone. Ht. 62 cm. Traces of wine-red color on the drapery; hair orange. Photo: Alinari 24746; Alinari/Art Resource, New York.

81 Metope attributed to the Sikyonian treasury at Delphi, ca. 575–550: Europa on the Bull. Delphi Museum. Limestone. Ht. 62 cm. Traces of wine-red color on the drapery. Photo: Alinari 24748; Alinari/Art Resource, New York.

82 Medusa and Pegasos, from Syracuse, ca. 575–550. Syracuse, Museo Archeologico Nazionale. Terracotta. Ht. 56 cm. Most of Medusa's chest, her left arm and adjacent background, the left side of her head, and right upper arm are restored. Photo: Anderson 29310; Alinari/Art Resource, New York.

83 Metopes from Temple C at Selinus, ca. 550: from left to right, the chariot of Apollo, Perseus and Medusa, Herakles and the Kerkopes. Palermo, Museo Nazionale Archeologico. Limestone. Ht. of panels, 1.47 m. The architectural surround is restored using original fragments. Photo: L. von Matt.

84 Metope from Temple C at Selinus, ca. 550: the chariot of Apollo. Palermo, Museo Nazionale Archeologico. Limestone. Ht. 1.47 m. Photo: Alinari 19579; Alinari/Art Resource, New York.

85 Metope from Temple C at Selinus, ca. 550: Athena superintends Perseus killing Medusa, who has already produced Pegasos. Palermo, Museo Nazionale Archeologico. Limestone. Ht. 1.47 m. Photo: Alinari 19580; Alinari/Art Resource, New York.

86 Detail of fig. 85: Athena and Perseus. Photo: Alison Frantz SC 7.

87 Metope from Temple C at Selinus, ca. 550: Herakles and the Kerkopes. Palermo, Museo Nazionale Archeologico. Limestone. Ht. 1.47 m. Photo: Anderson 29196; Alinari/Art Resource, New York.

88 Metope from the Heraion at Foce del Sele, ca. 550: Herakles and the Kerkopes. Paestum, Museo Nazionale. Sandstone. Ht. 78 cm. Photo: GFN E47898; Gabinetto Fotografico Nazionale, Rome.

89 Metope from the Heraion at Foce del Sele, ca. 550: Herakles kills Antaios. Paestum, Museo Nazionale. Sandstone. Ht. 78 cm. Photo: GFN E47892; Gabinetto Fotografico Nazionale, Rome.

90 Metope from the Heraion at Foce del Sele, ca. 550: Herakles and Apollo fight over the Delphic tripod. Paestum, Museo Nazionale. Sandstone. Ht. 78 cm. Photo: GFN E47884; Gabinetto Fotografico Nazionale, Rome.

91 Metope from the Heraion at Foce del Sele, ca. 550: Orestes kills Aigisthos. Paestum, Museo Nazionale. Sandstone. Ht. 78 cm. Photo: Alinari 54657; Alinari/Art Resource, New York.

92 Winged Nike by Archermos of Chios, from Delos, ca. 550. Athens NM 21. Ht. 90 cm. For the badly damaged inscription on the base (not illustrated), see chapter 9.3. Photo: UCLA Classics Archive.

93 Kore dedicated by Cheramyes, from the Heraion at Samos, ca. 560. Paris, Louvre 686. Ht. 1.92 m. Inscribed on the front hem of the himation "Cheramyes dedicated me as a delight (agalma) for Hera." Photo: Giraudon 28900; Giraudon/Art Resource, New York.

94 Kore dedicated by Cheramyes, from the Heraion at Samos, ca. 560.

Samos (Vathy) Museum. Ht. 1.92 m. Inscribed on the front hem of the himation "Cheramyes dedicated me as a delight (*agalma*) for Hera." Photo: DAI Athens, Samos Grabungsarchiv 1557.12.

95 Detail of the kore, fig. 93. Photo: Giraudon 28905; Giraudon/Art Resource, New York.

96 Another view of the kore, fig. 94. Photo: DAI Athens, Samos Grabungsarchiv 1557.11.

97 Group made by Geneleos and dedicated by [. . .]arches, from the Heraion at Samos, ca. 550. Berlin and Samos (Vathy) Museum. L. of base, 6.08 m. The seated figure is inscribed "Phileia; Geneleos made us"; the two girls are Philippe and Ornithe; and the reclining figure is [. . .]arches, who says that he dedicated them to Hera. Photo: DAI Athens, Samos 2546.

98 [. . .]arches from the group in fig. 97. Samos (Vathy) Museum 768. L. 1.58 m. Photo: DAI Athens 70.1096.

99 Philippe from the group in fig. 97. Samos (Vathy) Museum. Ht. 1.68 m. Photo: Alison Frantz AE 7.

100 Colossal kouros dedicated by Ischys, from the Heraion at Samos, ca. 570. Samos (Vathy) Museum. Ht. of joined fragments, 4.07 m.; of entire statue, originally ca. 4.75 m. The left thigh is inscribed "Ischys son of Rhesis dedicated me"; the head (fig. 102) has now been joined to the body. Photo: H. Kyrieleis.

101 Another view of the kouros, fig. 100. Photo DAI Athens 81.89.

102 Head of the kouros, fig. 100. Photo: H. Kyrieleis.

103 Head of a colossal kouros from Samos, ca. 550–540. Istanbul Museum 1645. Ht. 47 cm. The head joins fragments from Samos, and the entire ensemble stood about 3.25 m. high. Photo: DAI Athens, Konst. 35.

104 Seated figure from Didyma, ca. 575–550. London, BM B 271. Ht. 1.55 m. Photo: BM C-599; Trustees of the British Museum.

105 Offering-bearer from Didyma, ca. 550–525. Berlin (East), Staatliche Museen 1710. Ht. 1.66 m. Photo: Sk 7503; Staatliche Museen zu Berlin—DDR, Antikensammlung.

106 Seated figures from Didyma, ca. 600–500. London, BM. Ht. 1.15–1.55 m. Photo: Hirmer Fotoarchiv 584.1574.

107 Chares, from Didyma, ca. 550. London, BM B278. Ht. 1.46 m. Inscribed on the right front leg of the throne: "I am Chares, son of Kleisis, ruler of Teichioussa. The delight (*agalma*) is Apollo's." Photo: BM XI-D(24); Trustees of the British Museum.

108 Seated figure from Didyma, ca. 550–525. Istanbul Museum 1945. Ht. 1.15 m. Photo: DAI Athens, Konst 24.

109 Lion from Miletos, ca. 550. Berlin (East), Staatliche Museen 1790. L. 1.76 m. Photo: Staatliche Museen zu Berlin—DDR, Antikensammlung.

110 Colossal Apollo dedicated by the Naxians on Delos, ca. 600–575. Ht. of fragments, 2.2 m and 1.2 m; original ht. ca. 8.5 m. Inscribed (in fourth-century script) "The Naxians to Apollo. I am the same stone, statue and base." Photo: author.

111 Lions, Delos, ca. 575. Ht. 1.72 m. Photo: Emile Serafis.

112 Sphinx dedicated by the Naxians at Delphi, ca. 575–550. Delphi Museum. Ht. 2.32 m.; of the column, 10.22 m. The upper parts of both wings are heavily restored. Photo: Alison Frantz.

113 Head of the sphinx, fig. 112. Photo: Alison Frantz.

114 Kore from the Athenian Akropolis, ca. 550. Akropolis Museum 677. Ht. 54.5 cm. Most of the left arm is restored. Photo: Emile Serafis.

115 Right side of the kore, fig. 114. Photo: Alison Frantz AT 426.

116 Back view of the kore, fig. 114. Photo: Alison Frantz AT 427.

117 Kouros from Melos, ca. 550. Athens NM 1558. Ht. 2.14 m. The lower right leg is restored. Photo: Hirmer Fotoarchiv 561.0405.

118 Kouros from Paros, ca. 550. Paris, Louvre MND 888. Ht. 1.03 m. Photo: Giraudon 26258; Giraudon/Art Resource, New York.

119 Three-quarter view of the Paros kouros, fig. 118. Photo: Giraudon 35611; Giraudon/Art Resource, New York.

120 Kouros from Volomandra, Attica, ca. 560. Athens NM 1906. Ht. 1.79 m. The front part of both feet are restored. Photo: TAP Photo Service.

121 Kouros, and the kore Phrasikleia by Aristion of Paros, as discovered in Merenda, Attica, ca. 550. Athens NM 4890, 4889. Ht. 1.89 and 1.76 m respectively. The two were buried together in a shallow pit, perhaps around 500; the base, long immured in a local church, is inscribed "The tomb of Phrasikleia. Maiden [kore] I will always be called, since instead of marriage this is what the gods have allotted me." The hair of both figures is red, and Phrasikleia's chiton is tinted reddish. From *AAA* 5 (1972): 305, fig. 7. Photo: TAP Photo Service.

122 Phrasikleia, NM 4889. From *AAA* 5 (1972): pl. 3.

123 Calf-bearer (Moschophoros) dedicated by [Rh]onbos, from the Akropolis, ca. 560. Athens, Akropolis Museum 624. Restored ht. 1.65 m. The base is inscribed "[Rh]onbos son of Palos dedicated me." See also fig. 126. Photo: Alison Frantz AT 131.

124 "Lyons kore" from the Athenian Akropolis, ca. 540. Lyons Museum (torso and head) and Athens, Akropolis Museum 269 (legs). Ht. 1.13 m. The upper body in the picture is a cast; the himation has a green meander border. Photo: Alison Frantz AT 430.

125 "Rampin rider" from the Athenian Akropolis, ca. 550. Athens, Ak-

ropolis Museum 590 and Paris, Louvre MA 3104 (the Rampin head). Ht. of ensemble, 81.5 cm. One of a pair; the head in the picture is a cast. See also fig. 127. Photo: DAI Athens 72.2953.

126 Head of the calf-bearer, fig. 123. Photo: Emile Serafis.

127 Head of the rider, fig. 125. Photo: Louvre 81 EN 4176; Musée du Louvre, Paris.

128 Reconstruction of the pair of riders, fig. 125. From H. von Roques de Maumont, *Antike Reiterstandbilder* (Berlin, 1958): 9, fig. 1.

129 The types of archaic and early classical Attic grave stelai. From Boardman 1978: fig. 224. Photo: J. Boardman.

130 Grave stele of a discus-thrower from the Dipylon cemetery, Athens, ca. 550. Athens NM 38. Ht. 34 cm. Photo: Hirmer Fotoarchiv 561.0408.

131 Grave stele of a boxer from the Themistoklean Wall, Athens, ca. 540. Athens, Kerameikos Museum P1054. Ht. 23 cm. Re-used as building material by the Athenians in 478. Photo: Alison Frantz AT 260.

132 Kroisos from Anavyssos, Attica, ca. 530. Athens NM 3851. Ht. 1.94 m. The base is inscribed "Stay and mourn at the tomb of dead Kroisos, whom raging Ares destroyed one day as he fought in the foremost ranks." Soon after its clandestine discovery in 1936 the statue was sawn in half and illegally exported to Paris, but was seized by Greek police and returned in 1937. Some minor restorations; traces of red paint in the hair, fillet, irises, and pubes. Photo: Emile Serafis.

133 Kouros, perhaps from Megara, ca. 530–520. Malibu, J. Paul Getty Museum. Ht. 2.06 m. Photo: The J. Paul Getty Museum.

134 Head of Kroisos, fig. 132. Photo: UCLA Classics Archive.

135 Head of the Getty kouros, fig. 133. Photo: The J. Paul Getty Museum.

136 Jumper from the Athenian Akropolis, ca. 520–510. Athens NM 6445. Bronze. Ht. 27 cm. The two hands are pierced with holes for jumping-weights. Photo: Alinari 24433; Alinari/Art Resource, New York.

137 Head of a kouros (the "Rayet" head) from Athens, ca. 520–510. Copenhagen, Ny Carlsberg Glyptotek 418. Ht. 31.5 cm. Perhaps to be associated with fragments of a kouros built into the Piraeus gate of the Themistoklean Wall in 478, near a base signed by Endoios and Philergos. Photo: UCLA Classics Archive.

138 Base for a kouros ("ballplayer" base) from the Themistoklean Wall, Athens, ca. 500: wrestlers (front). Athens NM 3476. Ht. 32 cm. Re-used as building material by the Athenians in 478. Red background. Photo: UCLA Classics Archive.

139 Left side of the base, fig. 138: ballplayers. Red background. Photo: UCLA Classics Archive.

140 Right side of the base, fig. 138: youths goading a cat and dog to fight. Red background. Photo: UCLA Classics Archive.

141 Base for a kouros from the Themistoklean Wall, Athens, ca. 500: (front) another version of the ballplayers on the base, fig. 139. Athens, Kerameikos Museum P1002. Ht. 29 cm. The base, which has a lion confronting a boar and two horsemen on its sides, was set on another, narrower block or pillar. Photo: DAI Athens, Ker 6309.

142 Attic belly amphora (type A) signed by Euthymides as painter, from Vulci (Etruria), ca. 510: revellers. Munich, Antikensammlung 2307. Ht. of picture, 22 cm. Photo: Antikensammlung 14N28; Staatliche Antikensammlungen und Glyptothek, Munich.

143 Grave stele from Attica, ca. 540–530. New York, MMA 11.185. Restored ht. 4.234 m. Inscribed on the base, in verse, "To dear dead Me[gakles?] his father and dear mother raised this monument. . . ." Reconstructed with casts of the girl's head, shoulder, and hand, which are in East Berlin (Staatliche Museen 1531). The many traces of color include: capital picked out in red and black; red background, also hair and pupils of the two figures and the sphinx; eyebrows and lids black; wings and tail of the sphinx picked out in red, black, and blue. Photo: MMA 177691B; Metropolitan Museum of Art, New York, Hewitt Fund, 1911; Rogers Fund, 1921, Munsey Fund, 1936, 1938, and Anonymous Gift, 1951 (11.185).

144 Head of the youth from the stele, fig. 143. Photo: MMA 71413B; Metropolitan Museum of Art, New York, Hewitt Fund, 1911; Rogers Fund, 1921, Munsey Fund, 1936, 1938, and Anonymous Gift, 1951 (11.185).

145 Grave stele of Aristion, made by Aristokles, from Velanideza, Attica, ca. 510. Athens NM 29. Ht. 2.4 m. Insribed "Of Aristion. The work of Aristokles." The hair and background are red, the helmet and corslet blue, with "ghosts" of patterns in other colors. Photo: Alinari IAC 91689; Alinari/Art Resource, New York.

146 Head of Aristion, fig. 145. Photo: Alison Frantz AT 224.

147 "Peplos" kore from the Athenian Akropolis, ca. 530. Athens, Akropolis Museum 679. Ht. 1.17 m. Hair, pupils, and lips red, traces of a painted necklace and green, red, and blue patterns on the drapery. The extended left forearm was made separately and inset. Photo: DAI Athens, Akr 1655.

148 Kore from the Athenian Akropolis, ca. 520–510. Athens, Akropolis Museum 675. Ht. 55 cm. The upper part of the chiton is green, she wears a green and red girdle, and there are numerous traces of white, green, red, and blue patterns on the drapery; the eyelids are outlined in black, the hair was red, and the stephane has a red palmette and

lotus pattern on a green ground. Photo: Alison Frantz AT 483.

149 Head and shoulders of the "Peplos" kore, fig. 147. Photo: DAI Athens.

150 Kore from the Athenian Akropolis, ca. 530–520. Athens, Akropolis Museum 594. Ht. 1.23 m. The hair is red, and there are numerous traces of green and red patterns on the drapery. Photo: Alison Frantz AT 487.

151 Detail of the kore, fig. 150. Photo: author.

152 Kore from the Athenian Akropolis, ca. 520–510. Athens, Akropolis Museum 673. Ht. 93 cm. The upper part of the chiton is green, and there are numerous traces of green, red, and blue patterns on the stephane and drapery. Photo: Hirmer Fotoarchiv 654.1905.

153 Kore from the Athenian Akropolis, ca. 520–510. Athens, Akropolis Museum 670. Ht. 1.15 m. The hair and lips are red, the eyes are rimmed with black and given red and black pupils, the bracelet is green, and there are numerous traces of green and red patterns on the stephane and drapery. Photo: Hirmer Fotoarchiv 592.0601.

154 Kore dedicated by the potter Nearchos and signed by Antenor, from the Athenian Akropolis, ca. 520. Athens, Akropolis Museum 681. Ht. 2.15 m. Inscribed on the base: "Nearchos [the pott]er dedicated me to Ath[ena] from the first-fruits of his work; Antenor son of Eumares made [the statue]." The association between statue and base is sometimes doubted, but without compelling reason. The kore's eyes were of purple glass set in lead; her hair was red, her chiton was blue, and there are numerous traces of green, blue, and red patterns on the drapery. Restorations include the middle of the shoulder-tresses, part of the left forearm, most of the legs and of the stacked folds hanging from the left arm. Photo: Alinari 24654; Alinari/Art Resource, New York.

155 Kore ("La Delicata") from the Athenian Akropolis, ca. 500. Athens, Akropolis Museum 674. Ht. 92 cm. The head and neck, the right forearm, and the drapery before the right leg were all carved from separate pieces of marble. The hair is red, the eyebrows and rims of the eyelids black, the pupils red and black, the upper part of the chiton green, and there are numerous traces of green, blue, and red patterns on the stephane and drapery. Photo: Hirmer Fotoarchiv 654.1906.

156 Head of the kore, fig. 155.

157 Dog from the Athenian Akropolis, ca. 520–500. Athens, Akropolis Museum 143. L. 1.25 m. One of a pair, possibly dedicated to Artemis Brauronia, the huntress. The right ear and the top of the left were carved separately, and the lids and pupils are black. Photo: DAI Athens, Schrader 133.

158 Right foot of a statue of Athena, from the Athenian Akropolis, ca. 520–500. Athens, Akropolis Museum 136. Ht. 88 cm. The capital is inscribed "Pythis made [it]. Epiteles dedicated [it] as first-fruits to Athena." The left foot was made separately and there is a cutting in the upper face of the capital for an upright spear. Photo: Alison Frantz AT 509.

159 Torso of Theseus fighting Prokrustes, from the Athenian Akropolis, ca. 500. Athens, Akropolis Museum 145. Ht. 63 cm. Prokrustes' hand grasps Theseus's shoulder from behind, while another fragment shows that the hero was gripping the baron's throat. Photo: DAI Athens 72.2971.

160 Rider from the Athenian Akropolis, ca. 520–500. Athens, Akropolis Museum 700. Ht. 1.12 m. His sandals are indicated in red and black; the horse's mane is blue and his eyes red and black. Photo: DAI Athens 72/2955.

161 Votive relief of a potter from the Athenian Akropolis, ca. 510. Athens, Akropolis Museum 1332. Ht. 1.22 m. Inscribed on the left margin with the name of the dedicator, [Pamph?]aios, and on the right with that of the sculptor, En[doios]. The inside of the frame was red, the background blue, the man's lips red, his himation red-brown, and the vases red and black; there is the "ghost" of a painted figure or object to the left. Photo: DAI Athens 69/1684.

162 Votive relief from the Athenian Akropolis, ca. 500. Athens, Akropolis Museum 702. Ht. 39 cm. The subject may be Hermes and the Nymphs, with the dedicator behind. The background was blue, the hair of the figures alternated between red and black, and the drapery of the girls between red and yellow. Photo: Alinari 24617; Alinari/Art Resource, New York.

163 Reconstruction of the exterior of the temple of Apollo at Didyma. From G. Gruben, *JdI* 78 (1963): 158, fig. 39.

164 Architrave block with Gorgon and lion, from the temple of Apollo at Didyma, ca. 540–520. Istanbul Museum 2182. Ht. 90 cm. Photo: DAI Istanbul 64.367.

165 Column drum relief from the temple of Apollo at Didyma, ca. 550–530. Berlin (West), Antikenabteilung 1721. Ht. 55.5 cm. Photo: Alison Frantz EV 68.

166 Column drum relief from the temple of Apollo at Didyma, ca. 550–530. Berlin (West), Antikenabteilung 1748. Ht. 27 cm. Photo: Alison Frantz EV 72.

167 Frieze slab from the Roman theater at Miletos, original ca. 500: the Apollo Philesios of Kanachos. Berlin (East) Staatliche Museen 1592. Ht. 79.5 cm. The god holds a bow in his left hand and a stag in his right. Photo: Staatliche Museen zu Berlin—DDR, Antikensammlung 1429.

168 Apollo from the Piraeus, ca. 530–510. Piraeus Museum. Bronze. Ht. 1.92 m. The god originally held an offering dish or phiale in his right hand and probably a bow in his left. Photo: Hirmer Fotoarchiv 654.1835.

169 Head of the Apollo, fig. 168. Photo: DAI Athens, NM 5575.

170 Reconstruction of the temple of Artemis at Ephesos. From F. Krischen, *Die griechische Staat: Wiederherstellung* (Berlin 1938), pl. 33.

171 Column drum relief from the temple of Artemis at Ephesos, ca. 550–530. London, BM B91. Ht. 30 cm. Photo: BM C-455; Trustees of the British Museum.

172 Column drum relief from the temple of Artemis at Ephesos, ca. 550–530. London, BM B89. Ht. 19 cm. Photo: G. Becatti.

173 Head of Artemis (?) from a deposit of chryselephantine sculptures found under the Sacred Way at Delphi, ca. 550–540. Delphi Museum. Ivory. Ht. 18 cm. Photo: Ecole française d'Athènes.

174 Artemis Ephesia (Roman copy), from Baiae, original, ca. 500 (or earlier?). Naples, Museo Nazionale 6278. Alabaster with bronze face, hands, and feet. Ht. 2.03 m. Version of the archaic cult statue attributed in antiquity to Endoios? Photo: Anderson 23071; Alinari/Art Resource, New York.

175 Kore (Leto?) from the agora at Delos, ca. 500. Athens NM 22. Ht. 1.34 m. Found with five other statues, reconstructed as Hera and Zeus enthroned at center, with Athena, Apollo, Artemis, and Leto standing around. Photo: Alison Frantz AT 397.

176 Relief from the heroon for the poet Archilochos (*floruit*, ca. 650) on Paros, ca. 500: banquet. Paros Museum. Ht. 73 cm. Photo: DAI Athens, Paros 595A.

177 Companion to fig. 176: lion attack. Photo: DAI Athens, Paros 595.

178 Herm from Siphnos, ca. 520. Athens NM 3728. Ht. 66 cm. Photo: Giraudon IAC 157195; Giraudon/Art Resource, New York.

179 Kouros from the sanctuary of Apollo Ptoios (Boeotia), ca. 530–520. Athens NM 12. Ht. 1.60 m. The lower legs are restored. Photo: Alinari 24213; Alinari/Art Resource, New York.

180 Kouros from the sanctuary of Apollo Ptoios (Boeotia), ca. 510–500. Athens NM 20. Ht. 1.03 m. Inscribed in two hexameters on the left thigh: "Pythias of Akraiphia and Aischrion dedicated me to the Ptoan . . . of the silver bow." Photo: Alinari 24212; Alinari/Art Resource, New York.

181 Hero-relief from Chrysapha, near Sparta, ca. 540–520. Berlin (East), Staatliche Museen 731. Limestone. Ht. 87 cm. Photo: Staatliche Museen zu Berlin—DDR, Antikensammlung.

182 Statuette of Alea Athena from Tegea, ca. 525–500. Athens NM 14828. Bronze. Ht. 13 cm. Perhaps a version of the cult statue of Alea Athena by Endoios. Photo: DAI Athens NM 6121.

183 Statuette of an armed runner at the starting-point of a race, ca. 500. Tübingen, Universitätssammlung. Bronze. Ht. 16.4 cm. Photo: Archäologisches Institut der Universität, Tübingen.

184 Head of a statue of Zeus found in a cave at Ugento, near Taranto in Italy, ca. 525–500. Taranto, Museo Nazionale. Bronze. Ht. of statue, 71.8 cm. Cf. fig. 185. Photo: Ministero per i Beni Culturali e Ambientali, Taranto, 1833.

185 Zeus from Ugento, fig. 184. The god once held a thunderbolt in his right hand and an eagle, flower, or bunch of grapes in his left. Photo: Ministero per i Beni Culturali e Ambientali, Taranto, 1879.

186 Delphi: plan of the sanctuary. From P. de la Coste-Messelière and G. de Miré, *Delphes* (Paris, 1943): 317.

187 West pediment of the Siphnian Treasury at Delphi, ca. 525: Struggle between Apollo (left, backed by Artemis) and Herakles for the Delphic Tripod, with Zeus at center. Delphi Museum. Ht. 74 cm, l. 5.82 m. The plinth was red, and traces of red occur on the hair of both men and horses. Photo: G. Becatti.

188 Reconstruction of the Treasury, ca. 525. From *FD* 2, 16: 225, fig. 133.

189 Kore (Caryatid) from the west façade of the Siphnian Treasury at Delphi, ca. 525. Delphi Museum. Ht. 1.75 m. Photo: Alison Frantz ST 71.

190 West frieze of the Siphnian Treasury at Delphi, ca. 525: unexplained subject, perhaps either the Judgment of Paris or the Apotheosis of Herakles (an old suggestion revived by V. Brinkmann). Delphi Museum. Ht. 64 cm. "Ghosts" of the painted reins and chariot-rail survive. Photo: Alinari 24767; Alinari/Art Resource, New York.

191 South frieze of the Siphnian Treasury at Delphi, ca. 525: abduction of Helen or Persephone. Delphi Museum. Ht. 64 cm. Photo: Alinari 24766; Alinari/Art Resource, New York.

192 East frieze of the Siphnian Treasury at Delphi, ca. 525: council of the gods and fight between Memnon and Achilles for the body of Antilochos. Delphi Museum. Ht. 64 cm. From left to right, the gods (named in paint) are: Ar[e]s, E[o]s, (Aphrodite?, Apollo?, Zeus, then probably Hermes and Poseidon in the missing portion), Athena, Hera, (Thetis?). Achill[es] is written on the base molding under Zeus's feet. The background was blue, hair and shields red, and some of the drapery

dark blue, with "ghosts" of patterns in other colors. Photo: UCLA Classics Archive.

193 East frieze of the Siphnian Treasury at Delphi, ca. 525: council of the gods and fight between Memnon and Achilles for the body of Antilochos. Delphi Museum. Ht. 64 cm. From left to right the heroes (named in paint) are: Lykos, Aineas, Mem[non], [Antiloch]os, [Achill]es, (. . . ? . . .), [Aut]omedon, Nestor. Photo: Emile Serafis.

194 Reconstruction of the east frieze. Drawing by Candace Smith.

195 North frieze of the Siphnian Treasury at Delphi, ca. 525: Gigantomachy. Delphi Museum. Ht. 64 cm. On the left is the chariot of Dionysos and Themis; the other participants (named in paint) are [. . . .]us, Apollo, Artemis, Tharos, the dead Ephialtes, Hyperphas, Alektos, and [.]us. The signature on the shield reads "[.] made these and those at the back." The background was blue, hair and shields red, and some of the drapery dark blue, with "ghosts" of patterns in other colors. Photo: UCLA Classics Archive.

196 North frieze of the Siphnian Treasury at Delphi, ca. 525: Gigantomachy. Delphi Museum. Ht. 64 cm. The chariot on the left probably belongs to Zeus and Hera; the other participants (named in paint) are the dead [Porphy]rion, (Aphrodite?), Athena, and Eriktypos. Photo: Alison Frantz ST 22.

197 Detail from fig. 195: lion of Themis's chariot mauling the Giant [.]us. Photo: UCLA Classics Archive.

198 Detail from fig. 196: a goddess (Aphrodite?) despatching [Porphy]rion. Photo: UCLA Classics Archive.

199 East pediment of the temple of Apollo at Delphi, ca. 510–500. Delphi Museum. Ht. at center, 2.30 m. Photo: DAI Athens, Delphi 349.

200 Reconstruction of the east and west façades of the temple of Apollo, Delphi, ca. 510–500. Drawing by Candace Smith.

201 Kore (probaby Themis) from the east pediment of the temple of Apollo at Delphi, ca. 510–500. Delphi Museum 1873. Ht. 1.25 m. The himation bears traces of blue, with painted ornamentation. Photo: Alison Frantz ST 74.

202 Kore (probaby Ge) from the east pediment of the temple of Apollo at Delphi, ca. 510–500. Delphi Museum 1794. Ht. 1.16 m. The himation bears traces of blue, with painted ornamentation. Photo: Alison Frantz ST 75.

203 Lion and deer group from the east pediment of the temple of Apollo at Delphi, ca. 510–500. Delphi Museum. Ht. 1.1 m. Red blood is spattered about the deer's body and the lion's legs. Photo: DAI Athens, Delphi 359.

204 Nike, akroterion from the east façade of the temple of Apollo at Delphi, ca. 510–500. Delphi Museum. Ht. 1.13 m. Blue remains on the drapery and wing feathers. Photo: DAI Athens, Delphi 350.

205 Head of the Athena from the west pediment of the "Old temple of Athena" on the Athenian Akropolis, ca. 510–500. Athens, Akropolis Museum 631A. Ht. of statue, 2 m. Cf. fig. 206. Photo: DAI Athens, Akropolis 1589.

206 Athena and a giant, from the west pediment of the "Old temple of Athena" on the Athenian Akropolis, ca. 510–500. Athens, Akropolis Museum 631A. Ht. 2 m. In the current museum display the two figures are separated by several meters, and fragments of another opponent of Athena and another lunging divinity have been inserted into the gap. Both figures are patched extensively in plaster. The giant's hair is dark blue, Athena's is red, her helmet has a blue-green patterned border, and her aegis a bluegreen scale pattern; red blood spatters the giant's thigh. Photo: DAI Athens.

207 Lunging giant from the west pediment of the "Old temple of Athena" on the Athenian Akropolis, ca. 510–500. Athens, Akropolis Museum 631B. Ht. 89 cm. Patched extensively in plaster. Photo: DAI Athens, Akropolis 72.2969.

208 Frieze-block from the Akropolis, ca. 510–500: charioteer mounting. Athens, Akropolis Museum 1342. Ht. 1.2 m. Other fragments show Hermes and a seated figure. Photo: DAI Athens, Akropolis 72.3002.

209 Metope from the Heraion at Foce del Sele, ca. 525–500. Paestum, Museo Nazionale. Sandstone. Ht. 85 cm. Photo: GFN E47863; Gabinetto Fotografico Nazionale, Rome.

210 a and b Nike (or Iris) from the Athenian Akropolis, 490 or just after. Athens, Akropolis Museum 690. Original ht., ca. 1.5 m. Associated with a column bearing the following inscription: "Kallimachos of Aphidna dedicated me to Athena: I, the immortal messenger of those who inhabit the broad sky. As Captain-general [polemarchos] of the Athenians he began the battle of Persians and Greeks, but fell that terrible day with other sons of Athens on the sacred sands of Marathon." A red meander pattern decorated the hem of the chiton, and a blue and red meander that of the himation. Photos: DAI Athens 68/140 (torso), 72/2933 (legs).

211 The Athenian Treasury at Delphi, ca. 490–480. Photo: Alison Frantz ST 60.

212 Sculptural program of the Treasury, ca. 490–480. Drawing by Candace Smith, based on J. J. Coulton, *Ancient and Greek Architects at Work* (1977): fig. 28.

213 Metope from the south frieze of the treasury, ca. 490–480: Theseus and Athena. Delphi Museum. Ht. 67 cm. Photo: Alison Frantz ST 47.

214 Metope from the south frieze of the treasury, ca. 490–480: Theseus and the Amazon. Delphi Museum. Ht. 67 cm. The Amazon's cuirass was red, and her left thigh was spattered with red blood. Photo: Hirmer Fotoarchiv 561.0609.

215 Detail of the metope, fig. 214. Photo: Alison Frantz ST 49.

216 Metope from the north frieze of the treasury, ca. 490–480: Herakles and the Hind. Delphi Museum. Ht. 67 cm. Photo: Hirmer Fotoarchiv 561.0610.

217 Detail of the metope, fig. 216. Photo: Alison Frantz ST 52.

218 Aristodikos, from near Mt. Olympos, Attica, ca. 500–490. Athens NM 3938. Ht. 1.95 m. The base is inscribed "Of Aristodikos." Photo: DAI Athens, NM 5041.

219 "Kritios Boy" from the Akropolis, ca. 490–480. Athens, Akropolis Museum 698. Ht. 1.17 m. Photographed after the head was taken off and reset at Jeffrey Hurwit's initiative in 1987: it is now turned rather farther away from frontal than before. Traces of red paint remain in the hair. Photo: J. Hurwit.

220 Head of the Kritian Boy, fig. 219. Photo: DAI Athens, Akr. 1617.

221 "Blond Boy" from the Akropolis, ca. 490–480. Athens, Akropolis Museum 689. Ht. 25 cm. A lower torso and upper thighs in the Akropolis Museum are often attributed to the same statue, but seem too small. The hair is blond. Photo: Alison Frantz AT 339.

222 "Blond Boy" with superimposed proportional scheme. Photo: author.

223 Head of the kore dedicated by Euthydikos, from the Akropolis, ca. 490–480. Akropolis Museum 686 (upper body). Ht. of fragment, 58 cm. Photo: DAI Athens.

224 a and b Kore dedicated by Euthydikos, from the Akropolis, ca. 490–480. Akropolis Museum 686 (a, upper body), 609 (b, feet and capital). Ht. 58 cm, 42 cm. Inscribed "Euthydikos son of Thaliarchos dedicated [me]." "Ghosts" of painted bands of decoration appear on the left shoulder of the chiton, of which the best preserved shows a race of four-horsed chariots. Originally set on a column. Photos: DAI Athens, Schr. 29 (686), Alison Frantz AT 520 (609).

225 Athena dedicated by Anghelitos and made by Euenor, from the Athenian Akropolis, ca. 480. Athens, Akropolis Museum 140. Ht. 77 cm. Sometimes associated with a column inscribed "Anghelitos dedicated me to the Mistress Athena. May you deli[ght in the gift]. Euenor made it." Traces of red survive on the back of the aegis, and the front carried a scale-pattern. Photo: DAI Athens 75.448.

226 a and b Attic red-figured cup attributed to the Foundry painter, from Vulci, ca. 490: bronze foundry. Berlin (East), Staatliche Museen 2294. W. 30.5 cm. Photos: UCLA Classics Archive.

227 The tyrannicides Harmodios and Aristogeiton by Kritios and Nesiotes (Roman copies), original 477/76. Naples, Museo Nazionale G103-4. Ht. 1.85 m. Aristogeiton's head is missing, and has been completed by a cast of the head in fig. 228. Photo: DAI Rome 1289.

228 Another copy of the Aristogeiton, fig. 227, from Rome, original 477/76. Rome, Museo Nazionale dei Conservatori 2404. Ht. 1.80 m. Parts of the legs are restored. Photo: DAI Rome 39.905.

229 Torso of a warrior from Daphni, Attica, ca. 490–480. Athens NM 1605. Ht. 73 cm. Photo: DAI Athens, NM 5170.

230 Roman plaster cast of the head of the Aristogeiton, from Baiae, original 477/76. Baiae, Deposito 174.479. Plaster. Ht. 21.6 cm. Photo: DAI Rome 78.1858.

231 Head of the Harmodios from the group, fig. 227. Photo: DAI Rome 58.1808.

232 Herm of Themistokles from Ostia (Roman copy), original, ca. 470. Museo Ostiense. Ht. 50 cm. Inscribed "Themistokles." Photo: DAI Rome 66.2287.

233 Another view of the Themistokles, fig. 232. Photo: DAI Rome 66.2290.

234 Attic red-figured pelike attributed to the Pan painter, ca. 470: three herms. Paris, Louvre C10793. Ht. 20 cm. Photo: Musée du Louvre.

235 Nike from Paros, ca. 470. Paros Museum 245. Ht. 1.38 m. Photo: DAI Athens, Paros 594.

236 West pediment of the temple of Apollo Daphnephoros at Eretria, ca. 500–490: Theseus and Antiope. Chalkis Museum 4. Ht. 1.10 m. Photo: Alison Frantz ST 31.

237 Head of Theseus, fig. 236. Photo: Alison Frantz ST 34.

238 West pediment of the temple of Apollo Daphnephoros at Eretria, ca. 500–490: Athena. Chalkis Museum 5. Ht. 74 cm. Photo: Alison Frantz ST 35.

239 Sanctuary of Aphaia at Aegina. Model in the Glyptothek, Munich. Photo: author.

240 West pediment (II) of the temple of Aphaia at Aegina, ca. 490–475: second sack of Troy, by the Greeks under Agamemnon. Munich, Glyptothek. Ht. 1.72 m, w. 15 m. Photo: author.

241 Detail of the Athena from the west pediment, fig. 240, ca. 490–475. Munich, Glyptothek. Ht. 1.72 m. Photo: author.

242 Head of the Athena, fig. 240. Photo: Staatliche Antikensammlungen und Glyptothek, Munich (Kaufmann).

243 Archer from the west pediment, fig. 240. Munich, Glyptothek. Ht. 1.04 m. Photo: Staatliche Antikensammlungen und Glyptothek, Munich.

244 Striding warrior from the west pediment (Ajax?), fig. 240. Munich, Glyptothek. Ht. 1.43 m. Photo: Staatliche Antikensammlungen und Glyptothek, Munich (Kaufmann).

245 Dying warrior from the west pediment, fig. 240. Munich, Glyptothek. L. 1.59 m. Photo: Staatliche Antikensammlungen und Glyptothek, Munich (Kaufmann).

246 Dying warrior from the east pediment (II), ca. 490–475. Munich, Glyptothek. L. 1.85 m. Photo: Staatliche Antikensammlungen und Glyptothek, Munich (Kaufmann).

247 Head of the dying warrior from the west pediment, fig. 245. Photo: Staatliche Antikensammlungen und Glyptothek, Munich (Kaufmann).

248 Head of the dying warrior from the east pediment, fig. 246. Photo: Staatliche Antikensammlungen und Glyptothek, Munich (Kaufmann).

249 Head of a warrior from the Athenian Akropolis, ca. 480. Athens NM 6446. Bronze. Ht. 25 cm. The helmet, made separately, is missing. Photo: Alinari 24455; Alinari/Art Resource, New York.

250 Head of Athena from the east pediment, fig. 251. Munich, Glyptothek. Ht. 31 cm. Photo: Staatliche Antikensammlungen und Glyptothek, Munich (Kaufmann).

251 East pediment (II) of the temple of Aphaia at Aegina, ca. 490–475: first sack of Troy, by Herakles and Telamon (left side). Munich, Glyptothek. Ht. 1.72 m, w. 15 m. Photo: Staatliche Antikensammlungen und Glyptothek, Munich (Kaufmann).

252 Herakles from the east pediment, fig. 251. Munich, Glyptothek. Ht. 79 cm. Photo: Staatliche Antikensammlungen und Glyptothek, Munich (Kaufmann).

253 Head of the Herakles from the east pediment, fig. 252. Photo: Staatliche Antikensammlungen und Glyptothek, Munich (Kaufmann).

254 Stele by Alxenor, from Orchomenos in Boeotia, ca. 490: a man offers a locust to a dog. Athens NM 39. Ht. 2.05 m. Inscribed "Alxenor of Naxos made me: just look!" Photo: Alinari 24366; Alinari/Art Resource, New York.

255 Statuette of an athlete pouring a libation, from Aderno in Sicily, ca. 470. Syracuse, Museo Nazionale Archeologico 31888. Bronze. Ht. 19.5 cm. Photo: Hirmer Fotoarchiv 601.3159.

256 Enthroned goddess from Taranto, ca. 470. Berlin (East), Staatliche Museen A17. Ht. 1.51 m. Photo: Staatliche Museen zu Berlin—DDR, Antikensammlung.

257 Metope from Temple E at Selinus, Sicily, ca. 470–450: Herakles and an Amazon. Palermo, Museo Nazionale Archeologico 3921A. Limestone, with the Amazon's head and feet inset in marble. Ht. 1.62 m. Photo: GFN C4212; Gabinetto Fotografico Nazionale, Rome.

258 Metope from Temple E at Selinus, Sicily, ca. 470–450: Zeus and Hera. Palermo, Museo Nazionale Archeologico 3921B. Limestone, with Hera's head, arms, and feet inset in marble. Ht. 1.62 m. Photo: Anderson 29198; Alinari/Art Resource, New York.

259 Metope from Temple E at Selinus, Sicily, ca. 470–450: Artemis and Actaeon. Palermo, Museo Nazionale Archeologico 3921C. Limestone, with Artemis's head and feet inset in marble. Ht. 1.62 m. Photo: Anderson 29199; Alinari/Art Resource, New York.

260 Head of Hera from the metope, fig. 258. Photo: GFN F1723; Gabinetto Fotografico Nazionale, Rome.

261 Attic red-figured calyx-krater attributed to the Niobid painter, from Orvieto, ca. 460–450: unexplained subject (Theseus and Peirithoos in Hades?). Paris, Louvre G341. Ht. 54 cm. Photo: Alinari 23684; Alinari/Art Resource, New York.

262 The sculptural program of the temple of Zeus at Olympia, ca. 470–457. Drawing by Candace Smith, based on J. J. Coulton, *Ancient and Greek Architects at Work* (1977): fig. 45.

263 Reconstruction of the pediments, ca. 470–457. Olympia Museum. Ht. 3.3 m, l. 26.4 m. Drawing by Candace Smith.

264 East pediment of the temple of Zeus at Olympia: central group of Pelops (G), Zeus (H), and Oinomaos (I). Olympia Museum. Original ht. of Zeus, ca. 3.15 m. Holes indicate that Pelops was given a bronze corselet at some later time; Zeus carried a thunderbolt in his left hand. Photo: Hirmer Fotoarchiv 561.0652.

265 East pediment of the temple of Zeus at Olympia: Hippodameia (K). Olympia Museum. Original ht. ca. 2.6 m. Photo: Alison Frantz PE 82.

266 East pediment of the temple of Zeus at Olympia: Sterope (F). Olympia Museum. Original ht. ca. 2.6 m. Photo: Alison Frantz PE 109.

267 East pediment of the temple of Zeus at Olympia: seer (N), perhaps Amythaon. Olympia Museum. Ht. 1.38 m. Photo: Alison Frantz PE 32.

268 East pediment of the temple of Zeus at Olympia: boy (E), perhaps Melampous. Olympia Museum. Original ht. ca. 1.1 m. Photo: Bildarchiv Foto Marburg 774; Marburg/Art Resource, New York.

269 Head of the seer, fig. 267. Photo: UCLA Classics Archive.

270 West pediment of the temple of Zeus at Olympia: Apollo (L). Olympia Museum. Original ht. ca. 3.1 m. He carried a bronze bow and arrow in his left hand. Photo: Bildarchiv Foto Marburg 134462; Marburg/Art Resource, New York.

271 West pediment of the temple of Zeus at Olympia: Eurytion (H) and Deidameia (I). Olympia Museum. Ht. 2.35 m. Eurytion once wore a metal crown. Photo: Alison Frantz 74.217.

272 West pediment of the temple of Zeus at Olympia: Centaur (P) and Lapith (Q). Olympia Museum. Ht. 2.05 m. Photo: Bildarchiv Foto Marburg 814; Marburg/Art Resource, New York.

273 Head of Deidameia, fig. 271. Photo: UCLA Classics Archive.

274 West pediment of the temple of Zeus at Olympia: detail of Lapith girl (E). Olympia Museum. Ht. of girl, 1.65 m. Photo: Bildarchiv Foto Marburg 809; Marburg/Art Resource, New York.

275 West pediment of the temple of Zeus at Olympia: Centaur (D). Olympia Museum. Ht. of fragment, 34 cm. Photo: Alison Frantz PE 136.

276 West pediment of the temple of Zeus at Olympia: Centaur (R), Lapith (S), and Lapith girl (T). Olympia Museum. Original ht. ca. 1.65 m. Photo: Alison Frantz PE 184.

277 Metope 3 from the temple of Zeus at Olympia: Herakles, Athena, and the Stymphalian Birds. Olympia Museum and Louvre, Paris. Ht. 1.6 m. The Athena, and the head and right arm of Herakles are original, the rest is completed with plaster casts of the fragments in Olympia. Traces of red were once detectable in the hair of the two figures, Herakles' beard, and Athena's aegis. Photo: Alison Frantz EU 303.

278 Metope 4 from the temple of Zeus at Olympia: Herakles and the Bull. Olympia Museum and Louvre, Paris. Ht. 1.6 m. The upper two-thirds, except the head of the Bull, is a plaster cast of the fragments in Paris. The background was blue, the bull was red-brown, and Herakles' hair was red. Photo: DAI Athens, Hege 560.

279 Metope 10 from the temple of Zeus at Olympia: Herakles, Athena, and Atlas with the Apples of the Hesperides. Olympia Museum. Ht. 1.6 m. Photo: Alison Frantz PE 33.

280 Metope 12 from the temple of Zeus at Olympia: Herakles, Athena, and the Augean Stables. Olympia Museum. Ht. 1.6 m. Photo: Alinari 24823; Alinari/Art Resource, New York.

281 Athena from metope 10, fig. 279. Photo: Bildarchiv Foto Marburg 866; Marburg/Art Resource, New York.

282 Detail of Athena from metope 12, fig. 280. Photo: Alison Frantz PE 237.

283 Detail of Athena from metope 3, fig. 277. Photo: L. Goldscheider.

284 Head of Herakles from metope 10, fig. 279. Photo: Bildarchiv Foto Marburg 863; Marburg/Art Resource, New York.

285 "Choiseul-Gouffier" Apollo (Roman copy), original ca. 470. Provenance unknown. London, BM 209. Ht. 1.78 m. Copies same original as the "Omphalos Apollo," fig. 286. Photo: BM CVIII-C23; Trustees of the British Museum.

286 "Omphalos Apollo" (Roman copy), from the Theater of Dionysos in Athens, original ca. 470. Athens NM 45. Ht. 1.76 m. The omphalos found nearby did not serve as the base to the statue, as once thought. Photo: Marburg/Art Resource, New York.

287 Zeus from Cape Artemision, ca. 450. Athens NM Br. 15161. Bronze. Ht. 2.09 m., span 2.10 m. Photo: Hirmer Fotoarchiv 561.0429.

288 Head of the Zeus, fig. 287. Photo: DAI Athens, NM 4539.

289 Statuette of Zeus from Dodona, ca. 470. Berlin (East) Staatliche Museen 10561. Bronze. Ht. 13.5 cm. Photo: UCLA Classics Archive.

290 Athena attributed to Myron (Roman copy), original ca. 450. Frankfurt 147. Ht. 1.73 m. Photo: Giraudon IA 23782; Giraudon/Art Resource, New York.

291 Marsyas attributed to Myron (Roman copy), original ca. 450. Rome, Museo Gregoriano Profano (ex-Lateran) BS 225. Ht. 1.59 m. Photo: Anderson 1837; Alinari/Art Resource, New York.

292 Warrior A from the sea off Riace Marina (Italy), ca. 460–440. Reggio Calabria, Museo Nazionale. Bronze. Ht. 1.98 m. Photo: Alinari 67000; Alinari/Art Resource, New York.

293 Warrior B from the sea off Riace Marina (Italy), ca. 460–440. Reggio Calabria, Museo Nazionale. Bronze. Ht. 1.97 m. Photo: Alinari 67017; Alinari/Art Resource, New York.

294 Head of warrior A from the sea off Riace Marina (Italy), fig. 292. Photo: Alinari/Art Resource, New York.

295a Torso of warrior A, fig. 292. Photo: Alinari 67006; Alinari/Art Resource, New York.

295b Right hand of warrior A, fig. 292. Photo: Alinari 67015; Alinari/Art Resource, New York.

296 Head and torso of warrior B, fig. 293. Photo: Alinari 67023; Alinari/Art Resource, New York.

297 "Charioteer" from Motya (W. Sicily), ca. 470–450. Marsala, Museo Archeologico. Ht. 1.81 m. Photo: author.

298 Detail of the drapery of the "Charioteer," fig. 297. Photo: author.

299 Herm of Pindar (Roman copy), original ca. 450. Provenance unknown. Rome, Museo Capitolino 587. Ht. 54 cm. Formerly believed to be the Spartan general Pausanias, but identified as Pindar by an inscribed bust

found at Aphrodisias in 1981. Photo: Anderson 1587; Alinari/Art Resource, New York.

300 "Lancellotti" Diskobolos (Roman copy), from Rome, original ca. 450. Rome, Museo Nazionale Romano (Terme) 126371. Ht. 1.55 m. Attributed to Myron. Photo: Alinari 50231; Alinari/Art Resource, New York.

301 Charioteer, part of a chariot group dedicated by Polyzalos of Gela at Delphi. Dedicated after a victory either in 478 or 474. Delphi Museum. Bronze. Ht. 1.80 m. As restored, the fragmentary inscription on the base reads: "Polyzalos, victorious with his horses, dedicated me; / Deinomenes' son, whom, honored Apollo, make to prosper." The first line was reinscribed, presumably after his fall from power; it originally read: "Polyzalos, Lord of Gela, dedicated me, this memorial; / Deinomenes' son. . . . " Photo: UCLA Classics Archive.

302 Head of the charioteer, fig. 301. Photo: Emile Serafis.

303 Stele of a youth crowning himself, from Sounion, ca. 470. Athens, NM 3344. Ht. 48 cm. Found with the cache of kouroi, figs. 44–46, at Sounion in 1915. The background was blue, the hair yellow. Photo: Emile Serafis.

304 Grave stele of a young girl holding two doves, from Paros, ca. 460. New York, MMA 27.45. Ht. 80 cm. Photo: Metropolitan Museum of Art, New York, Fletcher Fund, 1927 (27.45).

305 Grave stele of a girl ("Giustiniani stele"), perhaps from Paros, ca. 460–450. Berlin (East), Staatliche Museen 1482. Ht. 1.43 m. She lifts a necklace(?), originally rendered in paint, from a box. Photo: Staatliche Museen zu Berlin—DDR, Antikensammlung, Bard 4.

306 "Ludovisi Throne," probably an altar, from Rome (Gardens of Sallust), ca. 460–50: two women help Aphrodite from the sea, flanked on the sides by a flutegirl and an acolyte burning incense. Rome, Museo Nazionale Romano (Terme) 8570. Ht. 1.04 m. Photo: Alinari 20112; Alinari/Art Resource, New York.

307 Head of the Aphrodite, fig. 306. Photo: Alinari 20113A; Alinari/Art Resource, New York.

308 Right side of the "throne," fig. 306. Photo: Alinari 20114; Alinari/Art Resource, New York.

309 "Boston Throne," acquired in Rome, purportedly ca. 460–450: an Eros weighs souls in the presence of two women (the left rejoicing, the right mourning), flanked on the sides by an old woman spinning and a youth playing the lyre. Boston, MFA 08.205. Ht. 96 cm. Though electron beam microprobe analysis has proved that the weathering layer on the back is ancient, the reliefs themselves were probably carved in the nineteenth century. Photo: UCLA Classics Archive.

310 Left side of the "throne," fig. 309. Photo: UCLA Classics Archive.

311 Right side of the "throne," fig. 309. Photo: UCLA Classics Archive.

312 "Kassel" Apollo (Roman copy), original ca. 450. Bought in Rome. Ht. 1.97 m. Photo: Staatliche Kunstsammlungen Kassel A-51825.

313 Composite cast of the "Lemnian" Athena, original ca. 450. Rome, Museo delle Gessi. Head (Roman copy): Bologna, Museo Civico; body (Roman copy): Dresden, Staatliche Kunstsammlungen (Albertinum) 50. Plaster, from marble originals. Ht. 2.19 m. The association between the two parts, made by Furtwängler in the nineteenth century, has recently been challenged (Hartswick 1983). Photo: GFN E2343; Gabinetto Fotografico Nazionale, Rome.

314 Head of the "Lemnian" Athena (Roman copy), original ca. 450. Provenance unknown. Bologna, Museo Civico. Ht. ca. 60 cm. Photo: DAI Rome 62.69.

315 The Akropolis. Plan. Key: (1) Temple of Athena Nike, (2) Propylaia, (3) Athena Promachos of Pheidias, (4) Erechtheion, (5) ruins of the Old Temple of Athena, (6) Parthenon. From Hesperia 5 (1936): 518, fig. 66.

316 View of the Parthenon. Photo: Alison Frantz AT2.

317 Cutaway of the Parthenon. Photo: G. Becatti, from W. B. Niemann, Berliner Bibliothekenführer für Stüdierende der technischen Hochschule (Berlin, 1926).

318 The sculptural program of the Parthenon, 447–432. Drawing by Candace Smith, based on J. J. Coulton, Ancient and Greek Architects at Work (1977): fig. 45.

319 South metope 4 from the Parthenon, 447–442: Lapith and Centaur. London, BM 307. Ht. 1.36 m. Photo: Trustees of the British Museum.

320 South metope 27 from the Parthenon, 447–442: Lapith and Centaur. London, BM 316. Ht. 1.37 m. Photo: BM XXII.D.48; Trustees of the British Museum.

321 Torso of Lapith from metope 27, fig. 320. Photo: G. Becatti.

322 South metope 28 from the Parthenon: Lapith and Centaur, 447–442. London, BM 317. Ht. 1.33 m. Photo: Trustees of the British Museum.

323 South metope 31 from the Parthenon: Lapith and Centaur, 447–442. London, BM 320. Ht. 1.32 m. Photo: BM VIII.E.9; Trustees of the British Museum.

324 Head of Centaur from metope 31, fig. 323. Photo: BM C1564; Trustees of the British Museum.

325 South metopes 9–16 from the Parthenon. Drawings by Jacques Carrey, 1674. Paris, Cabinet des Médailles. Photo: DAI Athens 31.644.

326 South metopes 17–24 from the Parthenon. Drawings by Jacques Carrey, 1674. Paris, Cabinet des Médailles. Photo: G. Becatti.

327 West frieze of the Parthenon, 442–438: view from below. Ht. of frieze, 1.06 m. Photo: Alison Frantz AT 27.

328 West frieze of the Parthenon: slabs vii–x in situ. Photo: Alison Frantz AT 29.

329 West frieze of the Parthenon, 442–438: two riders (ii.2, 3). London, BM 326. Ht. 1.06 m. Photo: BM XXIX.C44; Trustees of the British Museum.

330 West frieze of the Parthenon: diagonal views. From Stillwell 1969: pl. 61.

331 West frieze of the Parthenon: man restraining his horse (viii.15). In situ. Photo: Underwood and Underwood (California Institute of Photography, Riverside, V 17135).

332 West frieze of the Parthenon: detail of rider (ii.2), from fig. 329. Photo: Alison Frantz EV 190.

333 North frieze of the Parthenon, 442–438: riders preparing to mount (xlii.130-34). London, BM 325. Ht. 1.06 m. Photo: BM PS 055694; Trustees of the British Museum.

334 North frieze of the Parthenon, 442–438: detail of horse and rider (xxxix.122). London, BM 325. Ht. 1.06 m. Photo: Schneider-Lengyel.

335 North frieze of the Parthenon, 442–438: cavalcade (xxxvi–ix). London, BM 325. Photo: Hirmer Fotoarchiv 561.0131.

336 North frieze of the Parthenon, 442–438: detail of cavalcade, fig. 335 (xxxvii.113–16). London, BM 325. Ht. 1.06 m. Photo: BM V.E.26; Trustees of the British Museum.

337 North frieze of the Parthenon, 442–438: apobatai (xvii.56–58). London, BM 325. Plaster cast of original in Athens. Ht. 1.06 m. Photo: DAI Athens, Akr. 1799.

338 North frieze of the Parthenon, 442–438: hydriaphoroi (vi.16–19). London, BM 325. Ht. 1.06 m. Photo: DAI Athens 72.2984.

339 South frieze of the Parthenon, 442–438: xxx.73–74. London, BM 327. Ht. 1.06 m. Photo: BM VI.E.32; Trustees of the British Museum.

340 South frieze of the Parthenon: detail of horses (xxx.73–74), fig. 339. Photo: G. Becatti.

341 South frieze of the Parthenon, 442–438: sacrificial procession; youths restraining a cow, and two youths leading a cow (xxxix–xl.109–18). Ht. 1.06 m. Photo: BM VI.E.25 and 45; Trustees of the British Museum.

342 East frieze of the Parthenon, central slab, 442–438. Top: Ares, Nike (or Iris), Hera, Zeus; two acolytes with stools. Center: the priestess of Athena receives the two acolytes with stools, while the archon Basileus takes the peplos from another acolyte; Athena, Hephaistos (v.28–37). London, BM 324. Ht. 1.06 m. Photos: BM PS 055715, C-2389, and PS 0557188; Trustees of the British Museum.

343 East frieze of the Parthenon, 442–438: Poseidon, Apollo, Artemis, Aphrodite, and Eros (vi.38–42). London, BM 324. Ht. 1.06 m. Photo: DAI Athens 72.2987.

344 East frieze of the Parthenon: detail of Artemis, fig. 343 (vi.40). Photo: Alison Frantz AT 155.

345 East frieze of the Parthenon, 442–438: "Eponymous heroes" (vi.42–48). Plaster cast of severely damaged original in London (BM 324), in the Ecole des Beaux-Arts, Paris. Ht. 1.06 m. Photo: Giraudon PE 1652; Giraudon/Art Resource, New York.

346 East frieze of the Parthenon, 442–438: girls (vii.49–56). Paris, Louvre MA 738. Ht. 1.06 m. Photo: Photo Bulloz 8648.

347 East pediment of the Parthenon (the birth of Athena), 438–432: Helios (A–C), Dionysos (D), Kore (E), Demeter (F), Artemis (G). London, BM 303. Ht. (of G) 1.73 m. Photo: BM C.1695; Trustees of the British Museum.

348 East pediment of the Parthenon, 438–432: Dionysos (D). London, BM 303. Ht. 1.21 m. Photo: G. Becatti.

349 East pediment of the Parthenon, 438–432: Kore (E), Demeter (F), Artemis (G). London, BM 303. Ht. (of G) 1.73 m. Photo: Hirmer Fotoarchiv 561.0102.

350 East pediment of the Parthenon, 438–432: Hestia (K), Dione (or Themis) (L), and Aphrodite (M). London, BM 303. Ht. (of K) 1.30 m. Photo: Trustees of the British Museum.

351 East pediment of the Parthenon: detail of Dione/Themis (L) and Aphrodite (M), fig. 350. Photo: Schneider-Lengyel 80.

352 East pediment of the Parthenon: detail of Aphrodite (M), fig. 350. Photo: BM LI.B.23; Trustees of the British Museum.

353 East pediment of the Parthenon, 438–432: horse from Selene's chariot (O). London, BM 303. L. 82 cm. Photo: BM C.1693; Trustees of the British Museum.

354 West pediment of the Parthenon (the contest between Athena and Poseidon). Drawing by Jacques Carrey, 1674. Paris, Cabinet des Médailles. Photo: Giraudon 8803; Giraudon/Art Resource, New York.

355 West pediment of the Parthenon (the contest between Athena and Poseidon). Drawing by Jacques Carrey, 1674. Paris, Cabinet des Médailles. Photo: Giraudon 8804; Giraudon/Art Resource, New York.

356 West pediment of the Parthenon, 438–432: reclining hero or divinity,

perhaps the river Ilissos (A). London, BM 304. L. 1.56 m. Photo: BM XIX.D.28; Trustees of the British Museum.

357 West pediment of the Parthenon, 438–432: Hermes (H). London, BM 304. Ht. 1.15 m. Photo: Trustees of the British Museum.

358 West pediment of the Parthenon, 438–432: Hermes (H). London, BM 304. Ht. 1.15 m. Photo: BM C.2383; Trustees of the British Museum.

359 West pediment of the Parthenon, 438–432: Poseidon (M). AkrM 885. Ht. 83 cm. The upper part is a cast of the fragment in the British Museum, BM 324. Photo: DAI Athens, Akr 2274.

360 West pediment of the Parthenon, 438–432: Iris (N). London, BM 304. Ht. 1.35 m. Photo: J. Ross 25.

361 Reconstruction of the Parthenon's interior with statue of Athena Parthenos, 447–438. Drawing by Candace Smith.

362 Small-scale replica of Athena Parthenos (Roman copy, "Varvakeion Athena"), from Athens, original 447–438. Athens, NM 129. Ht. 1.045 m. Photo: Alinari 24215; Alinari/Art Resource, New York.

363 Head of the Athena, fig 362. Photo: Alinari 24217; Alinari/Art Resource, New York.

364 Neo-Attic relief excerpted from shield of Athena Parthenos (Roman copy), from Piraeus harbor, original 447–438: fighting Amazon. Piraeus Museum. Ht. of fragment, 19 cm. Photo: G. Becatti.

365 Shield of Athena Parthenos ("Strangford Shield"; Roman copy), from Athens, original 447–438: Amazonomachy. London, BM 302. D. 50 cm. Photo: BM LVII-C.43; Trustees of the British Museum.

366 Detail of the Strangford shield, fig. 365: supposed portraits of Pheidias and Perikles. Photo: BM XX-C.36; Trustees of the British Museum.

367 Shield of Athena Parthenos (Roman copy), from Patras, original 447–438: Amazonomachy. Patras Museum. D. 45 cm. Photo: DAI Athens 73.2291.

368 Attic red-figured calyx-krater from Ruvo, ca. 400: Gigantomachy. Naples, Museo Nazionale 2883. Original ht. ca. 31 cm. Photo: Hirmer Fotoarchiv 571.0542.

369 Reconstruction of the shield of the Athena Parthenos. From Harrison 1981: 297, ill. 4.

370 Neo-Attic relief excerpted from the shield of Athena Parthenos (Roman copy), from Piraeus harbor, original, 447–438: Greek and Amazon, with architectural background. Piraeus Museum. Ht. 90 cm. Photo: DAI Athens, Pir. 150.

371 Neo-Attic relief excerpted from the shield of Athena Parthenos (Roman copy), from Piraeus harbor, original, 447–438: Greek and Amazon. Piraeus Museum. Ht. 90 cm. Photo: DAI Athens, Pir. 149.

372 Hadrianic sestertii of Elis, A.D. 133: Zeus. Berlin, Staatliche Münzkabinett, and Florence, Museo Nazionale Archeologico. Silver. D. 3 cm. From J. Liegle, Der Zeus des Phidias (Berlin, 1922): pl. 1.

373 Fragment of an Attic red-figured bell-krater from Baksy (South Russia), ca. 400: above, Zeus on his throne, which is embellished with a Niobid frieze; below, two riders. Leningrad, Hermitage, Baksy no. 8. Ht. of vase, ca. 74 cm. The Zeus quotes the Zeus at Olympia, the two riders the pair from the west frieze of the Parthenon, fig. 329. Photo: B. Shefton.

374 Reconstruction of the krater, fig. 373. The arrangement of the Hera, Zeus, and Athena duplicates that of the east pediment of the Parthenon. From Shefton 1982: 150, fig. 3.

375 Frieze of Niobids (Roman copy), original ca. 430–420. Rome, Villa Albani 885. Ht. 53 cm. The left half of the relief and parts of the limbs of the figures to the right are restored. Photo: Alinari 27611; Alinari/Art Resource, New York.

376 Mold for drapery, from the workshop of Pheidias at Olympia, ca. 430–420. Olympia Museum. Terracotta. Ht. 32 cm. Photo: DAI Athens, Ol. 4018.

377 Tools, from the workshop of Pheidias at Olympia, ca. 430–420. Olympia Museum. Photo: DAI Athens, Ol. 4009.

378 Doryphoros of Polykleitos (Roman copy), from the Palaestra at Pompeii, original ca. 440. Naples, Museo Nazionale Archaeologico 6146. Ht. 2.12 m. Photo: Anderson 23079; Alinari/Art Resource, New York.

379 Doryphoros of Polykleitos (Roman copy), from the Mediterranean sea off Italy, original ca. 440. Minneapolis Institute of Arts 86.6. Ht. 1.98 m. Photo: The Minneapolis Institute of Arts.

380 Herm of Doryphoros of Polykleitos (Roman copy), from the Villa dei Papiri at Herculaneum, original ca. 440. Naples, Museo Nazionale 4885. Bronze. Ht. 54 cm. Signed "Apollonios son of Archias of Athens made [it]." Photo: DAI Rome 64.1804.

381 Left profile of the herm, fig. 380. Photo: DAI Rome 67.582.

382 Reconstruction of the Doryphoros of Polykleitos, indicating chiasmus, original ca. 440. Drawing by Candace Smith.

383 Diadoumenos of Polykleitos (Roman copy), from Delos, original ca. 430. Athens NM 1826. Ht. 1.86 m. Photo: DAI Athens, NM 5321.

384 Head of the Diadoumenos, fig. 383. Photo: DAI Athens, NM 5326.

385 Left profile of the head, fig. 384. Photo: DAI Athens, NM 5327.

386 Athlete crowning himself ("Westmacott boy"; Roman copy), original ca. 450–420. Provenance unknown. London, BM 1754. Ht. 1.49 m.

The left hand is restored. Photo: BM I-D(27); Trustees of the British Museum.

387 Modern cast of another Roman copy of the "Westmacott boy" from Castelgandolfo, with buttocks and thighs of an ancient cast from Baiae inserted, original ca. 450–420. Roman copy in Castelgandolfo, Villa Papale; ancient plaster cast in Baiae, Deposito; modern cast in Basel, Skulpturhalle. Plaster. Ht. 1.20 m.

388 Wounded Amazon ("Sosikles Amazon"; Roman copy), from Italy, original ca. 430. Rome, Museo Capitolino 651. Ht. 2.02 m. Inscribed "Sosikles" on the support. The nose, right arm, lower left arm and hand, drapery curling away from the wound, and some drapery folds are restored. Photo: Anderson 1645; Alinari/Art Resource, New York.

389 Wounded Amazon ("Mattei" type; Roman copy), from Italy, original ca. 430. Rome, Museo Capitolino 733. Ht. 1.97 m. The head, from a replica of the "Sosikles" type, is alien; the right arm, upper left arm, bow, right foot, lower left thigh and knee, and plinth are restored. Photo: Alinari 597; Alinari/Art Resource, New York.

390 Wounded Amazon ("Sciarra" type; Roman copy), from Italy, original ca. 430. Vatican 2252. Ht. 1.98 m. The nose, parts of the lips and neck, both arms, right leg, lower left leg, quiver, tree-trunk, and plinth are restored. Photo: Alinari 6486; Alinari/Art Resource, New York.

391 Head of "Sosikles Amazon" type (Roman copy), from Rome, original ca. 430. Rome, Palazzo dei Conservatori 1091. Ht. 31 cm. The tip of the nose is restored. Photo: Brogi 16651.

392 Quiver of the "Mattei" Amazon, fig. 389. Photo: DAI Rome 75.2236.

393 Ancient cast of the girdle and adjacent area of the chiton of the "Mattei" Amazon, from Baiae (Italy), original ca. 430. Baiae (Thermae) 174.693. Plaster. Ht. 16 cm. Photo: DAI Rome 78.1854.

394 Detail of the girdle area of the "Mattei" Amazon, fig. 389. Photo: Dr. Klaus Fittschen.

395 Ancient cast of the right foot of the "Mattei" Amazon, from Baiae (Italy), original, ca. 430. Baiae (Thermae) 174.531. Plaster. L. 11 cm. Photo: DAI Rome 78.1786.

396 Detail of the right foot of a copy of the "Mattei" Amazon, Vatican 748. Photo: Dr. Klaus Fittschen.

397 Perikles attributed to Kresilas (Roman copy), from Tivoli, original ca. 425. London, BM 549. Ht. 48 cm. Inscribed "Perikles." The nose is restored. Photo: G. Becatti.

398 Perikles attributed to Kresilas (Roman copy), from Lesbos, original ca. 425. Berlin, Staatliche Museen SK 1530. Ht. 54 cm. Photo: Berlin SK 3212b.

399 Prokne and Itys dedicated by Alkamenes, from the Akropolis, ca. 430–420. Athens, Akropolis Museum 1358. Ht. 1.63 m. Photo: DAI Athens 75.421.

400 Hermes Propylaios by Alkamenes (Roman copy), from Pergamon, ca. 430–420. Istanbul, Archaeological Museum 527. Ht. 1.19 m. For the inscription, see T 73a. Photo: GFN N43091; Gabinetto Fotografico Nazionale, Rome.

401 "Borghese Ares" (Roman copy), from Italy, original ca. 420–400. Paris, Louvre MA 866. Ht. 2.11 m. Photo: Musée du Louvre, Paris.

402 "Farnese Athena" (Roman copy), from Italy, original ca. 420–400. Naples, Museo Archeologico 6024. Ht. 2.24 m. The arms and the animals on the helmet are restored. Photo: Anderson 23147; Alinari/Art Resource, New York.

403 Reconstruction of the Nemesis of Rhamnous by Agorakritos of Paros, original ca. 430–420. Ht. 4.5 m., with base, 5.4 m. From G. I. Despinis, Praktika (1979): 14, fig. 6.

404 Nemesis of Rhamnous (Roman copy, reduced in size), original ca. 430–420. Copenhagen, Ny Carlsberg Glyptotek 304a. Ht. 1.85 m. Photo: Ny Carlsberg Glyptotek, Copenhagen.

405 Fragment from the right side of the chiton overfold of the Nemesis, ca. 430–420. Athens NM. Ht. 49.5 cm. Photo: National Archeological Museum, Athens.

406 Corresponding area of another reduced copy of the Nemesis, from Athens, original ca. 430–420. Athens NM 3949. Ht. 1.9 m. Photo: author.

407 Relief with figures excerpted from the base of the Nemesis, fig. 403 (Roman copy), from the Tiber near Marmorato, original ca. 430–420. Stockholm, Nationalmuseum Sk 150. Ht. 54 cm. The right forearm of the right-hand figure and other minor details are restored. Photo: Stockholm C 4188.

408 Nike by Paionios, dedicated by the Messenians and Naupaktians at Olympia, ca. 420. Olympia Museum 46-8. Ht. 1.95 m, originally set on a 9 m-high pillar. For the inscription, see T 81. Photo: Emile Serafis.

409 Right profile of the Nike, fig. 408. Photo: DAI Athens, Hege 667.

410 Model of the Nike, fig. 408. Olympia Museum. Photo: Alinari 28454; Alinari/Art Resource, New York.

411 Detail of Nike of Paionios, fig. 408. Photo: DAI Athens 79.763.

412 Attic red-figured hydria attributed to the Meidias Painter, ca. 410: rape of the Leukippidai. London, BM E 224. Ht. 52.1 cm. Photo: Hirmer Fotoarchiv 561.0232.

413 View of the temple of Athena Nike, showing east and south friezes,

ca. 420: assembly of the gods and battle between Greeks and Persians (Marathon?). Ht. of friezes, 45 cm. The south frieze is a concrete cast of the original in the British Museum. Photo: author.

414 The sculptural program of the temple of Athena Nike, ca. 420. Drawing by Candace Smith, after Dinsmoor, *The Architecture of Ancient Greece* (1975): fig. 68.

415 South frieze, ca. 420: center of the battle. London, BM 424. Ht. 45 cm. Photo: BM LXXXV-C(31); Trustees of the British Museum.

416 South frieze, ca. 420: the Persian defeat. London, BM 423. Ht. 45 cm. Photo: BM LXXXV-C(30); Trustees of the British Museum.

417 West frieze, ca. 420: Greeks fight Greeks. London, BM 422. Ht. 45 cm. Photo: BM LXXXV-D(2); Trustees of the British Museum.

418 East frieze, ca. 420: Assembly of the gods (at far right, Poseidon and Athena). Plaster cast. Ht. 45 cm. From Blümel 1950/51: fig. 17.

419 Parapet, ca. 420–400: Athena and a Nike. Athens, Akropolis Museum 989. Ht. 1.01 m. Photo: Alison Frantz AT 138.

420 Nike binding her sandal, ca. 420–400. Athens, Akropolis Museum 973. Ht. 1.01 m. Photo: Alison Frantz AT 136; Trustees of the British Museum.

421 Nikai and bull, ca. 420–400. Athens, Akropolis Museum 972. Ht. 1.01 m. Photo: Alison Frantz AT137.

422 Roman version of a slab of the parapet, original, ca. 420–400: two women and a bull. Provenance unknown. Florence, Uffizi 330. Ht. 68 cm. Photo: Alinari 29351; Alinari/Art Resource, New York.

423 Detail of the right-hand Nike, fig. 421. Photo: author.

424 Standing Nike, ca. 420–400. Athens, Akropolis Museum 1003. Ht. 1.01 m. Photo: author.

425 Agora Aphrodite, ca. 420. Athens, Agora S1882. Ht. 1.83 m. Photo: Agora 82-214.

426 Aphrodite ("Fréjus/Genetrix" Aphrodite; Roman copy), original ca. 410. Provenance unknown. Paris, Louvre MA 525. Ht. 1.65 m. The head has been re-set on the body. Photo: Alinari 22752; Alinari/Art Resource, New York.

427 Votive relief to the river god Kephisos, dedicated by Xenokrateia, ca. 410. From New Phaleron, near Athens. Athens NM 2756. Ht. 57 cm. Its base is inscribed: "Xenokrateia founded the sanctuary of Kephisos and dedicated this gift from the dramatic competitions to the gods who hold altars in common; Xenokrateia the daughter of Xeniades and mother of Xeniades, from Kollyte. Sacrifice to whom you wish in thanks for your goods." Photo: TAP Photo Service.

428 Grave relief ("Albani" relief), from Rome, ca. 420–410. Rome, Villa Albani 985. Ht. 1.80 m. Photo: DAI Rome.

429 Grave relief ("cat" stele), supposedly from Aegina or Salamis, ca. 420. Athens NM 715. Ht. 1.04 m. Photo: Emile Serafis.

430 Gravestone of Ktesileos and Theano, from Athens, ca. 410–400. Athens, NM 3472. Ht. 93 cm. Inscribed "Ktesileos; Theano." Photo: Hirmer Fotoarchiv 561.0443.

431 The Erechtheion on the Athenian Akropolis, ca. 420–406. Three-quarter view of south porch. Ht. of korai (Caryatids) 2.31 m. Since this photograph was taken the korai have been removed to the Akropolis Museum and replaced with concrete casts. Photo: Alison Frantz AT 44.

432 Kore (Caryatid) from the south porch of the Erechtheion, 420–410. Now removed to the Akropolis Museum. Ht. 2.31 m. Photo: Alison Frantz AT 122; Trustees of the British Museum.

433 Frieze fragment from the Erechtheion, 409–406. Athens, Akropolis Museum 1077. Ht. of frieze, 49 cm. Photo: Alison Frantz AT 141.

434 Frieze fragment from the Erechtheion, 409–406. Athens, Akropolis Museum 1071. Ht. of frieze, 49 cm. Photo: Alison Frantz AT 145.

435 Frieze fragment from the Erechtheion, 409–406. Athens, Akropolis Museum 1074. Ht. of frieze, 49 cm. Photo: Alison Frantz AT 142.

436 Relief of dancing maenad attributed to Kallimachos (Roman copy), from Rome, original ca. 410–400. Rome, Palazzo dei Conservatori 1094. Ht. 1.43 m. Photo: Alinari 29354; Alinari/Art Resource, New York.

437 Relief of dancing maenad attributed to Kallimachos (Roman copy), original, ca. 410–400. Provenance unknown. Madrid, Prado 42. Ht. 1.41 m. Photo: UCLA Art Library 91027.

438 Document relief from the Akropolis, for a decree honoring Samos, 403. Athens, Akropolis 1333. Ht. 1.13 m. Photo: DAI Athens 72/3003.

439 Diomedes (Roman copy), from Cumae, original ca. 420. Naples, Museo Archeologico 144978. Ht. 1.77 m. Photo: DAI Rome 66.1832.

440 Another copy of the Diomedes, fig. 439, from Italy, original ca. 420. Munich, Glyptothek 302. Ht. 1.02 m. Photo: Koppermann 304.1; Staatliche Antikensammlungen und Glyptothek, Munich.

441 Base of the (now lost) dedication of the Argives at Delphi, by Antiphanes of Argos, ca. 370–360: Herakles and the kings of Argos. Delphi, in situ. D. 13.7 m. From Arnold 1969, fig. 40c.

442 Diskobolos (Roman copy) sometimes attributed to Naukydes of Argos, from Rome, original ca. 400. Paris, Louvre MA 89. Ht. 1.66 m. The head does not belong, and the legs are restored. Photo: Anderson 1365; Alinari/Art Resource, New York.

443 Statuette of Phrixos holding the ram's head, possibly after a bronze by Naukydes of Argos, original ca. 400. Provenance unknown. Malibu, J. Paul Getty Museum 58.AB.6. Bronze. Ht. 17.5 cm. Photo: The J. Paul Getty Museum.

444 Head of a Greek from a metope of the Argive Heraion, ca. 420–400: Amazonomachy. Athens NM 1573. Ht. 17 cm. Photo: author.

445 Head of an Amazon from the metopes of the Argive Heraion, ca. 420–400. Athens NM 1562. Ht. 15 cm. Photo: author.

446 Head of a Greek from the metopes of the Argive Heraion, ca. 420–400. Athens NM 1568. Ht. 16 cm. Photo: author.

447 Greek from the metopes of the Argive Heraion, ca. 420–400. Athens NM 1572. Plaster cast in the Museum of Classical Archaeology, Cambridge, from original marble in Athens. Ht. 55 cm. Photo: author.

448 Program of the temple of Apollo at Bassai/Phigaleia, ca. 400. Drawing by Candace Smith, based on J. J. Coulton, *Ancient and Greek Architects at Work* (1977): 116.

449 Amazonomachy from the temple of Apollo at Bassai/Phigaleia, ca. 400. London, BM 531. Ht. 64 cm. Photo: Trustees of the British Museum.

450 Amazonomachy from the temple of Apollo at Bassai/Phigaleia, ca. 400. London, BM 535. Ht. 64 cm. Photo: Trustees of the British Museum.

451 Centauromachy from the temple of Apollo at Bassai/Phigaleia, ca. 400. London, BM 524. Ht. 64 cm. Photo: Trustees of the British Museum.

452 Centauromachy from the temple of Apollo at Bassai/Phigaleia, ca. 400. London, BM 527. Ht. 64 cm. Photo: Trustees of the British Museum.

453 Centauromachy from the temple of Apollo at Bassai/Phigaleia, ca. 400: detail. London, BM 521. Ht. 64 cm. Photo: Trustees of the British Museum.

454 Metope from the temple of Apollo at Bassai/Phigaleia, ca. 400: rape scene. London, BM 517. Ht. 41.9 cm. Photo: BM C-764; Trustees of the British Museum.

455 East akroterion of the temple of Asklepios at Epidauros, ca. 380–370: Nike. Athens NM 162. Ht. 25 cm. Photo: DAI Athens 74.1160.

456 West akroterion of the temple of Asklepios at Epidauros, ca. 380–370: Nike with partridge. Athens NM 155. Ht. 85 cm. Photo: author.

457 West akroterion of the temple of Asklepios at Epidauros, ca. 380–370: Aura (breeze). Athens NM 156. Ht. 74 cm. Photo: author.

458 West akroterion of the temple of Asklepios at Epidauros, ca. 380–370: Aura (breeze). Athens NM 157. Ht. 78 cm. Photo: author.

459 East pediment (Ilioupersis) of the temple of Asklepios at Epidauros, ca. 380–370: Priam. Athens NM 144. Ht. 15 cm. Photo: DAI Athens, Epid. 151.

460 East pediment (Ilioupersis) of the temple of Asklepios at Epidauros, ca. 380–370: lunging youth. Athens NM 148. L. 97 cm. Photo: author.

461 West pediment (Amazonomachy) of the temple of Asklepios at Epidauros, ca. 380–370: Penthesilea. Athens NM 136. Ht. 90 cm. Photo: author.

462 West pediment (Amazonomachy) of the temple of Asklepios at Epidauros, ca. 380–370: Achilles. Athens NM 4757. Ht. 70 cm. Photo: author.

463 West pediment (Amazonomachy) of the temple of Asklepios at Epidauros, ca. 380–370: Amazon and Greek. Athens NM 4752. Ht. 55 cm. Photo: author.

464 West pediment (Amazonomachy) of the temple of Asklepios at Epidauros, ca. 380–370: dead Greek. Athens NM. L. 91 cm. Photo: DAI Athens, Epid. 249.

465 West pediment (Amazonomachy) of the temple of Asklepios at Epidauros, ca. 380–370: dead Greek. Athens NM 4492. L. 97 cm. Photo: author.

466 "Lycian Sarcophagus" from Sidon, ca. 400–375. Istanbul, Archaeological Museum 63. Ht. of friezes, 1.34 m. Photo: Hirmer Fotoarchiv 571.2061.

467 Detail of the sarcophagus, fig. 466. Photo: Hirmer Fotoarchiv 571.2072.

468 The "Nereid Monument" (tomb of Erbbina?), from Xanthos, ca. 390–380. London, BM. Ht. 8.07 m. Photo: Trustees of the British Museum.

469 Detail of the tomb, fig. 468, ca. 390–380: Nereid. London, BM 912. Ht 1.42 m. Photo: BM VII-D(35); Trustees of the British Museum.

470 Detail of the tomb, fig. 468, ca. 390–380: Nereid. London, BM 909. Ht. 1.40 m. Photo: BM 11-C(42); Trustees of the British Museum.

471 Detail of a Nereid from the tomb, fig. 468, ca. 390–380. London, BM 910. Ht. of figure, 1.44 m. Photo: author.

472 Detail of frieze II from the tomb, fig. 468, ca. 390–380: city-siege. London, BM 872, 877, 871b. Ht. of upper frieze, 63 cm. Photo: William A. P. Childs.

473 Detail of frieze II from the tomb, fig. 468, ca. 390–380: Lycian phalanx. London, BM 868b. Ht. 63 cm. Photo: BM X-D(11); Trustees of the British Museum.

474 Detail of frieze I from the tomb, fig. 468, ca. 390–380: battle. London, BM 858. Ht. of frieze, 1.01 m. Photo: BM X-D(25); Trustees of the British Museum.

475 Heroon at Trysa, Lycia, ca. 370: city-siege, with sacrifice (top left), rulers enthroned on the battlements, and attackers below. Vienna, Kun-

sthistorisches Museum, blocks A9/B10-11. Limestone. Ht. of friezes, 1.1 m. Photo: William A. P. Childs.

476 Landscape tomb at Pinara, ca. 370–360: panel D with representation of city. London, BM 762. Plaster cast of original still in situ. Rock relief. Ht. 86.3 cm. Photo: William A. P. Childs.

477 Grave stele of Hegeso, from the Kerameikos, Athens, ca. 400. Athens NM 3624. Ht. 1.58 m. Inscribed "Hegeso daughter of Proxenos." Photo: UCLA Classics Archive.

478 Grave relief from the Piraeus, ca. 380. Athens NM 726. Ht. 1.21 m. Photo: Alinari 24382; Alinari/Art Resource, New York.

479 Grave stele ("Telauges Mnema"), ca. 370. Athens NM 3716. Ht. 1.375 m. Photo: G. Koch.

480 Grave relief of Dexileos, from Athens, 394–393. Athens, Kerameikos Museum. Ht. 1.40 m. For the inscription see chapter 1.2. Photo: Emile Serafis.

481 Athenian strategos ("Pastoret" head), sometimes identified as Konon (Roman copy), original, ca. 400–375. Acquired in Paris. Copenhagen, Ny Carlsberg Glyptotek 438. Ht. 34 cm. Photo: NyC 438; Ny Carlsberg Glyptotek, Copenhagen.

482 Head from a wreck off Porticello (Italy), ca. 400. Reggio Calabria, Museo Nazionale. Bronze. Ht. 42 cm. Photo: Donald Frey, courtesy Dr. Cynthia J. Eiseman and B. S. Ridgway.

483 Head of Sokrates ("type A"; Roman copy), from Italy, original ca. 390–370. Naples, Museo Nazionale 6129. Ht. 37 cm. Photo: DAI Rome 36/894.

484 Krater by the Pronomos painter, from Ruvo, ca. 400: actors holding masks for a satyr play. Naples, Museo Nazionale 3240. Ht. 75 cm. From J. Charbonneaux, *Classical Greek Art* (London, 1972): 274, fig. 315.

485 Eirene and Ploutos by Kephisodotos (Roman copy), from Italy, original ca. 375–370. Munich, Glyptothek 219. Ht. 2.01 m. The arms of both figures, and Eirene's mantle at her right side, are restored. Photo: UCLA Classics Archive.

486 Another view of the Eirene, fig. 485, with the restorations removed. Photo: Koppermann 219.1; Staatliche Antikensammlungen und Glyptothek, Munich.

487 Head of the Eirene, fig. 486. Photo: UCLA Classics Archive.

488 Head of an old woman ("Lysimache"; Roman copy), acquired in Rome, original, ca. 400–375. London, BM 2001. Ht. 30 cm. Photo: BM C-1078; Trustees of the British Museum.

489 Votive relief to Herakles, from Marousi, ca. 400–375. Athens, NM 2723. Ht. 47 cm. Photo: Alinari 24267; Alinari/Art Resource, New York.

490 Document relief commemorating the treaty between Athens and Kerkyra (Corfu), from Athens, 375/74. Athens NM 1467. Ht. 95 cm. Photo: G. Koch.

491 The decree relief of Molon, from Athens, 362/61. Athens, NM 1481. Ht. 46 cm. Photo: DAI Athens, NM 3873.

492 Statue base from a group of Leto, Apollo, and Artemis at Mantineia (Arkadia), ca. 330–320: Apollo, Skythian, and Marsyas. Athens NM 215. Ht. 98 cm. Photo: UCLA Classics Archive.

493 Statue base from a group of Leto, Apollo, and Artemis at Mantineia (Arkadia), ca. 330–320: Three Muses. Athens NM 216. Ht. 98 cm. Photo: UCLA Classics Archive.

494 Statue base from a group of Leto, Apollo, and Artemis at Mantineia (Arkadia), ca. 330–320: Three Muses. Athens NM 217. Ht. 98 cm. Photo: UCLA Classics Archive.

495 Bust of a youth, perhaps the Eubouleus of Praxiteles, from the Ploutonion at Eleusis, ca. 330. Athens NM 181. Ht. 47 cm. The figure was cut down to a bust in antiquity, the hair and drapery were retooled, and the face was repolished. Photo: DAI Athens 74.1145.

496 Head of Herakles attributed to Praxiteles (the "Aberdeen" head), from Greece, ca. 350–330. London, BM 1600. Ht. 29 cm. Photo: BM C-2710; Trustees of the British Museum.

497 Youth from the sea off Marathon, attributed to Praxiteles or his workshop, ca. 330. Athens NM Br. 15118. Bronze. Ht. 1.3 m. The arms were restored in antiquity.

498 Satyr pouring wine attributed to Praxiteles (Roman copy), from Torre del Greco, original ca. 370. Palermo, Museo Nazionale Archeologico. Ht. 1.53 m. Photo: Anderson 29204; Alinari/Art Resource, New York.

499 Head of the youth, fig. 497.

500 The "Leconfield" Aphrodite attributed to Praxiteles, ca. 330. Petworth (England), Leconfield House. Ht. 41 cm. The nose and part of the upper lip are restored. Photo: author.

501 Aphrodite (Roman copy) attributed to Praxiteles, from Arles, original ca. 370–350. Paris, Louvre MA 439. Ht. 1.94 m. The head (which does not join break-on-break) was reset on the body, the arms were restored, and the entire body smoothed down by François Girardon in 1685. Photo: Giraudon 29635; Giraudon/Art Resource, New York.

502 Reconstruction of the temple of Aphrodite Euploia at Knidos. From Love 1972: 74, ill. 9.

503 Aphrodite of Knidos by Praxiteles ("Venus Colonna"; Roman copy),

from Italy, original ca. 350–340. Vatican 812. Ht. 2.04 m. The neck, right forearm and hand, left arm from below the armband to the fingers, right foot and ankle, left leg below the knee, and plinth are restored. Photo: G. Becatti.

504 Back view of the Aphrodite, fig. 503. Photo: Alinari 6672B; Alinari/Art Resource, New York.

505 Aphrodite of Knidos (Roman statuette), probably from Syria, original ca. 350–340. Malibu, J. Paul Getty Museum 72.AA.93. Ht. 97 cm. Photo: The J. Paul Getty Museum.

506 Aphrodite of Knidos by Praxiteles ("Kaufmann" head; Hellenistic copy), from Tralleis (Turkey), original ca. 350–340. Paris, Louvre MA 3518. Ht. 35 cm. Photo: Musée du Louvre, Paris.

507 Another view of the "Kaufmann" head, fig. 508. Photo: Louvre 71 EN 2041; Musée du Louvre, Paris.

508 Artemis sometimes attributed to Praxiteles (Roman copy), from Gabii, original ca. 340. Paris, Louvre MA 529. Ht. 1.65 m. The right hand, parts of the left arm and hand, the right leg, and some drapery folds are restored. Photo: Louvre 79 DM 8814; Musée du Louvre, Paris.

509 Apollo Sauroktonos by Praxiteles (Roman copy), from Italy, original ca. 350. Paris, Louvre MA 441. Ht. 1.49 m. The neck and parts of the arms are restored. Photo: Alinari 22548; Alinari/Art Resource, New York.

510 Resting Satyr attributed to Praxiteles (Roman copy), from Tivoli, original ca. 350–330. Rome, Museo Capitolino 739. Ht. 1.7 m. The nose, left arm, and head of the panther-skin are restored. Photo: DAI Rome 70.351.

511 Athena from the Piraeus, ca. 350, if not a late Hellenistic copy. Piraeus Museum. Bronze. Ht. 2.35 m. Photo: DAI Athens 70.1310.

512 Apollo Kitharoidos, probably the Apollo Patroos of Euphranor, from the Metroon in the Athenian Agora, ca. 340–330. Athens, Agora Museum S2154. Ht. 2.54 m. Fragments of a kithara were found with the statue. Photo: Agora 83.167; Agora Museum, Athens.

513 Plato, attributed to Silanion (Roman copy), reportedly from Athens, original, ca. 340. Switzerland, private collection. Ht. 35 cm. Photo: D. Widmer 1770.

514 Boxer from Olympia, sometimes attributed to Silanion, ca. 330. Athens NM Br. 6439. Bronze. Ht. 28 cm. Photo: DAI Athens 72.333.

515 Grave relief of Thraseas and Euandria, from the Kerameikos, Athens, ca. 350. Berlin (East), Staatliche Museen K34. Ht. 1.60 m. Inscribed "Thraseas Perithoides; Euandria." Photo: Ägyptisches Museum, Staatliche Museen Preussischer Kulturbesitz, Berlin.

516 Grave relief ("Grands Adieux"), from the Kerameikos, Athens, ca. 340. Athens NM 870. Ht. 1.7 m. Photo: G. Koch.

517 Grave relief of a young hunter, from the river Ilissos, Athens, ca. 330. Athens NM 869. Ht. 1.68 m. Photo: Hirmer Fotoarchiv 561.0458.

518 Head of the hunter, fig. 517. Photo: DAI Athens, NM 4674.

519 Head of the old man, fig. 517. Photo: DAI Athens, NM 4675.

520 Votive relief to Asklepios and his family, from Loukou, ca. 375–350. Athens NM 1402. Ht. 53 cm. The inscription is modern. Photo: DAI Athens, NM 4656.

521 Votive relief to Demeter, from Athens, ca. 350–330. Paris, Louvre MA 756. Ht. 66 cm. Photo: Louvre 65.DN.720; Musée du Louvre, Paris.

522 Votive relief to the Nymphs, with Hermes and Pan, from a cave on Mt. Pendeli, near Athens, ca. 330–300. Athens NM 4466. Ht. 1.74 m; of the relief, 70 cm. Inscribed "Agathemeros offered [this] to the Nymphs." Photo: DAI Athens, NM 4757.

523 Document relief from the Athenian Agora, 336: Demos crowned by Demokratia. Athens, Agora Museum I6524. Ht. of stele, 1.57 m. Photo: G. Koch.

524 Reconstruction of the Mausoleum at Halikarnassos, ca. 365–350. Drawing by Candace Smith.

525 Head of Apollo from the Mausoleum at Halikarnassos, ca. 360–350. London, BM 1058. Ht. 42 cm. Photo: BM C-712; Trustees of the British Museum.

526 Bearded male from the Mausoleum at Halikarnassos, ca. 360–350. London, BM 1054. Ht. 35 cm. Photo: BM LII-C(24); Trustees of the British Museum.

527 Persian rider from the Mausoleum at Halikarnassos, ca. 360–350. London, BM 1045. L. 2.15 m. Photo: Trustees of the British Museum.

528 Panther from the Mausoleum at Halikarnassos, ca. 360–350. London, BM 1095. L. 1.0 m. Photo: Trustees of the British Museum.

529 Amazon frieze from the Mausoleum at Halikarnassos, ca. 360–350. London, BM 1013. Ht. 90 cm. The background was blue, bodies of Greeks brown, Amazons white, and drapery green or yellow. Photo: Hirmer Fotoarchiv 561.0169.

530 Amazon frieze from the Mausoleum at Halikarnassos, ca. 360–350. London, BM 1014. Ht. 90 cm. Photo: Hirmer Fotoarchiv 561.0169.

531 Detail of the Amazon and Greek, fig. 530. Photo: B. Ashmole.

532 Amazon frieze from the Mausoleum at Halikarnassos, ca. 360–350. London, BM 1020. Ht. 90 cm. Photo: Hirmer Fotoarchiv.

533 Detail of the charging warrior, fig. 532. Photo: B. Ashmole.

534 Amazon frieze from the Mausoleum at Halikarnassos, ca. 360–350:

fragment of dying Amazon. London, BM. Ht. 40 cm. Photo: B. Ashmole.

535 Carian lady and nobleman ("Artemisia" and "Maussolos") from the Mausoleum at Halikarnassos, ca. 360–350. London, BM 1000 and 1001. Ht. 2.67 m and 3 m. Photo: Trustees of the British Museum.

536 Detail of the man, fig. 535. Photo: BM B5060; Trustees of the British Museum.

537 Lion from the Mausoleum at Halikarnassos, ca. 360–350. London, BM 1075. Ht. 1.5 m. Photo: BM C-874; Trustees of the British Museum.

538 Horse, from the chariot group of the Mausoleum at Halikarnassos, ca. 360–350. London, BM 1002. Ht. 2.33 m. Photo: Trustees of the British Museum.

539 "Mourning Women" sarcophagus from the royal nekropolis at Sidon, ca. 360–340. Istanbul, Archaeological Museum 368. Ht. 1.8 m. Photo: Hirmer Fotoarchiv 571.2077.

540 Temple of Alea Athena, Tegea, ca. 350–340: the sculptural program. Drawing by Candace Smith.

541 Reconstruction of the interior of the temple, ca. 350–340. Drawing by Candace Smith, based on Naomi J. Norman, "The Temple of Athena Alea at Tegea," AJA (1984): 183.

542 Head of Telephos from the west pediment of the temple of Alea Athena at Tegea, ca. 350–340. Tegea Museum 60. Ht. 31.4 cm. Photo: author.

543 Head of a warrior from the west pediment of the temple of Alea Athena at Tegea (cast), ca. 350–340. Athens NM 180. Ht. 32.6 cm. The cast was taken before the right side of the face was in-filled with plaster. Photo: author.

544 Another view of the head, fig. 543. Photo: author.

545 Head supposedly from Tegea. Malibu, J. Paul Getty Museum 79.AA.1. Ht. 30 cm. Modern forgery after the head, figs. 543–544. Photo: The J. Paul Getty Museum.

546 Pothos by Skopas (Roman copy), from Rome, original ca. 330. Rome, Palazzo dei Conservatori (Braccio Nuovo) 2417. Ht. 1.80 m. Photo: Museum.

547 Statuette of a maenad attributed to Skopas (Roman copy), original, ca. 360. Provenance unknown. Dresden, Staatliche Skulpturensammlung (Albertinum) 133. Ht. 45 cm. Photo: Dresden 174.

548 "Lansdowne" Herakles attributed to Skopas (Roman copy), from Tivoli, original, ca. 360. Malibu, J. Paul Getty Museum 70.AA.109. Ht. 1.93 m. Photo: The J. Paul Getty Museum.

549 Meleager attributed to Skopas (Roman copy), from Rome, original, ca. 340. Vatican 490. Ht. 2.10 m. The left hand originally held a boar spear vertically against the shoulder. The cloak was painted red. Photo: DAI Rome 66.2279.

550 Perseus from a wreck off Antikythera (Greece), ca. 350–330. Athens NM Br. 13396. Bronze. Ht. 1.94 m. Photo: DAI Athens, NM 5357a.

551 Reconstruction of the Daochos Monument, 337/36–333/32. Delphi Museum. L. 11.6 m. From left to right, the subjects are; Sisyphos (II), Daochos (II: the dedicator), Sisyphos (I), Daochos (I), Agelaos, Telemachos, Agias, Aknonios, Apollo. Drawing by Candace Smith.

552 Agias, from the Daochos Monument, 337/36–333/32. Delphi Museum 369. Ht. 2 m. His ankles and knees are restored. The inscription reads: "First from the land of Thessaly, Pharsalian Agias, son of Aknonios, you conquered in the Olympic pankration; five times at Nemea, five at Pytho, five times at the Isthmos; and no-one ever set up trophies of your hands." Photo: DAI Athens, Delphi 368.

553 Head of the Agias, fig. 552. Photo: DAI Athens, Delphi 374.

554 Apoxyomenos attributed to Lysippos (Roman copy), from Rome, original ca. 320. Rome, Vatican Museum. Ht. 2.05 m. Most of the nose, the left ear, and parts of the fingers, strigil, and toes are restored. Photo: Vatican Museums.

555 Relief of Kairos by Lysippos (Roman copy), original ca. 330. Provenance unknown. Turin Museum D317. Ht. 60 cm. Photo: DAI Rome.

556 Statuette of a dancing flutegirl (Roman copy), original ca. 330–320. Provenance unknown. Santa Barbara Museum of Art 1981.64.4. Bronze. Ht. 16.2 cm. Photo: Santa Barbara Museum of Art.

557 Head of Sokrates ("type B"; Roman copy), from Rome, original ca. 340–320. Rome, Museo Nazionale Romano (Terme) 1236. Ht. 35.5 cm. The tip of the nose and the left part of the upper lip are restored. Photo: Anderson 2034; Alinari/Art Resource, New York.

558 Statuette of Sokrates ("type B"; Hellenistic or Roman copy), from Alexandria, original ca. 340–320. London, BM 1925.11-18.1. Ht. 27.5 cm. Photo: Trustees of the British Museum.

559 Tetradrachm of Lysimachos of Thrace, 306–281: Alexander with diadem and Ammon's horns. London, BM. Silver. D. 2.9 cm. Photo: Hirmer Fotoarchiv 13.0580V.

560 Head of Alexander from the Akropolis, ca. 340–335, if not a Roman copy. Athens, Akropolis Museum 1331. Ht. 35 cm. Photo: DAI Athens, Akr 2368.

561 Head of Alexander ("Schwarzenberg" Alexander; Roman copy), reportedly from Tivoli, original ca. 335–320. Vienna, Erkinger Schwarzenberg Collection, on loan to the Kunsthistorisches Museum. Ht. 37 cm. Photo: author.

562 Head of Alexander ("Azara" Alexander; Roman copy), from Tivoli, original ca. 335–320. Paris, Louvre MA 436. Ht. 68 cm. The face has been smoothed over, and the lips, nose, and eyebrows restored. Photo: Giraudon IAC 93608; Giraudon/Art Resource, New York.

563 Statuette of Alexander Aigiochos (Roman copy), from Alexandria, original ca. 330–310. London, BM 1922.7-11.1. Bronze. Ht. 31 cm. Photo: Trustees of the British Museum.

564 Statuette of Alexander ("Fouquet" Alexander; Roman copy), from Alexandria, original ca. 335–320. Paris, Louvre 370. Bronze. Ht. 16.5 cm. Photo: Bulloz 91170.

565 Statuette of Alexander ("Nelidow" Alexander; Roman copy), acquired in Istanbul, original ca. 335–320. Cambridge, Mass., Fogg Art Museum 1956.20. Bronze. Ht. 10 cm. The legs are restored below the knee. Photo: Courtesy of the Arthur M. Sackler Museum, Harvard University, Cambridge, Massachusetts. Gift of Mr. C. Rexton Love, Jr.

566 Herakles ("Farnese" type; Roman copy), from Foligno or Perugia, original ca. 320. Paris, Louvre Br 652. Bronze. Ht. 42.5 cm. Photo: Musée du Louvre, Paris.

567 Charging Herakles (Roman copy), from Rome, original, ca. 330–320. Rome, Palazzo dei Conservatori 1088. Ht. 1.74 m. The nose is restored. Photo: Anderson 1675; Alinari/Art Resource, New York.

568 Statuette of Zeus, ca. 330–300, if not Roman. New York, private collection. Bronze. Ht. 24.5 cm. Photo: Courtesy of the Merrin Gallery, New York; copyright Justin Kerr 1402-137.

569 Artemis, from Piraeus, ca. 330–320. Piraeus Museum. Bronze. Ht. 1.95 m. Photo: National Archaeological Museum, Athens.

570 Head of the Artemis, fig. 569. Photo: National Archaeological Museum, Athens.

571 Head of the Demeter of Knidos, fig. 572. Photo: BM C-471; Trustees of the British Museum.

572 Demeter, cult statue of the sanctuary of Demeter at Knidos, ca. 340–330. London, BM 1300. Ht. 1.47 m. Photo: BM LXIX-C(44); Trustees of the British Museum.

573 "Belvedere" Apollo (Roman copy), from Italy, original ca. 330. Vatican 1015. Ht. 2.24 m. Photograph taken after the statue was remounted in 1981. Traces of pigment in the hair. Photo: Vatican Museums.

574 Head of Asklepios ("Blacas" head), from Melos, ca. 330. London, BM 550. Ht. 58.4 cm. Photo: BM LVII-B(48); Trustees of the British Museum.

575 Colossal female torso, perhaps of Demokratia, from the Stoa Basileos in the Athenian Agora, ca. 330–300. Athens, Agora Museum S 2370. Ht. 1.54 m. Photo: American School of Classical Studies at Athens, Agora Excavations.

576 Head of Alexander, reportedly from Megara, ca. 320. Malibu, J. Paul Getty Museum 73.AA.27. Ht. 28 cm. Acquired with numerous other fragments, presumably from the same monument; the hair was recut in antiquity. Photo: The J. Paul Getty Museum.

577 Head of a youth, perhaps Alexander's companion Hephaistion, from the same ensemble as the head, fig. 576, ca. 320. Malibu, J. Paul Getty Museum 73.AA.28. Ht. 26 cm. The hair was recut in antiquity. Photo: The J. Paul Getty Museum.

578 Detail of the torso of "Demokratia," fig. 575. Photo: author.

579 Sophokles (Roman copy), from Terracina, original, probably 338–324. Vatican, Museo Gregoriano Profano (ex-Lateran) 9973. Ht. 2.04 m. Extensively reworked in the nineteenth century. Photo: Anderson 1842; Alinari/Art Resource, New York.

580 Cast of the head of the Sophokles, fig. 579, taken before restoration. Photo: DAI Rome 6656.

581 Votive relief dedicated by Neoptolemos of Melite, from the Athenian Agora, ca. 330–320: Zeus presides over an assembly of divinities (left, Demeter, Apollo, Artemis; right, two Nymphs, Pan, and Acheloos), while Hermes delivers the infant Dionysos to a Nymph at center. Athens, Agora Museum I7154. Ht. 64.5 cm. Inscribed: "Neoptolemos, son of Antikles, from the deme of Melite." Photo: G. Koch.

582 Detail of the Neoptolemos relief, fig. 581: Demeter, Apollo, Artemis. Photo: G. Koch.

583 Detail of the Neoptolemos relief, fig. 581: Hermes delivers Dionysos to a Nymph. Photo: G. Koch.

584 Grave relief of Demetria and Pamphile, from the Kerameikos, Athens, ca. 330–317. Ht. 2.15 m. Inscribed: "Demetria; Pamphile."

585 Grave relief of Aristonautes, from the Kerameikos, Athens, ca. 330–317. Athens NM 738. Ht. 2.91 m., of figure, 2 m. Inscribed: "Aristonautes son of Archenautes of Alaieus." Photo: DAI Athens.

586 Grave relief of Hieron and Lysippe from Rhamnous, ca. 330–317. Athens NM 833. Ht. 1.81 m. Photo: DAI Athens, NM 4662.

587 Reconstruction of the relief, fig. 586, after the recovery of sections of the architectural frame and base. The architrave is inscribed: "Hieron son of Hierokles of Rhamnous; Lysippe." The base is inscribed "Raise high your glance, stranger, and remark the tomb / of five siblings, who left their family bereaved. / Hieron, too, went last to Hades' halls,/ leaving his spirit far behind in rich old age." From Praktika 1977: 10, fig. 5.

588 The "Alexander" sarcophagus (probably in fact the sarcophagus of King Abdalonymos of Sidon), from the royal nekropolis of Sidon, ca. 320–310. Istanbul, Archaeological Museum 370. Ht. of friezes, 69 cm. For the extensive remains of the polychromy, see chapter 16.3. Photo: Hirmer Fotoarchiv.

589 Pediment relief from the sarcophagus, fig. 588: murder of Perdikkas in 321? Photo: D. Johannes (DAI Kairo).

590 Hunt on the long side of the sarcophagus, fig. 588: Alexander hunting in the Persian royal park at Sidon in 332? Photo: Hirmer Fotoarchiv 571.2089.

591 Hunt on the long side of the sarcophagus, fig. 588: Alexander hunting in the Persian royal park at Sidon in 332? Photo: Anderson; Alinari/Art Resource, New York.

592 Battle on the long side of the sarcophagus, fig. 588 (left side): Alexander at the battle of the Issos in 333. Photo: Hirmer Fotoarchiv 571.2084.

593 Battle on the long side of the sarcophagus, fig. 588 (right side): Alexander at the battle of the Issos in 333. Photo: Hirmer Fotoarchiv 571.2086.

594 Detail of the battle, fig. 588: Alexander. Photo: Hirmer Fotoarchiv 571.2088.

595 Column drum from the temple of Artemis at Ephesos, ca. 330–310: Thanatos, Iphigeneia (?), and Hermes Psychopompos. London, BM 1206. Ht. 1.82 m. Photo: BM XLV-C(15); Trustees of the British Museum.

596 Another view of the drum, fig. 595: Hermes, Klytemnestra (?) and Kalchas (?). Photo: BM I-C(36); Trustees of the British Museum.

597 Plinth from the temple of Artemis at Ephesos, ca. 330–310: fight (Herakles and a giant?). London, BM 1204. Ht. 1.85 m. Photo: BM CXVIC(49); Trustees of the British Museum.

598 Plinth from the temple of Artemis at Ephesos, ca. 330–310: unexplained subject (seated man and two women). London, BM 1200. Ht. 1.85 m. Photo: BM C-847; Trustees of the British Museum.

599 Dionysos, from the west pediment of the temple of Apollo at Delphi, ca. 330. Delphi Museum 1344 and 2380. Ht. 1.5 m. By Praxias or Androsthenes of Athens; the god held a kithara in the crook of his left arm. Photo: Ecole française d'Athènes 44474.

600 Apulian red-figured loutrophoros, ca. 330. Malibu, J. Paul Getty Museum 82.AE.16. Ht. 98 cm. Photo: The J. Paul Getty Museum.

601 Relief from a Tarentine funerary monument, ca. 320–300: Orestes and Elektra at the tomb of Agamemnon? New York, MMA 29.54. Limestone. Ht. 58.5 cm. Photo: Metropolitan Museum of Art, New York, Fletcher Fund, 1929 (29.54).

602 Themis from Rhamnous (Attica), dedicated by Megakles and carved by Chairestratos, both of Rhamnous, ca. 300. Athens, NM 231. Ht. 2.22 m. For the inscription, see chapter 1.2. Photo: DAI Athens 72/444.

603 Head of the Themis, fig. 602. Photo: DAI Athens 72/449.

604 Statuettes from the Asklepieion at Cos, ca. 300–275. Istanbul Museum 832. Ht. 55 cm, 63 cm. From JdI 38–39 (1923–24): pl. 7.

605 Head of a statuette from the Asklepieion at Cos, ca. 300–275. Stuttgart, Württembergisches Landesmuseum, Altes Schloss. Ht. 20 cm. Photo: Württembergisches Landesmuseum Stuttgart, Antikensammlung.

606 Head of a woman from Chios, ca. 320–300. Boston, MFA 10.70. Ht. 36 cm. Photo: Gift of Nathaniel Thayer; Courtesy, Museum of Fine Arts, Boston, C33450.

607 Hermes and the infant Dionysos, from the Heraion at Olympia, ca. 300–250(?). Olympia Museum. Ht. 2.15 m. Attributed by Pausanias (T 93) to Praxiteles. The entire left leg below the knee and the right leg from knee to ankle are restored. Photo: U.C. Berkeley Archive.

608 Detail of the Hermes, fig. 607. Photo: Emile Serafis.

609 Fresco in the Casa del Naviglio at Pompeii: Hermes and the infant Dionysos. From Rizzo 1932: pl. 107.

610 Inscribed bust of Menander, attributed to the sons of Praxiteles (Roman copy), original ca. 300. Provenance unknown. Malibu, J. Paul Getty Museum 72.AB.108. Bronze. Ht. 17 cm. Inscribed "Menander." Photo: The J. Paul Getty Museum.

611 Epikouros, from a double herm of Epikouros and Metrodoros (Roman copy), from Rome, original ca. 270. Rome, Museo Capitolino, Stanza dei Filosofi 52. Ht. 60 cm. Inscribed "Epikouros," and on the other side, "Hermarchos." Photo: Museo Capitolino, Rome.

612 Statuette of Hermarchos (Roman copy), from a Roman villa in Tuscany, original ca. 270. Florence, Museo Archeologico 70989. Ht. 1.07 m. Photo: Soprintendenza dell' Antichità di Etruria.

613 Head of Menander attributed to the sons of Praxiteles (Roman copy), original ca. 300. Dumbarton Oaks 46.2. Ht. 34 cm. Photo: D.O. 66.139.11, courtesy of the Trustees of Harvard University.

614 Demosthenes by Polyeuktos (Roman copy), from Campania (Italy), original, 280/79. Copenhagen, Ny Carlsberg Glyptotek 2782. Ht. 2.02 m. Photo: Ny Carlsberg Glyptotek, Copenhagen.

615 Head, fig. 614. Photo: Ny Carlsberg Glyptotek, Copenhagen.

616 Profile of the head of the statue, fig. 614. Photo: Ny Carlsberg Glyptotek, Copenhagen.

617 Athlete cleaning his strigil, from Ephesos, ca. 300, if not a Roman overcasting. Vienna, Kunsthistorisches Museum VI.3168. Bronze. Ht. 1.92 m. Photo: Kunsthistorisches Museum I15372, Vienna.

618 Athlete adjusting his crown ("Getty Bronze"), from the Adriatic sea, ca. 300. Malibu, J. Paul Getty Museum 77.AB.30. Bronze. Ht. 1.51 m. Photo: The J. Paul Getty Museum.

619 Head of the athlete from Ephesos, fig. 617. Photo: Kunsthistorisches Museum I21839, Vienna.

620 Head of the Getty athlete, fig. 618.

621 Herm identified as King Demetrios Poliorketes (Roman copy), from the Villa dei Papiri at Herculaneum, original probably 306–283. Naples, Museo Nazionale 6149. Ht. 43.5 cm. Photo: Anderson 23068; Alinari/Art Resource, New York.

622 Profile of the herm, fig. 621. Photo: DAI Rome 59.759.

623 Tetradrachm of King Demetrios Poliorketes, 306–283: Demetrios with diadem and bull's horns; Poseidon. Silver. D. 2 cm. Inscribed "Of King Demetrios." Photo: Hirmer Fotoarchiv 13.0573V, R.

624 Colossal head identified as King Demetrios Poliorketes, from the steps of the Dodekatheon at Delos, ca. 306–301(?). Delos Museum A4184. Ht. 55 cm. Two cuttings for marble horns are present in the hair. Photo: DAI Athens, Delos 112.

625 Statuette identified as King Demetrios Poliorketes (Roman copy), from Herculaneum, original probably 306–283. Naples, Museo Nazionale 5026. Bronze. Ht. 30 cm. Photo: Alinari 11229; Alinari/Art Resource, New York.

626 Statuette of the Tyche (Fortune) of Antioch by Eutychides (Roman copy), from Rome, original ca. 300–290. Vatican, Galleria dei Candelabri IV.49. Ht. 89 cm. The head, though ancient, is from another statue. Photo: Alinari 6497; Alinari/Art Resource, New York.

627 Statuette of the Tyche (Fortune) of Antioch by Eutychides (Roman copy), from Rome, original ca. 300–290. Budapest, Museum of Fine Arts 4742. Ht. 47 cm. Photo: Courtesy, Museum of Fine Arts, Budapest.

628 Coin of Volusianus, minted in Antioch, A.D. 251–53: the Tyche in her portable shrine. Paris, Cabinet des Médailles. Bronze. D. 2.8 cm. After Dohrn 1960: pl. 31.5.

629 Tetradrachm of King Antiochos IV of Syria, 175–164: the Apollo Mousagetes of Bryaxis at Daphne. Washington, Arthur A. Houghton Collection. Silver. D. 1.8 cm. Photo: Steve Beals, Caelestis Productions.

630 Bust identified as King Seleukos I Nikator of Syria (Roman copy), from the Villa dei Papiri at Herculaneum, original probably 306–281. Naples, Museo Nazionale 5590. Bronze. Ht. 50 cm. Photo: Alinari 11251; Alinari/Art Resource, New York.

631 Tetradrachm of Philetairos of Pergamon, 283–264: King Seleukos I Nikator of Syria. Private collection. Silver. D. 1.8 cm. Photo: Hirmer Fotoarchiv 14.0736V.

632 Statuette of the Sarapis by Bryaxis (Roman copy), from Ostia, original, ca. 286–278. Museo Ostiense 1125. Ht. 24 cm. Photo: GFN E27312; Gabinetto Fotografico Nazionale, Rome.

633 Head of the Sarapis by Bryaxis (Roman copy), acquired in Rome, original ca. 286–278. Cambridge, Fitzwilliam Museum GR 15.1850. Ht. 22 cm. Photo: Fitzwilliam Museum AT 246; Fitwilliam Museum, Cambridge.

634 Roman gem showing Sarapis in his temple. Provenance unknown. London, BM 1773. D. 1.4 cm. Photo: J. Felbermeyer.

635 The Sarapeion at Memphis. From Lauer-Picard 1955: pl. 27b.

636 The baby Dionysos riding Kerberos, from the Sarapeion at Memphis, ca. 250. Limestone. Ht. 1.80 m. From Lauer-Picard 1955: pl. 24.

637 Dionysos (now missing) riding a peacock, from the Sarapeion at Memphis, ca. 250. Limestone. Ht. 1.80 m. From Lauer-Picard 1955: pl. 20.

638 Pindar, from the semicircle of sages, fig. 635, ca. 250–150(?). Limestone. Ht. 1.85 m. Inscribed "Pindar. Dionysi[os made it?]." From Lauer-Picard 1955: pl. 4.

639 Column drum or altar base from Azerita (Alexandria), ca. 250–150: from left, Hera, Zeus (enthroned), Hermes, Hestia(?), Asklepios(?), Aphrodite(?). Alexandria, Graeco-Roman Museum. Ht. ca. 1 m. Photo: author.

640 Draped torso from Alexandria, ca. 300–250. Alexandria, Graeco-Roman Museum 3928. Ht. 75 cm. Photo: A. Adriani.

641 Gravestone of Niko, from Alexandria, ca. 250. Cairo, Egyptian Museum C.G. 9259. Limestone. Ht. (including base, not shown) 69 cm. Photo: DAI Kairo F5691-3.

642 Tetradrachm of King Ptolemy I Soter of Egypt: head of Ptolemy, diademed, 306–282. Private collection. Silver. D. 1.8 cm. Photo: Hirmer Fotoarchiv 15.0799V.

643 King Ptolemy I Soter, supposedly from Greece or Asia Minor, ca. 300–275. Paris, Louvre MA 849. Ht. 24 cm. Only the face is antique. Photo: Musée du Louvre, Paris.

644 Head of a Ptolemy, perhaps King Ptolemy III Euergetes, ca. 250–200. Reportedly from Egypt. Swiss Private Collection. Ht. 34.5 cm. Photo: University of Bern, Archaeological Seminar.

University of Bern, Archaeological Seminar.

645 Ptolemaic Queen or Aphrodite, ca. 275–225. Formerly Munich art market. Ht. 30 cm. Photo: Koppermann; Staatliche Antikensammlungen and Glyptothek, Munich.

646 Black boy, ca. 300–200. New York, MMA 18.145.10. Bronze. Ht. 18 cm. Photo: MMA 45622/76; Metropolitan Museum of Art, New York, Rogers Fund, 1918.

647 Grotesque phallic dancer, ca. 300–200. Baltimore, Walters Art Gallery 48.1784. Faience. Ht. 6.3 cm. Photo: Walters H53; Walters Art Gallery, Baltimore.

648 The "Baker Dancer," from Egypt, ca. 250–220. New York, MMA 72.118.95. Bronze. Ht. 21 cm. Photo: G. Becatti.

649 Black boy ("Black Orpheus") playing a small harp, from Chalons-sur-Saône (France), ca. 250–200, or perhaps first century A.D. Paris, Bibliothèque Nationale, Cabinet des Médailles 1009. Bronze. Ht. 20.2 cm. Found with seventeen other bronzes in an oak chest in 1763. Photo: Giraudon 8211; Giraudon/Art Resource, New York.

650 Metope from the temple of Athena at Ilion: Helios, ca. 300–280. Berlin (East), Staatliche Museen (Pergamonmuseum) 142. Ht. 85 cm. Photo: Staatliche Museen zu Berlin—DDR, Antikensammlung.

651 Metope from the temple of Athena at Ilion, ca. 300–281: defeated giant. Çanakkale Museum 550. Ht. 82 cm. Photo: DAI Rome.

652 Coffer relief from the Mausoleum at Belevi, near Ephesos, ca. 300–280: boxing match. Izmir Museum 1082. Ht. 1.13 m. Photo: Österreichisches Archäologishes Institut, Vienna.

653 Coffer relief from the Mausoleum at Belevi, near Ephesos, ca. 300–280: Centauromachy. Izmir Museum 1077. Ht. 95 cm. The background was blue, the beard, mouth, and eyelids of the centaur red, together with the animal skin, and the armor and eyeballs of the Lapith; his helmet and shield were yellow. Photo: Österreichisches Archäologishes Institut, Vienna.

654 Lapith from a coffer relief from the Mausoleum at Belevi, near Ephesos, ca. 300–280. Izmir Museum 989. Ht. of fragment, 1 m. Photo: Österreichisches Archäologishes Institut, Vienna.

655 Centaur from a coffer relief from the Mausoleum at Belevi, near Ephesos, ca. 300–280. Izmir Museum 1073. Ht. of fragment, 38 cm. The background was blue. Photo: Österreichisches Archäologishes Institut, Vienna.

656 Griffin and vase, roof decoration of the Mausoleum at Belevi, near Ephesos, perhaps ca. 246–240. Izmir Museum 1085-7. Ht. of griffin, 1.4 m; of vase, 1.07 m. Photo: Österreichisches Archäologishes Institut, Vienna.

657 King (Antiochos II Theos of Syria?) on a couch, from the tomb chamber of the Mausoleum at Belevi, near Ephesos, perhaps ca. 246–240. Selçuk Museum. Ht. 2.11 m. Photo: Österreichisches Archäologishes Institut, Vienna.

658 Metope from a funerary naiskos on the Via Umbria, Taranto, ca. 275–250: warrior and barbarian. Taranto, Museo Archeologico 113835. Limestone. Ht. 43 cm. Photo: Joseph Coleman Carter.

659 Reconstruction of a funerary naiskos from the Via Umbria, Taranto, ca. 275–250. Limestone. Original ht. ca. 7 m. After Carter 1975: pl. 70.

660 Metopal figure from the naiskos, fig. 659: barbarian. Taranto, Museo Archeologico 113836. Limestone. Ht. 39.2 cm. Photo: Joseph Coleman Carter.

661 Head of the barbarian, fig. 659. Photo: Joseph Coleman Carter.

662 Herm of Philetairos of Pergamon (Roman copy), from the Villa dei Papiri at Herculaneum, original ca. 275–250. Naples, Museo Nazionale 6148. Ht. 40 cm. Photo: Alinari 11050; Alinari/Art Resource, New York.

663 Profile of the herm, fig. 662. Photo: DAI Rome 59.1926.

664 Tetradrachm of King Attalos I of Pergamon, 241–197: Philetairos. Private Collection. Silver. D. 1.6 cm. Photo: Hirmer Fotoarchiv 14.0737V.

665 Tetradrachm of Pergamon (detail), probably 181 or 177: Athena Polias Nikephoros. Copenhagen, Royal Collection of Coins and Medals. Silver. D. 1.6 cm. From Mørkholm 1984: pl. 27.9.

666 Model of the Akropolis at Pergamon, Berlin (East), Staatliche Museen. Photo: L. Goldscheider.

667 Dying Celtic Trumpeter (Roman copy), attributed to Epigonos of Pergamon, from Rome, original ca. 220. Rome, Museo Capitolino 747. Ht. 93 cm. The right arm and right side of the plinth up to the trumpeter's body are restored. Photo: DAI Rome 70.2117.

668 Another view of the trumpeter, fig. 667. Photo: DAI Rome 70.2116.

669 Another view of the trumpeter, fig. 667. Photo: DAI Rome 70.2112.

670 Head of the trumpeter, fig. 667. Photo: Anderson 1710a; Alinari/Art Resource, New York.

671 Suicidal Celt (Roman copy, "Ludovisi Gaul"), perhaps from Rome, original ca. 220. Rome, Museo Nazionale Romano (Terme) 8608. Ht. 2.11 m. Restorations include the Celt's right arm with the sword-hilt, the left forearm, the fluttering end of the cloak, and the woman's nose, left arm, and lower right arm. Photo: Anderson 1944; Alinari/Art Resource, New York.

672 Another view of the Celt, fig. 671. Photo: Anderson 1943; Alinari/Art Resource, New York.

673 Another view of the Celt, fig. 671. Photo: Anderson 3318; Alinari/Art Resource, New York.

674 Head of the Celt, figs. 671–673. Photo: Anderson 3295; Alinari/Art Resource, New York.

675 Dying Iranian (Roman copy), from Rome, original ca. 220. Rome, Museo Nazionale Romano (Terme) 603. Ht. 33.5 cm. Photo: Anderson 2157; Alinari/Art Resource, New York.

676 Drunken satyr ("Barberini Faun"), from Rome, ca. 230–200. Munich Glyptothek 218. Ht. 2.15 m. The legs and pendant left arm are restored; the right leg is too high, and its foot should rest on the point of the rock. Photo: UCLA Classics Archive.

677 Head of the satyr, fig. 676. Photo: L. Goldscheider.

678 Herm of Antisthenes (Roman copy), from Tivoli, original ca. 250–220. Vatican, Sala delle Muse 288. Ht. 56 cm. Inscribed "Antisthenes"; attributed to Phyromachos of Athens. The nose is restored. Photo: Vatican Museums.

679 Bronze coins of Pergamon showing the Asklepios of Phyromachos, ca. 190–150. Berlin (East), Staatliche Museen. Bronze. D. 1.9, 2.5 cm. From O. Deubner, *Das Asklepieion von Pergamon* (Berlin 1938), 9, fig. 3.

680 Head identified as Attalos I, from Pergamon, ca. 240–200. Berlin (East), Staatliche Museen P130. Ht. 39.5 cm. The head was re-cut in antiquity, presumably after Attalos declared himself king ca. 237, to receive the plaster wig and diadem shown in the next two pictures. Photo: Staatliche Museen zu Berlin—DDR, Antikensammlung PM 992.

681 Front view of the Attalos, fig. 680, with plaster wig attached. Photo: Staatliche Museen zu Berlin—DDR, Antikensammlung PM 1309.

682 Side view of the Attalos, fig. 680, with plaster wig attached. Photo: Staatliche Museen zu Berlin—DDR, Antikensammlung PM 1310.

683 "Wild Man" (perhaps the Centaur Cheiron) from the Asklepieion at Pergamon, ca. 220–180. Bergama Museum 478. Ht. 48 cm. Photo: DAI Istanbul 66/153.

684 Another view of the head, fig. 683. Photo: DAI Istanbul 66/156.

685 Four figures (Roman copies) attributed to the "Small Pergamene Dedication" on the Athenian Akropolis, from Rome (Palazzo Madama), originals ca. 200 (or 150): clockwise from lower left, dead Persian, dying Celt, dead Giant, and dead Amazon. Naples, Museo Nazionale 6012–15. L. 1.25–1.37 m. Both arms of the Persian, the left arm of the Celt, and minor parts of the limbs of the other figures are restored, together with their noses and other details. Photo: Brogi 5270.

686 Dying Celt (Roman copy) from the group, fig. 685. Photo: Anderson 23121; Alinari/Art Resource, New York.

687 Dead Amazon (Roman copy) from the group, fig. 685. Photo: Alinari 11008; Alinari/Art Resource, New York.

688 Head of the dead Giant (Roman copy) from the group, fig. 685. Photo: DAI Rome.

689 Falling Celt attributed to the group, fig. 685 (Roman copy), from Italy. Venice, Museo Archeologico 55. Ht. 78 cm. The left arm and parts of the other limbs are restored. Photo: DAI Rome 68/5020.

690 Head of a defeated Celt attibuted to the group, fig. 685 (Roman copy), from Italy. Paris, Louvre MA 324. Ht. 83 cm. Photo: Giraudon 35202; Giraudon/Art Resource, New York.

691 Head of a defeated Celt attributed to the group, fig. 685 (Roman copy), from Italy. Venice, Museo Archeologico 57. Ht. of figure, 75 cm. Photo: DAI Rome 68.5023.

692 View of the "Great Altar," ca. 180–150, as reconstructed in the Pergamon Museum, (East) Berlin. Ht. of monument, 5.6 m; of Gigantomachy frieze, 2.28 m; of Telephos frieze, 1.58 m. Photo: Staatliche Museen zu Berlin—DDR, Antikensammlung.

693 The sculptural program of the "Great Altar," ca. 180–150. Drawing by Candace Smith, based on Lullies and Hirmer, *Greek Sculpture*.

694 East frieze: Porphyrion, Zeus (name inscribed), and two other giants. Photo: Staatliche Museen zu Berlin—DDR, Antikensammlung PM 7327.

695 East frieze: Alkyoneus, Athena (name inscribed), Ge (name inscribed), and Nike. Photo: Staatliche Museen zu Berlin—DDR, Antikensammlung PM 7328.

696 Head of Alkyoneus from the east frieze, fig. 695. Photo: DAI Rome 52/172.

697 East frieze: Leto (name inscribed) and Apollo. Photo: Staatliche Museen zu Berlin—DDR, Antikensammlung PM 208.

698 East frieze: head of Artemis's opponent Photo: author.

699 Head of Alexander(?) from Pergamon, perhaps from the Gigantomachy of the "Great Altar." Istanbul, Archaeological Museum 1138. Ht. 42 cm. Photo: UCLA Classics Archive.

700 South frieze: a goddess, probably Eos. Photo: DAI Rome 63.1902.

701 South frieze: Helios. Photo: author.

702 South frieze: unidentified goddess and steer-giant. The giant to the right is a cast of the marble found at Worksop, England. Photo: Staa-

tliche Museen zu Berlin—DDR, Antikensammlung PM 7407.

703 North frieze: Aphrodite (name inscribed) and Eros. Photo: Staatliche Museen zu Berlin—DDR, Antikensammlung PM 7339.

704 North frieze: "Nyx" (probably Persephone). Photo: Staatliche Museen zu Berlin—DDR, Antikensammlung PM 7343.

705 North frieze: Lion-goddess. See also fig. 715. Photo: author.

706 North frieze: head of "Nyx"/Persephone, fig. 704. Photo: Staatliche Museen zu Berlin—DDR, Antikensammlung.

707 North frieze: head of the "biting Giant." Photo: Staatliche Museen zu Berlin—DDR, Antikensammlung.

708 East frieze: head of Hekate's opponent. Photo: Staatliche Museen zu Berlin—DDR, Antikensammlung.

709 East frieze: torso of Zeus. Photo: Staatliche Museen zu Berlin—DDR, Antikensammlung.

710 North frieze: hippocamp from Poseidon's chariot. Photo: author.

711 West frieze: left projection with Triton and Amphitrite (names inscribed); stair-frieze with Nereus (name inscribed) and Doris. Photo: Staatliche Museen zu Berlin—DDR, Antikensammlung.

712 Telephos frieze: sacrifice at a shrine, and Herakles finding Telephos on Mt. Parthenion. The plane-tree at the top of the relief is unfinished. Photo: Staatliche Museen zu Berlin—DDR, Antikensammlung PM 830.

713 Telephos frieze: building the box for Auge. Photo: Staatliche Museen zu Berlin—DDR, Antikensammlung PM 813.

714 Telephos frieze: Teuthras, king of Mysia, hastens to meet Auge. Photo: Staatliche Museen zu Berlin—DDR, Antikensammlung PM 510.

715 Gigantomachy frieze: detail of the lion-goddess, fig. 705. Photo: author.

716 Telephos frieze: Telephos and the Argive princes. Photo: Staatliche Museen zu Berlin—DDR, Antikensammlung PM 1260.

717 Tragedy, from Pergamon, ca. 190–160. Berlin (East), Staatliche Museen (Pergamonmuseum) P47. Ht. 1.80 m. Photo: Staatliche Museen zu Berlin—DDR, Antikensammlung PM 1338.

718 Athena Parthenos, from Pergamon, ca. 190. Berlin (East), Staatliche Museen (Pergamonmuseum) P24. Ht. 3.51 m. Photo: Staatliche Museen zu Berlin—DDR, Antikensammlung PM 1304.

719 "Crouching Aphrodite" (Roman copy), original ca. 200–150. Provenance unknown. Naples, Museo Nazionale 6293. Ht. 1.13 m. Her forearm, left hand, and the soles of her feet are restored, together with Eros's lower legs, his arms, and parts of his wings. Photo: Alinari 11945; Alinari/Art Resource, New York.

720 "Crouching Aphrodite" (Roman copy), from Hadrian's Villa at Tivoli, original ca. 200–150. Rome, Museo Nazionale (Terme) 108 597. Ht. 1.02 m. Photo: L. Goldscheider.

721 Girl preparing a sacrifice, from Anzio (Italy), ca. 200–150. Rome, Museo Nazionale (Terme) 50 170. Ht. 1.74 m. Photo: Alinari 27268; Alinari/Art Resource, New York.

722 Head of the girl, fig. 721. Photo: Anderson 2094; Alinari/Art Resource, New York.

723 Satyr from the "Invitation to the Dance" (Roman copy), original ca. 200–150(?). Provenance unknown. Florence, Uffizi 220. Ht. 1.43 m. The head and parts of the arms and legs are restored. Photo: Anderson 9328; Alinari/Art Resource, New York.

724 Nymph from the "Invitation to the Dance" (Roman copy), original ca. 200–150 (?). Provenance unknown. Florence, Uffizi 190. Ht. 1.01 m. The head and parts of the arms and legs are restored. Photo: Alinari 1269; Alinari/Art Resource, New York.

725 Coin of Kyzikos depicting the group of fig. 723–724. From *Zeitschrift der bildenden Kunst* 44 (1909): 102, fig. 2.

726 Reconstruction of the group by W. Klein. From *Zeitschrift der bildenden Kunst* 44 (1909): 106, fig. 9.

727 Satyr and hermaphrodite (Roman copy), original ca. 150(?). Provenance unknown. Dresden, Staatliche Kunstsammlungen (Albertinum) 155. Ht. 91 cm. Restorations include much of the arms of both figures, the left foot of the nymph, and the lower legs of the satyr. Photo: J. Frel Archive.

728 Satyr and hermaphrodite, once Geneva market, original ca. 150 (?). Present location unknown. Ht. unknown. Photo: Borel-Boissonnaas.

729 Nike from Samothrace, ca. 190. Paris, Louvre MA 2369. Ht. of figure, ca. 2 m. Photo: Giraudon 34390; Giraudon/Art Resource, New York.

730 Torso of the Nike, fig. 729. Photo: Photo Bulloz 8731B.

731 Side view of the Nike, fig. 729. Photo: Giraudon IAC 48793; Giraudon/Art Resource, New York.

732 Reconstruction of the cave at Sperlonga (Italy), with sculptural groups by Hagesandros, Athanodoros, and Polydoros of Rhodes, ca. 20 B.C. to A.D. 20(?), after originals of the mid second century. At front, Odysseus with the body of Achilles (left), and with Diomedes and the Trojan Palladion (right); at center, Odysseus fighting Skylla; at right rear, Odysseus and companions blinding Polyphemos. Sperlonga Museum. Ht. of human figures, 2.0–2.2 m; of Polyphemos, ca. 3.5 m. Signed on the outrigger of the ship, "Athanodoros son of Hagesandros, Hagesandros son of Paionios, and Polydoros son of Polydoros the Rhodians made [it]." Drawing by Candace Smith.

733 Plaster reconstruction of the Polyphemos group, fig. 732. Sperlonga Museum. Photo: DAI Rome 72/2416.

734 Roman sarcophagus relief with the blinding of Polyphemos, ca. A.D. 180. Catania, Museo Civico. Ht. 73 cm. Photo: DAI Rome 71/797.

735 Polyphemos group: "third companion." Photo: B. Conticello 72/161 Vo; Soprintendenza Archeologica del Lazio.

736 Head of the "third companion," fig. 735. Photo: B. Conticello 72/164 Vo; Soprintendenza Archeologica del Lazio.

737 Polyphemos group: foot of Polyphemos. Photo: B. Conticello 72/179 Vo; Soprintendenza Archeologica del Lazio.

738 Polyphemos group: Odysseus. Photo: J. Felbermeyer.

739 Skylla group: Odysseus's ship. Photo: DAI Rome 65.109.

740 Head of the helmsman from fig. 739. Photo: J. Felbermeyer.

741 Palladion group: Diomedes grasping the Palladion. Photo: B. Conticello 72/207 Vo; Soprintendenza Archeologica del Lazio.

742 Laokoon and his sons, by Hagesandros, Athanodoros, and Polydoros of Rhodes, from the substructures of the Baths of Trajan at Rome, ca. 20 B.C. to A.D. 20(?), perhaps after an original of the mid second century. Vatican, Cortile del Belvedere 1059, 1064, 1067. Ht. 1.84 m. Photo: Vatican XIII.11.14; Vatican Museums.

743 Head of Laokoon from the group, fig. 742. Photo: Brogi 3412A.

744 Legs and torso of the Laokoon from the group, fig. 742. Photo: J. Ross.

745 Menelaos with the body of Patroklos (?) (Roman copy), from Rome, original ca. 150–125. Florence, Loggia dei Lanzi. Ht. 2.2 m. Restored: parts of "Patroklos" and the torso of "Menelaos." Photo: Conway Lib. A.83/2637.

746 Menelaos with the body of Patroklos (?) ("Pasquino"; Roman copy), from Rome, original ca. 150–125. Rome, on the wall of the Palazzo Braschi, overlooking the Piazza Pasquino. Ht. 1.92 m. Photo: Brogi 16293.

747 Head of "Menelaos" from another copy of the group, figs. 745–746, from Hadrian's Villa at Tivoli, original ca. 150–125. Vatican, Sala dei Busti 311. Ht. 47 cm. The nose, parts of the lips, and eyes, details of the hair, and the bust are restored. Photo: Vatican XXXII.154.30; Vatican Museums.

748 Marsyas ("red" type; Roman copy), from Italy, original ca. 200–150. Florence, Uffizi 199. Ht. 2.43 m. Parts of the arms, legs, and the nose are restored. Photo: Brogi 9262.

749 Scythian knife-grinder (Roman copy), from Rome, original ca. 200–150. Florence, Uffizi 230. Ht. 1.06 m. The tip of the nose, some of the fingers, and parts of the drapery are restored, and the surface has been repolished. Photo: Brogi 7561.

750 Head of another version ("white" type) of the Marsyas, fig. 748. Roman copy, from Italy. Paris, Louvre MA 542. Ht. 2.56 m. Photo: Musée du Louvre, Paris.

751 Antonine coin of Alexandria, A.D. 138–160: Marsyas group, with Apollo. Florence, Museo Archeologico. Bronze. D. 2 cm. From Fleischer 1975: 110, fig. 6.

752 Engraved gem showing the Marsyas group, with Apollo. Private collection. Carnelian. D. 1.4 cm. Roman. From Fleischer 1975: 110, fig. 5.

753 Drunken old woman (Roman copy), from Rome, original ca. 225–200. Munich, Glyptothek 437. Ht. 92 cm. Photo: Staatliche Antikensammlungen und Glyptothek, Munich (Kaufmann).

754 Head of the old woman, fig. 753. Photo: Staatliche Antikensammlungen und Glyptothek, Munich (Kaufmann).

755 Old fisherman (Roman copy), from Anzio, original, ca. 200. Vatican, Galleria dei Candelabri IV. 38. Ht. 1.6 m. Restorations (by Algardi) include the nose, chin and lower lip, the right hand, the left forearm and hand, the feet, the lower part of the support, and the plinth. Photo: Anderson 1437; Alinari/Art Resource, New York.

756 King Ptolemy IV Philopator of Egypt, from the Sarapeion at Alexandria, ca. 217–204. Paris, Louvre MA 3168. Ht. 35 cm. For the polychromy see chapter 3.2. Photo: Musée du Louvre, Paris.

757 Sarapis, from the Sarapeion at Alexandria, ca. 217–204. Alexandria, Greco-Roman Museum 3912. Ht. 53 cm. For the polychromy see chapter 3.2. Photo: DAI Kairo.

758 Queen Arsinoe III of Egypt, from the Sarapeion at Alexandria, ca. 217–204. Alexandria, Graeco-Roman Museum 3908. Ht. 46 cm. For the polychromy see chapter 3.2. Photo: DAI Kairo.

759 Celt, from the Fayum, ca. 175–150. Cairo, Egyptian Museum. Ht. 37 cm. Photo: DAI Kairo.

760 Relief from the Minoe fountain on Delos, ca. 200: Queen Arsinoe II of Egypt sacrificing, accompanied by satyrs. Delos Museum A1319. Bronze. Ht. 50 cm. Photo: Ecole française d'Athènes 16266.

761 Relief signed by Archelaos of Priene, from Bovillae (Italy), ca. 200–150: apotheosis of Homer, with the Muses, Apollo, a poet, and Zeus above. London, BM 2191. Ht. 1.18 m. For the inscriptions, see chapter 18.2. Photo: BM XXI-D(26); Trustees of the British Museum.

762 Detail of the Archelaos relief, fig. 761: Apollo and the Muses, with the poet standing by the Delphic tripod at far right. Photo: BM C-1803; Trustees of the British Museum.

763 Detail of the Archelaos relief, fig. 761: Oikoumene and Chronos crown Homer, whose throne is attended by Iliad and Odyssey, with Myth at far right. Photo: BM XIII-D(44); Trustees of the British Museum.

764 "Polyhymnia" (Roman copy), from Rome, original ca. 230–150. Rome, Museo Capitolino Nuovo 2135. Ht. 1.50 m. Photo: DAI Rome 63.426.

765 Dancing Muse (Roman copy), original ca. 230–150. Provenance unknown. Florence, Uffizi 303. Ht. 1.53 m. The left arm and adjacent drapery, most of the right arm and part of the drapery held in the hand, and the neck are restored; the head is ancient, but some doubt whether it belongs; the crown of the head, nose, and lips are restored; the surface has been repolished. Photo: Alinari 1278; Alinari/Art Resource, New York.

766 "Klio" (Roman copy), acquired in Rome, original ca. 230–150. Munich Glyptothek 266. Ht. 1.66 m. The head, neck, right arm, left forearm, and the pillar are restored. Photo: Antikensammlungen und Glyptothek, Munich (Kaufmann).

767 Tetradrachm of King Antiochos IV Epiphanes of Syria, 168: Zeus. Paris, Cabinet des Médailles v. 493. Silver. D. 1.9 cm. From C. Boehringer, *Zur Chronologie mittelhellenistischer Münzserien* (Berlin, 1972), pl. 19.1.

768 Head of a ruler, either King Antiochos IV Epiphanes of Syria or (more probably) Antiochos VII Sidetes, from Shami (Southern Iran), ca. 170 or 130/129. Teheran, Iran Bastan Museum 2477. Bronze. Ht. 26.7 cm. From Stein 1940: pl. 4.

769 Statuette of a reclining woman (Anahita?) from Iran, ca. 150–100. New York, MMA. Alabaster. L. 17.4 cm.

770 Portrait head, perhaps King Euthydemos I of Baktria (Roman copy), ca. 230–200. Provenance unknown. Rome, Villa Albani. Ht. 33 cm. The tip of the nose is restored. Photo: DAI Rome 33.23.

771 Colossal foot from a cult statue (of Zeus?) at Ai Khanoum in Baktria (Afghanistan), ca. 200–140. Kabul Museum. Photo: Délégation archéologique française en Afghanistan.

772 Statuette of a woman from the temple at Ai Khanoum in Baktria (Afghanistan), ca. 200–140. Kabul Museum. Ht. 1 m. Photo: Délégation archéologique française en Afghanistan.

773 Statuette of a goddess from Ai Khanoum in Baktria (Afghanistan), ca. 200–140. Kabul Museum 0.1245. Bone. Ht. 16.2 cm. Photo: Délégation archéologique française en Afghanistan.

774 Statuette of Herakles from Ai Khanoum in Baktria (Afghanistan), ca. 200–140. Kabul Museum. Bronze. Photo: Délégation archéologique française en Afghanistan.

775 Gravestone of a youth from Ai Khanoum in Baktria (Afghanistan), ca. 200–140. Kabul Museum. Ht. 57 cm. Photo: Délégation archéologique française en Afghanistan.

776 The Stoic philosopher Chrysippos, reconstruction using a Roman copy of the body and a cast of the head in the British Museum, original ca. 200. Paris, Louvre MA 80. Marble and plaster (the head). Ht. 1.2 m. Photo: Giraudon IA 49513; Giraudon/Art Resource, New York.

777 Head of Chrysippos (Roman copy), original ca. 200. Provenance unknown. Naples, Museo Nazionale 6127. Ht. 43 cm. The nose is restored. Photo: DAI Rome 60.608.

778 Head of a philosopher, from a wreck off Antikythera (Greece), ca. 230–170. Athens NM Br. 13400. Bronze. Ht. 29 cm. Photo: Alison Frantz AT 90.

779 Head of King Antiochos III of Syria (Roman copy), reportedly from Italy, original, ca. 200. Paris, Louvre MA 1204. Ht. 35 cm. The tip of the nose is restored. Photo: Louvre 13329; Musée du Louvre, Paris.

780 Right profile of the Antiochos, fig. 779. Photo: Musée du Louvre, Paris.

781 Head of a priest, from Athens. Athens NM 351. Ht. 31 cm. Photo: author.

782 Tetradrachm of King Antiochos III of Syria, minted in Ekbatana, ca. 205: Antiochos, diademed; Apollo on omphalos. Silver. D. 2 cm. From C. Boehringer, *Zur Chronologie mittelhellenistischer Münzserien* (Berlin, 1972), pl. 13.1.

783 "Medusa Rondanini" (Roman copy), from Rome, original ca. 200–170. Munich, Glyptothek 252. Ht. 40 cm. The left wing is restored. Photo: UCLA Classics Archive.

784 Apollo Kitharoidos (Roman copy), from Cyrene, original ca. 200–150. London, BM 1380. Ht. 2.29 m. Photo: BM C-2719; Trustees of the British Museum.

785 Head of the Apollo, fig. 784. Photo: BM LV-C(19); Trustees of the British Museum.

786 Frieze from the base of the victory monument of Aemilius Paullus at Delphi, 168: the battle of Pydna. Delphi Museum. Ht. 31 cm. or shortly after. From *FD* 4: pl. 78.

787 Black boy restraining a horse, from Athens, ca. 150–125. Athens NM 4464. Ht. 2 m. The hair and flesh of the boy are painted black, the stick (a whip?) in his hand is red, the horse and helmet above his rump are brown, and a brown wedge-shaped strip runs down the upper left side of the relief; there are also signs of preparation for color on the background and the boy's clothing, suggesting that the polychromy was total. Photo: DAI Athens 69.40.

788 Reconstruction of the sanctuary of Despoina at Lykosoura in Arkadia, ca. 175–150: from left, Artemis, Demeter, Despoina, Anytos, by Damophon of Messene. Lykosoura Museum and Athens NM 1734-7, 2171-5. Ht. of ensemble, ca. 5.7 m. Drawing by Candace Smith.

789 Heads of Artemis, Demeter, and Anytos from Lykosoura, by Damophon of Messene, ca. 175–150. Athens NM 1734–1736. Ht. of heads, 46 and 67 cm. Photo: author.

790 Head of Artemis from Lykosoura. Much of the right side of the face is restored. Photo: author.

791 Head of Anytos from Lykosoura. Photo: DAI Athens, NM 2098.

792 Robe of Despoina from Lykosoura, ca. 175–150. Athens NM 1737. Ht. 1.13 m. Photo: Alinari 24301; Alinari/Art Resource, New York.

793 Colossal head of Zeus by Eukleides of Athens, from Aigeira in Achaea, ca. 150. Athens NM 3377. From an akrolith. Ht. 87 cm. Photo: author.

794 Colossal head of King Ptolemy IX Soter II of Egypt, from Memphis, ca. 100–80. Boston, MFA 59.51. Ht. 64 cm. Recut in antiquity, presumably from a portrait of the usurper Ptolemy X Alexandros I, who ousted Soter in 107 but was killed in 88. Photo: author.

795 Front view of the head, fig. 794. Photo: author.

796 Colossal head of King Seleukos I Nikator of Syria, from Esen Tepe, near Iskenderun (Turkey), ca. 100. Antakya Museum 14319. Ht. 53.5 cm. Photo: A. Houghton.

797 King Antiochos IX of Syria, from Esen Tepe, near Iskenderun (Turkey), ca. 114–95. Antakya Museum 14318. Ht. 43.1 cm. Photo: A. Houghton.

798 Tetradrachm of King Mithradates III of Pontos, ca. 246–190. London, BM. Silver. D. 1.8 cm. Photo: Hirmer Fotoarchiv 14.0769V.

799 Tetradrachm of King Mithradates VI Eupator of Pontos, ca. 100–63. London, BM. Silver. D. 1.8 cm. Photo: Hirmer Fotoarchiv 140775V.

800 Head identified as King Mithridates VI Eupator of Pontos (Roman copy), original, ca. 100–75. Provenance unknown. Paris, Louvre MA 2321. Ht. 35 cm. Much of the nose is restored, together with parts of the lips and chin. Photo: Louvre 64.Y.110; Musée du Louvre, Paris.

801 Homer (Roman copy), from Rome, original ca. 150–100. Paris, Louvre MA 440. Ht. 54 cm. The tip of the nose and some details of the beard and hair are restored. Photo: Musée du Louvre, Paris.

802 Karneades (Roman copy), original ca. 140. Provenance unknown. Basel, Antikenmuseum 201. Ht. 35 cm. Photo: Museum.

803 Portrait ("Sulla"), reportedly from Asia Minor, ca. 100–75. Malibu, J. Paul Getty Museum 73.AB.8. Bronze. Ht. 28 cm. Photo: J. Paul Getty Museum, Malibu.

804 Colossal Athena attributed to Euboulides, from Athens, ca. 100. Athens NM 234. Ht. 60 cm. Photo: author.

805 Nike by Euboulides, from Athens, ca. 100. Athens NM 233. Ht. 1.23 m. The right shoulder and adjacent parts of the chest and neck are restored. Photo: author.

806 Aphrodite from Melos ("Venus de Milo"), ca. 100. Paris, Louvre MA 399. Ht. 2.04 m. Associated with a base (now lost) signed by [Alex]andros of Antioch on the Maeander. Photo: Photo Bulloz 85219.

807 Aphrodite from Satala in Armenia, ca. 100–75. London, BM Br 266. Bronze. Ht. 38 cm. Photo: BM C-3667; Trustees of the British Museum.

808 Aphrodite from Rhodes, ca. 100. Rhodes Museum. Ht. 49 cm. Photo: Hirmer Fotoarchiv 562.0720.

809 The Three Graces (Roman copy) from Italy, original ca. 100–50. Paris, Louvre MA 287. Ht. 1.05 m. All three heads are restored. Photo: Photo Bulloz 8677.

810 "Borghese Warrior" (Roman copy), from Anzio, ca. 100–75. Paris, Louvre MA 527. Ht. 1.99 m. Signed on the support by Agasias son of Dositheos of Ephesos. The arms are restored. Photo: Alinari 22625; Alinari/Art Resource, New York.

811 Head of the Borghese Warrior, fig. 810. Photo: Giraudon 26044; Giraudon/Art Resource, New York.

812 Head of a statue of Herakles, reportedly from Alexandria, ca. 150–100, eyes and hair recut slightly in the second century A.D. Malibu, J. Paul Getty Museum 83.AA.11. Marble (originally completed in wood?). Ht. of head and bust, 58 cm. Photo: The J. Paul Getty Museum.

813 The Herakles, fig. 812, complete. Photo: The J. Paul Getty Museum.

814 Boxer from Rome, ca. 100–50. Rome, Museo Nazionale Romano (Terme) 1055. Bronze. Ht. 1.28 m. Photo: Brogi 1055.

815 Jockey from a wreck off Cape Artemision (Greece), ca. 150–125. Athens NM Br 15177. Bronze. Ht. of jockey, 84 cm. Photo: Alison Frantz AT 78.

816 Jockey (fig. 815) and horse from the Artemision wreck, ca. 150–125. Athens NM Br 15177. Bronze. L. of horse, 2.5 m. The horse's tail is restored, with parts of its body. Photo: DAI Athens 80.59.

817 Old shepherdess (Roman copy), from Rome, original ca. 150. Rome, Conservatori 1111. Ht. 1.15 m. The head is restored. Photo: Anderson 1754; Alinari/Art Resource, New York.

818 "Old market woman" (Roman copy), from Rome, original ca. 150–

100. New York, MMA 09.39. Ht. 1.26 m. The face is partly restored. Photo: MMA 6027B; Metropolitan Museum of Art, New York, Rogers Fund, 1909 (09.39).

819 Sleeping hermaphrodite (Roman copy), from Rome, original ca. 150–100. Rome, Museo Nazionale Romano (Terme) 1087. L. 1.48 m. Photo: Anderson 2160; Alinari/Art Resource, New York.

820 Detail of another copy of the hermaphrodite, fig. 819, from Rome, original ca. 150–100. Paris, Louvre 231. L. 1.47 m. The mattress is seventeenth century. Photo: Giraudon 35660; Giraudon/Art Resource, New York.

821 Sleeping Eros from Rhodes, ca. 150–100. New York, MMA 43.11.4. Bronze. L. 78 cm. Photo: MMA 131094; Metropolitan Museum of Art, New York, Rogers Fund, 1943 (43.11.4).

822 Gravestone of Exakestes and Metreis, probably from Smyrna (Turkey), ca. 200–100. London, BM 704. Ht. 77 cm. Inscribed: "The demos [to] Exakestes son of Androboulos; the demos [to] Metreis daughter of Hermippos, wife of Exekestes." Photo: BM XCVIII-C; Trustees of the British Museum.

823 Gravestone with funerary banquet, from Asia Minor, ca. 200–100. London, BM 734. Ht. 55 cm. Photo: BM XCVII-C(40); Trustees of the British Museum.

824 Votive relief, allegedly from Corinth, but probably Attic, ca. 150–100. Munich, Glyptothek 206. Ht. 61 cm. The divinities may be Asklepios and Hygieia, Dionysos and Ariadne, or Isis and Sarapis/Osiris. Photo: UCLA Classics Archive.

825 Votive relief with Pan, Apollo, Hermes, and the Nymphs, from the south side of the Akropolis at Athens, ca. 100. Athens NM 1966. Ht. 39 cm. Photo: DAI Athens 71.72.

826 Votive relief from Piraeus, ca. 150–125: Dionysos visits a poet. Paris, Louvre MA 741. Ht. 55 cm. Photo: Louvre 65 DN 904; Musée du Louvre, Paris.

827 Relief with Dionysos visiting a poet (Roman copy), original, late first century B.C. London, BM 2190. Ht. 91 cm. Many details restored. Photo: BM 1D-43; Trustees of the British Museum.

828 Frieze of the temple of Hekate at Lagina in Caria (Turkey), ca. 130–100. Istanbul Archaeological Musem 1914. Ht. 93 cm. Photo: Hirmer Fotoarchiv 571.2013.

829 Detail of the west frieze at Lagina, fig. 828: Artemis, Apollo and the Giants. Photo: DAI Istanbul 781246.

830 Detail of the north frieze at Lagina, fig. 828: treaty between Roma and the Carian cities. Photo: DAI Istanbul 78/275.

831 Reconstruction of the Establishment of the Poseidoniasts of Berytos (Beirut) on Delos, ca. 150–125. From Délos 6: 32, fig. 26.

832 The goddess Rome (Thea Roma Euergetis), on a base signed by Melas son of Menandros of Athens, from the Establishment of the Poseidoniasts of Berytos (Beirut), ca. 150–100. In situ. Ht. 1.54 m. For the dedicatory inscription and signature, see chapter 4.2. Photo: G. Koch.

833 Nymph being disrobed by a satyr, from the Establishment of the Poseidoniasts of Berytos (Beirut), ca. 100. Delos Museum A4156. Ht. 73 cm. Photo: Ecole française d'Athènes.

834 Aphrodite, Pan, and Eros, from the Establishment of the Poseidoniasts of Berytos (Beirut), ca. 100. Athens NM 3335. Ht. 1.32 m. Inscribed: "Dionysios son of Zenon son of Theodoros of Berytos, benefactor, [dedicated this] on behalf of himself and his children to his native gods" (ID 1783). Photo: TAP Photo Service.

835 Statuettes of the Knidian Aphrodite of Praxiteles and another Aphrodite leaning on a statuette, from Delos, ca. 100. Delos Museum A4409, 1818. Ht. 45 cm, 37 cm. Photo: Ecole française d'Athènes 18388.

836 Statuette recalling the Eirene of Kephisodotos, from Delos, ca. 100. Delos Museum A4127. Ht. 1.09 m. Photo: Ecole française d'Athènes 16312.

837 Kleopatra and Dioskourides, in their house on Delos, 138/37. Ht. 1.67 m. Inscribed: "Kleopatra daughter of Adrastos of Myrrhinous [set up this portrait of] her husband Dioskourides son of Theodoros of Myrrhinous, having dedicated the two Delphic tripods of silver in the temple of Apollo by each door-post, in the archonship of Timarchos at Athens" (ID 1987). Photo: Hirmer Fotoarchiv 562.0705.

838 Fallen Celt, from the Agora of the Italians on Delos, ca. 100. Athens NM 247. Ht. 93 cm. The head, allegedly found on Mykonos, probably does belong to this statue. Photo: author.

839 Reconstruction of the niche of C. Ofellius Ferus in the Agora of the Italians on Delos, ca. 100. Ht. of statue, ca. 3 m. For the dedication and signature, see T 160. Drawing by Candace Smith.

840 Colossal portrait statue from the House of the Diadoumenos on Delos, ca. 100–88. Athens NM 1828. Ht. 2.55 m. Unfinished. Photo: TAP Photo Service.

841 Portrait of a man, from Delos, ca. 100–88. Delos Museum A4186. Ht. 49.2 cm. Photo: author.

842 Portrait head ("Worried Man") from Delos, ca. 100. Athens NM Br14612. Bronze. Ht. 32.5 cm. Photo: Alison Frantz.

843 "Altar of Domitius Ahenobarbus," from Rome, ca. 130–100: marriage of Poseidon and Amphitrite. Munich, Glyptothek 239. Ht. 1.52 m.,

recut to fit the census slabs of figs. 846–847.

844 Detail from another slab of the "Altar," fig. 843: Nereid on hippocamp. Photo: author.

845 "Altar of Domitius Ahenobarbus," from Rome, ca. 100–70: census, with Mars looking on. Paris, Louvre MA 975. Ht. 1.52 m.

846 "Altar of Domitius Ahenobarbus," from Rome, ca. 100–70: sacrifice at the census (suovetaurilia). Paris, Louvre MA 975. Ht. 1.52 m.

847 Herm signed by Boethos of Kalchedon, from the Mahdia wreck, ca. 130–100. Tunis, Bardo Museum. Bronze. Ht. 1 m. Probably belongs with the winged youth, fig. 848. Inscribed "Boethos of Kalchedon made [it]." Photo: DAI Rome 61.438.

848 Winged youth (probably Eros Enagonios), from the Mahdia wreck, ca. 130–100. Tunis, Bardo Museum. Bronze. Ht. 1.40 m. Probably belongs with the herm, fig. 847. Photo: DAI Rome 61.436.

849 Another version of the herm (not from the same mold), fig. 847, first or second century A.D. Malibu, J.Paul Getty Museum 79.AB.138. Bronze. Ht. 1.04 m. Photo: The J. Paul Getty Museum.

850 Head of the herm, fig. 849. Photo: J. Paul Getty Museum.

851 Head of the youth, fig. 848. Photo: DAI Rome 63.292.

852 Grotesque dancer from the Mahdia wreck, ca. 130–100. Tunis, Bardo Museum. Bronze. Ht. 32 cm. Photo: DAI Rome 61.455.

853 Fragments of a krater from the Mahdia wreck, ca. 130–100: Dionysos supported by a satyr. Tunis, Bardo Museum 26. Ht. of figures, 60 cm; of krater, 1.75 m. Photo: DAI Rome.

854 Fragments of a krater from the Mahdia wreck, ca. 130–100: Dionysiac thiasos. Tunis, Bardo Museum 26. Ht. of figures, 60 cm; of krater, 1.75 m. Photo: DAI Rome.

855 "Borghese" krater from Italy, ca. 100: Dionysiac thiasos. Paris, Louvre MA 86. Ht. 1.71 m. Photo: Louvre 65.DN.849; Musée du Louvre, Paris.

856 "Belvedere torso" (Philoktetes?) by Apollonios son of Nestor of Athens, from Rome, ca. 50. Vatican, Atrio del Torso 1192. Ht. 1.42 m. Signed on the rock, "Apollonios son of Nestor the Athenian made [it]." Photo: Hirmer Fotoarchiv 671.9293.

857 Apollo from the sea off Piombino (Italy), ca. 50. Paris, Louvre inv. 61. Bronze. Ht. 1.15 m. Inscribed in silver on the left foot "…os to Athena, a tithe . . . ," and on a lead strip inside the body "[M]enodo[tos of Tyre and . . .]phon of Rhodes made [it]." Photo: Giraudon 9562; Giraudon/Art Resource, New York.

858 Colossal head of Hercules from the Capitoline, Rome, ca. 150–125. Rome, Museo Nuovo Capitolino 2381. Ht. 57 cm. Photo: DAI Rome 34.225.

859 Statuette of Jupiter Capitolinus, original ca. 80–69. Provenance unknown. New York, MMA 17.230.32. Bronze. Ht. 10.4 cm. Photo: MMA 47402; Metropolitan Museum of Art, New York.

860 Athlete signed by Stephanos, pupil of Pasiteles, from Rome, ca. 50. Rome, Villa Albani. Ht. 1.44 m. Inscribed on the support: "Stephanos pupil of Pasiteles made [it]." The top of the head, locks falling over the forehead, tip of the nose, right arm, left forearm, right foot, and most of the plinth are restored. Photo: Alinari 27564; Alinari/Art Resource, New York.

861 Orestes and Elektra signed by Menelaos, pupil of Stephanos, from Rome, ca. 30. Rome, Museo Nazionale Romano (Terme) 8604. Ht. 1.92 m. Inscribed: "Menelaos pupil of Stephanos made [it]." On the youth the tip of the nose, most of the right arm and several fingers of the hand, and on the woman the front part of the hair, the left forearm, and some of the fingers are restored; the drapery has been textured and the flesh smoothed. Photo: Alinari 6269; Alinari/Art Resource, New York.

862 Roman general ("Hellenistic ruler"), from Rome, ca. 150–125. Rome, Museo Nazionale Romano (Terme) 1049. Bronze. Ht. 2.22 m. Photo: Alinari 6271; Alinari/Art Resource, New York.

863 Head of the general, fig. 862. Photo: Anderson 2150; Alinari/Art Resource, New York.

864 Head of the general (profile), fig. 862. Photo: Anderson 2151; Alinari/Art Resource, New York.

865 Roman general from the temple of Hercules at Tivoli, ca. 100–50. Rome, Museo Nazionale Romano (Terme) 106 513. Ht. 1.88 m. The right shoulder and the upper part of the support are restored. Photo: Anderson 28853; Alinari/Art Resource, New York.

866 "Tower of the Winds" (Horologion of Andronikos), Athens, ca. 50, if not late second century B.C.: view of the winds Skiron (NW), Zephyros (W), and Lips (SW). In situ. Ht. of reliefs, 1.65 m. Photo: P. Lawrence.

867 Euros (SE wind), from the "Tower of the Winds," fig. 866. Photo: DAI Athens 80.556.

868 Caryatid from the Lesser Propylaia at Eleusis, after 54 to after 48. Eleusis Museum. Ht. 2 m. Photo: DAI Athens.

869 Priest, from the Athenian Agora, ca. 50. Athens, Agora Museum S333. Ht. 29 cm. Photo: Agora 3-142-S333; American School of Classical Studies at Athens, Agora Excavations.

870 Head of an Egyptian priest ("Green head"), from Egypt, ca. 100–50. Berlin (West), Agyptisches Museum 12500. Green schist. Ht. 21 cm.

Photo: Ägyptisches Museum, Staatliche Museen Preussischer Kultur-besitz, Berlin.

871 Bust of Poseidonios (Roman copy), ca. 75–50. Naples, Museo Nazion-ale 6142. Ht. 44 cm. The tip of the nose and most of the ears are restored. Photo: DAI Rome 62.859.

872 Head probably of Diodoros Pasparos, from the "Marmorsaal" of his gymnasium at Pergamon, ca. 80–60. Bergama Museum 3438. Ht. 44 cm. Photo: DAI Istanbul PE 75/559.

873 Plan of the Hierothesion of Antiochos I of Commagene at Nemrud Dagh (Eastern Turkey). From F. K. Doerner, *Kommagene* (Gundholzen, 1967), 20, fig. 5.

874 Hierothesion of Antiochos I of Commagene at Nemrud Dagh, ca. 50–35: heads of Antiochos and Artagnes-Herakles-Ares on the west ter-race. In situ. Limestone. Ht. of heads, ca. 1.6 m. Photo: author.

875 Hierothesion of Antiochos I of Commagene at Nemrud Dagh, ca. 50–35: general view of the east terrace. From left to right, the seated figures (flanked by eagles and lions) are Antiochos, Commagene, Zeus-Oro-masdes, Apollo-Mithras-Helios-Hermes, and Artagnes-Herakles-Ares. Limestone. Ht. of figures, ca. 8 m. Photo: author.

876 Hierothesion of Antiochos I of Commagene at Nemrud Dagh, ca. 50–35: stelai showing Antiochos with gods and heroes, and lion-horo-scope. In situ. Limestone. Ht. 2 m. Photo: author.

877 Hierothesion of Antiochos I of Commagene at Nemrud Dagh, ca. 50–35: detail of lion-stele with horoscope of Antiochos. In situ. Limestone. Ht. of stele, ca. 1.2 m. Photo: W. Horn.

878 Tetradrachm of Queen Kleopatra VII Thea of Egypt, possibly minted in Antioch, 42–30. Cambridge, Fitzwilliam Museum. Silver. D. 2.7 cm. Photo: Fitzwilliam Museum, Cambridge.

879 Queen Kleopatra VII Thea of Egypt, from Rome, ca. 50–30. Vatican, Sala a Croce Greca 179. Ht. 30 cm. The nose is restored. Photo: DAI Rome 3284.

880 Octavian, from Italy, ca. 35–25. Rome, Museo Capitolino 413. Ht. 37 cm. Part of the nose is restored, as are some small areas of the flesh surfaces; the bust is ancient, but does not belong. Photo: DAI Rome 30.2.

881 Queen Kleopatra VII Thea of Egypt, ca. 50–30. Provenance unknown. Berlin (West), Antikenmuseum 1976.10. Ht. 29.5 cm. Photo: Mu-seum.

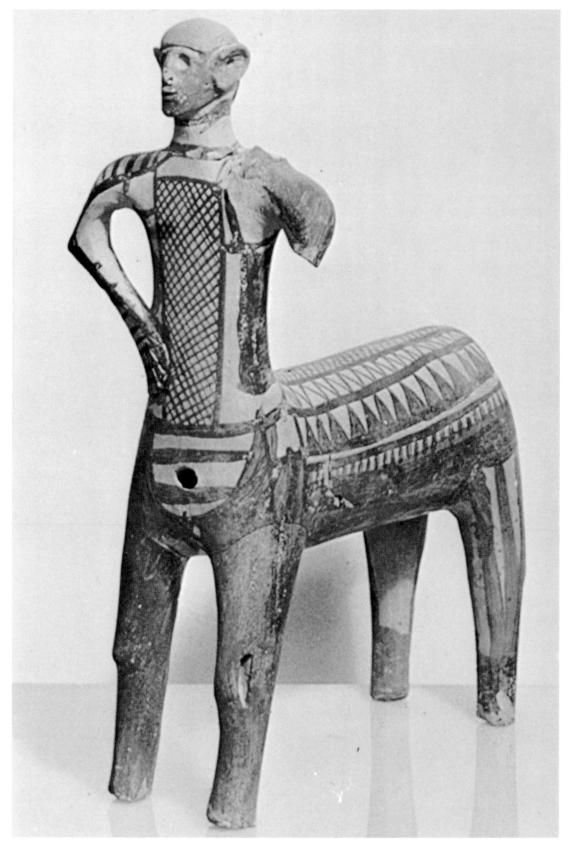

1 Centaur from a tomb at Lefkandi, Euboea, ca. 950–900. Terracotta, ht.
36 cm. Eretria.

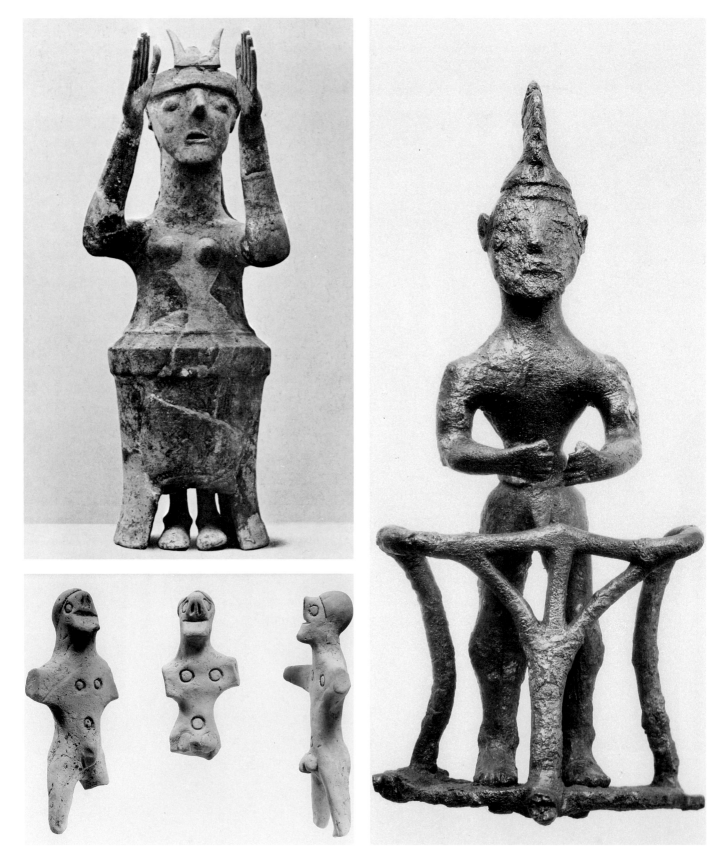

2 Adorant or goddess from Karphi, Crete, ca. 1000. Terracotta, ht. 67 cm. Heraklion.

4 "Zeus" figurines from Olympia, ca. 750–725. Terracotta, ht. 12.8 cm, 9.2 cm, 13 cm.

3 Charioteer from Olympia, ca. 775–750. Bronze, ht. 13.5 cm.

From Mycenaean to Geometric
2–4

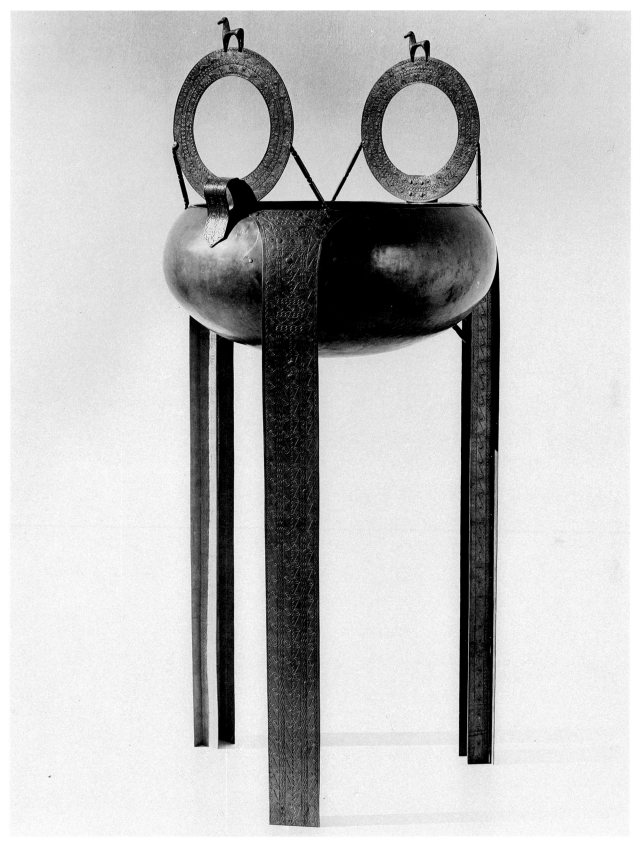

5 Reconstruction of a late Geometric caldron, Olympia. Bronze, ht. 1.54
 m.

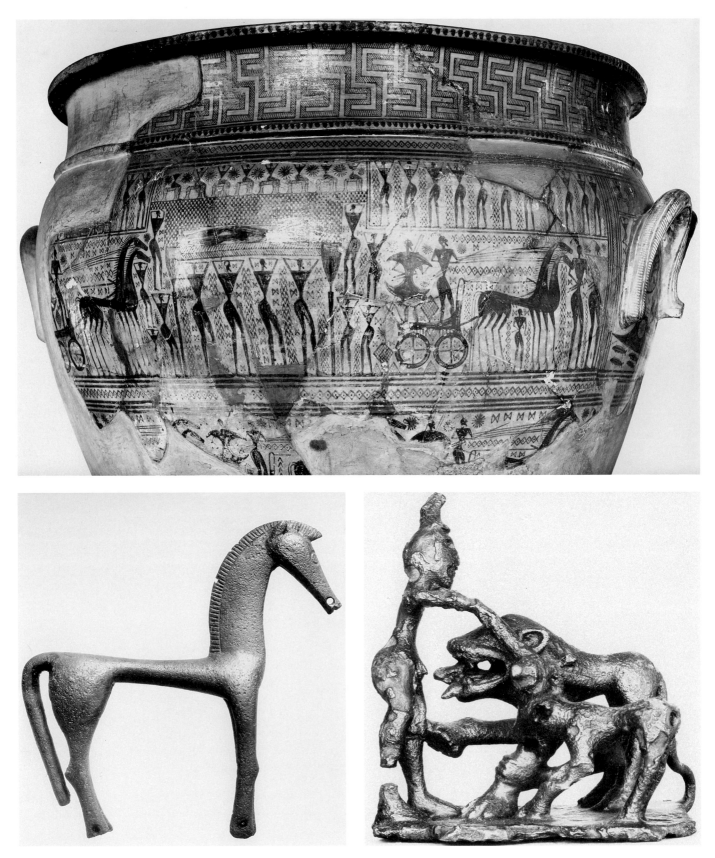

6 Funerary krater attributed to the "Dipylon" painter, from Athens, ca. 750. Ht. 40 cm. Paris.

7 Horse from the ring-handle of a large tripod-caldron at Olympia, ca. 750–700. Bronze, ht. 11.2 cm. See fig. 5.

8 Hunter and dog attacking a lion, from Samos, ca. 700. Bronze, ht. 9 cm.

Geometric Bronzes from Olympia and Samos
6–8

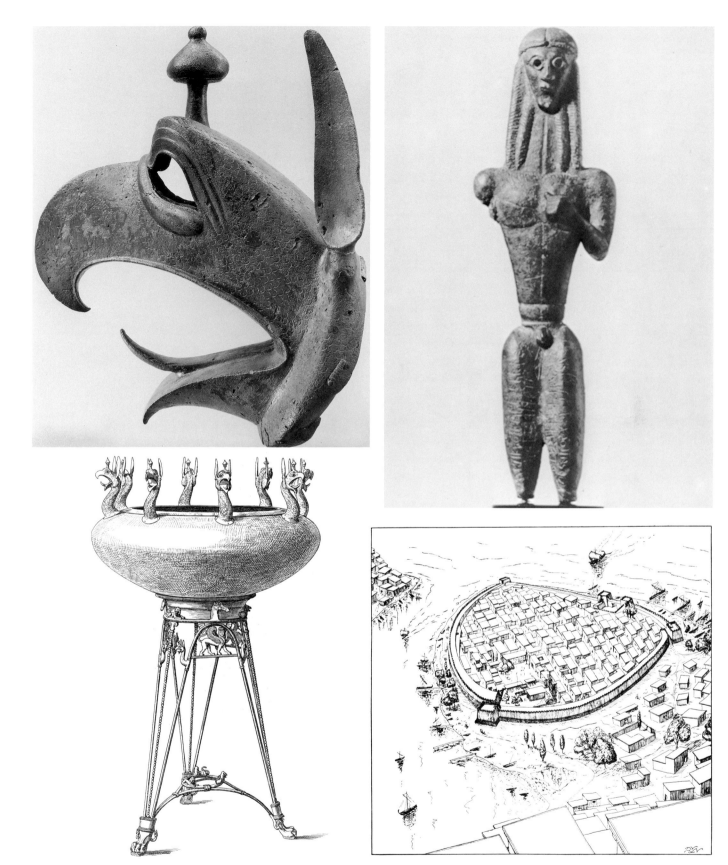

9 Griffin from the rim of a large tripod-caldron at Olympia, ca. 650–625.
 Hammered bronze, ht. 27.8 cm. See fig. 10.
10 Reconstruction of an orientalizing tripod-caldron.

11 Man from Thebes, dedicated by Mantiklos to Apollo, ca. 700–675.
 Bronze, ht. 20 cm. Boston.
12 The polis of Old Smyrna in the seventh century BC.

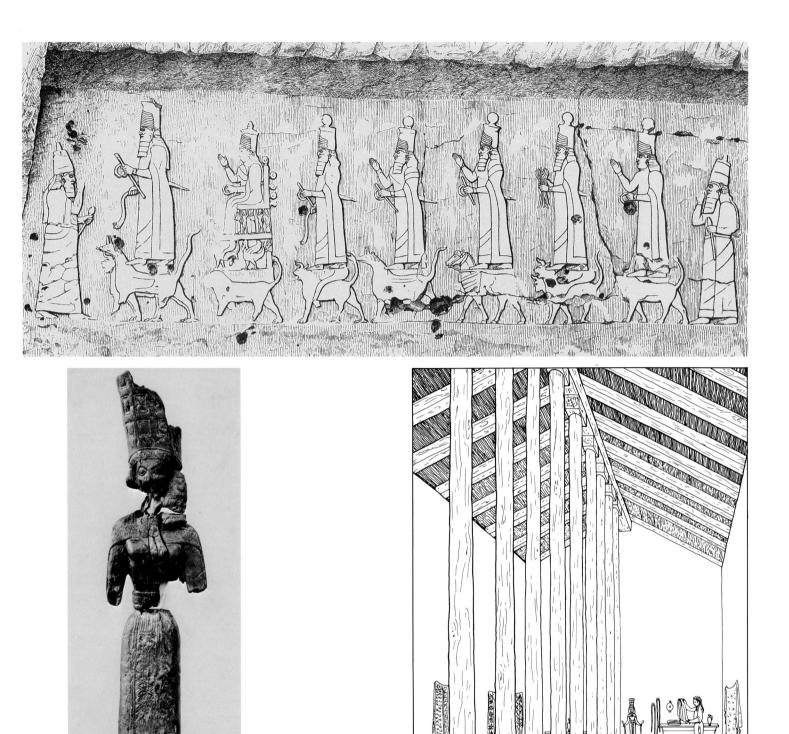

13 Neo-Assyrian rock-relief at Maltaya in Iraq, ca. 700. Ht. 1.85 m. The king, at each end of the panel, supplicates seven deities, each mounted on an animal.

14 Goddess (presumably Hera) from the Heraion at Samos, ca. 650–625. Wood, ht. 28.7 cm.

15 Reconstruction of the Heraion at Samos in the seventh century BC.

The Cult Image: Origins and Early Development
13–15

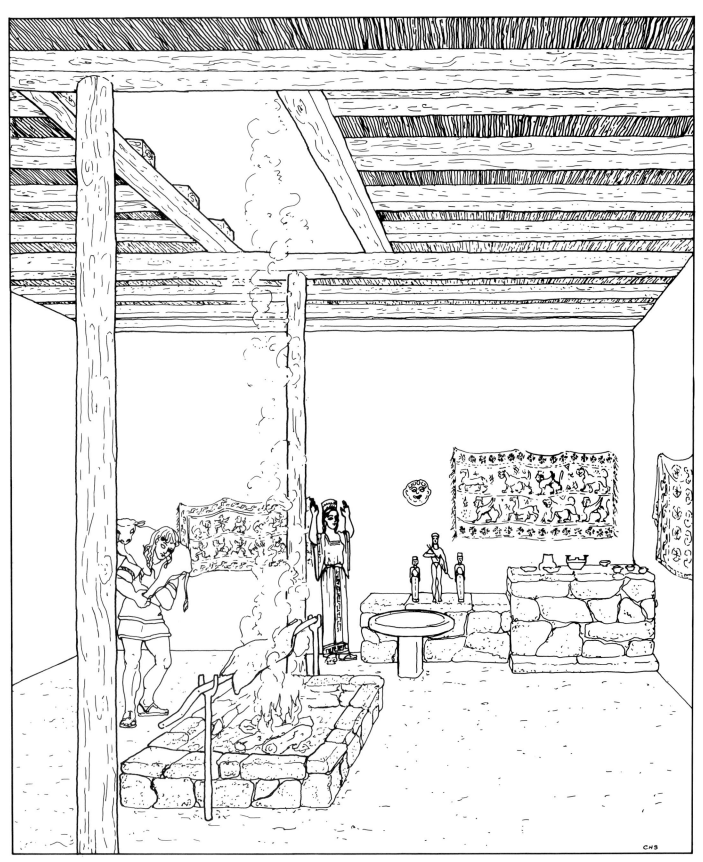

16 Reconstruction of the interior of the temple of Apollo at Dreros (Crete)
 in the seventh century BC.

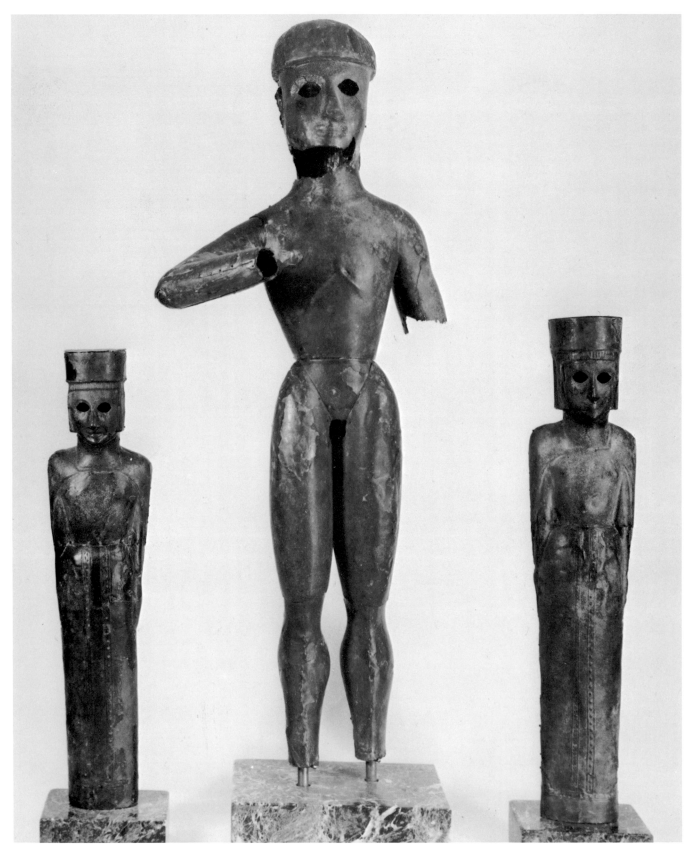

17 Apollo, Leto, and Artemis, from the temple of Apollo at Dreros
 (Crete), ca. 700. Hammered bronze (*sphyrelaton*), ht. 80 cm and 40 cm.
 Heraklion.

The Cult Image: Origins and Development
17

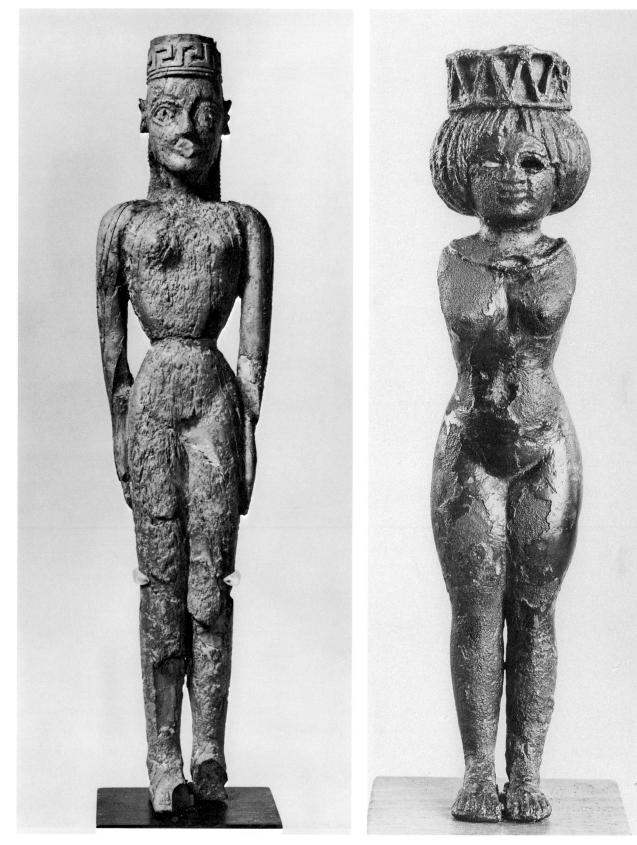

18 Girl from a grave in Athens, ca. 725. Ivory, ht. 24 cm.

19 Egyptian statuette of a naked girl from Samos, ca. 700–600. Bronze, ht. 17.3 cm.

20 Two "Astarte" plaques from Khania (Crete), ca. 700–650. Molded ter-
 racotta, ht. 13 cm. Heraklion.
21 Daedalic figurine from Kameiros (Rhodes), ca. 700–650. Terracotta,
 ht. 9 cm. London.

22 Sphinx from Perachora on the Isthmus of Corinth, ca. 650. Ivory, ht. 8
 cm. Athens.
23 Perseus killing Medusa, from Samos, ca. 650–625. Ivory, ht. 10.8 cm.

The Daedalic Style
20–23

24–25 Jumper from Samos, ca. 650–625, *at right*. Ivory, ht. 14.5 cm. Probably one of a pair supporting the frame of a lyre, reconstructed in fig. 24, *at left*.

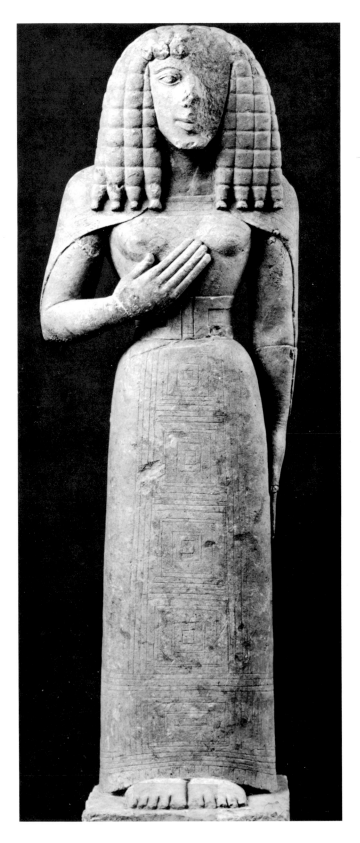

26 Seated woman from the "sanctuary of Athena" at Gortyn, Crete, ca. 700–650. Limestone, ht. 80 cm. Heraklion.

27–28 Kore (the "Auxerre goddess"), ca. 650–625. Limestone, ht. 65 cm. Paris.

Cretan Stone Daedalic
26–28

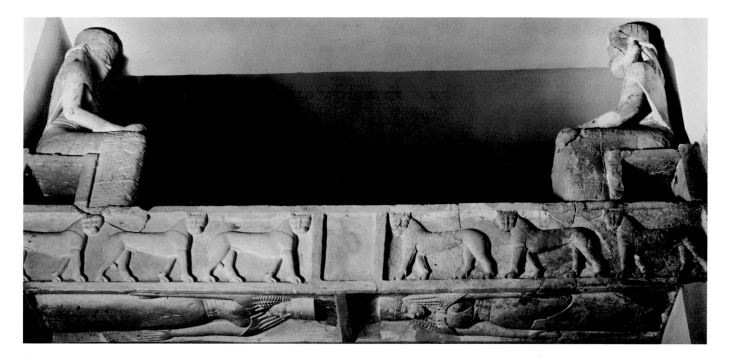

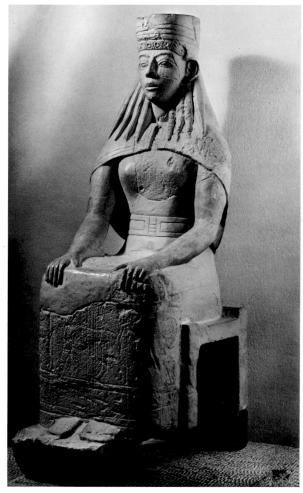

29 Lintel from a temple at Prinias (Crete), ca. 650–625. Limestone, ht. of seated women, 82 cm. Heraklion. The lower parts of both the seated and standing women and some areas of the frieze are restored.

30 Seated goddess from the lintel, fig. 29.

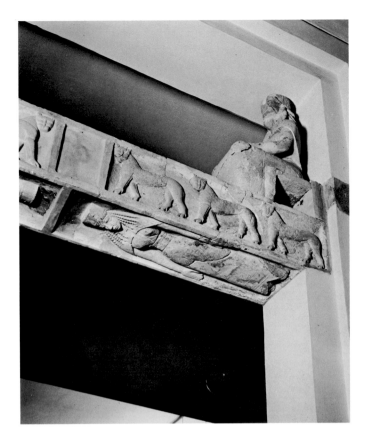

31 Three-quarter view of the lintel, fig. 29, *top left*.
32 Frieze from the temple at Prinias (Crete), ca. 650–625, *bottom*. Limestone, ht. 84 cm. Heraklion.

33 Relief from the temple of Apollo at Gortyn (Crete), ca. 650–625. A striding god (probably Apollo) grasps two nude goddesses (probably Leto and Artemis) around the shoulders. Limestone, ht. 1.5 m. Heraklion. Most of the left-hand figure and the polos of the right-hand one have been restored from casts of a duplicate found nearby.

Architectural Sculpture in Seventh-Century Crete
31–33

34–35 Kore dedicated by Nikandre to Artemis, from Delos, ca. 650–625.
Ht. 1.75 m. Athens.

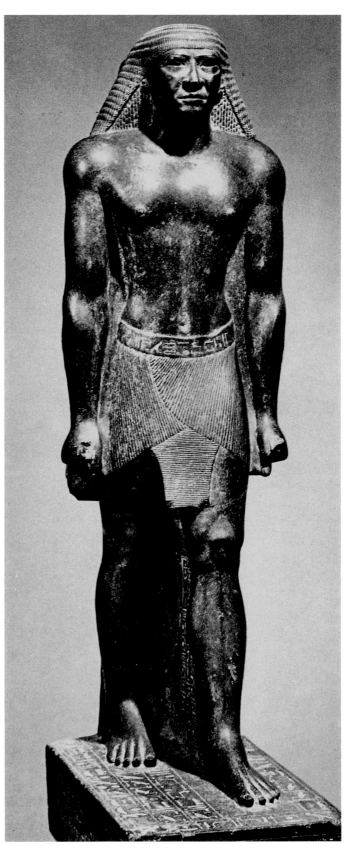

36 Kouros from Delphi, ca. 650–625. Bronze, ht. 19.7 cm.

37 Mentuemhet, prince of Egyptian Thebes, from Karnak, 713–664. Granite, ht. 1.34 m. Cairo.

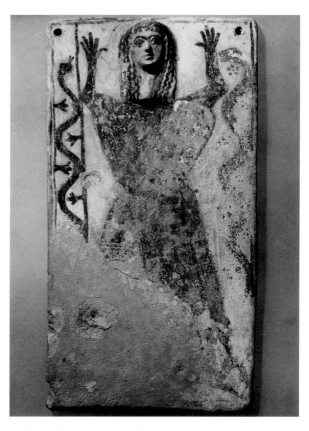

38 Kouros from Thera, ca. 650–625. Ht. 1.03 m.
39 Kouros from Delos, ca. 600. Ht. 85 cm. See also fig. 40.

40 Kouros base with ram-, lion-, and Gorgon-head bosses, signed by Eu-
thykartides of Naxos, from Delos, ca. 625–600. Ht. 58 cm.
41 Painted votive plaque with a goddess and snakes, from the Athenian
Agora, ca. 650–600. Terracotta, ht. 24.8 cm.

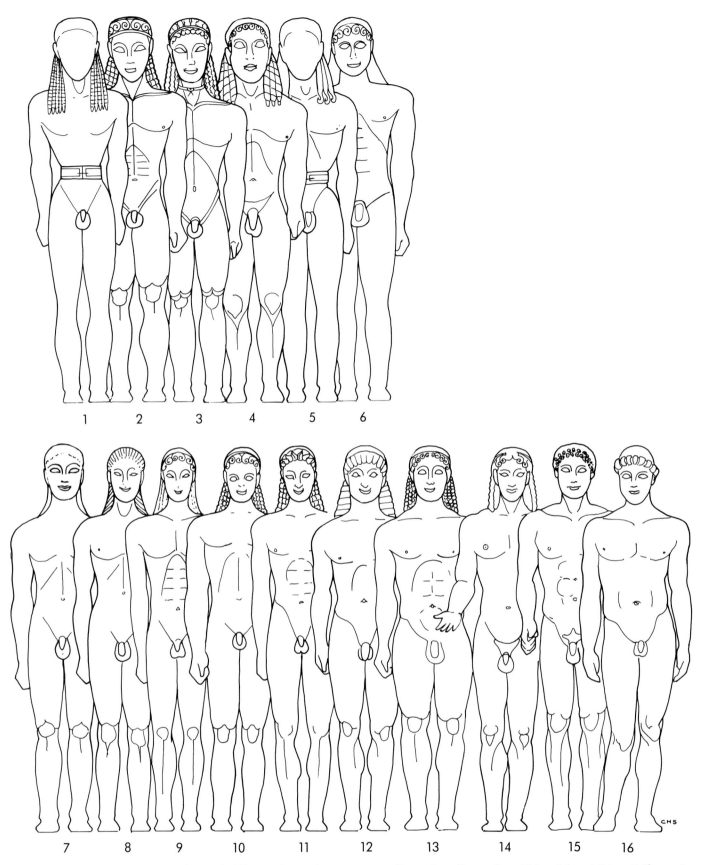

42 Archaic Greek kouroi, late seventh to early fifth centuries BC, shown to the same scale; missing parts of the statues have been conjecturally restored: 1. Kouros, Delos A 333 (fig. 39); 2. Kouros from Sounion, Athens NM 2720 (fig. 44); 3. Kouros from Attica, New York 32.11.1 (fig. 49); 4. "Kleobis," Delphi 467 (fig. 56); 5. Apollo of the Naxians, Delos A 4094 and unnumbered, with London, BM B 322 (fig. 110); 6. Kouros from Orchomenos, Athens NM 9 (fig. 60); 7. Kouros dedicated by Ischys, Samos (fig. 100); 8. Kouros from Samos, Samos 5235 and Istanbul 1645 (fig. 103); 9. Kouros from Melos, Athens NM 1558 (fig. 117); 10. Kouros from Paros, Louvre MND 888 (fig. 118); 11. Kouros from Volomandra in Attica, Athens NM 1906 (fig. 120); 12. Kouros from Tenea, Munich Glyptothek 168; 13. Kroisos from Anavyssos, Athens NM 3851 (fig. 132); 14. Bronze Apollo from Piraeus, Piraeus Museum (fig. 168); 15. Kouros from the sanctuary of Apollo Ptoios in Boeotia, Athens NM 20 (fig. 180); 16. "Kritian Boy," Akropolis Museum 698 (fig. 219).

The Development of the Kouros

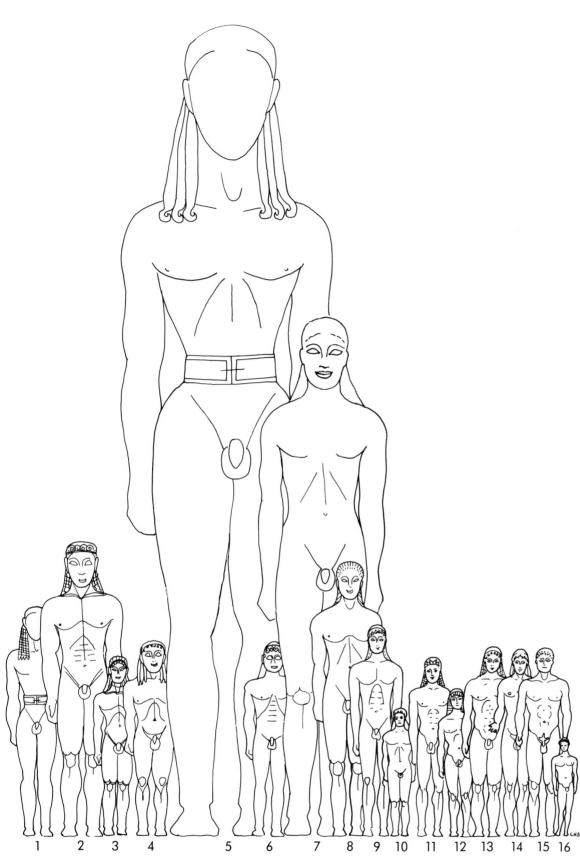

1 2 3 4 5 6 7 8 9 10 11 12 13 14 15 16

43 Archaic Greek kouroi as in fig. 42, but shown at their actual scales; miss-
ing parts of the statues have been conjecturally restored.

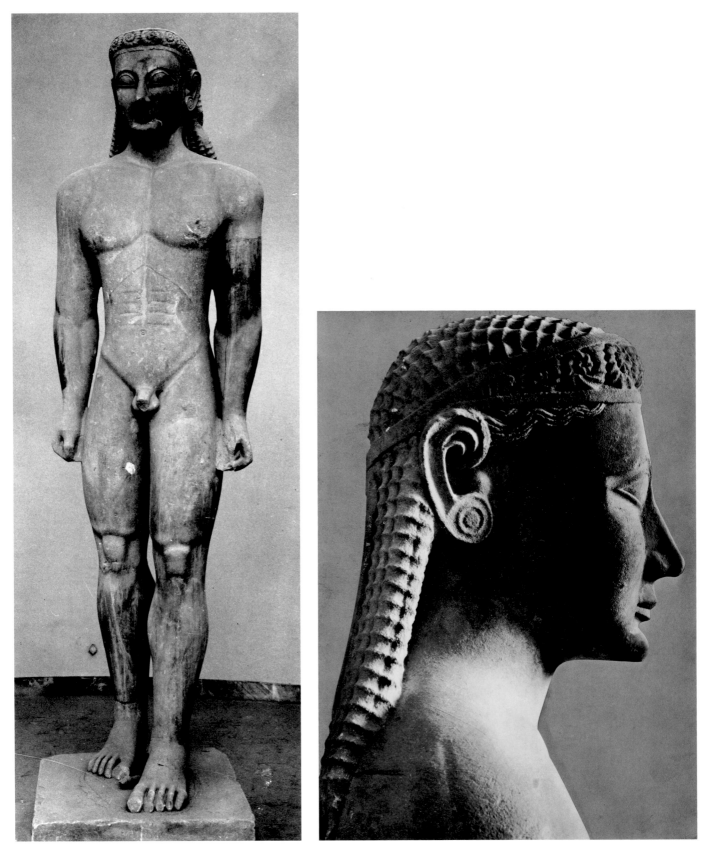

44–45 Kouros from Sounion (Attica), ca. 600–575. Ht. 3.05 m. Athens.
Most of the left side of the face, with the nose and lips, and the legs be-
tween the knee and ankle have been restored.

Early Attic Kouroi: The Sounion Group
44–45

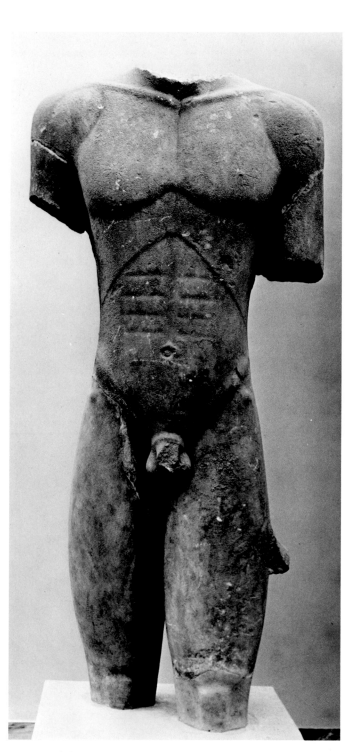

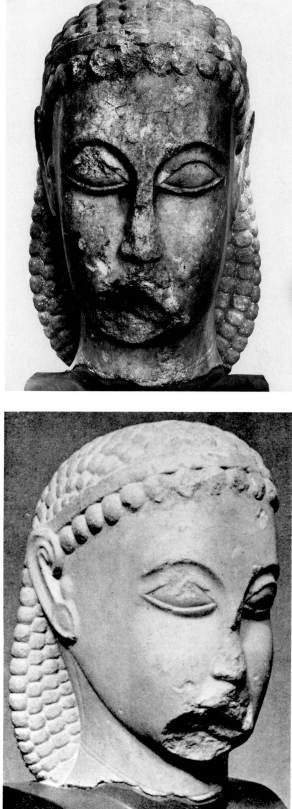

46 Torso of a kouros from Sounion (Attica), ca. 600–575. Ht. 1.65 m. Athens.

47–48 Head of a kouros from the Dipylon cemetery in Athens, ca. 600–575. Ht. 44 cm.

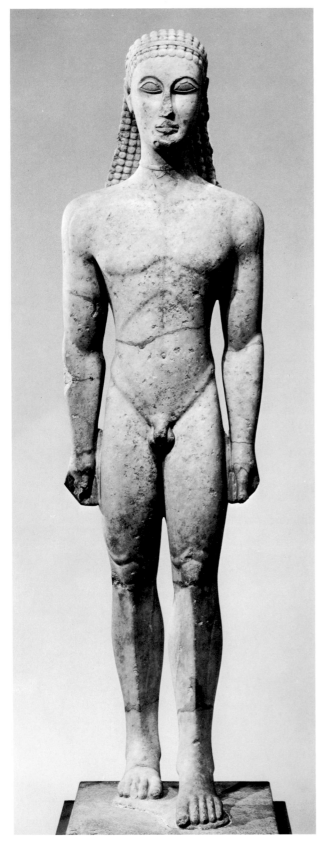 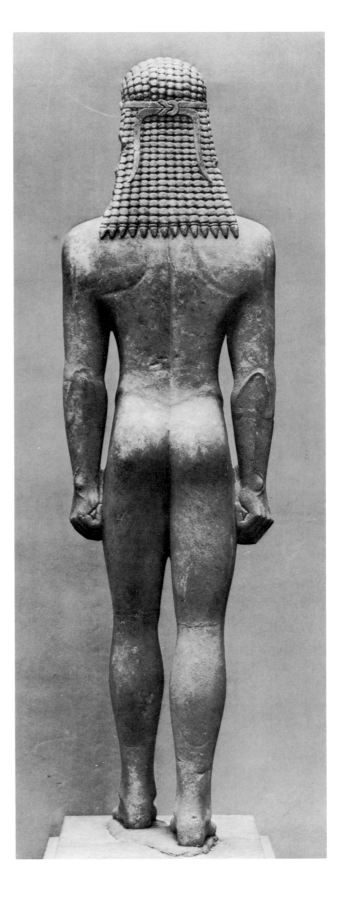

49–50 Kouros from Attica, ca. 600–575. Ht. 1.84 m. New York.

Early Attic Kouroi: The Sounion Group
49–50

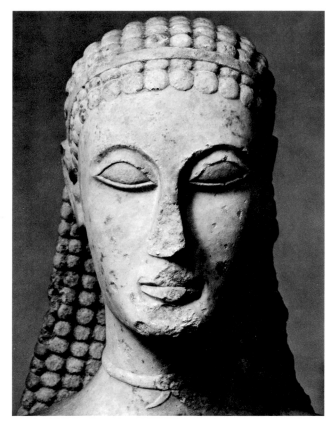

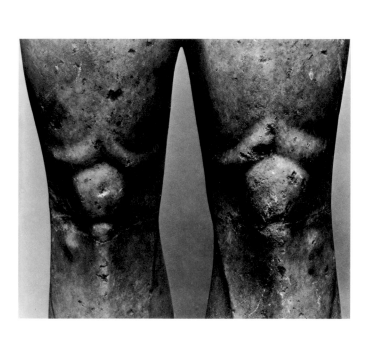

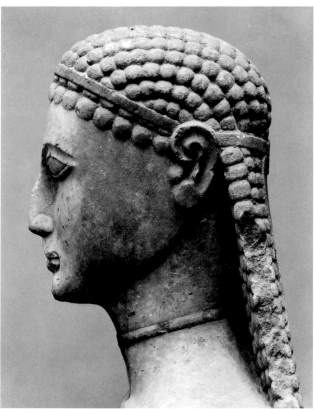

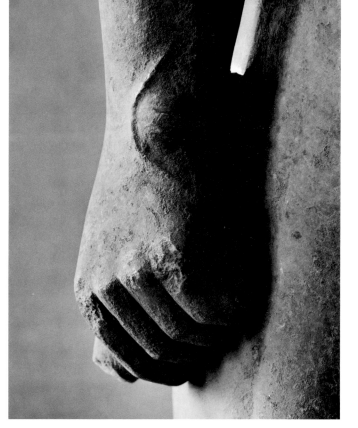

51–54 Details of the kouros, fig. 49.

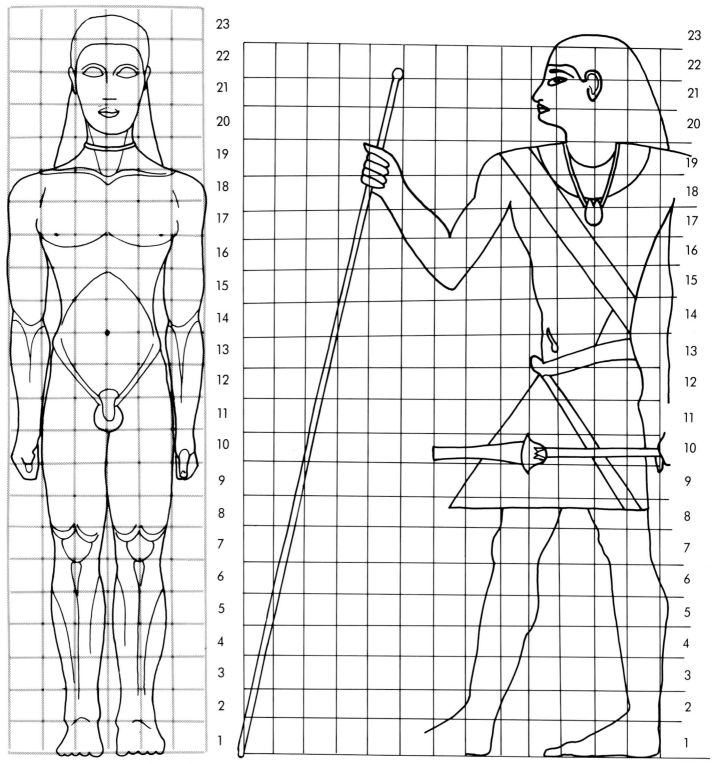

55 The New York kouros and the second Egyptian canon (after ca. 680).

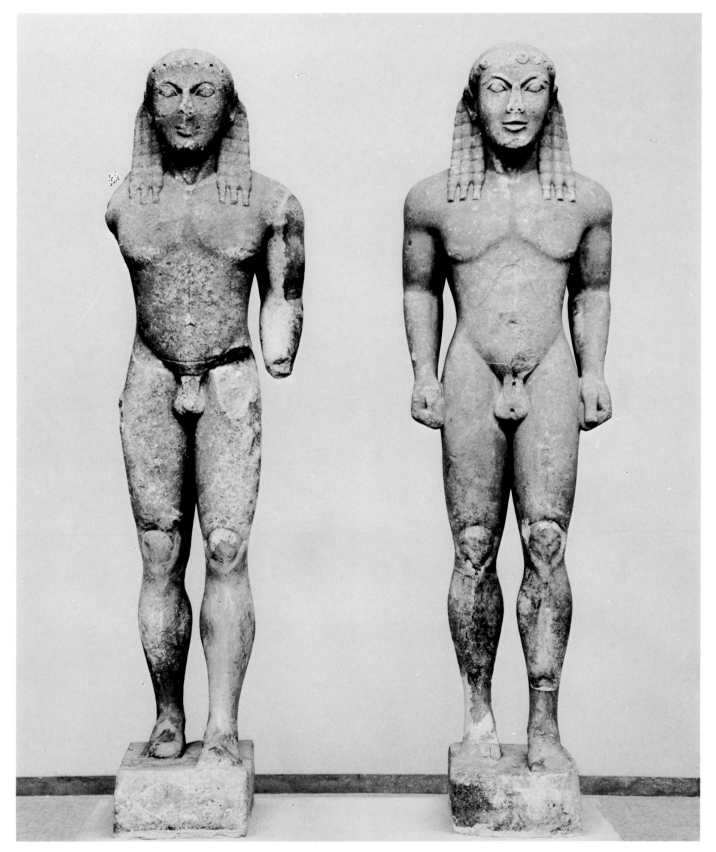

56 Two kouroi (Kleobis and Biton?) signed by [Poly]medes of Argos, from
 Delphi, ca. 600–575. Ht. 1.97 m. The feet of both figures and the left
 lower leg of the left-hand one are restored.

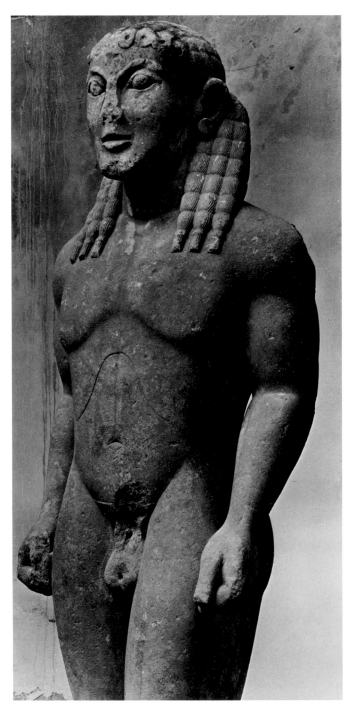

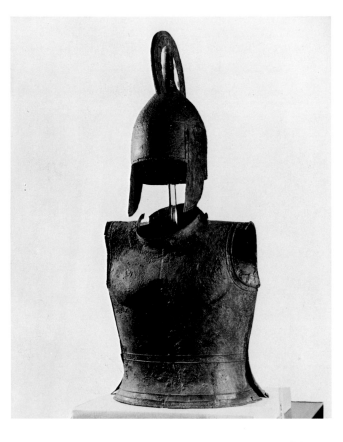

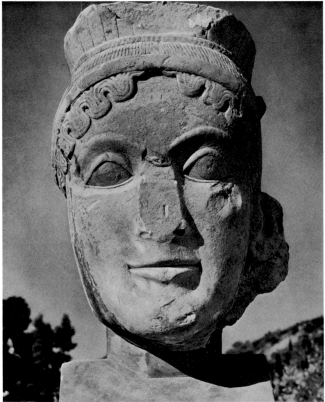

57 Detail of the right-hand kouros from fig. 56.

58 Panoply from a tomb at Argos, ca. 725–700. Bronze, ht. 47.4 cm.
59 Colossal head of a woman (Hera or a sphinx?) from Olympia, ca. 600–575. Limestone, ht. 52 cm.

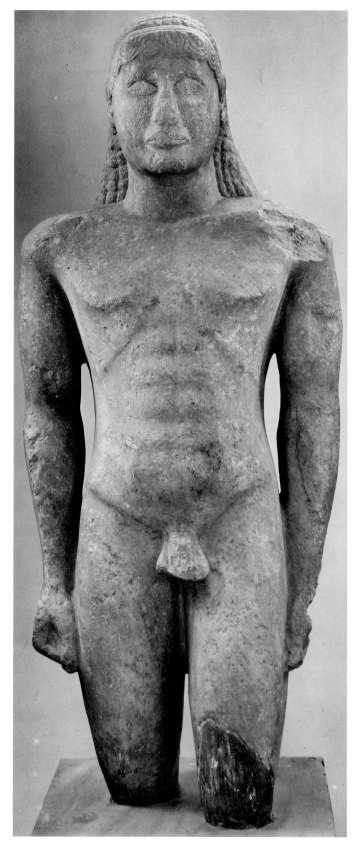

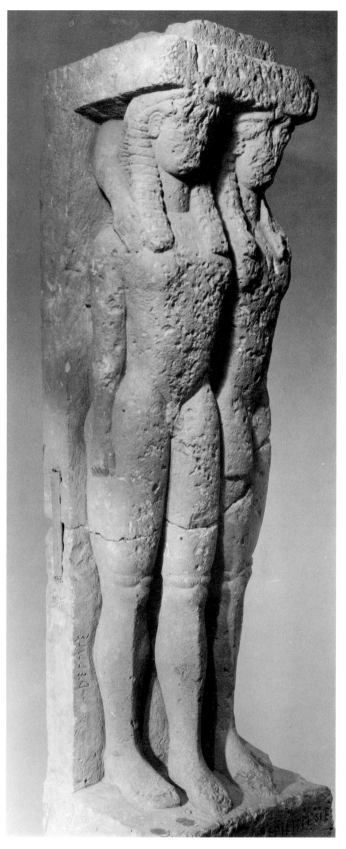

60 Kouros from Orchomenos (Boeotia), ca. 575. Ht. 1.27 m. Athens.

61 Funerary monument erected by Amphalkes to Dermys and Kittylos, from Tanagra (Boeotia), ca. 600–575. Limestone, ht. 1.47 m. Athens.

Early Boeotian Sculpture
60–61

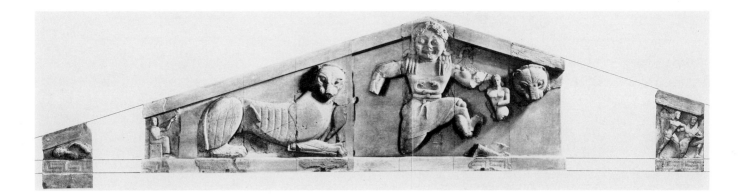

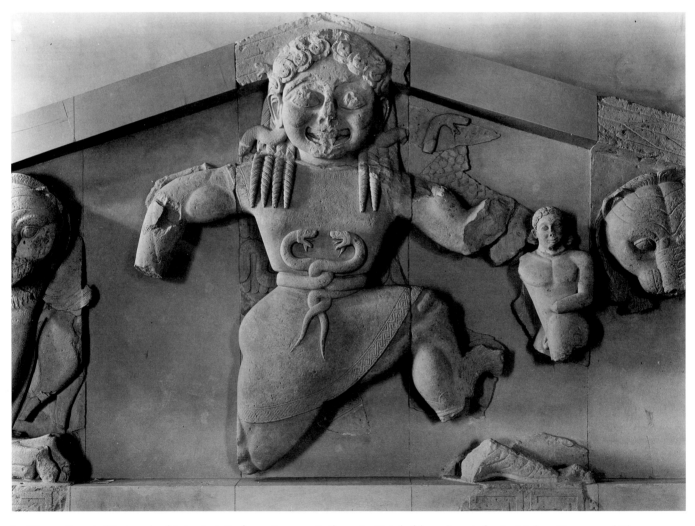

62 West pediment of the temple of Artemis at Corfu, ca. 600–575. In the wings, the gods (Zeus and perhaps Poseidon) fight the Titans; lion-leopards; and in the center, Medusa and her children Pegasos and Chrysaor. Limestone, ht. 3.15 m, l. 22.16 m. Much of the background and the frame are restored.

63 Detail of the pediment, fig. 62: Medusa, Pegasos, and Chrysaor.

Early Architectural Sculpture: The Corfu Pediment
62–63

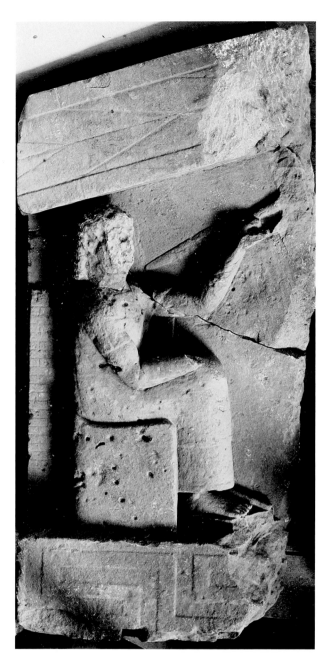

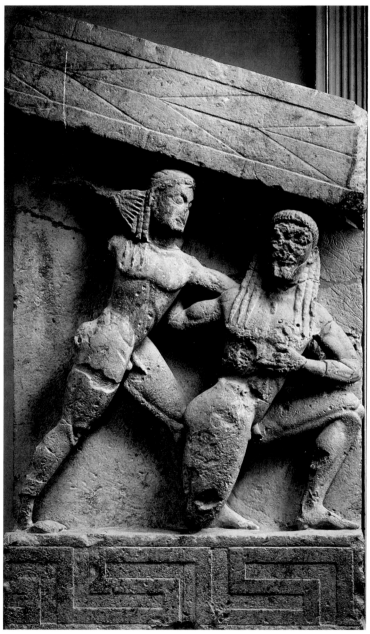

64–65 Details of the pediment, fig. 62: Poseidon(?) and a Titan (Rhea?);
 Zeus and a Titan (presumably Kronos).

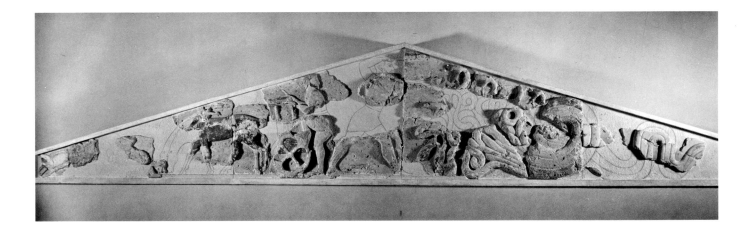

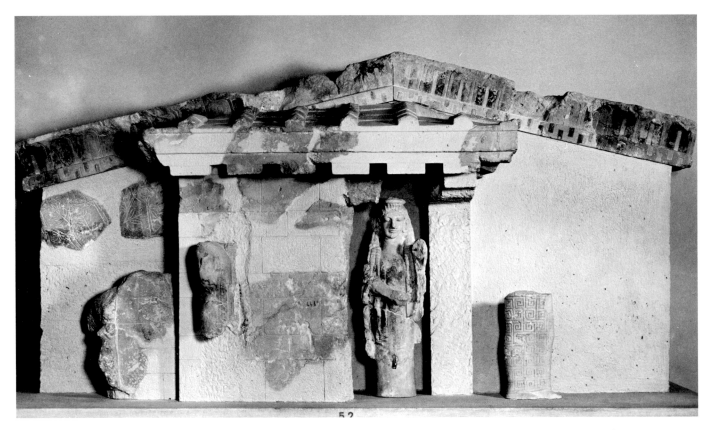

66 Pediment from the Athenian Akropolis, ca. 575–550. Herakles fights the Hydra, with Iolaos and the crab sent by Hera to torment the hero on the left. Limestone, ht. 79 cm, l. 5.8 m.

67 "Olive-tree" pediment from the Athenian Akropolis, ca. 550. Unexplained subject: Achilles ambushes Troilos and Polyxena outside Troy, or an Attic myth involving Athena's olive-tree? Limestone, ht. 80 cm. There is much in-filling between the fragments.

Poros Pediments from the Athenian Akropolis
66–67

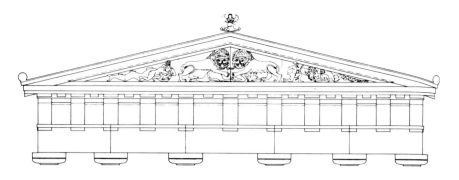

WEST NACH W.-H. SCHUCHHARDT

0 1 2 3 4 5 6 7 8 9 10 11 12 13 14 15 16 17 18 19 20 M

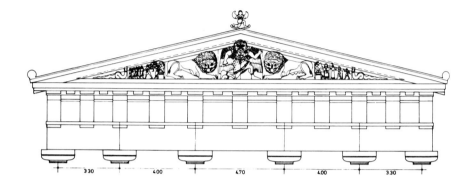

3.30 4.00 4.70 4.00 3.30

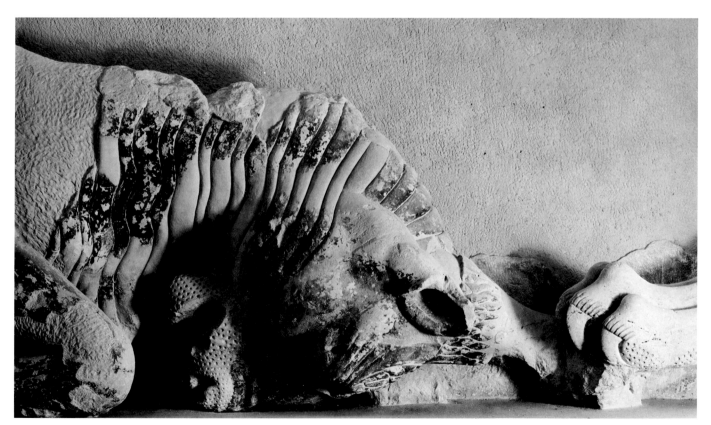

68 Conjectural reconstruction of the pediments of the temple of Athena (figs. 69–75) on the Athenian Akropolis, by Immo Beyer. Limestone, restored ht. ca. 2.1 m, l. ca. 15.4 m.

69 Head of a bull from a pedimental group of a lion and lioness savaging a bull (so-called lion group VIII), from the Athenian Akropolis, ca. 575–550. Limestone, ht. 97 cm. All the roughly textured areas are restorations.

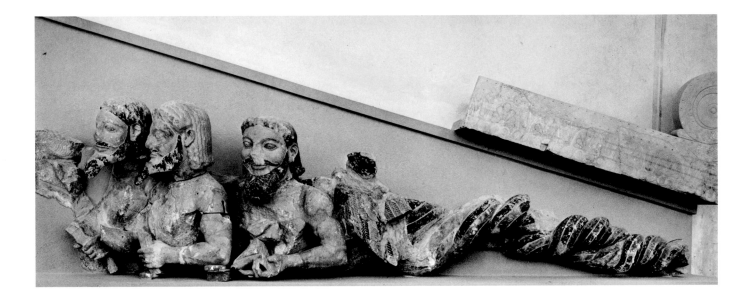

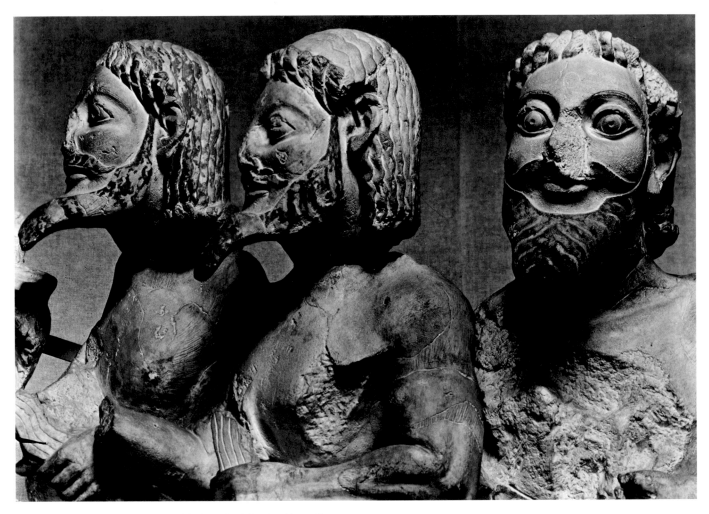

70–71 Pedimental group ("Bluebeard") from the Athenian Akropolis, ca. 575–550. Perhaps Okeanos, Pontos, and Aither. Limestone, ht. 90 cm. The background is largely restored, and there is some in-filling of details.

The Temple of Athena on the Athenian Akropolis
70–71

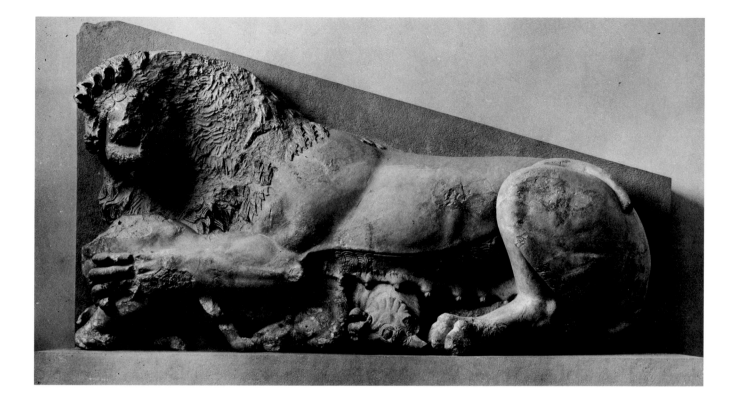

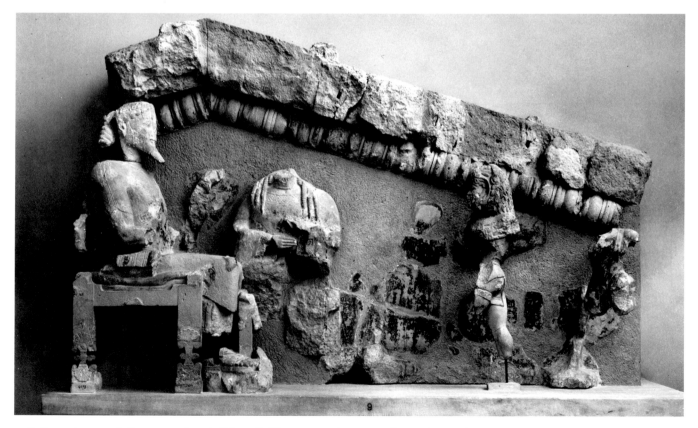

72 Pedimental group of a lioness savaging a bull (so-called lion group VII), from the Athenian Akropolis, ca. 575–550. Limestone, ht. 1.6 m. Most of the lioness's body is restored.

73 Pedimental group from the Athenian Akropolis, ca. 575–550. The Introduction of Herakles to Olympos. Limestone, ht. 94 cm. Parts of Zeus's throne and other details have been restored, together with all the background adjoining the cornice, which probably does not belong with this pediment.

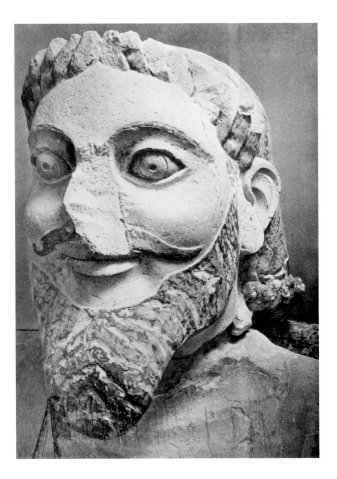

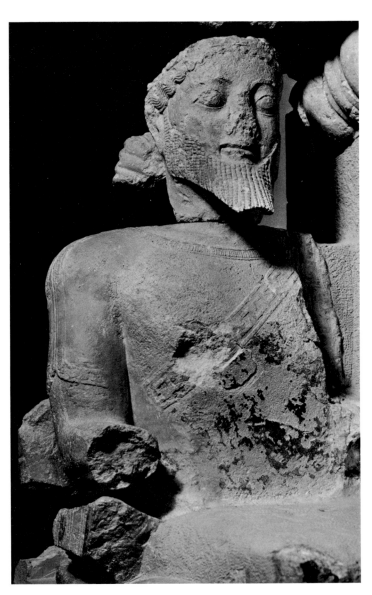

74 Detail of fig. 70: head of "Bluebeard."

75 Detail of fig. 73: Zeus.

The Temple of Athena on the Athenian Akropolis
74–75

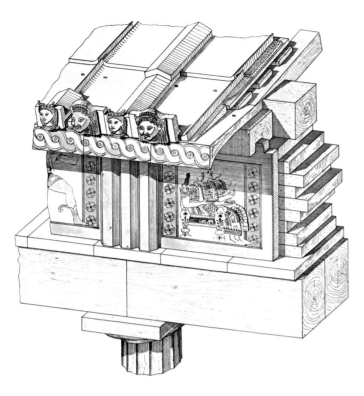

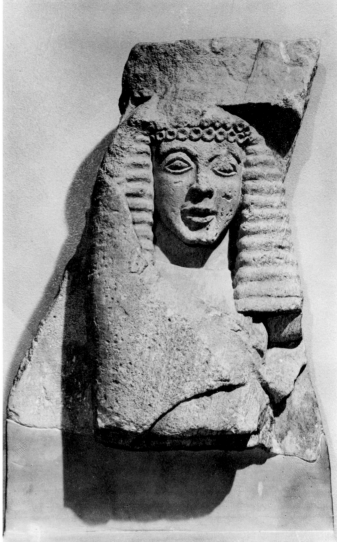

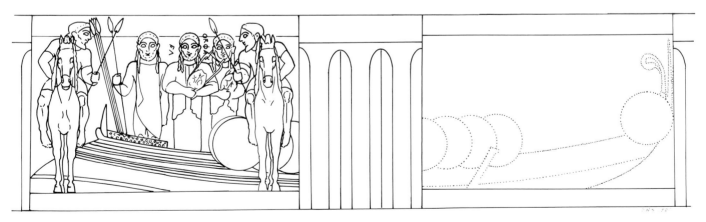

76 Conjectural reconstruction of the frieze of a temple at Thermon in Ae-
 tolia (Northwest Greece), ca. 630, *top left*. Wood with painted terracotta
 metopes. Ht. of metopes, 60 cm.

77 Relief from Mycenae, ca. 625–600, *top right*. Limestone, ht. 40 cm.

78 Conjectural restoration of a metope attributed to the Sikyonian treasury
 at Delphi (fig. 79), and its (fragmentary) neighbor, ca. 575–550. The
 ship Argo with Orpheus and another playing the kithara, with a Dios-
 kouros on horseback to the left. Limestone, ht. 62 cm.

Early Architectural Sculpture: Metopes
76–78

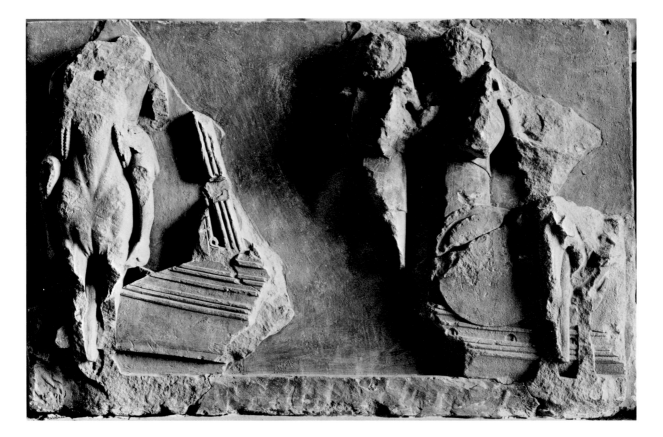

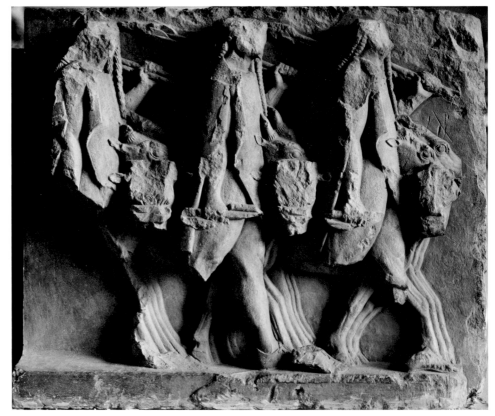

79 Metope attributed to the Sikyonian treasury at Delphi, ca. 575–550. The ship Argo with Orpheus (compare fig. 78). Limestone, ht. 62 cm.

80 Metope attributed to the Sikyonian treasury at Delphi, ca. 575–550. The Dioskouroi (named), Idas (named), and Lynkeus (name missing) raiding cattle. Limestone, ht. 62 cm.

The "Sikyonian Treasury" at Delphi
79–81

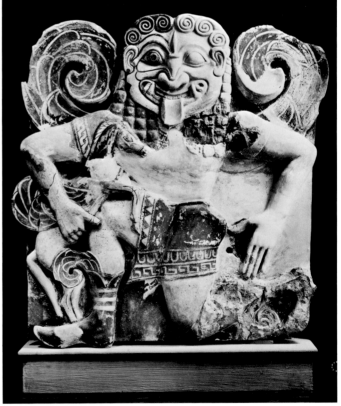

81 Metope attributed to the Sikyonian treasury at Delphi, ca. 575–550. Europa on the Bull. Limestone, ht. 62 cm.

82 Medusa and Pegasos, from the pediment of the temple of Athena at Syracuse, ca. 575–550. Terracotta, ht. 56 cm. Most of Medusa's chest, her left arm and adjacent background, the left side of her head, and right upper arm are restored.

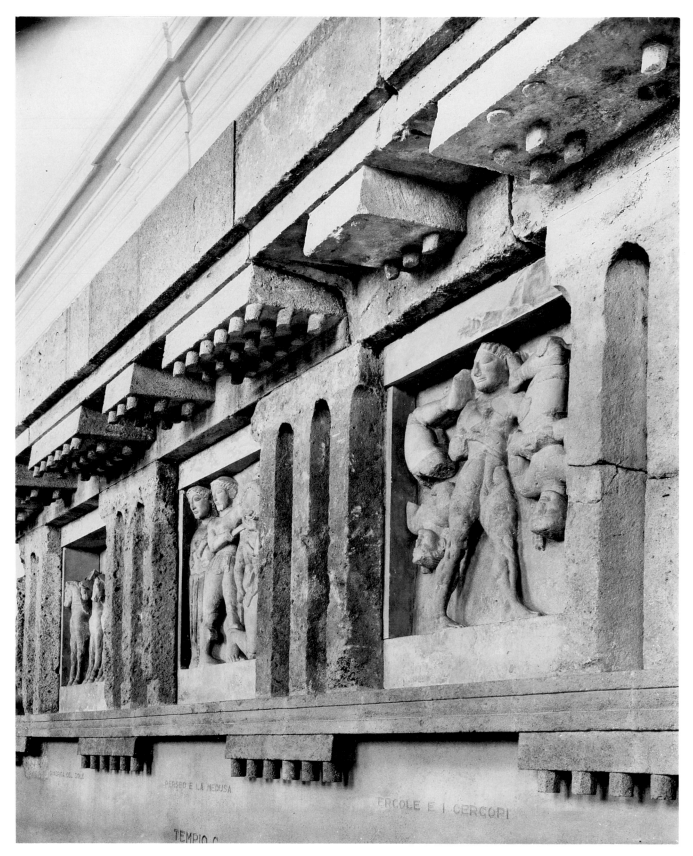

83 Metopes from temple C at Selinus, ca. 550. From left to right, the char-
iot of Apollo, Perseus and Medusa, and Herakles capturing the Ker-
kopes. Limestone, ht. of panels, 1.47 m. Palermo. The architectural
surround is restored using original fragments.

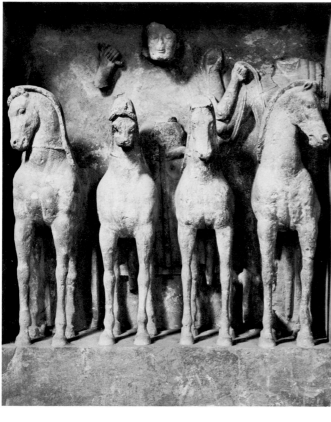

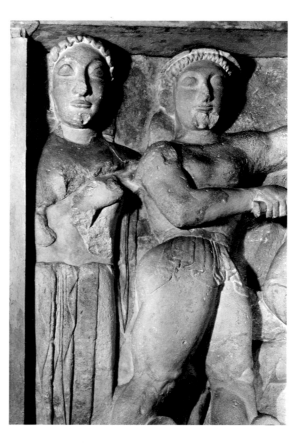

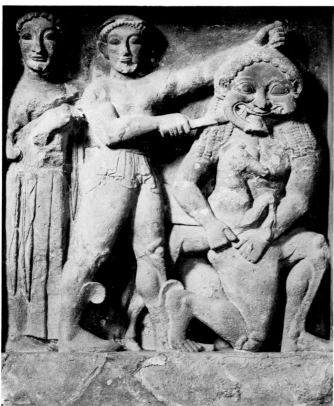

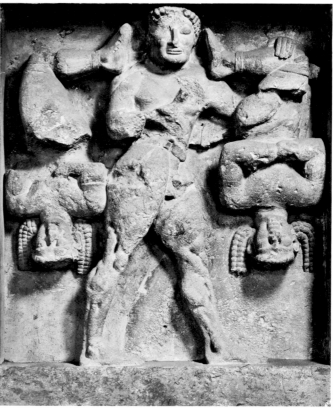

84–85, 87 Metopes from temple C at Selinus, ca. 550. The chariot of Apollo, *top left,* Perseus killing Medusa, *bottom left,* and Herakles capturing the Kerkopes, *bottom right.* Limestone, ht. 1.47 m. Palermo.

86 Detail of fig. 85: Athena and Perseus.

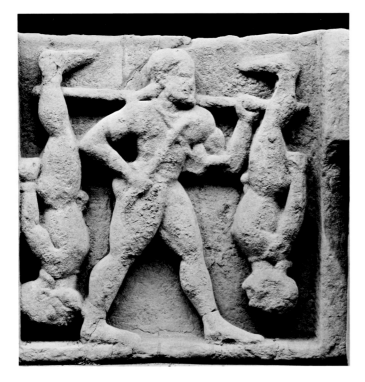 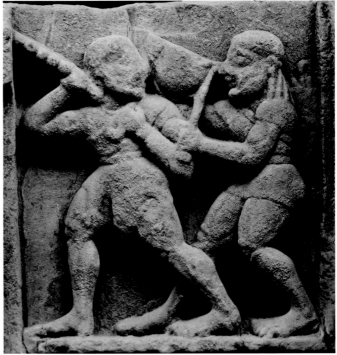

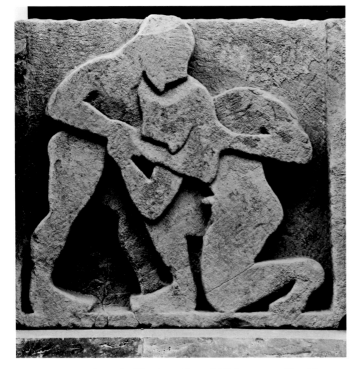 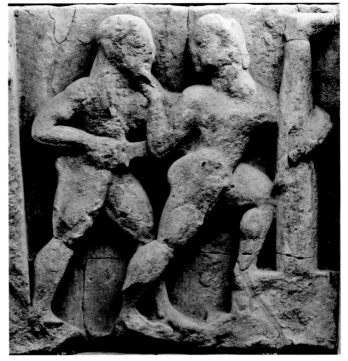

88–91 Metopes from the Heraion at Foce del Sele, ca. 550. Herakles captures the Kerkopes, *top left*; Herakles kills Antaios, *bottom left*; Herakles and Apollo fight over the Delphic tripod, *top right*; and Orestes kills Aigisthos, *bottom right*. Sandstone, ht. 78 cm. Paestum.

The Heraion at Foce del Sele
88–91

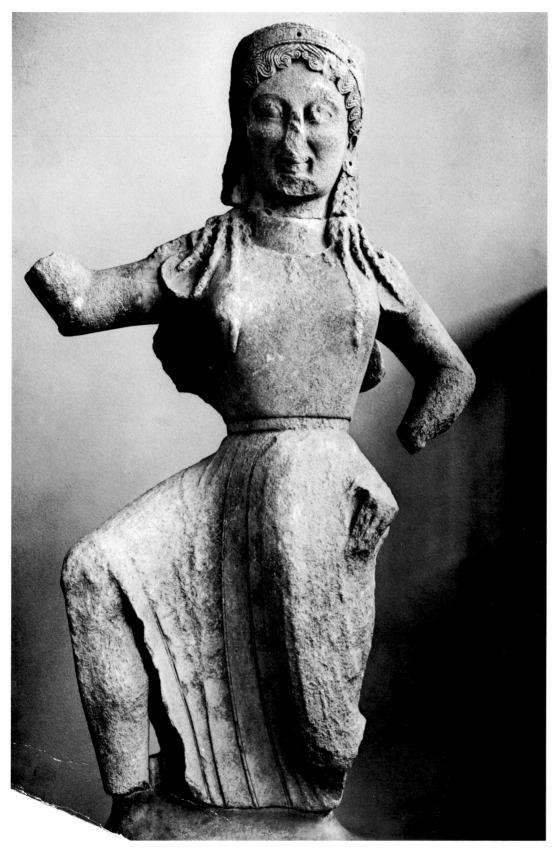

92 Winged Nike by Archermos of Chios, from Delos, ca. 550. Ht. 90 cm.
Athens. For the badly damaged inscription on the base (not illustrated),
see chapter 9.3.

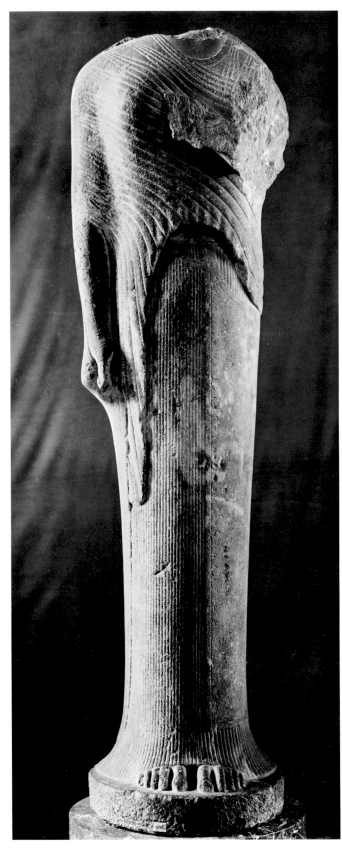

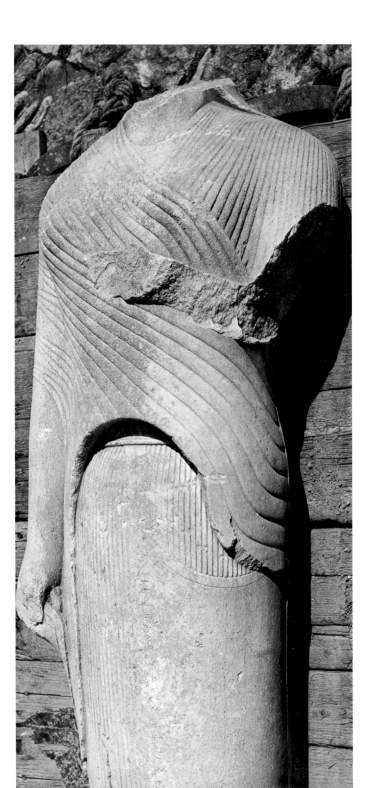

93 Kore dedicated by Cheramyes, from the Heraion at Samos, ca. 560. Ht. 1.92 m. Paris.

94 Kore dedicated by Cheramyes, from the Heraion at Samos, ca. 560. Ht. 1.92 m. Samos.

Samian Sculpture: Dedications by Cheramyes
93–94

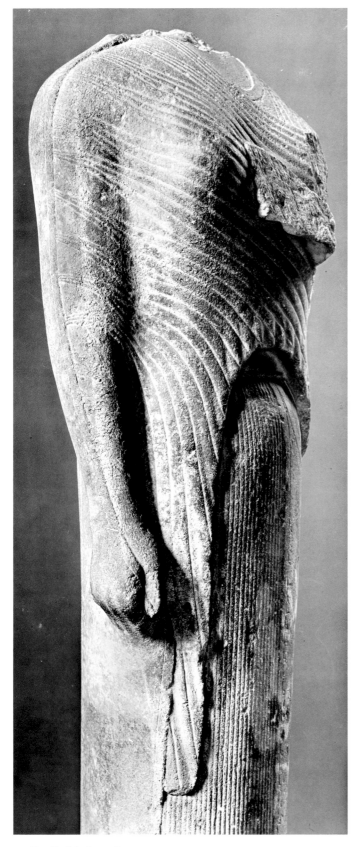

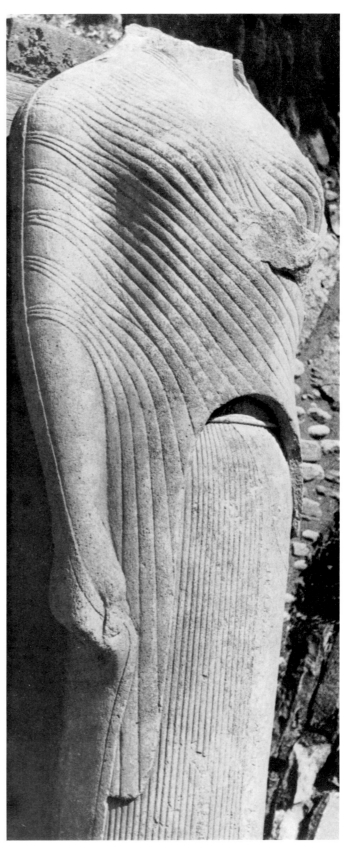

95 Detail of the kore, fig. 93.

96 Another view of the kore, fig. 94.

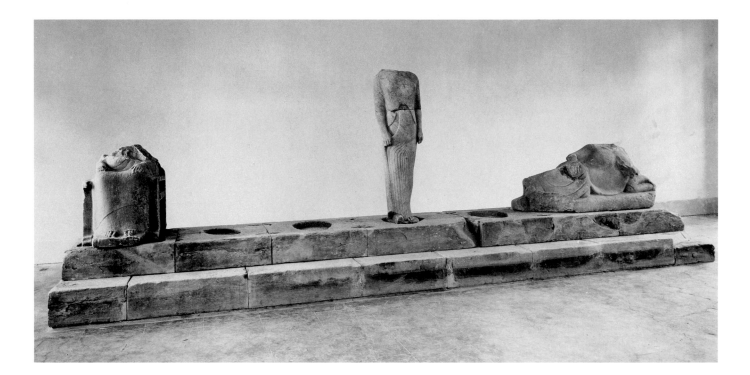

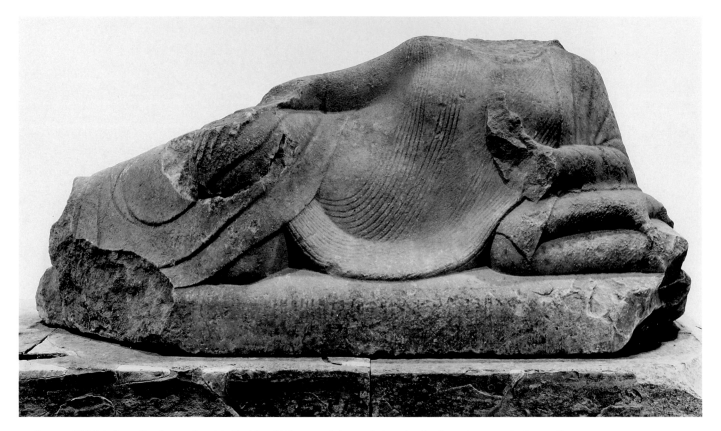

97 Group of Phileia (seated), a boy and a girl, Ornithe, Philippe, and the reclining [. . .]arches, signed by Geneleos and dedicated by [. . .]arches, from the Heraion at Samos, ca. 550. Length of base, 6.08 m. Berlin and Samos.

98 [. . .]arches from the group in fig. 97. Samos.

Sculpture by Geneleos of Samos
97–99

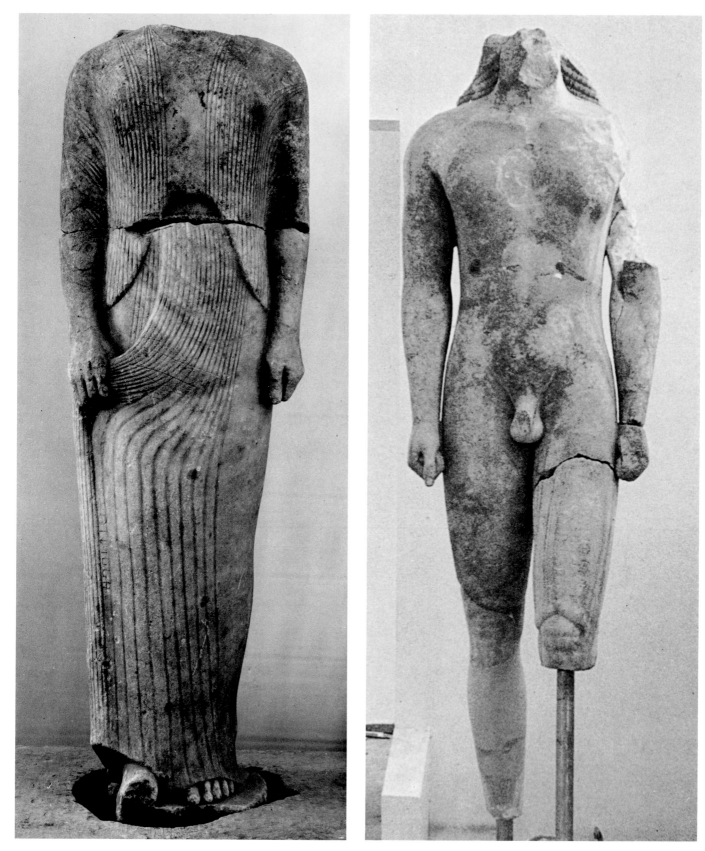

99 Philippe from the group in fig. 97. Ht. 1.68 m. Samos.

100 Colossal kouros dedicated by Ischys, from the Heraion at Samos, ca. 570. Ht. of joined fragments, 4.07 m.; of entire statue, originally ca. 4.75 m. The head (fig. 102) has now been joined to the body.

The Ischys Kouros
100

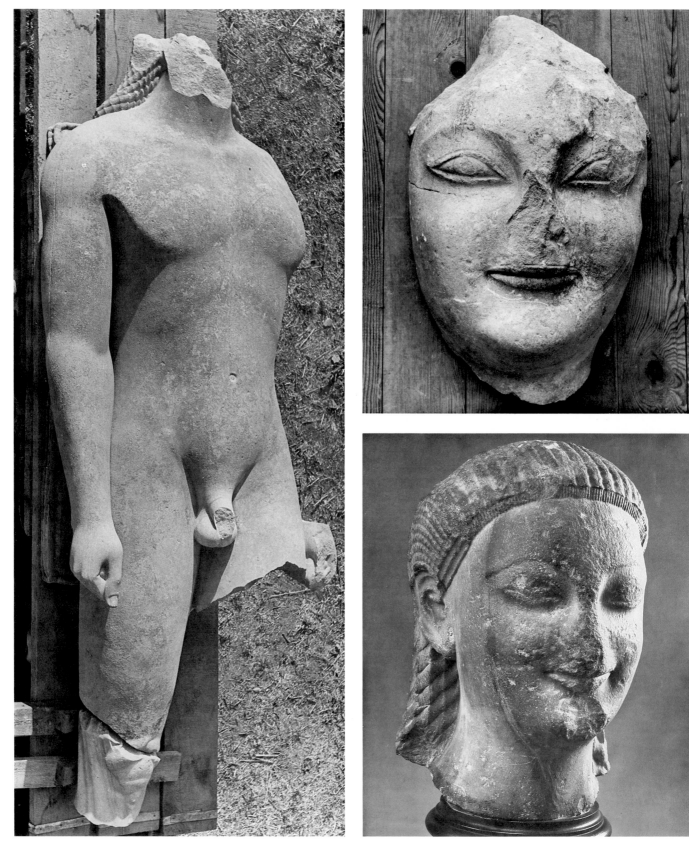

101 Another view of the kouros, fig. 100.

102 Head of the kouros, fig. 100.

103 Head of a colossal kouros from Samos, ca. 550–540. Ht. 47 cm. Istanbul. The head joins fragments from Samos, and the entire ensemble stood about 3.25 m. high.

Samian Kouroi
101–103

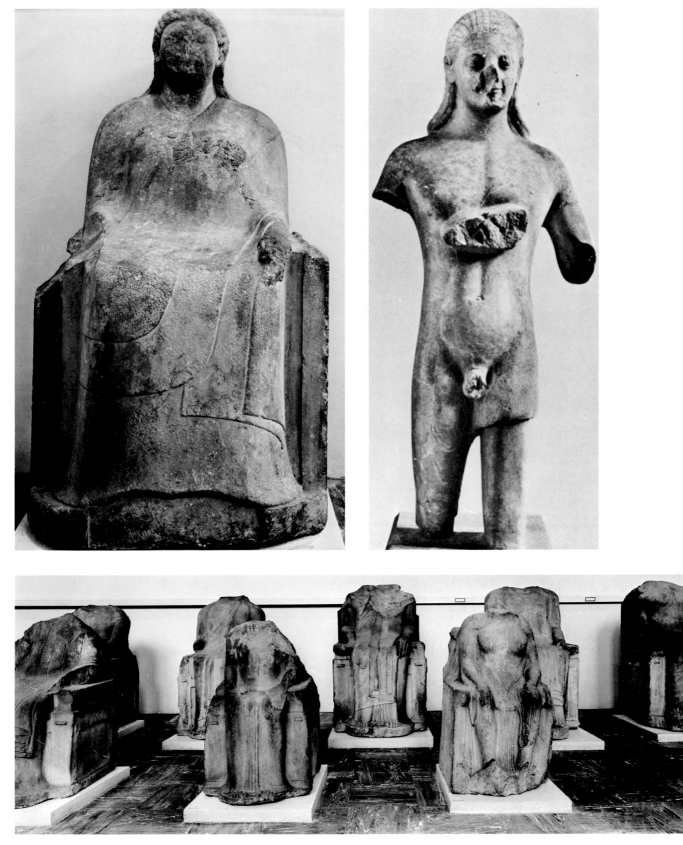

104 Seated figure from Didyma, *top left,* ca. 575–550. Ht. 1.55 m. London.
105 Offering-bearer from Didyma, *top right,* ca. 550–525. Ht. 1.66 m.
 Berlin.

106 Seated figures from Didyma, *ca. 600–500.* Ht. 1.15–1.55 m. London.

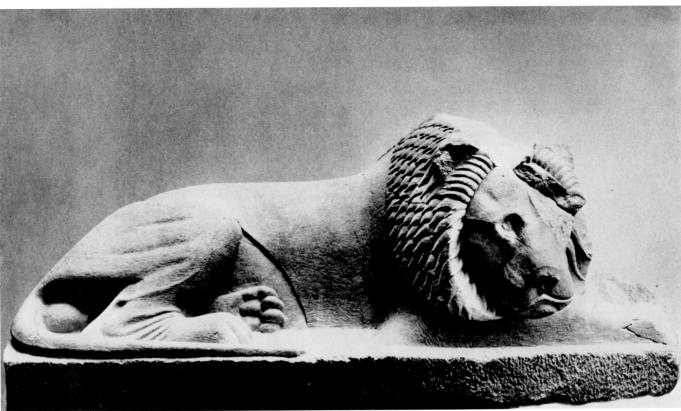

107 Chares, dedicated by himself to Apollo, from Didyma, *top left*, ca. 550.
 Ht. 1.46 m. London.
108 Seated figure from Didyma, *top right*, ca. 550–525. Ht. 1.15 m. Istanbul.

109 Lion from Miletos, ca. 550. L. 1.76 m. Berlin.

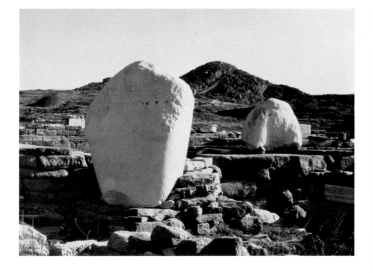

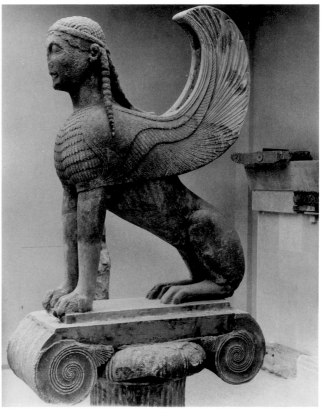

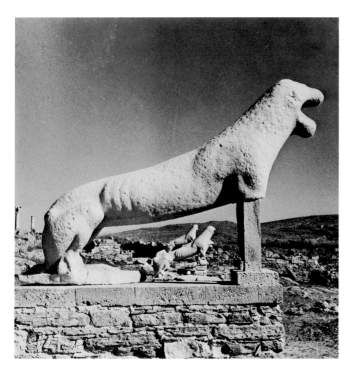

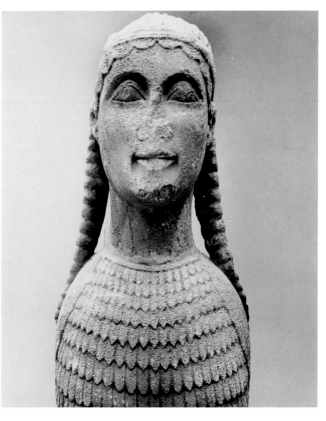

110 Colossal Apollo dedicated by the Naxians to Apollo, Delos, ca. 600–
575. Ht. of fragments, 2.2 m, 1.2 m; original ht. ca. 8.5 m.
111 Lions, Delos, ca. 575. Ht. 1.72 m.

112–113 Sphinx dedicated by the Naxians at Delphi, ca. 575–550. Ht. 2.32
m; of the column, 10.22 m. The upper parts of both wings are heavily
restored.

Naxian Sculpture
110–113

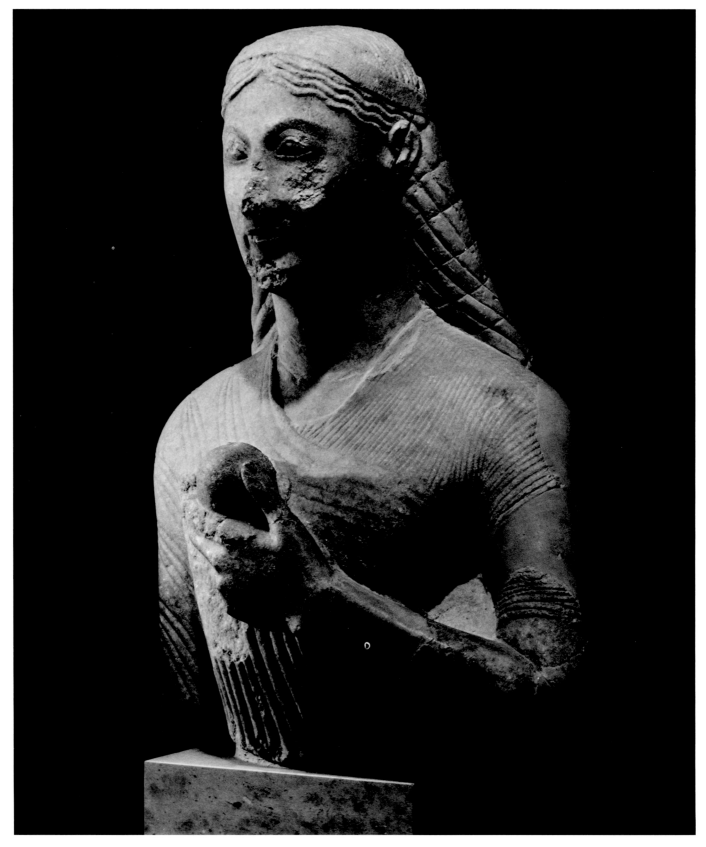

114 Kore 677 from the Athenian Akropolis, ca. 550. Ht. 54.5 cm. Most of
the left arm is restored.

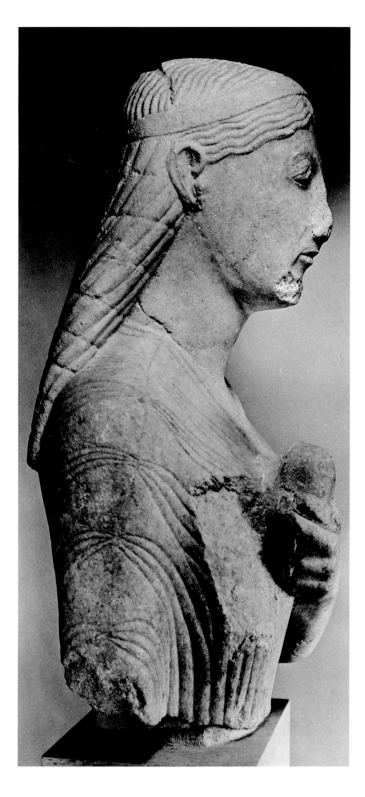

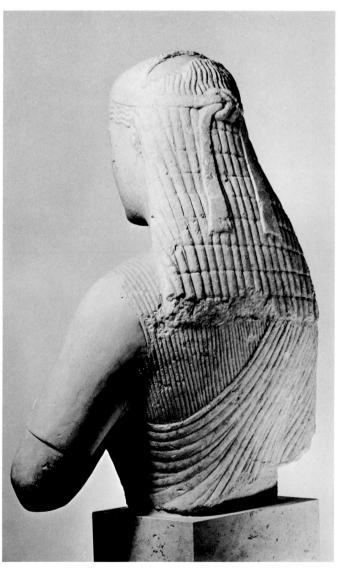

115–116 Right side and back of the kore, fig. 114.

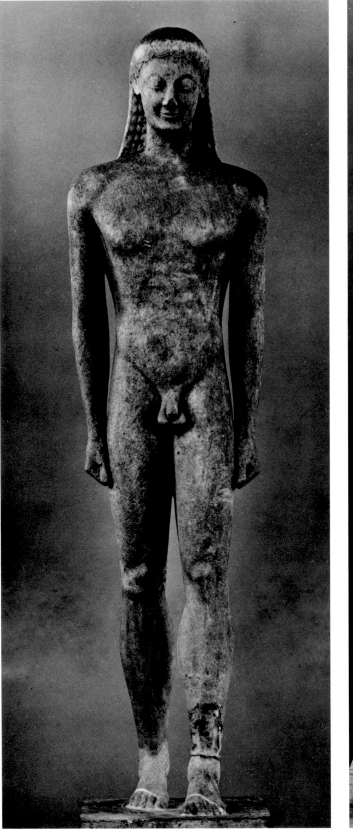

117 Kouros from Melos, ca. 550. Ht. 2.14 m. Athens. The lower right leg is restored.

118 Kouros from Paros, ca. 550. Ht. 1.03 m. Paris.

Naxian and Parian Kouroi
117–118

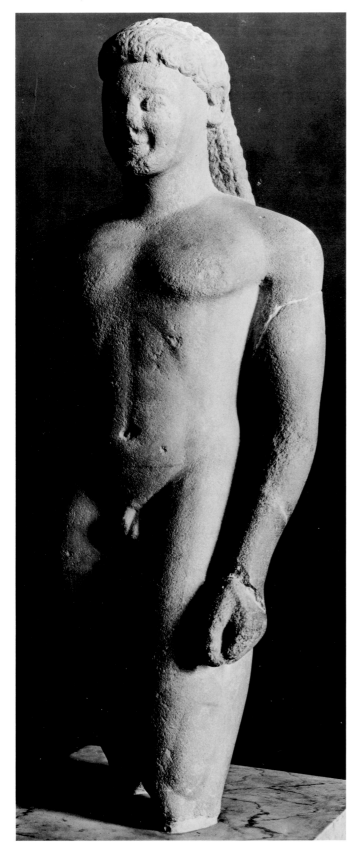

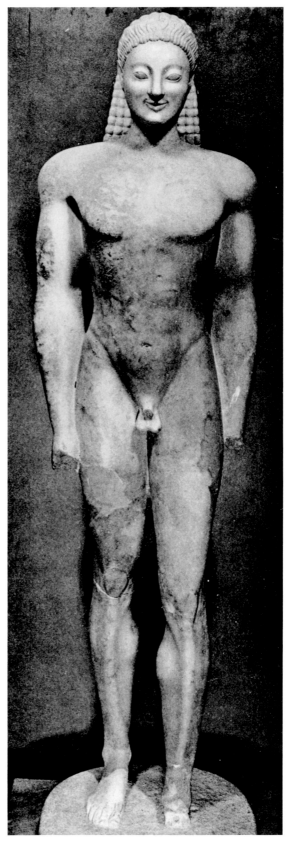

119 Three-quarter view of the Paros kouros, fig. 118.

120 Kouros from Volomandra (Attica), ca. 560. Ht. 1.79 m. Athens. The front part of each foot is restored.

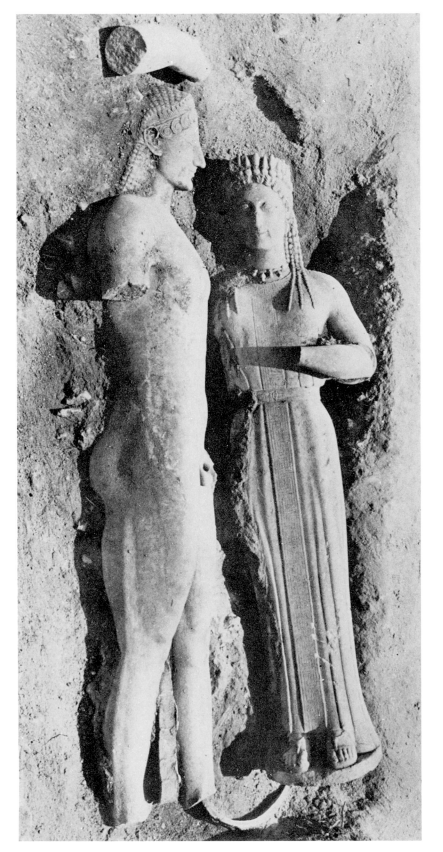

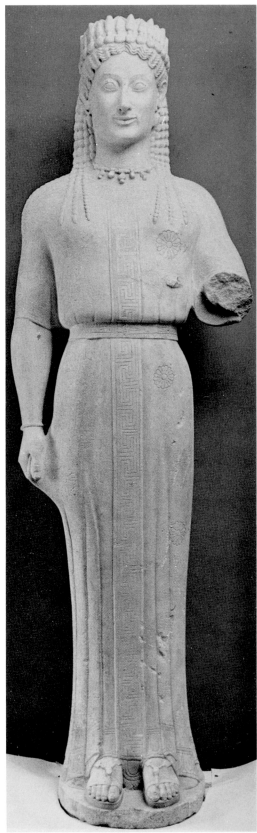

121–122 Kouros, and the kore Phrasikleia by Aristion of Paros, from Mer-
enda (Attica), ca. 550. Ht. 1.89 m and 1.76 m, respectively. Athens.
The two were buried together in a shallow pit, perhaps around 500; the
base, long immured in a local church, carries Phrasikleia's epitaph and
the sculptor's signature.

Aristion of Paros
121–122

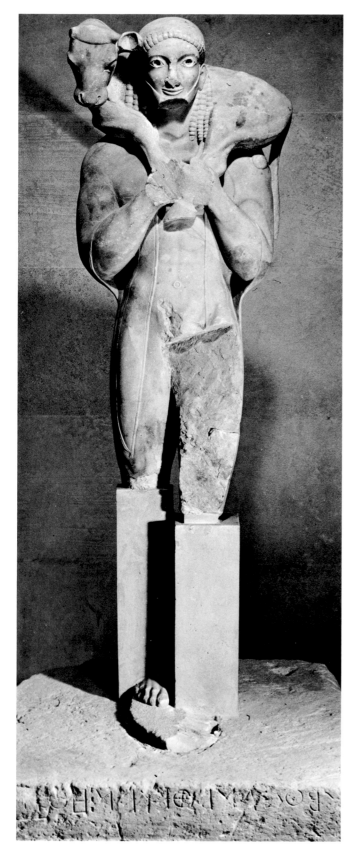

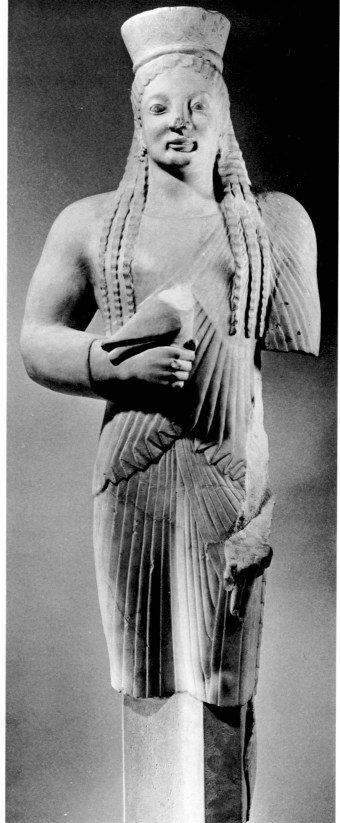

123 Calf-bearer (Moschophoros) dedicated by [Rh]onbos, from the Akropolis, ca. 560. Restored ht. 1.65 m.

124 "Lyons kore" from the Akropolis, ca. 540. Ht. 1.13 m. The upper body in the picture is a cast taken from the original in Lyons.

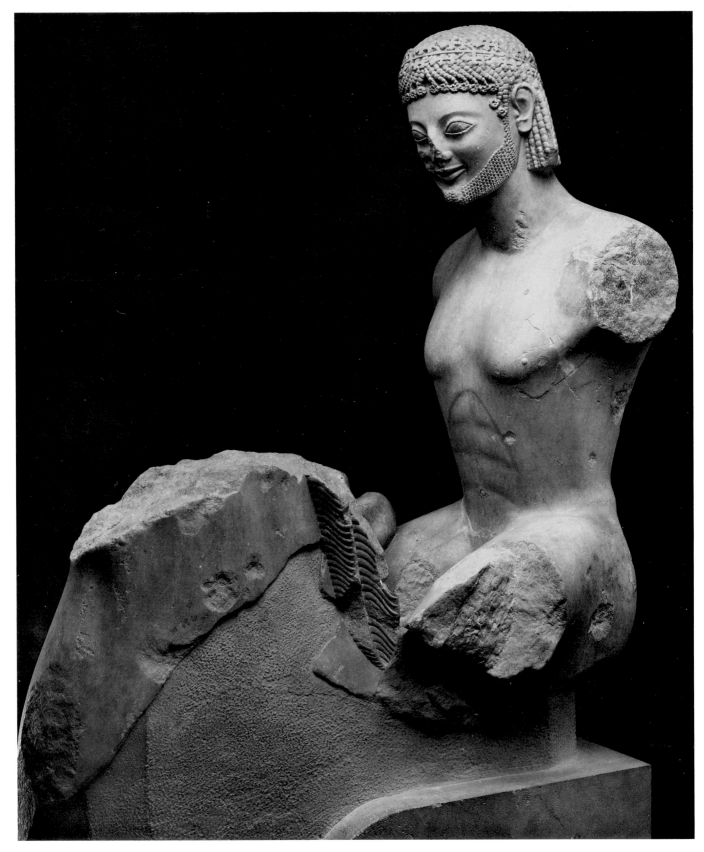

125 "Rampin rider" from the Athenian Akropolis, ca. 550. Ht. of ensemble, 81.5 cm. One of a pair; the head in the picture is a cast taken from the original in the Louvre.

The Rampin Rider and the Moschophoros
125–128

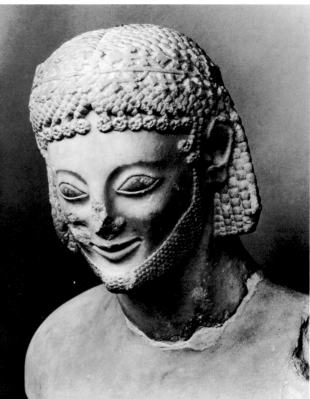

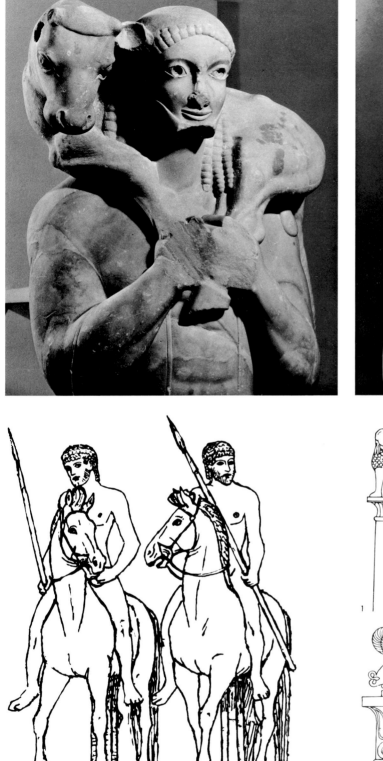

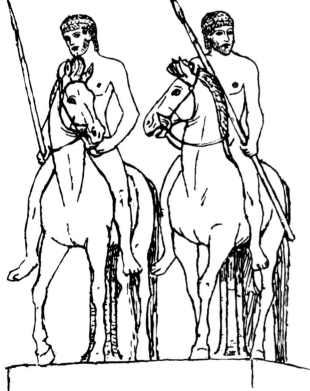

126 Head of the calf-bearer, fig. 123.
128 Reconstruction of the pair of riders, fig. 125.

127 Head of the rider, fig. 125.
129 The types of archaic and early classical Attic grave stelai.

130 Grave stele of a discus-thrower from the Dipylon cemetery at Athens, ca. 550. Ht. 34 cm.

131 Grave stele of a boxer from the Themistoklean Wall, Athens, ca. 540. Ht. 23 cm. Re-used as building material by the Athenians in 478.

Attic Gravestones
130–131

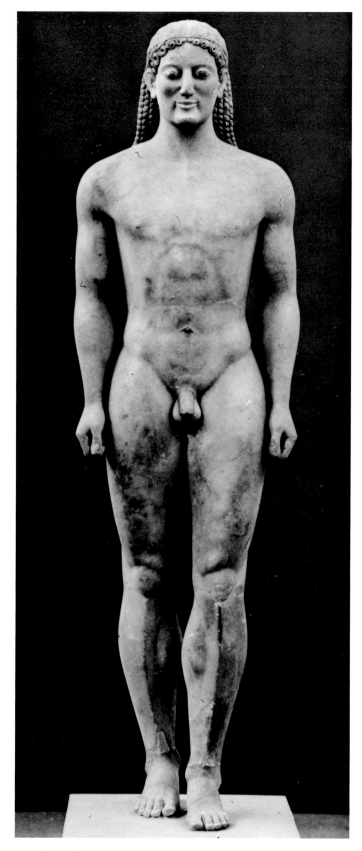

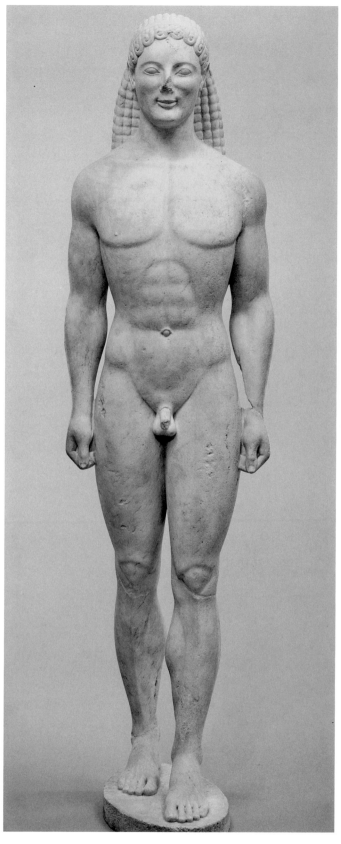

132 Kroisos from Anavyssos, Attica, ca. 530. Ht. 1.94 m. The base carries the youth's epitaph, stating that he fell in battle.

133 Kouros, perhaps from Megara, ca. 530–520. Ht. 2.06 m. Malibu.

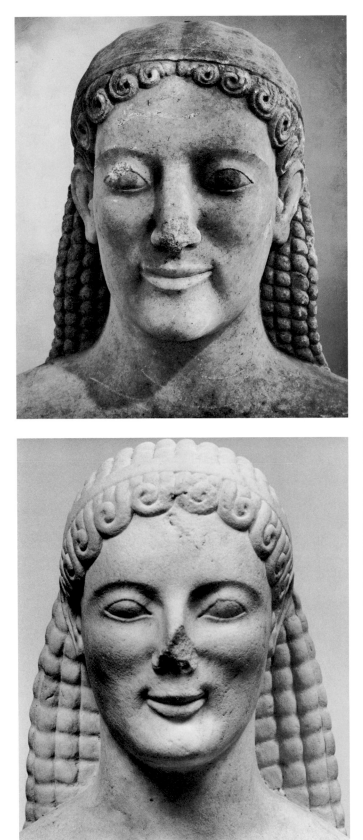

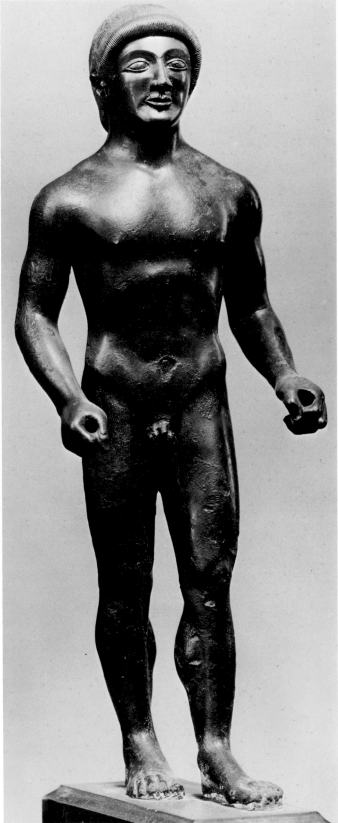

134 Head of Kroisos, fig. 132.
135 Head of the Getty kouros, fig. 133.

136 Jumper from the Athenian Akropolis, ca. 520–510. Bronze, ht. 27 cm.
The two hands are pierced with holes for jumping-weights.

Attica: Kroisos and His Influence
134–136

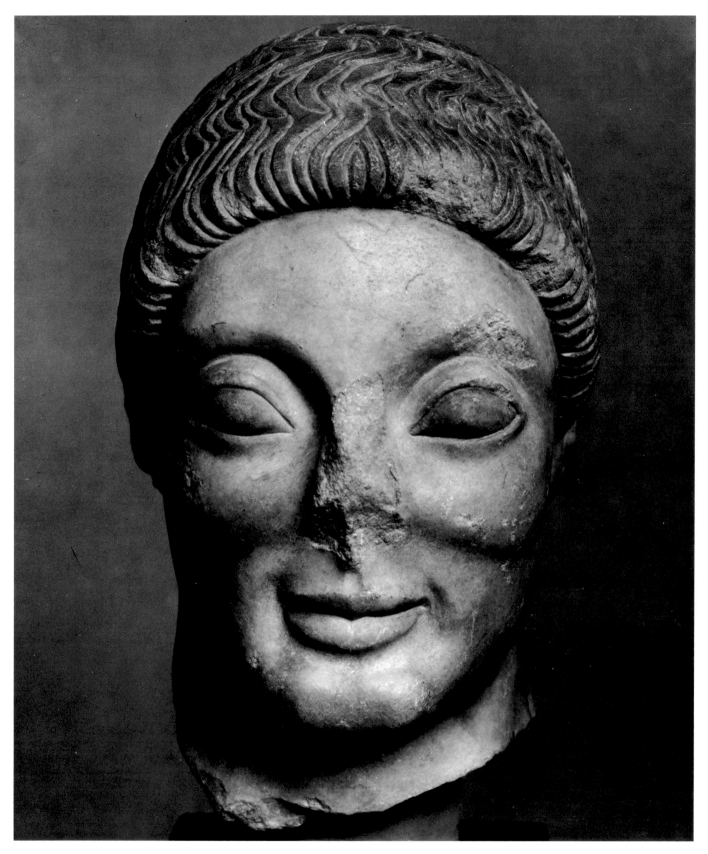

137 Head of a kouros (the "Rayet" head) from Athens, ca. 520–510. Ht. 31.5 cm. Copenhagen. Sometimes associated with fragments of a kouros built into the Piraeus gate of the Themistoklean Wall in 478, near a base signed by Endoios and Philergos.

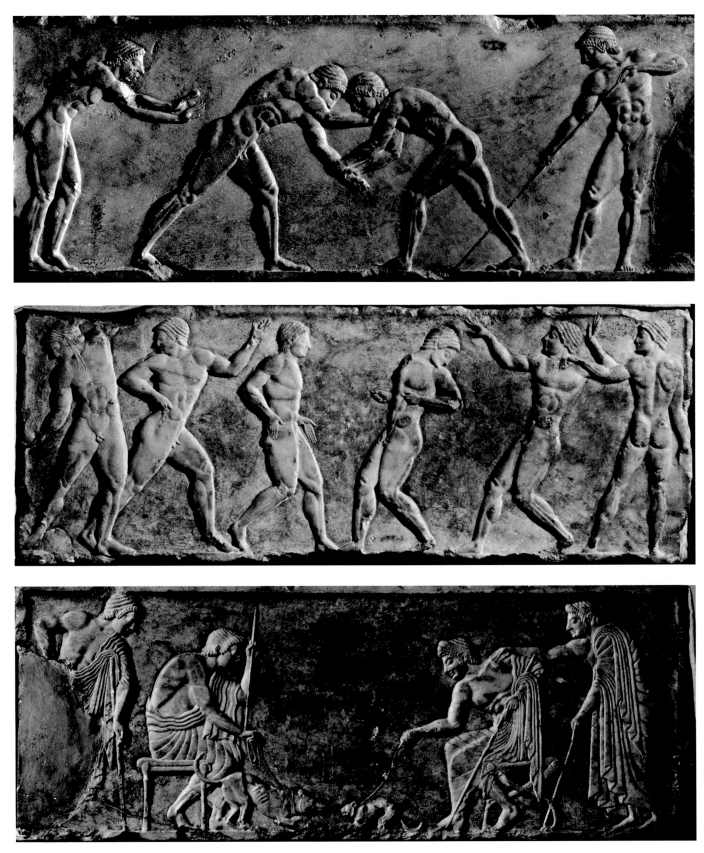

138–140 Base for a kouros ("ballplayer" base) from the Themistoklean
Wall, Athens, ca. 500. Wrestlers, ballplayers, and youths goading a dog
and a cat to fight. Ht. 32 cm. Re-used as building material by the Athe-
nians in 478.

In Search of Endoios
138–140

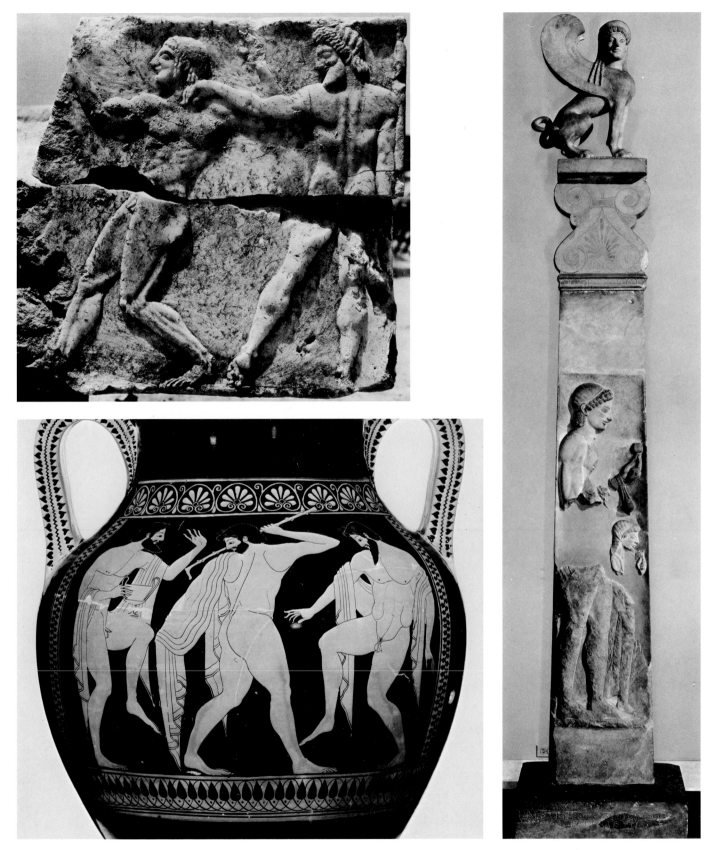

141 Base for a kouros from the Themistoklean Wall, Athens, ca. 500. Another version of the ballplayers on the base, fig. 139. Ht. 29 cm.

142 Attic belly amphora (type A) signed by Euthymides as painter, from Vulci (Etruria), ca. 510. Revellers. Ht. of picture, 22 cm. Munich.

143 Grave stele from Attica, ca. 540–530. Restored ht. 4.23 m. New York, reconstructed with casts of the girl's head, shoulder, and hand, which are in East Berlin. The inscription records that it was erected in memory of Me[gakles?] by his parents.

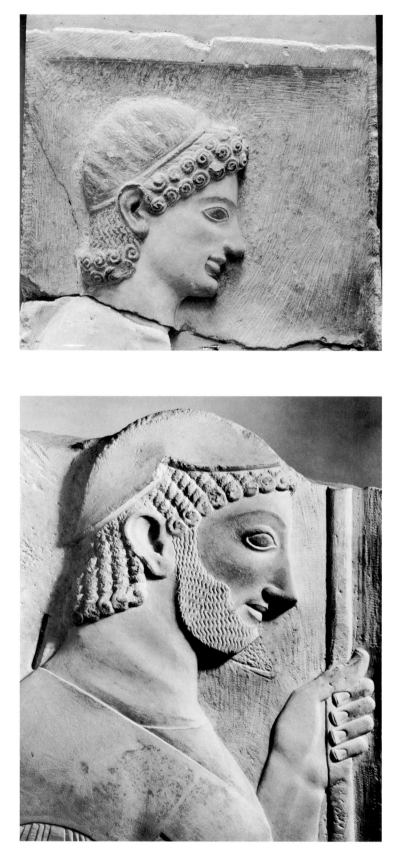

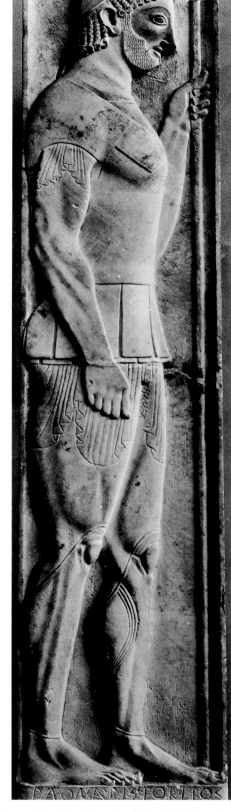

144 Head of the youth from the stele, fig. 143.

145–146 Grave stele of Aristion, signed by Aristokles, from Velanideza (Attica), ca. 510. Ht. 2.4 m. Athens.

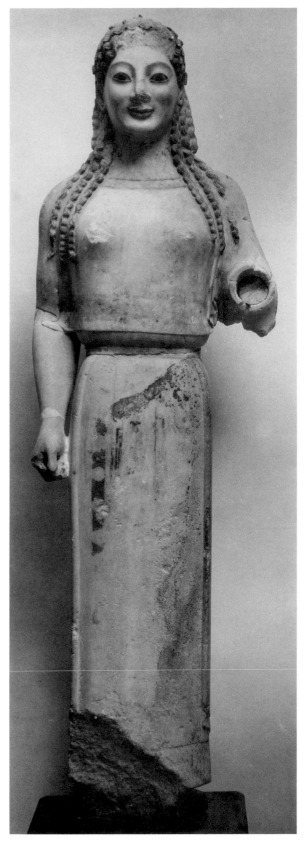

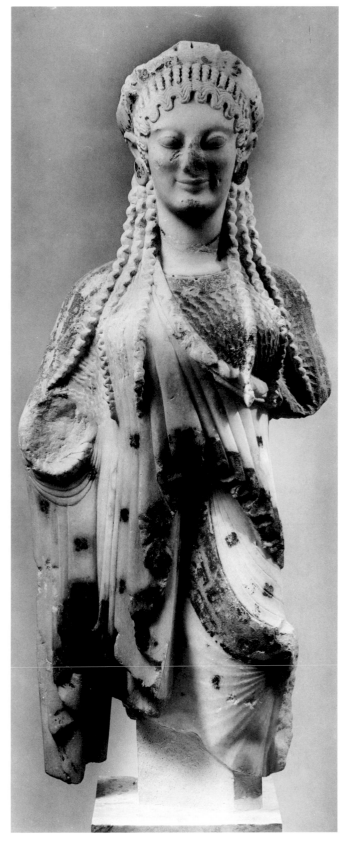

147 "Peplos" kore (679) from the Athenian Akropolis, ca. 530. Ht. 1.17 m.

148 Kore 675 from the Athenian Akropolis, ca. 520–510. Ht. 55 cm.

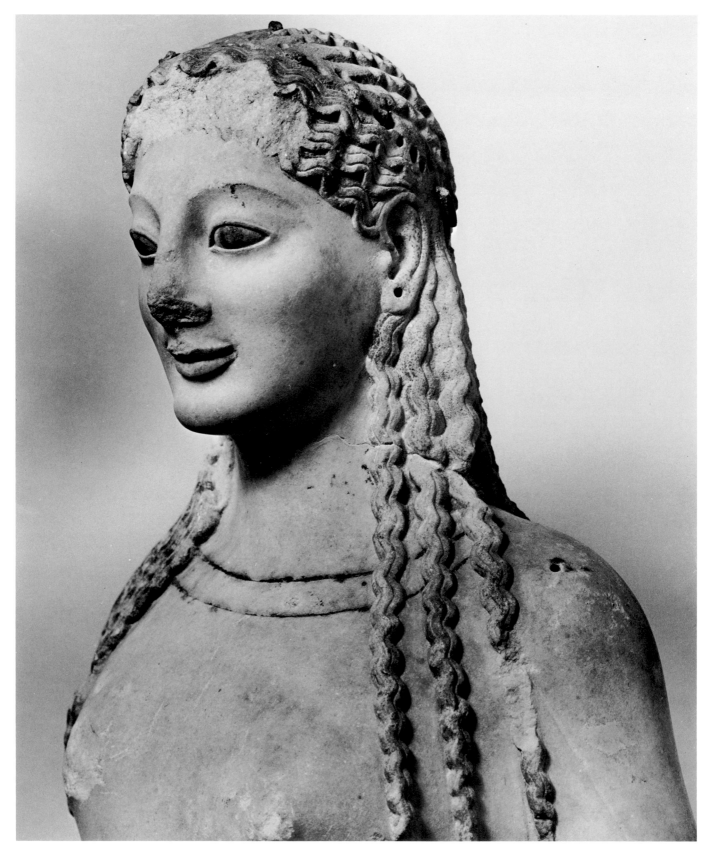

149 Head and shoulders of the "Peplos" kore, fig. 147.

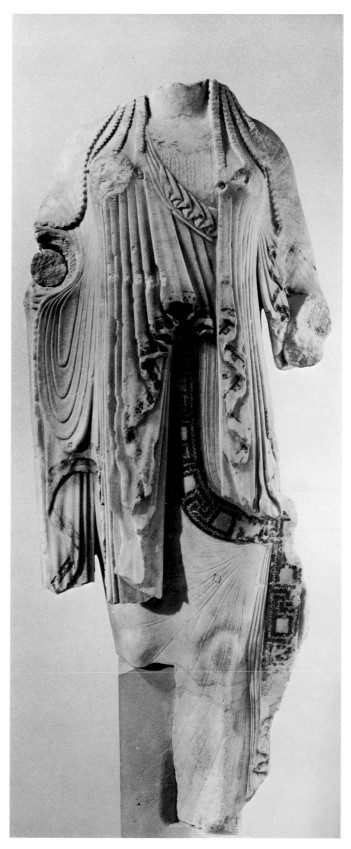

150–151 Kore 594 from the Athenian Akropolis, ca. 530–520. Ht. 1.23 m.

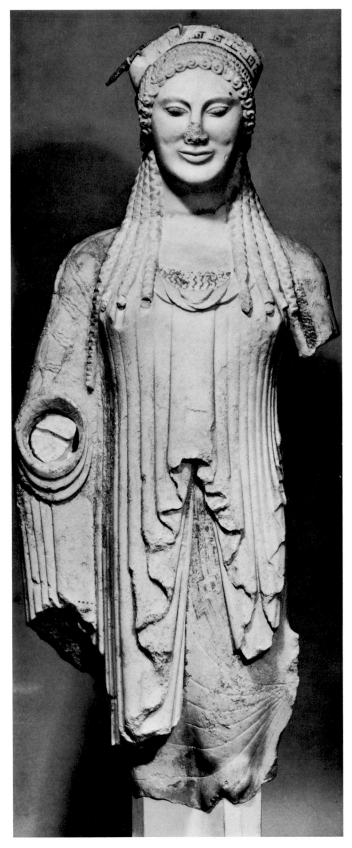

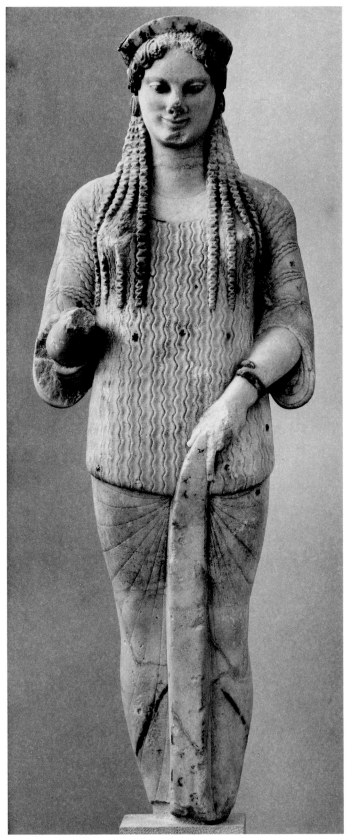

152 Kore 673 from the Athenian Akropolis, ca. 520–510. Ht. 93 cm.

153 Kore 670 from the Athenian Akropolis, ca. 520–510. Ht. 1.15 m.

The Athenian Akropolis: Korai
152–153

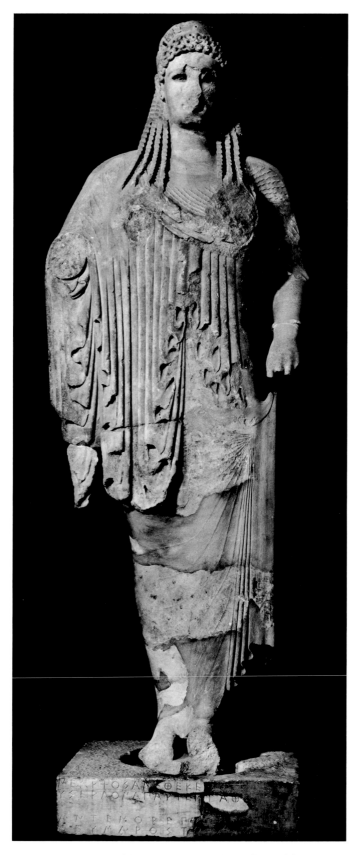 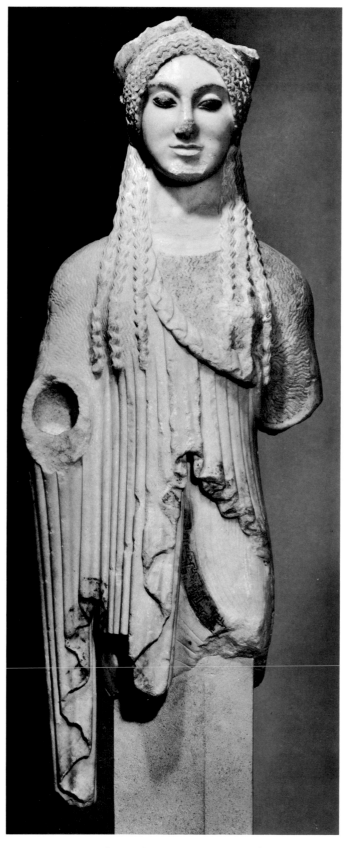

154 Kore 681, dedicated by the potter Nearchos and signed by Antenor, from the Athenian Akropolis, ca. 520. Ht. 2.15 m. The association between statue and base is sometimes doubted, but without compelling reason. Restorations include the middle of the shoulder-tresses, part of the left forearm, most of the legs and of the stacked folds hanging from the left arm.

155 Kore 674 ("La Delicata") from the Athenian Akropolis, ca. 500. Ht. 92 cm.

The Athenian Akropolis: Korai
154–155

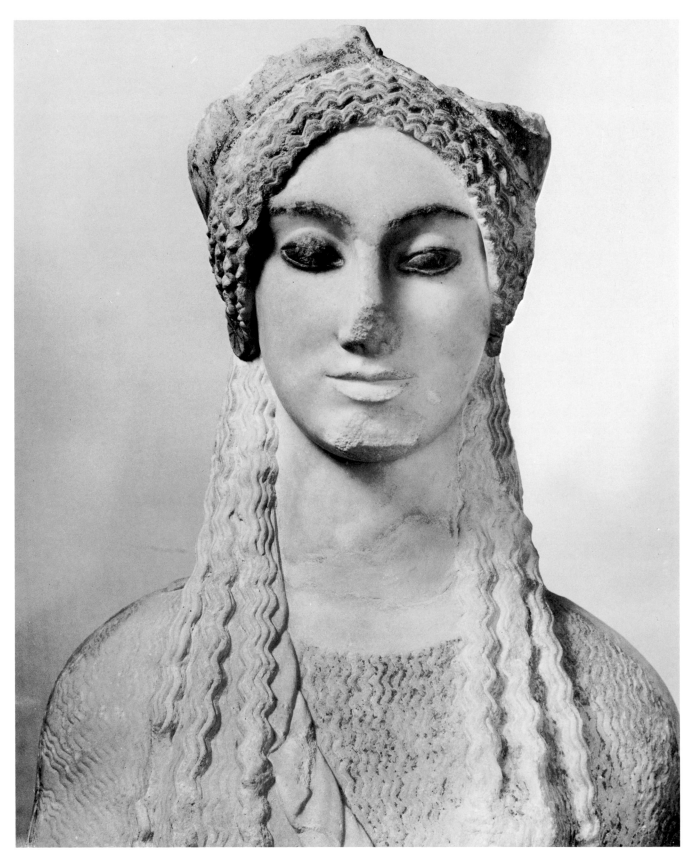

156 Head of the kore, fig. 155.

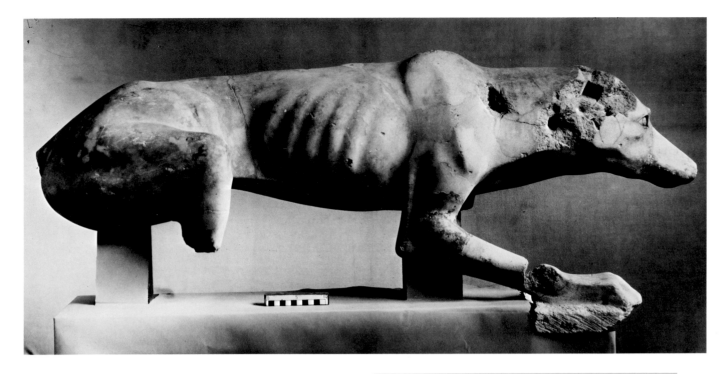

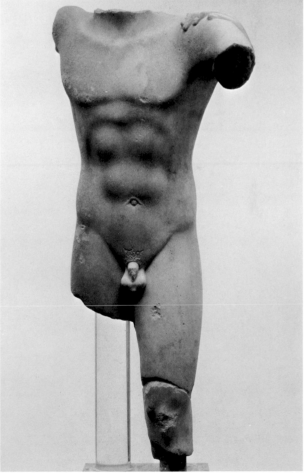

157 Dog from the Athenian Akropolis, ca. 520–500. L. 1.25 m. One of a pair, possibly dedicated to Artemis Brauronia, the huntress.

158 Right foot of a statue of Athena signed by Pythis and dedicated by Epiteles, from the Athenian Akropolis, ca. 520–500. The left foot was made separately and there is a cutting in the upper face of the capital for an upright spear.

159 Torso of Theseus fighting Prokrustes, from the Athenian Akropolis, ca. 500. Ht. 63 cm. Prokrustes' hand grasps Theseus's shoulder from behind, while another fragment shows that the hero was gripping the baron's throat.

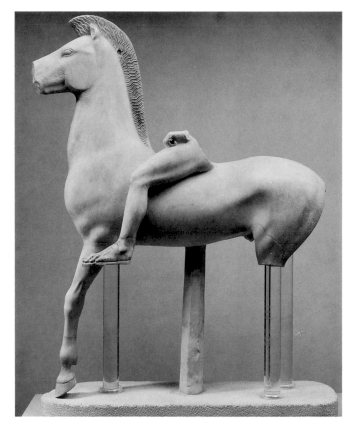

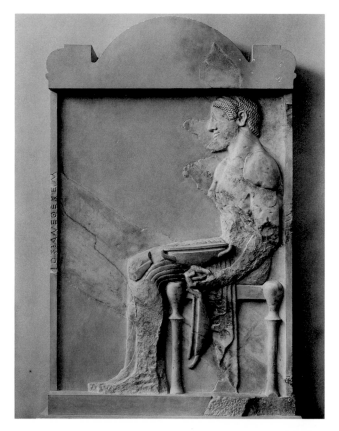

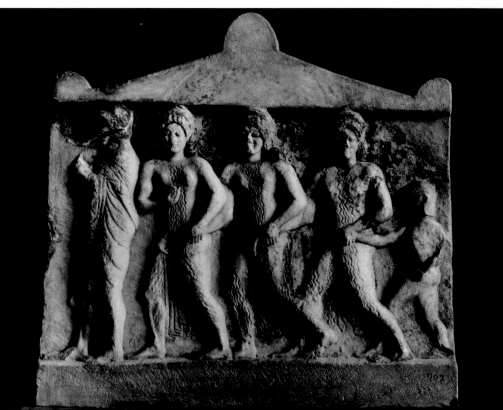

160 Rider from the Athenian Akropolis, ca. 520–500. Ht. 1.12 m.

161 Votive relief of a potter from the Athenian Akropolis, ca. 510, *top right*. Ht. 1.22 m. Dedicated by [Pamph?]aios, and signed by En[doios]; there is the "ghost" of a painted figure or object to the left.

162 Votive relief from the Athenian Akropolis, ca. 500. Ht. 39 cm. Possibly Hermes and the Nymphs, with the dedicator behind.

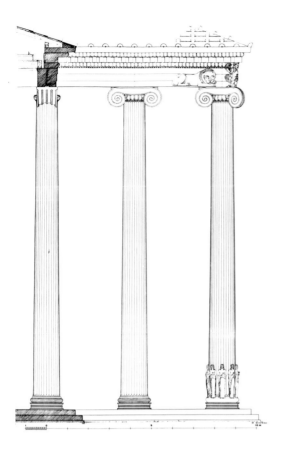

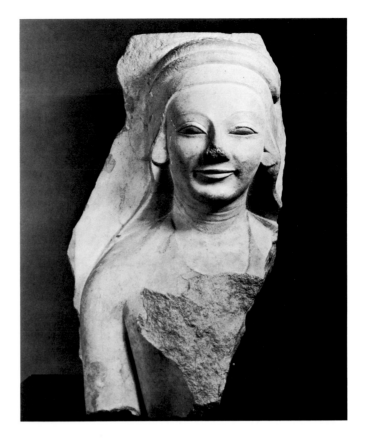

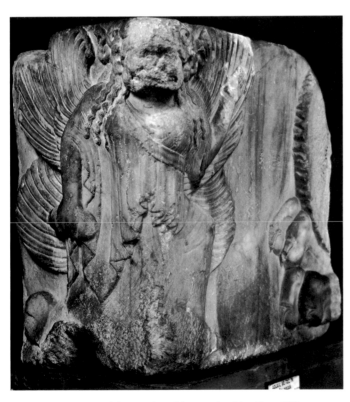

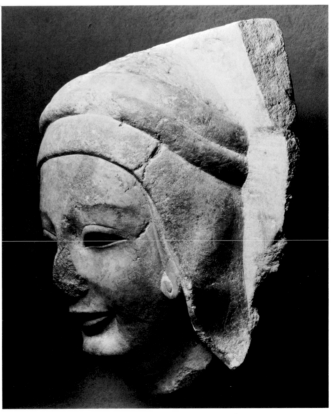

163 Reconstruction of the exterior of the temple of Apollo at Didyma.

164 Architrave block with Gorgon and lion, from the temple of Apollo at Didyma, ca. 540–520. Ht. 90 cm. Istanbul.

165–166 Column drum reliefs from the temple of Apollo at Didyma, ca. 550–530. Hts. 55.5 cm, 27 cm. Berlin.

167 Frieze slab from the Roman theater at Miletos: the Apollo Philesios of Kanachos. Roman copy: original, ca. 500. Ht. 79.5 cm. Berlin. The god holds a bow in his left hand and a stag in his right.

168–169 Apollo from the Piraeus, ca. 530–510, if not a later copy. Bronze, ht. 1.92 m. The god probably held an offering-dish or *phiale* in his right hand, and a bow in his left.

Kanachos's Cult Statue of Apollo at Didyma
167–169

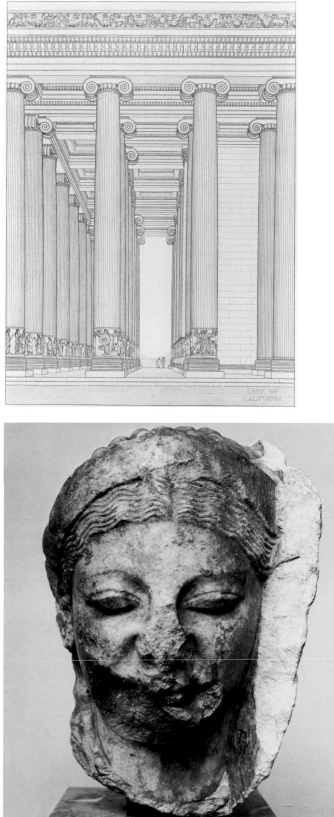

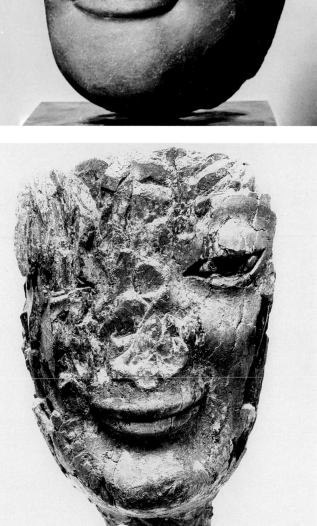

170 Reconstruction of the temple of Artemis at Ephesos.
171–172 Column drum reliefs from the temple of Artemis at Ephesos, ca.
550–530, *bottom left* and *top right*. Hts. 30 cm, 19 cm. London.

173 Head of Artemis (?) from a deposit of chryselephantine sculptures
found under the Sacred Way at Delphi, ca. 540–530. Ivory, ht. 18 cm.

East Greek Temples: Ephesos
170–173

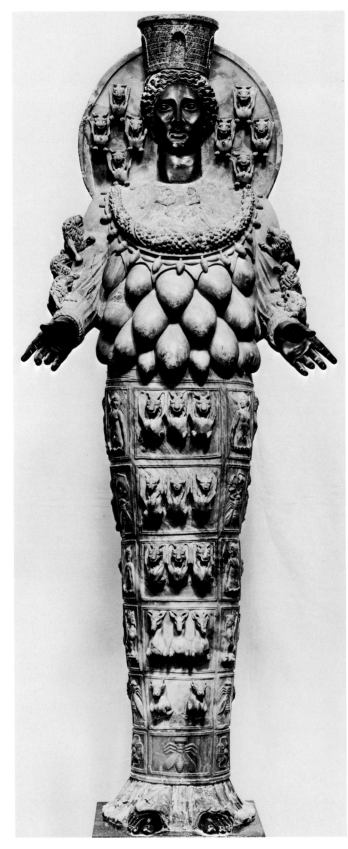

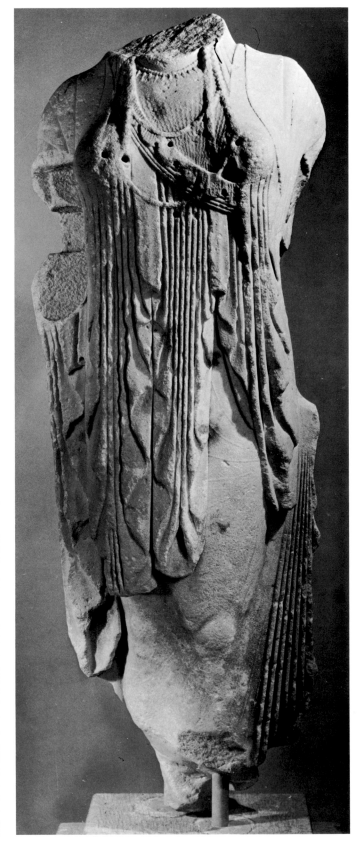

174 Artemis Ephesia (Roman copy), original ca. 500 or earlier? Alabaster with bronze face, hands, and feet; ht. 2.03 m. Naples. Version of the archaic cult statue attributed in antiquity to Endoios?

175 Kore (Leto?) from the agora at Delos, ca. 500. Ht. 1.34 m. Athens. Found with five other statues, reconstructed as Hera and Zeus enthroned at center, with Athena, Apollo, Artemis, and Leto standing around.

Artemis Ephesia and a Group of Cult Statues on Delos
174–175

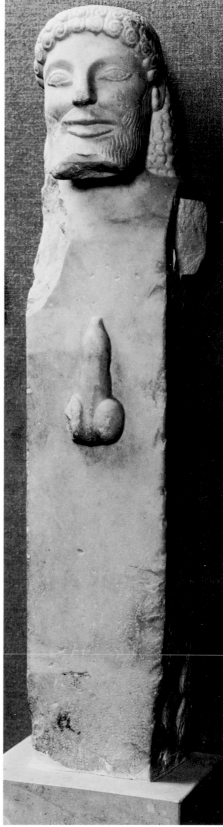

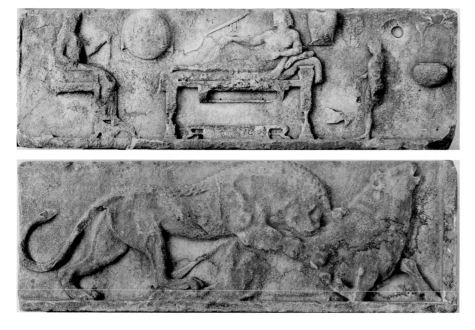

176–177 Relief from the heroon for the poet Archilochos (*floruit* ca. 650) on Paros, ca. 500. Banquet and lion attack. Ht. 73 cm.

178 Herm from Siphnos, ca. 520. Ht. 66 cm. Athens.

Cycladic Sculpture
176–178

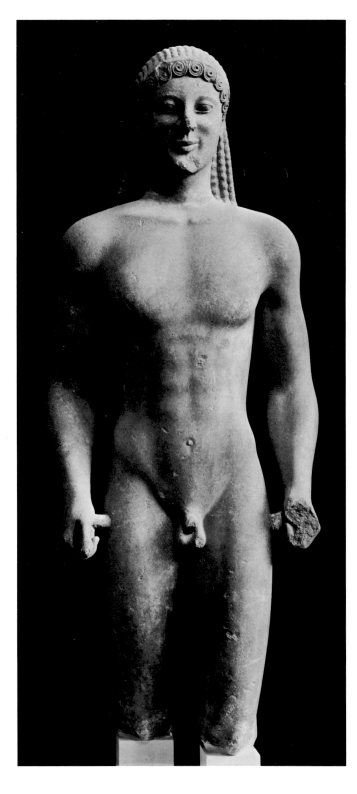

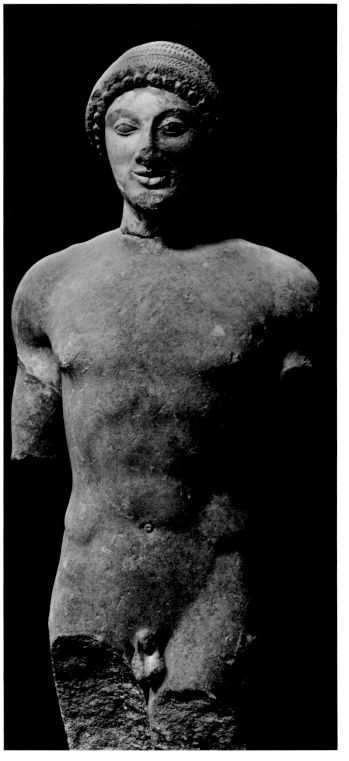

179 Kouros from the sanctuary of Apollo Ptoios (Boeotia), ca. 530–520. Ht. 1.60 m.

180 Kouros from the sanctuary of Apollo Ptoios (Boeotia), ca. 510–500. Ht. 1.03 m. The dedicatory inscription by Pythias and Aischrion is on the left thigh.

The Last Boeotian Kouroi
179–180

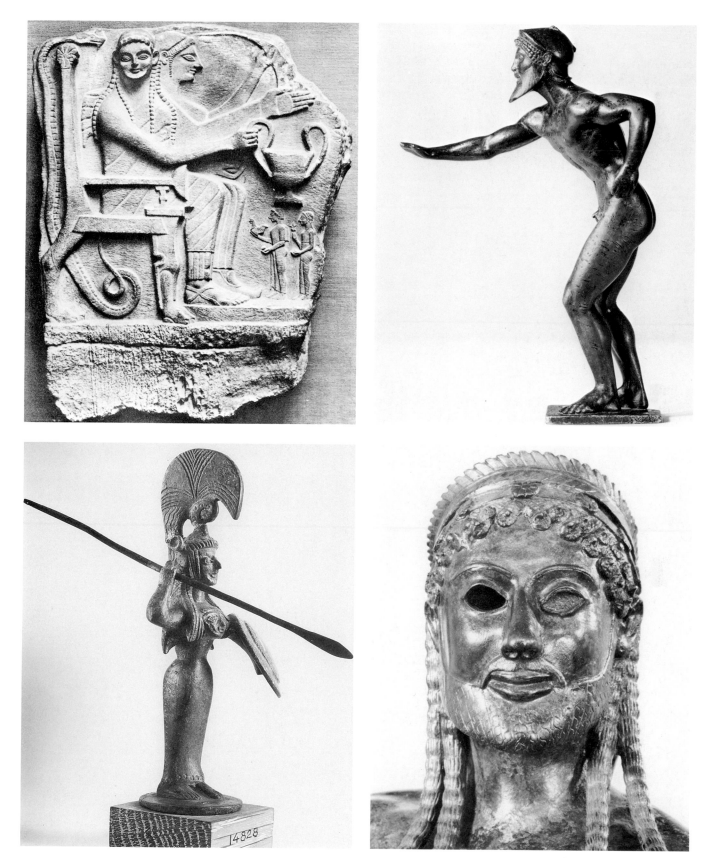

181 Hero relief from Chrysapha, near Sparta, ca. 540–520. Limestone, ht. 87 cm. Berlin.

182 Statuette of Alea Athena from Tegea, ca. 525–500. Bronze, ht. 13 cm. Athens. Perhaps a version of the cult statue of Alea Athena by Endoios.

183 Statuette of an armed runner at the starting-point of a race, ca. 500. Bronze, ht. 16.4 cm. Tübingen.

184 Head of a statue of Zeus found in a cave at Ugento (near Taranto in Italy), ca. 525–500. Bronze, ht. of statue, 71.8 cm. Taranto.

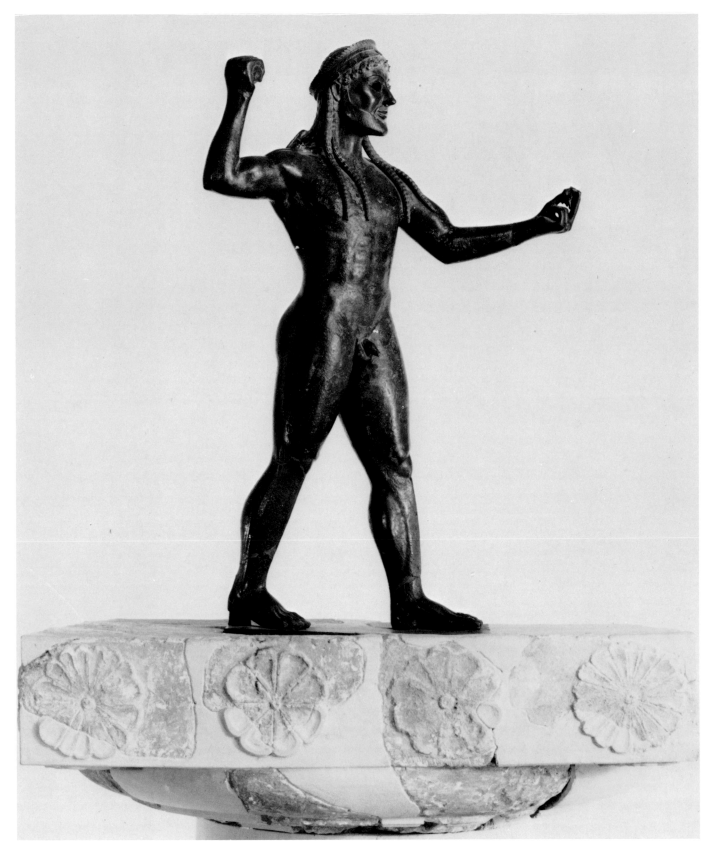

185 Zeus from Ugento, fig. 184. The god once held a thunderbolt in his
right hand and an eagle, flower, or bunch of grapes in his left.

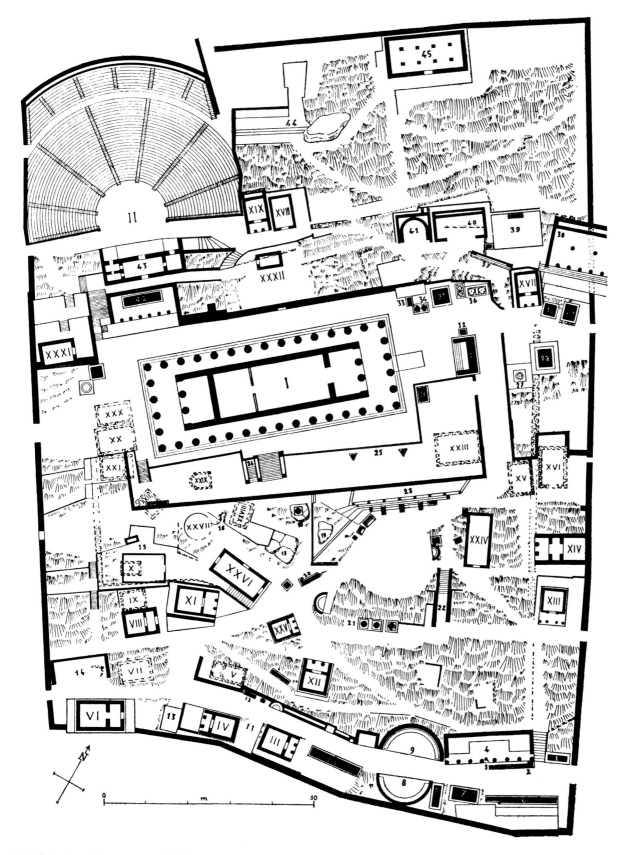

186 Delphi: plan of the sanctuary. The following monuments are discussed in this book: Aemilius Paullus Monument (26), Argive Monument (Antiphanes) (9), Arkadian (Tegean) dedication (2), Athenian Treasury (XI), Daochos Monument (40), Krateros Monument (Leochares and Lysippos) (42), Lysander Monument (Polykleitan School) (6), Marathon dedication (Pheidias) (7), Naxian Sphinx (18), Sikyonian Treasury (III), Siphnian Treasury (IV), Tarentine dedication (Hageladas) (10), Temple of Apollo (I).

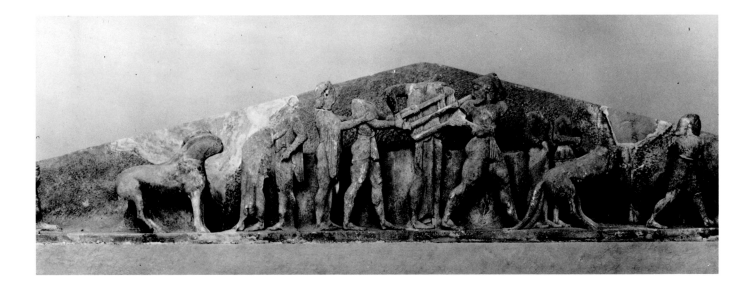

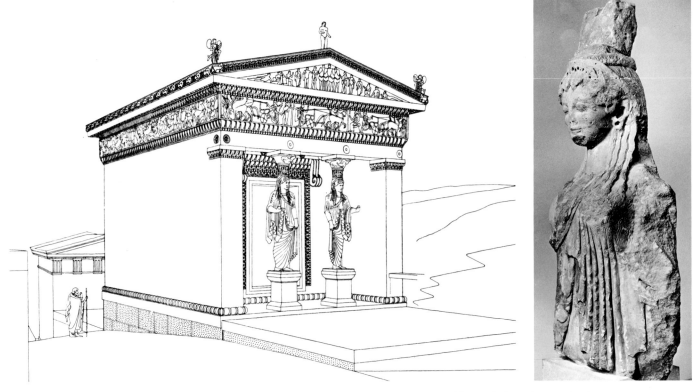

187 West pediment of the Siphnian Treasury at Delphi, ca. 525. Struggle between Apollo (left, backed by Artemis) and Herakles for the Delphic Tripod, with Zeus at center. Ht. 74 cm, l. 5.82 m.

188 Reconstruction of the treasury.

189 Kore (Caryatid) from the west façade, ca. 525. Ht. 1.75 m.

The Siphnian Treasury at Delphi
187–189

190 West frieze, ca. 525. Unexplained subject, perhaps either the Judgment of Paris or the Apotheosis of Herakles (an old suggestion revived by V. Brinkmann). Ht. 64 cm.

191 South frieze, ca. 525. Abduction of Helen or Persephone. Ht. 64 cm.

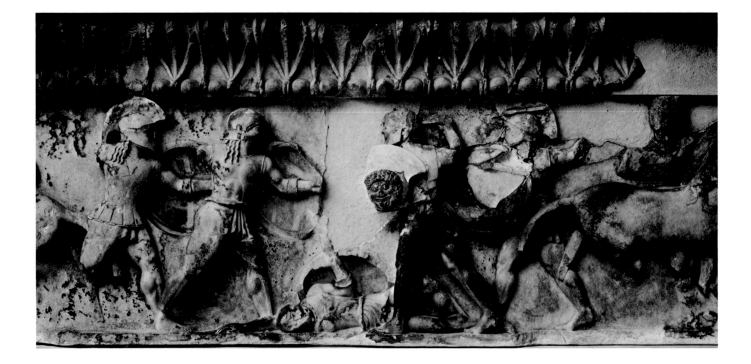

192–193 East frieze, ca. 525. Council of the gods and fight between Memnon and Achilles for the body of Antilochos. Ht. 64 cm. The painted and etched names are, from left to right: Ar[e]s, E[o]s, (Aphrodite?, Apollo?, Zeus, then probably Hermes and Poseidon in the missing por- tion), Athena, Hera, (Thetis?). Achill[es] is written on the base molding under Zeus's feet. The heroes are: Lykos, Aineas, Mem[non], [Antiloch]os, [Achill]es, (. . . ?. . .), [Aut]omedon, Nestor.

The Siphnian Treasury at Delphi
192–193

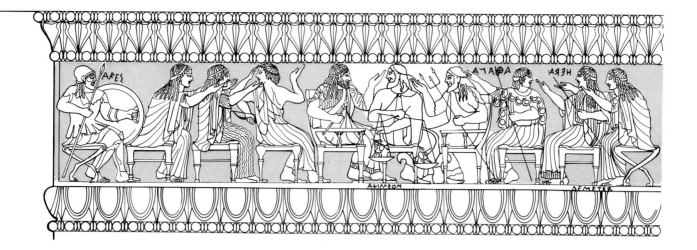

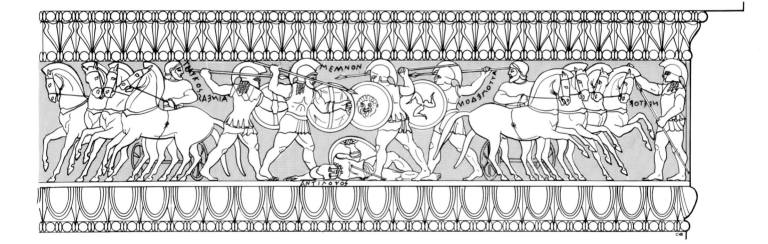

194 Reconstruction of the east frieze.

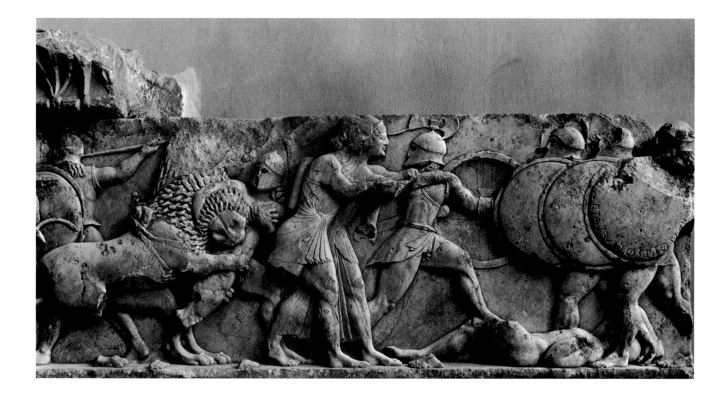

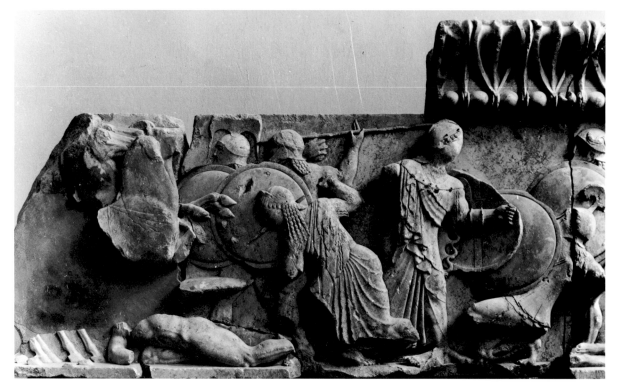

195–196 North frieze, ca. 525. Gigantomachy. Ht. 64 cm. At top left is the chariot of Dionysos and Themis; the other participants (named in paint) are [.]us, Apollo, Artemis, Tharos, the dead Ephialtas, Hyperphas, Alektos, and [.]us. The defaced signature on the shield reads "[.] made these and those at the back." The chariot at bottom left probably belongs to Zeus and Hera; to the right are the dead [Porphy]rion, (Aphrodite?), Athena, and Eriktypos.

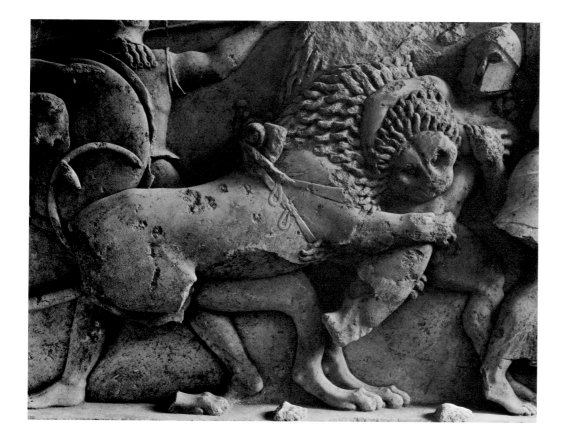

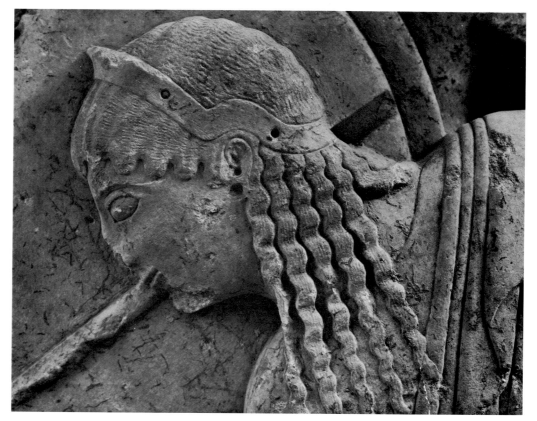

197 Detail from fig. 195: lion of Themis's chariot mauling the Giant [.]us.

198 Detail from fig. 196: a goddess (Aphrodite?) despatching [Por-phy]rion.

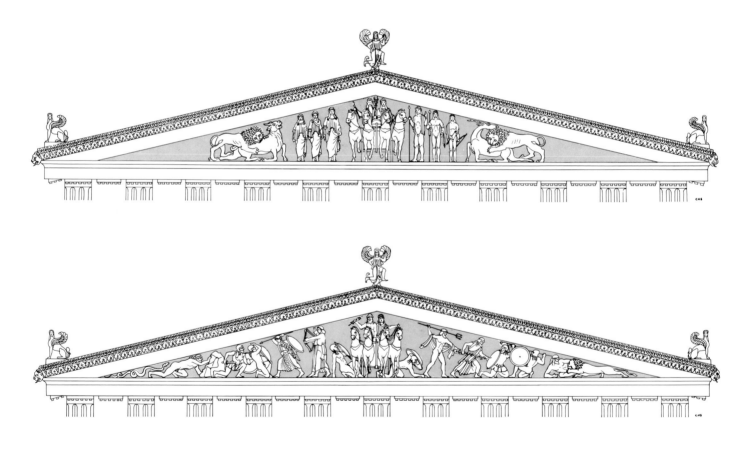

199 East pediment, ca. 510–500. Ht. at center, 2.30 m. 200 Restoration of the east and west façades.

The Temple of Apollo at Delphi
199–200

201–202 Korai (probaby Themis and Ge) from the east pediment, ca. 510–
500. Ht. 1.25 m, 1.16 m.

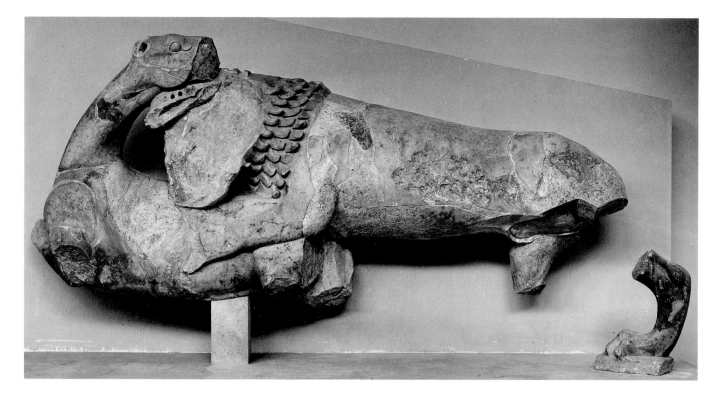

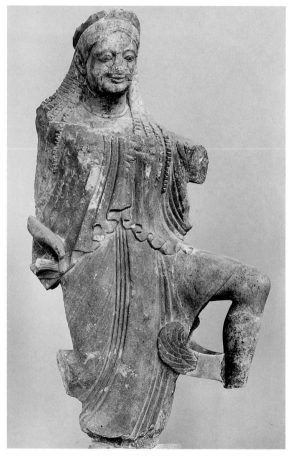

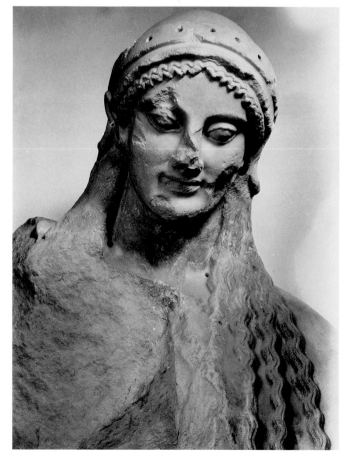

203 Lion and deer group from the east pediment of the temple of Apollo at Delphi, ca. 510–500. Ht 1.1 m.

204 Nike, akroterion from the east façade of the temple of Apollo at Delphi, ca. 510–500. Ht. 1.13 m.

205 Head of the Athena from the west pediment of the "Old temple of Athena" on the Athenian Akropolis, ca. 510–500. Ht. of statue, 2 m.

The Temples of Apollo at Delphi and of Athena on the Athenian Akropolis
203–205

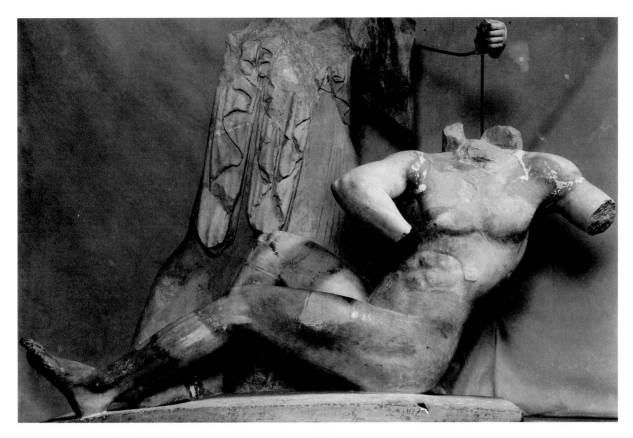

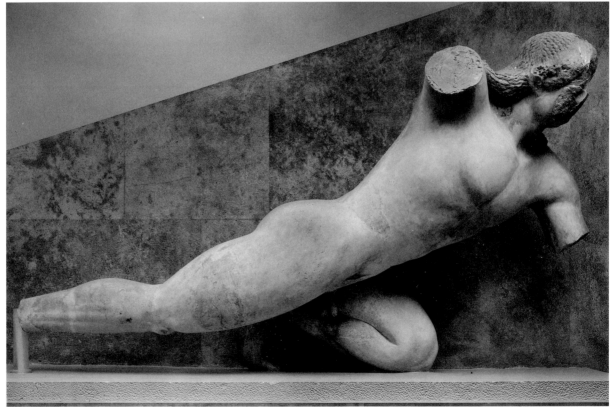

206–207 Athena and a giant, and a lunging giant, from the west pediment,
ca. 510–500. Ht. 2 m, 89 cm. As now displayed, Athena and her op-
ponent are separated by several meters, and fragments of another giant
and divinity have been inserted into the gap. All figures are patched
extensively in plaster.

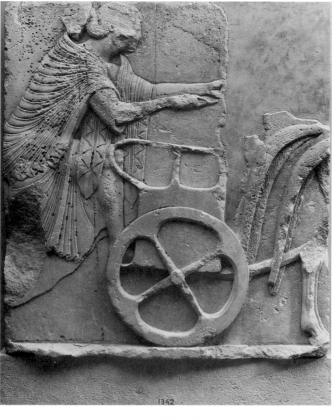

208 Frieze-block from the Akropolis, ca. 510–500. Charioteer mounting. Ht. 1.2 m. Other fragments show Hermes and a seated figure.

209 Metope from the Heraion at Foce del Sele, ca. 525–500. Sandstone, ht. 85 cm. Paestum.

210 a and b Nike (or Iris) from the Athenian Akropolis, 490 or just after. Original ht., ca. 1.5 m. Associated with a column dedicated (posthumously) by Kallimachos, the Athenian captain-general, recording that he died in the moment of victory at Marathon.

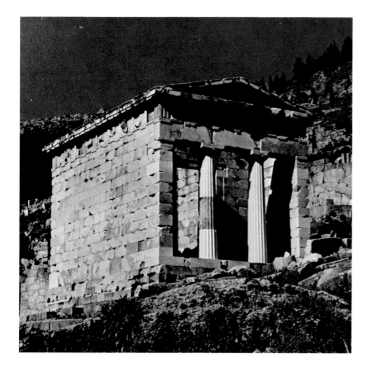

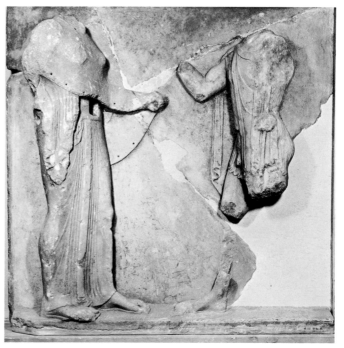

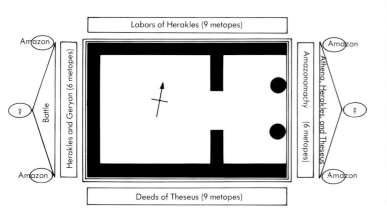

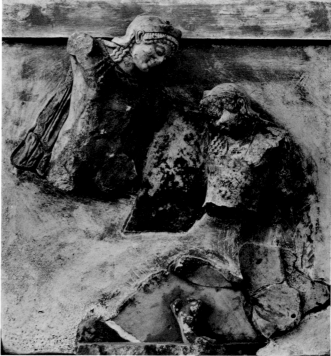

211 The Athenian Treasury at Delphi, ca. 490–480.
212 Sculptural program of the treasury.

213–214 Metopes from the treasury: Theseus and Athena, Theseus and the Amazon. Ht. 67 cm.

The Athenian Treasury at Delphi
211–214

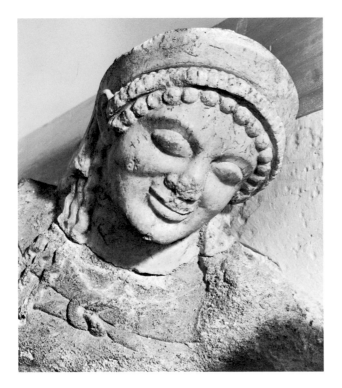

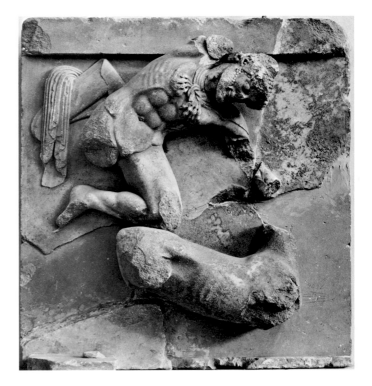

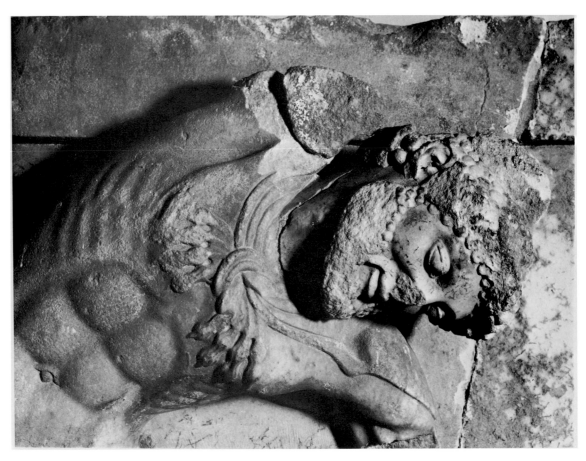

215 Detail of the metope, fig. 214.

216–217 Metope from the treasury: Herakles and the Hind. Ht. 67 cm.

The Athenian Treasury at Delphi
215–217

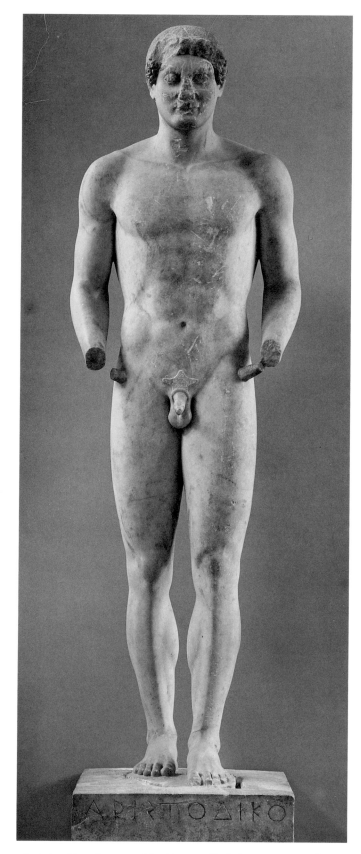

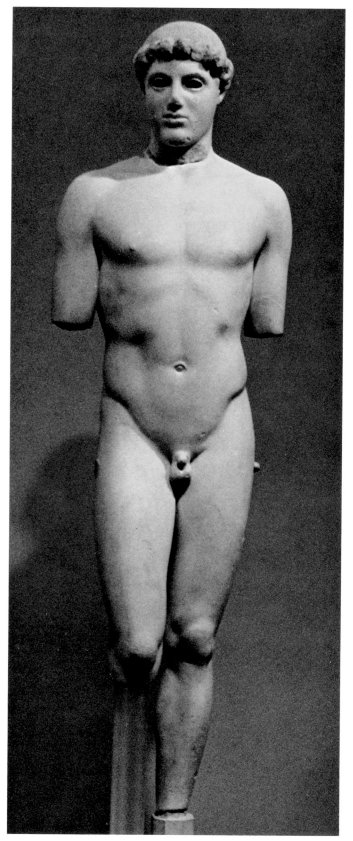

218 Aristodikos, from near Mt. Olympos (Attica), ca. 500–490. Ht. 1.95 m. Athens.

219 "Kritios Boy" from the Akropolis, ca. 490–480. Ht. 1.17 m. Photographed after the head was taken off and reset at Jeffrey Hurwit's initiative in 1987: it is now turned rather farther away from frontal than before.

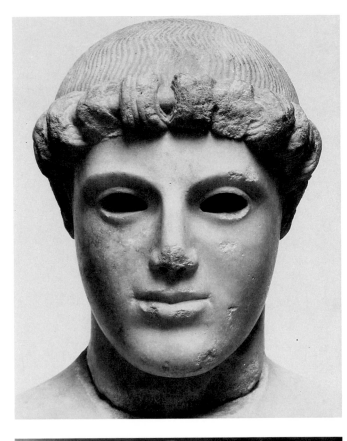

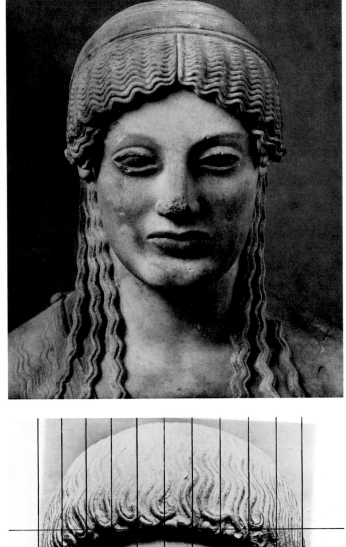

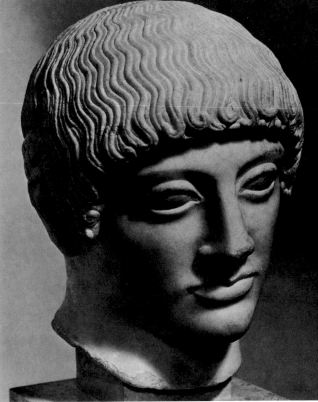

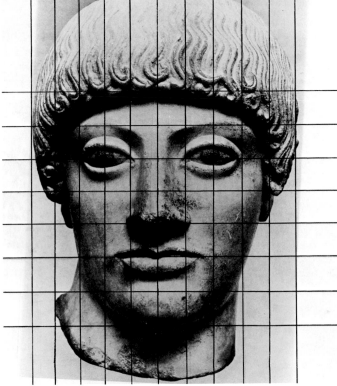

220 Head of the Kritian Boy, fig. 219.
221–222 "Blond Boy" from the Akropolis, ca. 490–480. Ht. 25 cm.

223 Head of the kore dedicated by Euthydikos, from the Akropolis, ca. 490–480, *top right*. See fig. 224.

Attic Sculpture: From Archaic to Classic
220–223

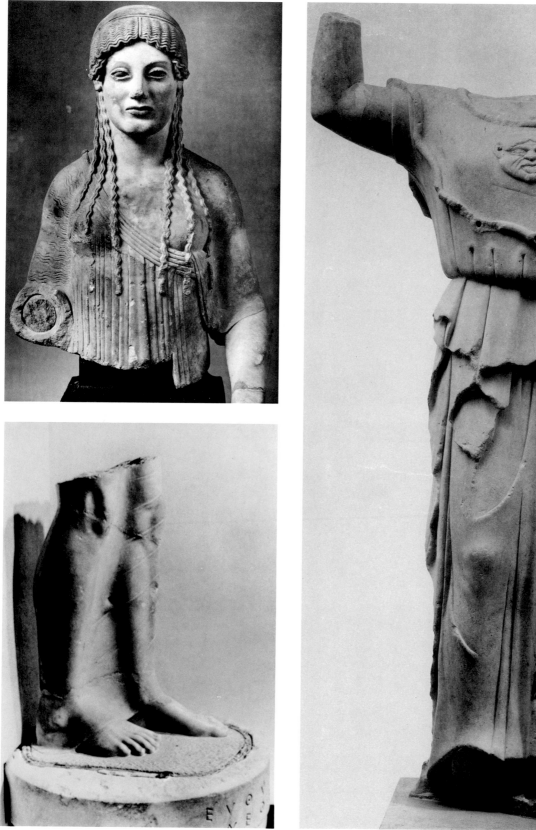

224 a and b Kore dedicated by Euthydikos, from the Akropolis, ca. 490–480. Ht. 58 cm, 42 cm.

225 Athena from the Athenian Akropolis, ca. 480. Ht. 77 cm. Often associated with a base dedicated by Anghelitos and signed by Euenor.

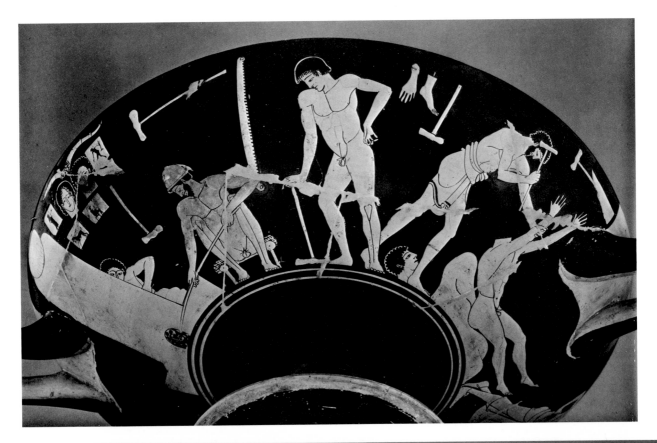

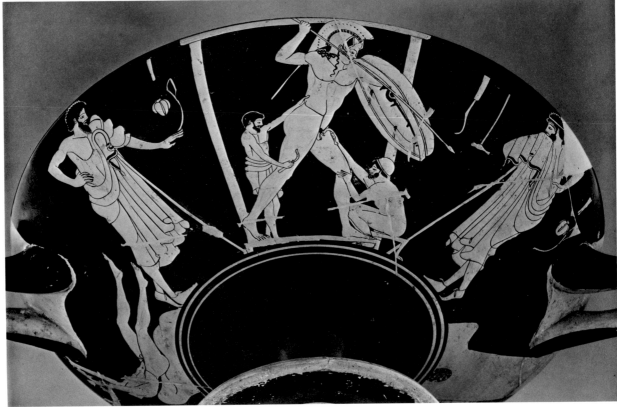

226 a and b Attic red-figured cup attributed to the Foundry painter, from
 Vulci, ca. 490. Bronze foundry. W. 30.5 cm. Berlin.

The Foundry Cup
226

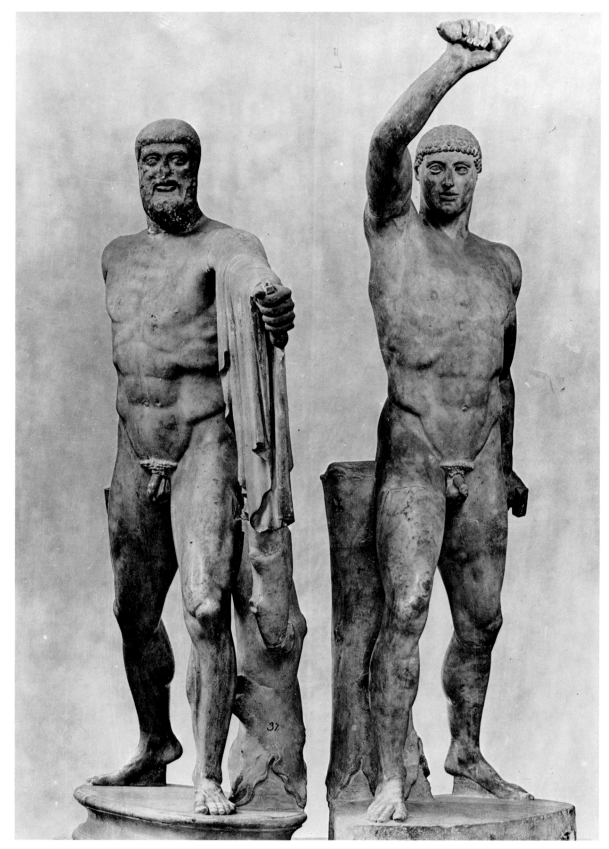

227 The tyrannicides Harmodios and Aristogeiton by Kritios and Nesiotes
(Roman copies), original 477/76. Ht. 1.85 m. Naples. Aristogeiton's
head is missing and has been completed by a cast of the head in fig. 228.

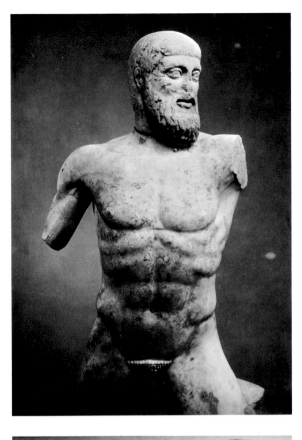

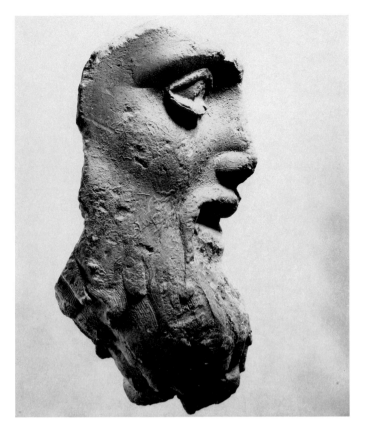

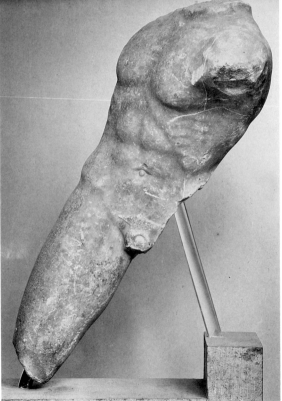

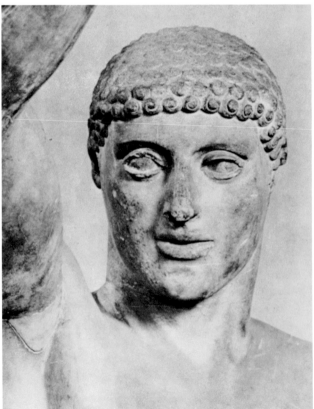

228 Another copy of the Aristogeiton, fig. 227. Ht. 1.8 m. Rome.
229 Torso of a warrior from Daphni (Attica), ca. 490–480. Ht. 73 cm. Athens.

230 Roman plaster cast of the head of the Aristogeiton (figs. 227–228), from Baiae. Plaster, ht. 21.6 cm.
231 Head of the Harmodios from the group, fig. 227.

The Tyrannicides of Kritios and Nesiotes
228–231

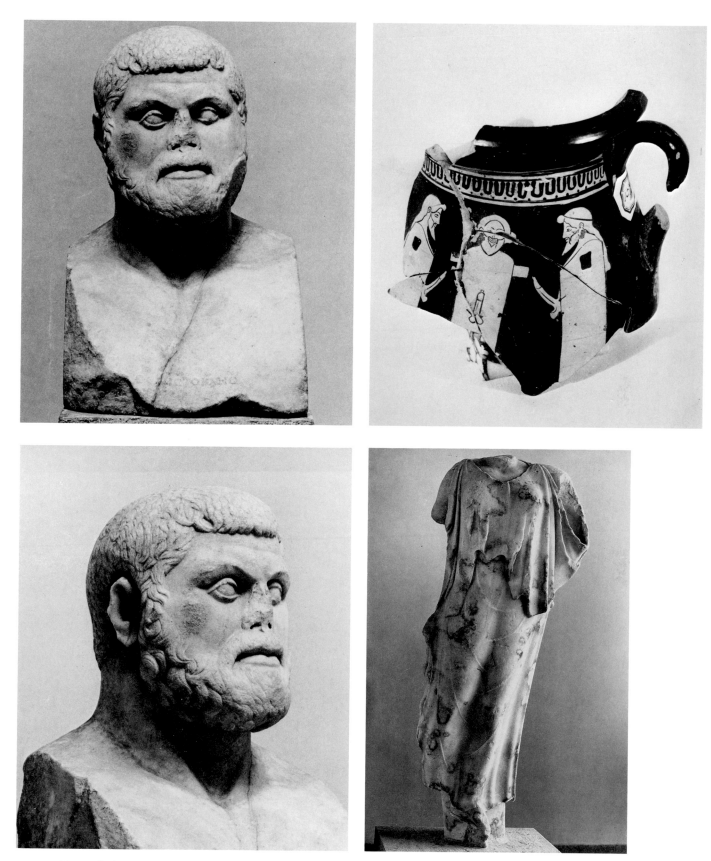

232–233 Herm of Themistokles from Ostia (Roman copy), original ca. 470. Ht. 50 cm.

234 Attic red-figured pelike attributed to the Pan painter, ca. 470. Three herms. Ht. 20 cm. Paris.
235 Nike from Paros, ca. 470. Ht. 1.38 m.

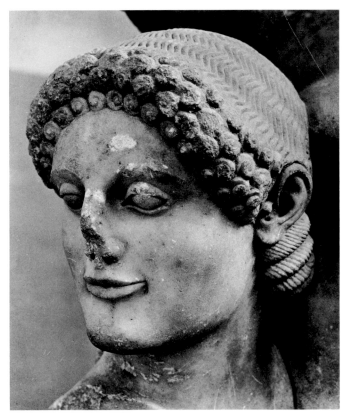

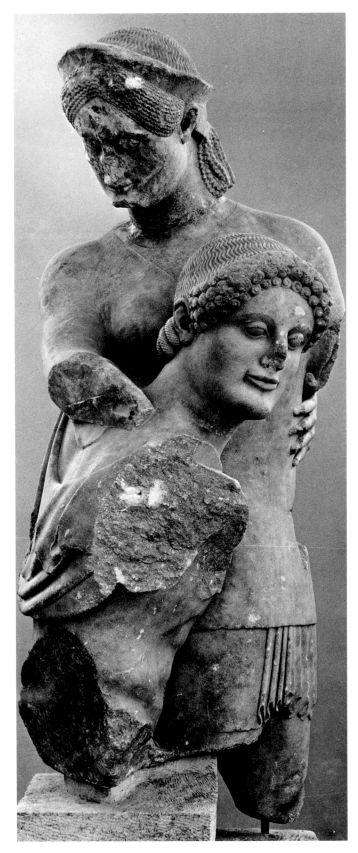

236–238 West pediment of the temple of Apollo Daphnephoros at Eretria, ca. 500–490. Theseus and Antiope, *left and top right*; Athena, *bottom right*. Ht. 1.10 m., 75 cm. Chalkis.

Eretria: The Temple of Apollo Daphnephoros
236–238

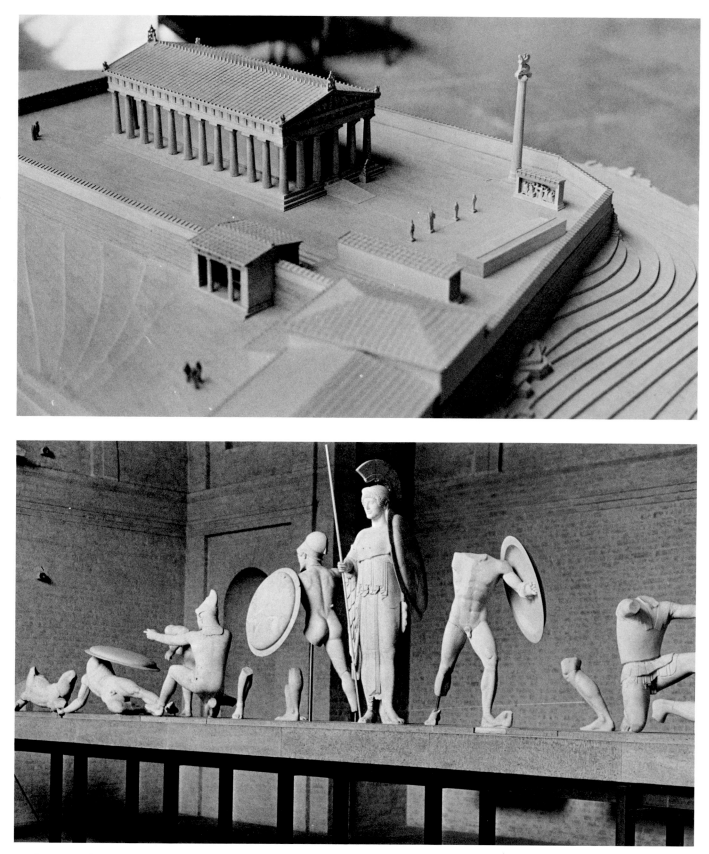

239 Sanctuary of Aphaia at Aegina. Model in the Glyptothek, Munich.

240 West pediment (II) of the temple of Aphaia at Aegina, ca. 490–475. Second sack of Troy, by the Greeks under Agamemnon. Ht. 1.72 m, w. 15 m. Munich.

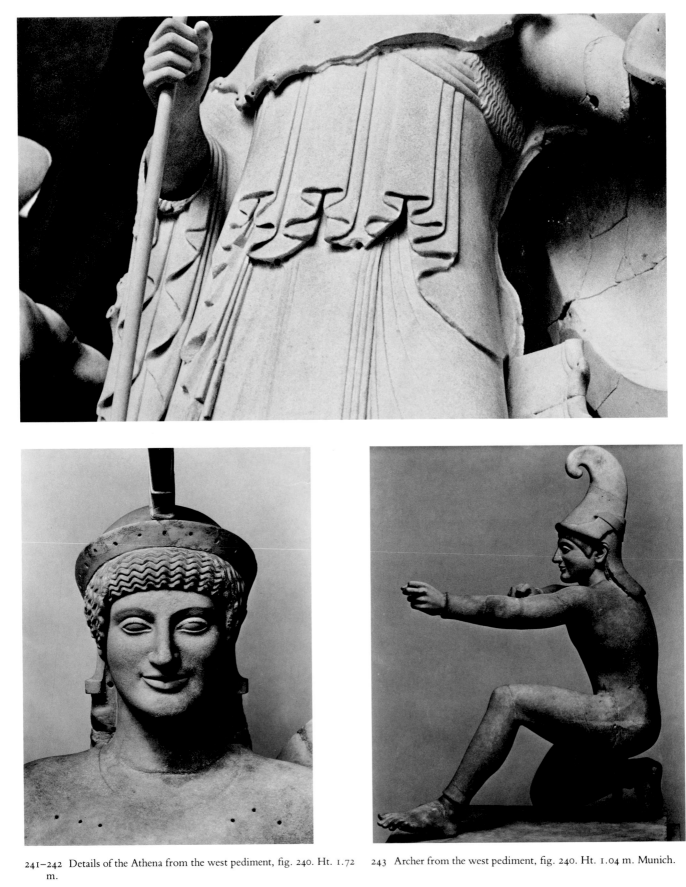

241–242 Details of the Athena from the west pediment, fig. 240. Ht. 1.72 m.

243 Archer from the west pediment, fig. 240. Ht. 1.04 m. Munich.

The Temple of Aphaia at Aegina
241–243

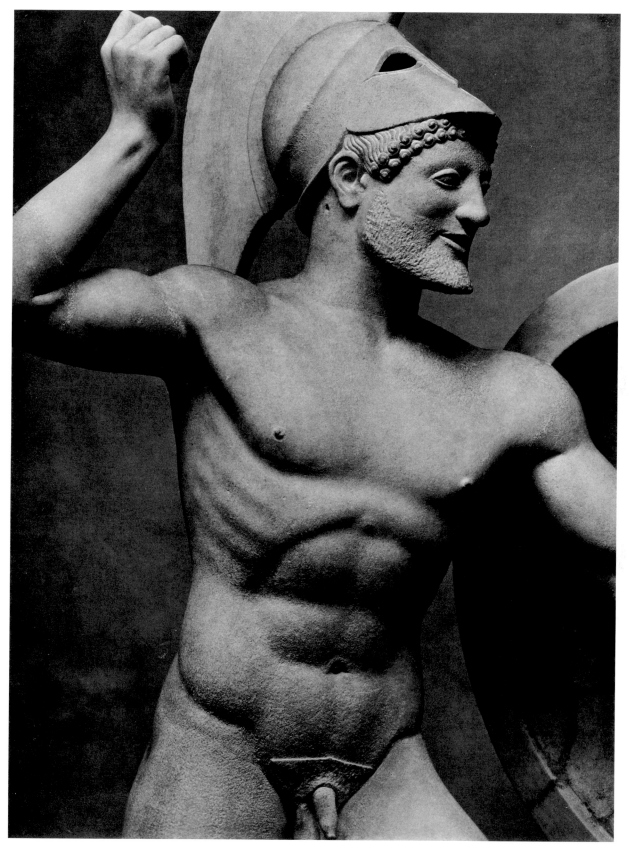

244 Striding warrior from the west pediment (Ajax?), fig. 240. Ht. 1.43 m.
Munich.

The Temple of Aphaia at Aegina
244

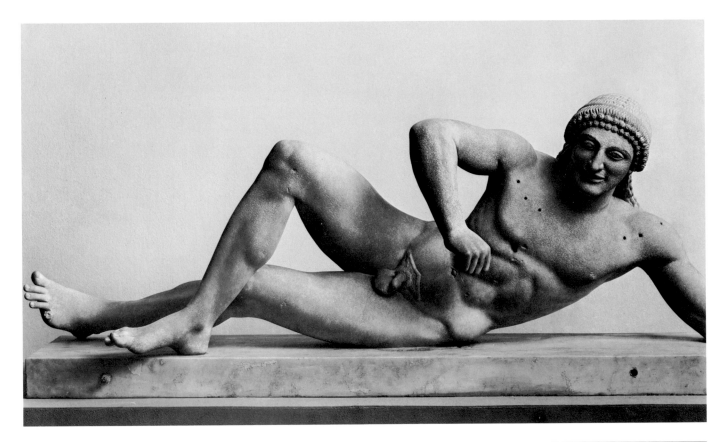

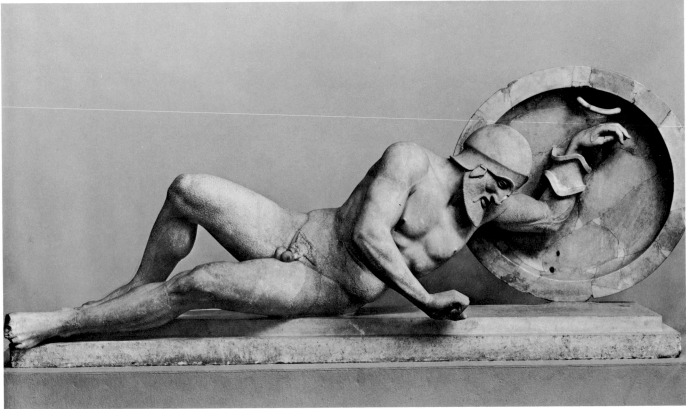

245 Dying warrior from the west pediment, fig. 240. L. 1.59 m. Munich.

246 Dying warrior from the east pediment (II), fig. 251, ca. 490–475. L. 1.85 m. Munich.

The Temple of Aphaia at Aegina
245–246

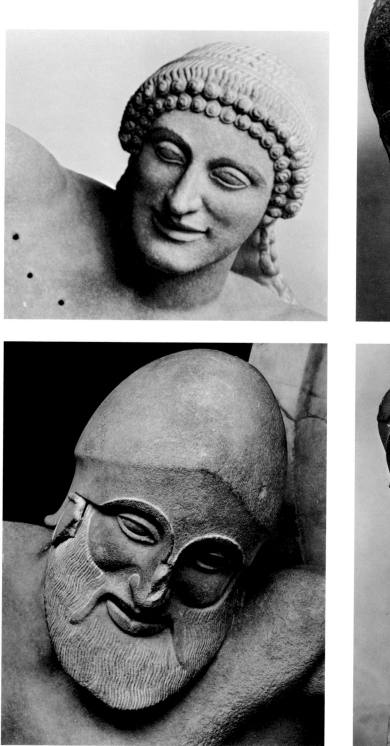

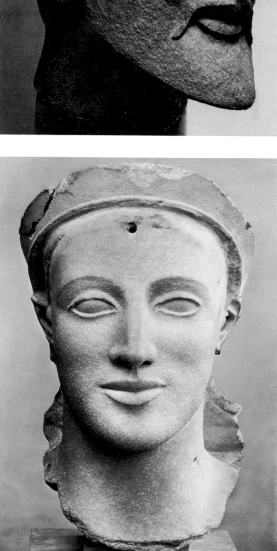

247 Head of the dying warrior from the west pediment, fig. 245.
248 Head of the dying warrior from the east pediment, fig. 246.

249 Head of a warrior from the Athenian Akropolis, ca. 480. Bronze, ht. 25 cm. The helmet, made separately, is missing.
250 Head of Athena from the east pediment, fig. 251. Ht. 31 cm. Munich.

The Temple of Aphaia at Aegina
247–250

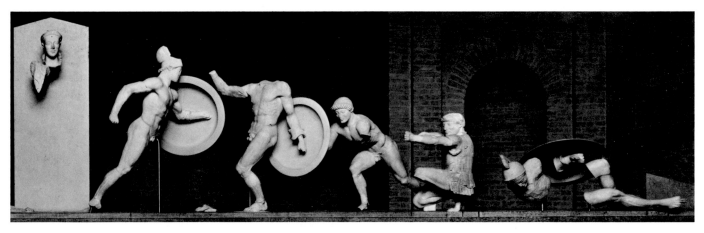

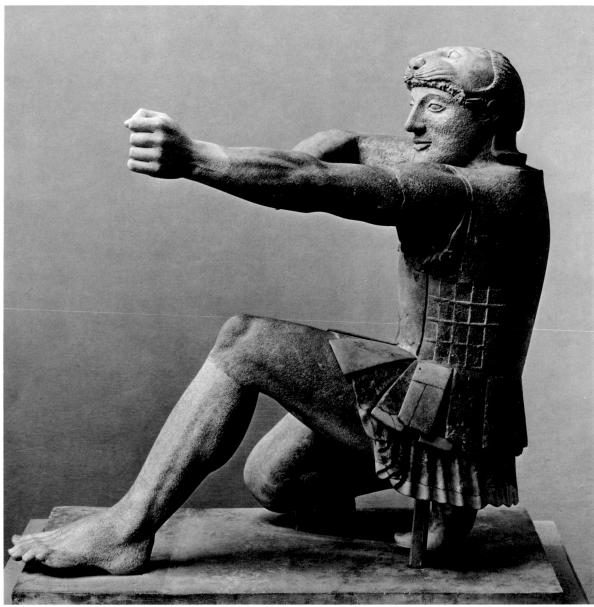

251 East pediment (II) of the temple of Aphaia at Aegina, ca. 490–475. First sack of Troy, by Herakles and Telamon. Ht. 1.72 m, w. 15 m. Munich.

252 Herakles from the east pediment, fig. 251. Ht. 79 cm. Munich.

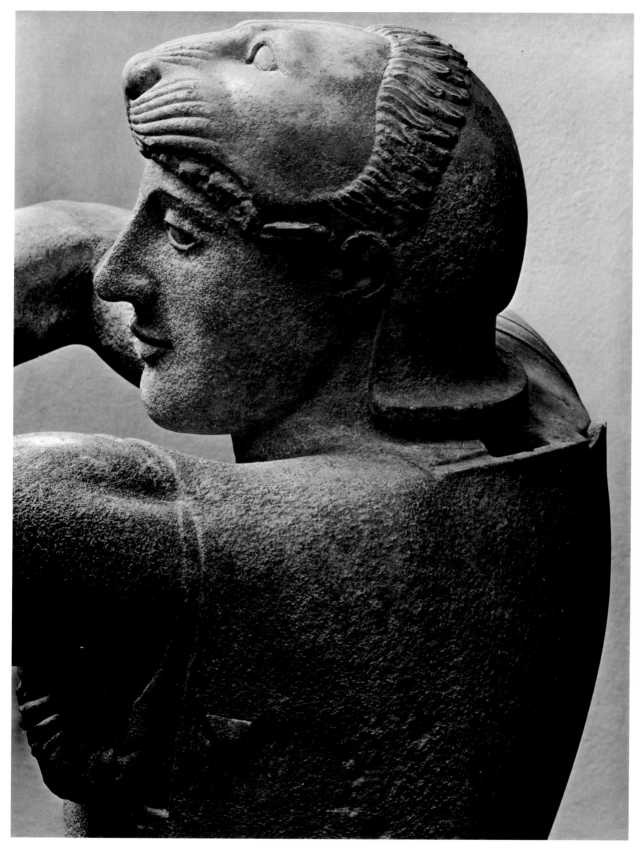

253 Head of the Herakles from the east pediment, fig. 252. Munich.

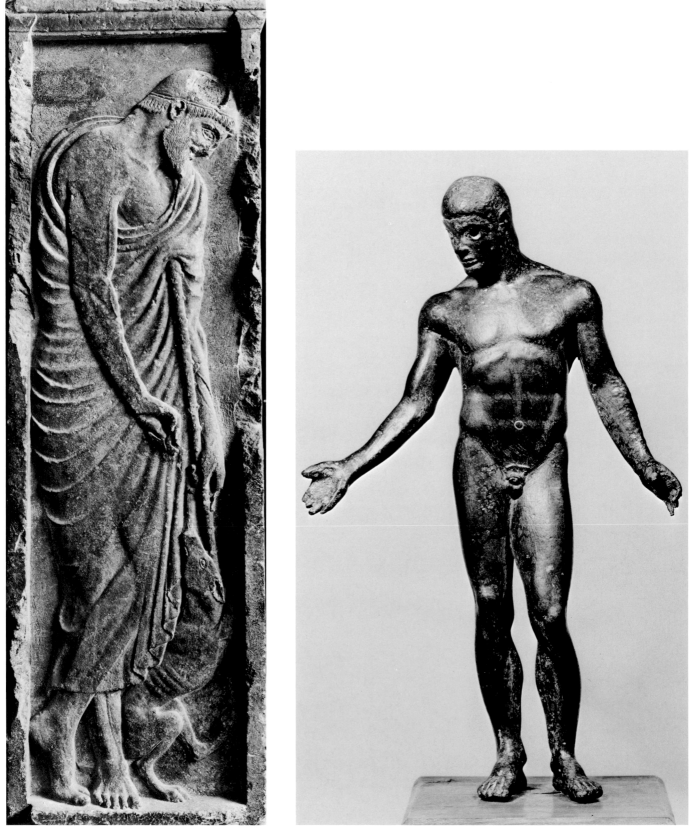

254 Stele signed by Alxenor, from Orchomenos (Boeotia), ca. 490. A man offers a locust to a dog. Ht. 2.05 m. Inscribed "Alxenor of Naxos made me: just look!"

255 Statuette of an athlete pouring a libation, from Aderno (Sicily), ca. 470. Bronze, ht. 19.5 cm. Syracuse.

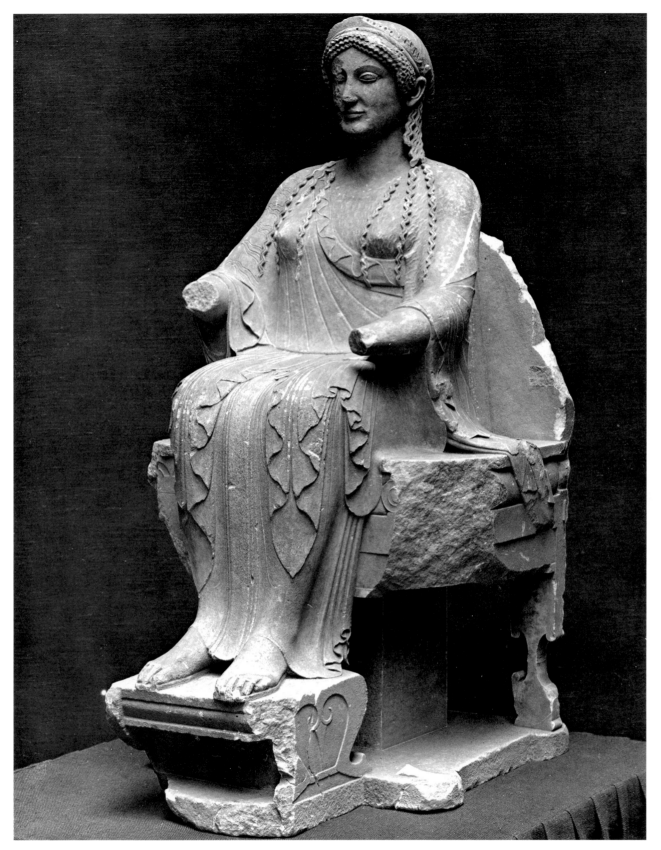

256 Enthroned goddess from Taranto, ca. 470. Ht. 1.51 m. Berlin.

The Taranto Goddess
256

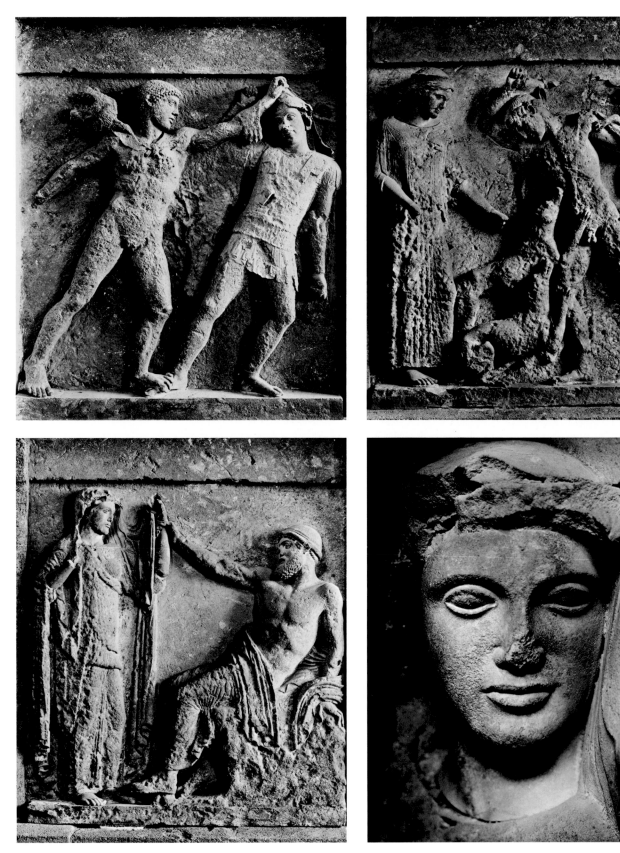

257–259 Metopes from temple E at Selinus (Sicily), ca. 470–450. Herakles and an Amazon, *top left*; Zeus and Hera, *bottom left*; Artemis and Actaeon, *top right*. Limestone, with some heads and limbs inset in marble; ht. 1.62 m. Palermo.

260 Head of Hera from the metope, fig. 258.

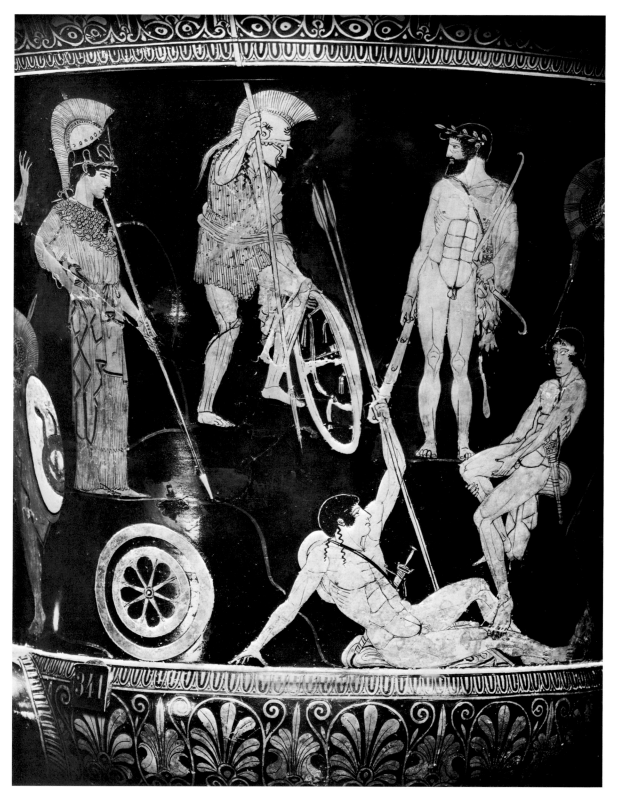

261 Attic red-figured calyx-krater attributed to the Niobid painter, from
Orvieto, ca. 460–450. Unexplained subject, perhaps Theseus and
Peirithoos in Hades. Ht. 54 cm. Paris.

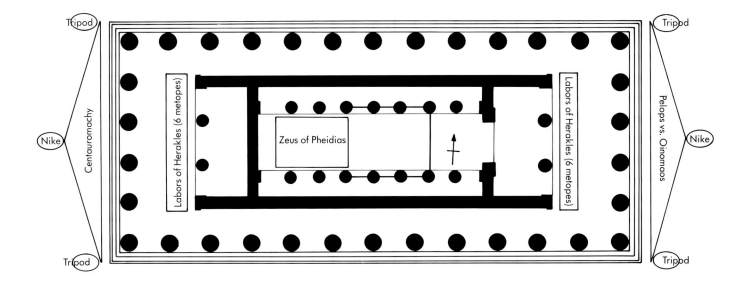

Tripod

Tripod

Centauromachy

Labors of Herakles (6 metopes)

Nike

Zeus of Pheidias

Nike

Labors of Herakles (6 metopes)

Pelops vs. Oinomaos

Tripod

Tripod

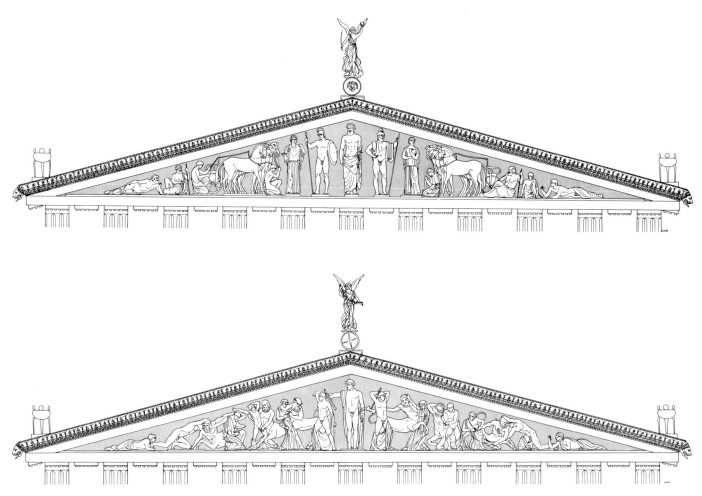

262–263 The sculptural program and a reconstruction of the pediments,
ca. 470–457. Ht. of pediments, 3.3 m, l. 26.4 m.

The Temple of Zeus at Olympia
262–263

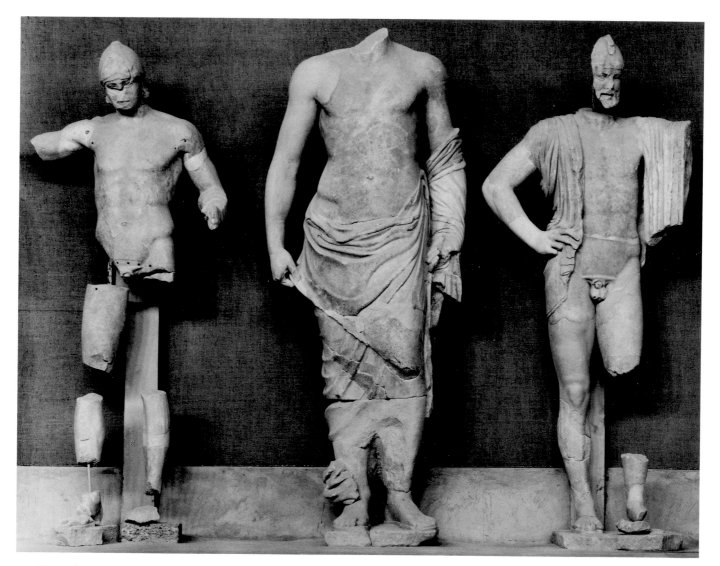

264 East pediment: central group of Pelops (G), Zeus (H), and Oinomaos
(I), ca. 450–457. Original ht. of Zeus, ca. 3.15 m.

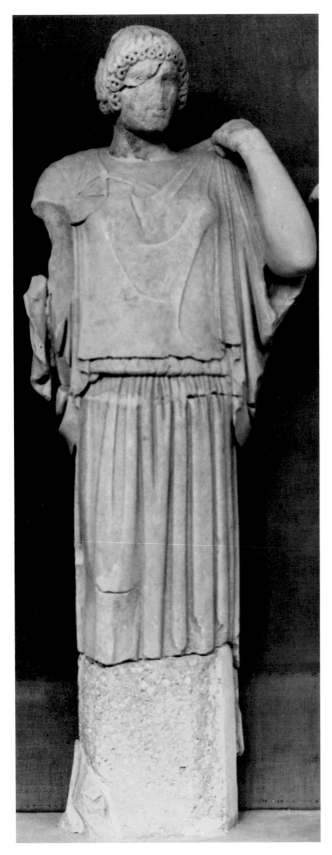
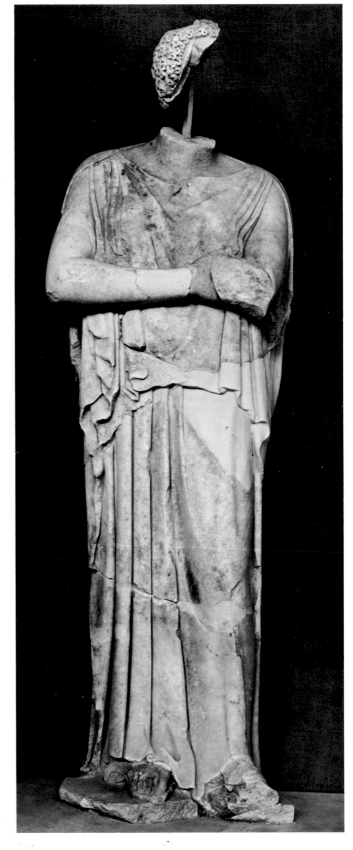

265–266 East pediment: Hippodameia (K) and Sterope (F), ca. 470–457.
Original ht. of both figures, ca. 2.6 m.

265–266
The Temple of Zeus at Olympia

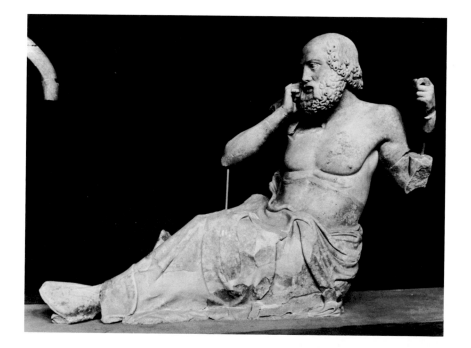

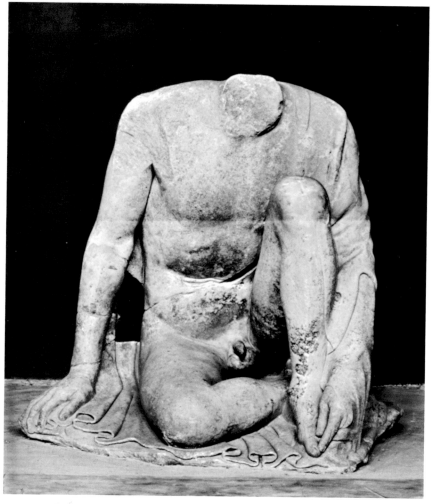

267–268 East pediment: seer (N) and boy (E), perhaps Amythaon and
Melampous, ca. 470–457. Ht. of N, 1.38 m., original ht. of E, ca.
1.1 m.

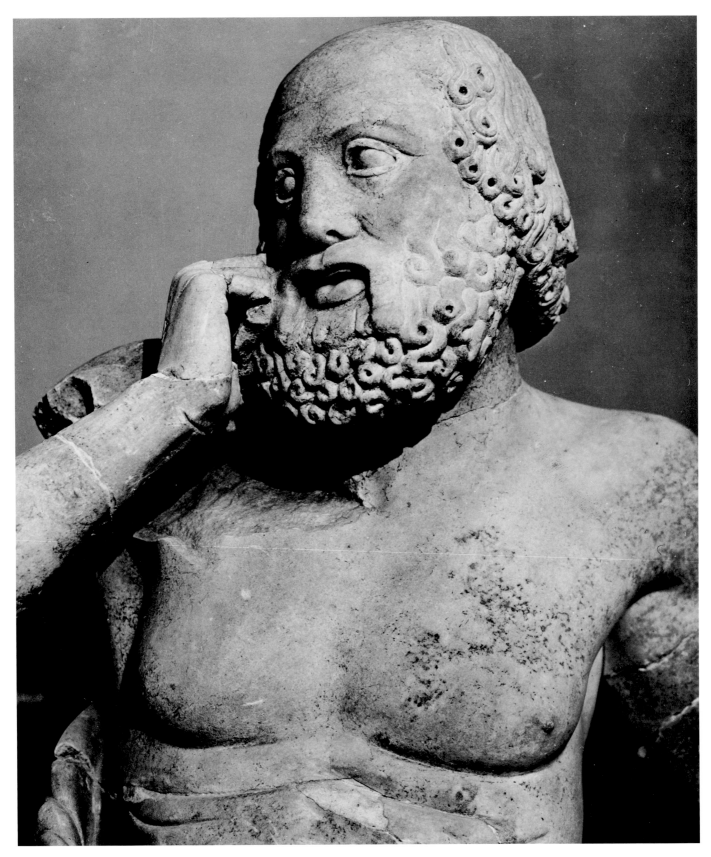

269 Head of the seer, fig. 267.

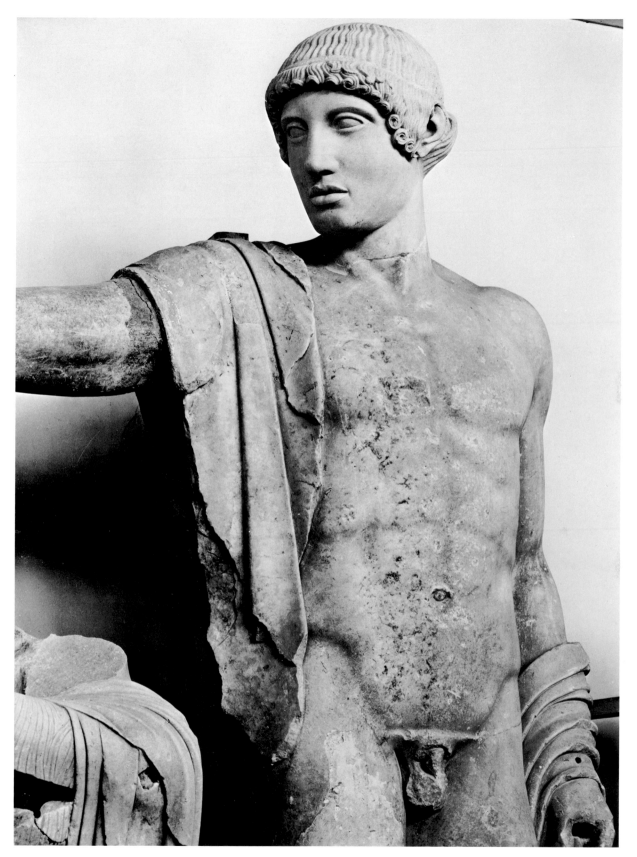

270 West pediment: Apollo (L), ca. 470–457. Original ht. ca. 3.1 m.

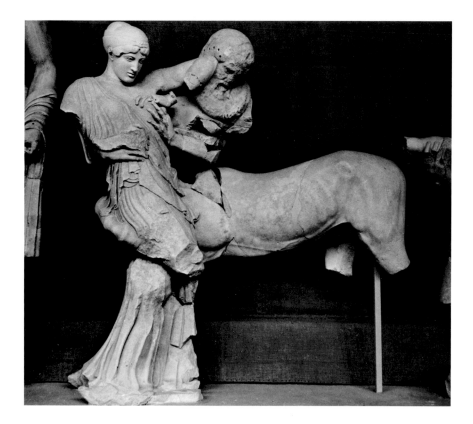

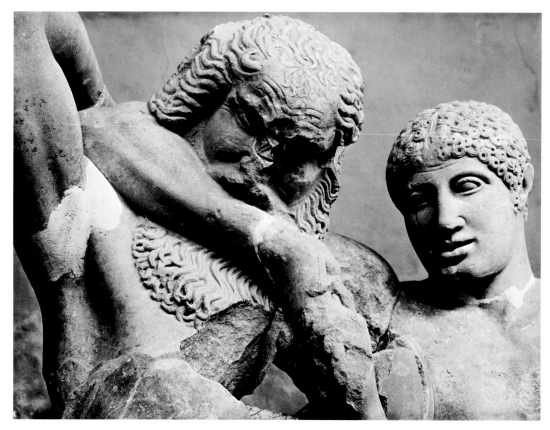

271–272 West pediment: Eurytion (H) and Deidameia (I); Centaur (P)
and Lapith (Q), ca. 470–457. Ht. 2.35 m., 2.05 m.

The Temple of Zeus at Olympia
271–272

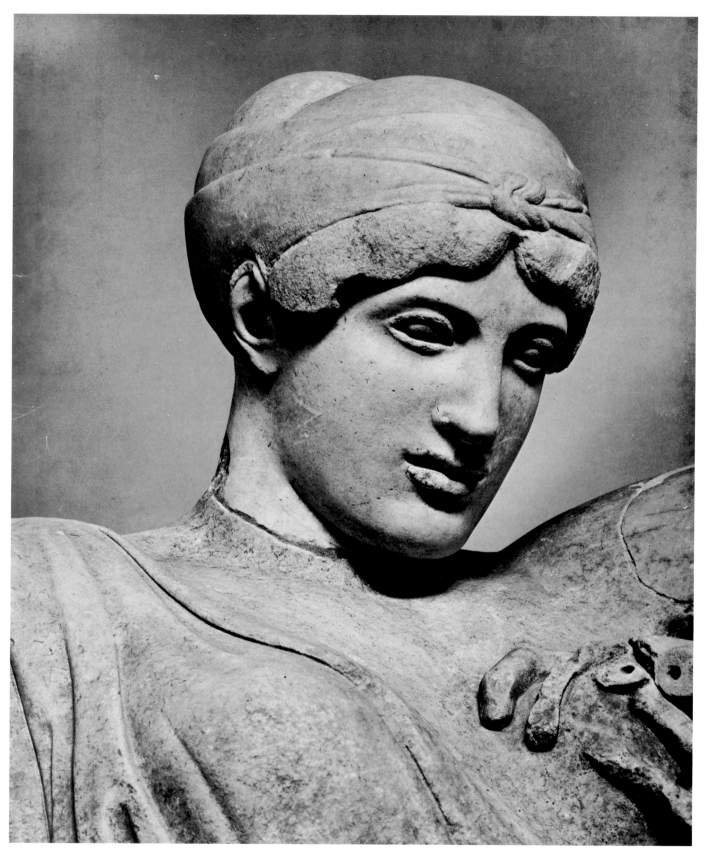

273 Head of Deidameia, fig. 271.

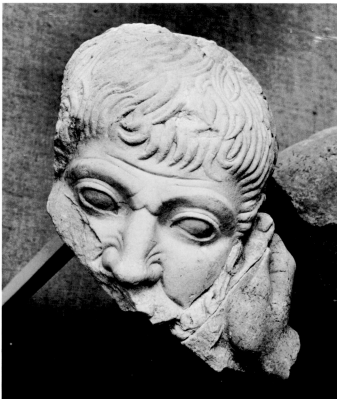

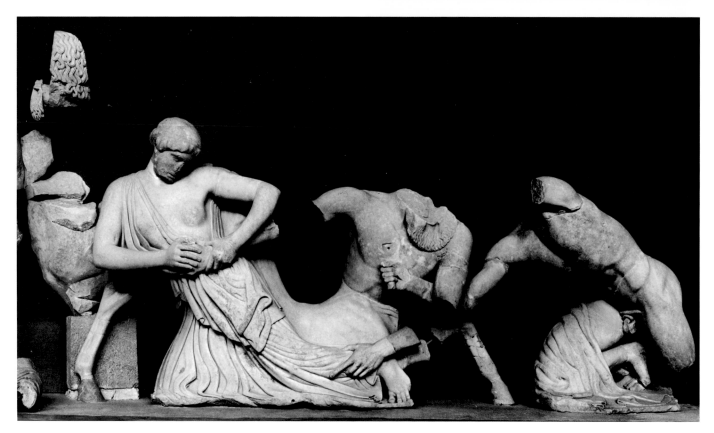

274–276 West pediment: Lapith girl (E); Centaur (D); Centaur (R), Lap-
ith (S), and Lapith girl (T), ca. 470–457. Ht. of E, 1.65 m.; of D,
34 cm.; of R, S, and T, 1 m.

The Temple of Zeus at Olympia
274–276

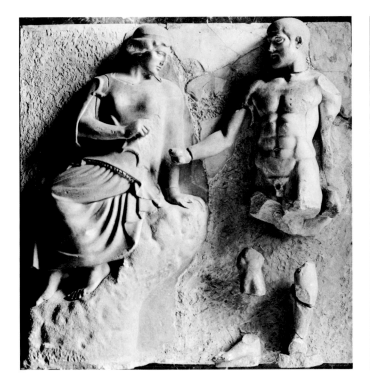

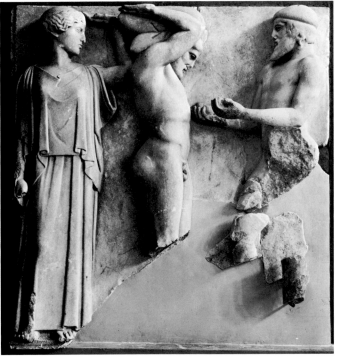

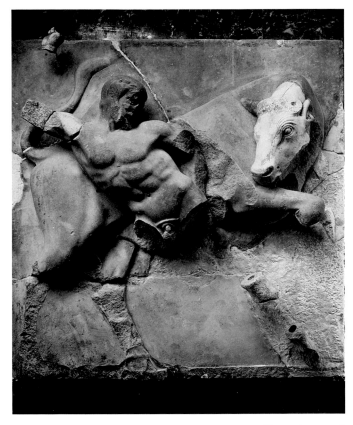

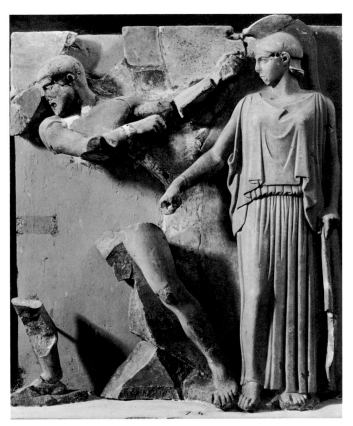

277–280 Metopes 3, 4, 10, and 12, ca. 470–457. Herakles, Athena, and the Stymphalian Birds, *top left*; Herakles and the Bull, *bottom left*; Herakles, Athena, and Atlas with the Apples of the Hesperides, *top right*; Herakles, Athena, and the Augean Stables, *bottom right*. Ht. 1.6 m.

On metope 3, in Paris, the Athena and the head and right arm of Herakles are original, the rest is completed with plaster casts of the fragments in Olympia; on metope 4, in Olympia, the upper two-thirds, except the head of the Bull, is a plaster cast of the fragments in Paris.

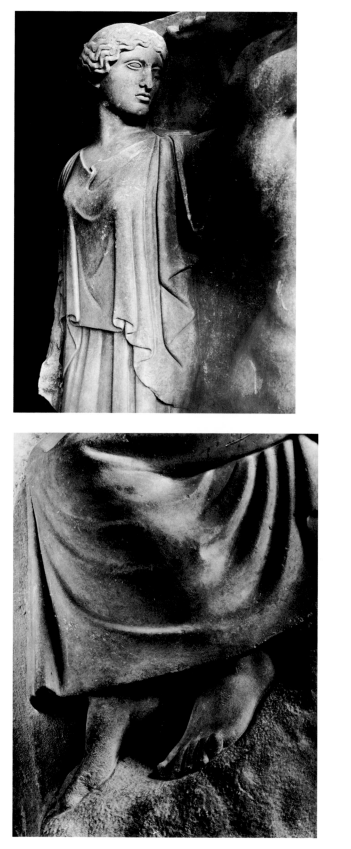

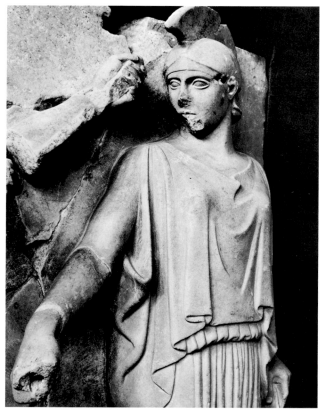

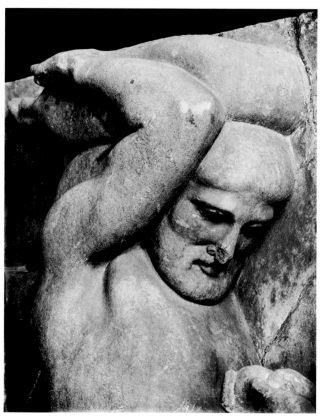

281–283 Athena from metopes 10 (*top left*), 12 (*top right*), and 3 (*bottom left*), figs. 279–280, 277.

284 Head of Herakles from metope 10, fig. 279.

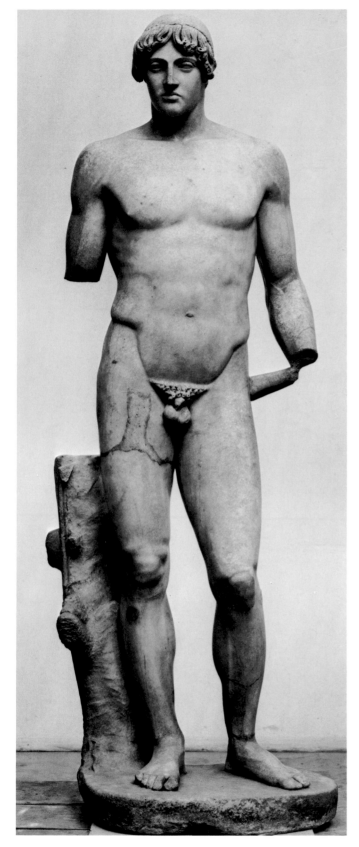

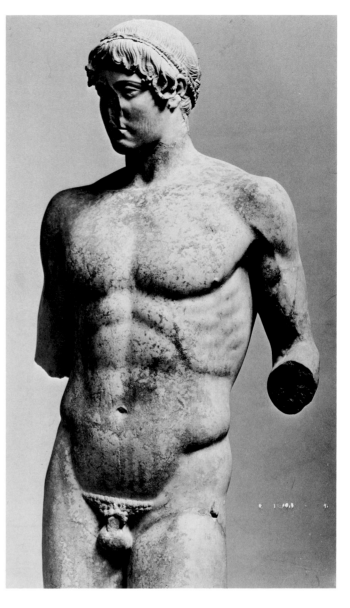

285 "Choiseul-Gouffier" Apollo (Roman copy), original ca. 470. Ht. 1.78 m. London. Copies same original as the "Omphalos Apollo," fig. 286.

286 "Omphalos Apollo" (Roman copy), from the Theater of Dionysos in Athens, original ca. 470. Ht. 1.76 m. The omphalos found nearby did not serve as the base to the statue, as once thought.

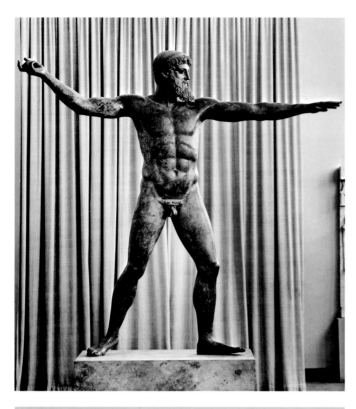

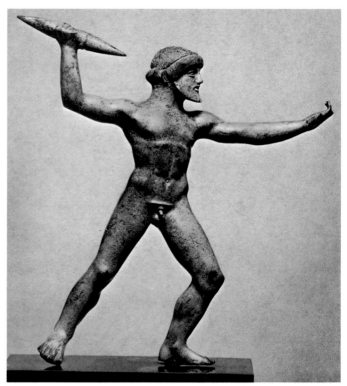

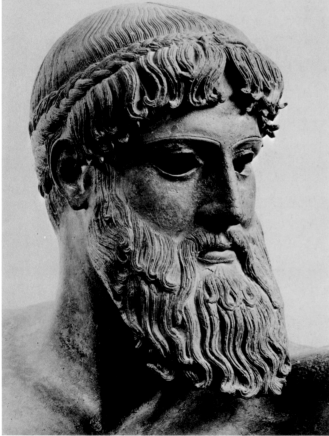

287–288 Zeus from Cape Artemision, ca. 450. Bronze, ht. 2.09 m., span 2.10 m. Athens.

289 Statuette of Zeus from Dodona, ca. 470. Bronze, ht. 13.5 cm. Berlin.

The Zeus from Cape Artemision
287–289

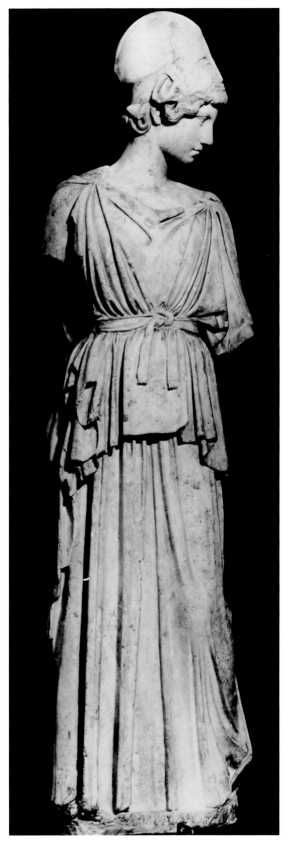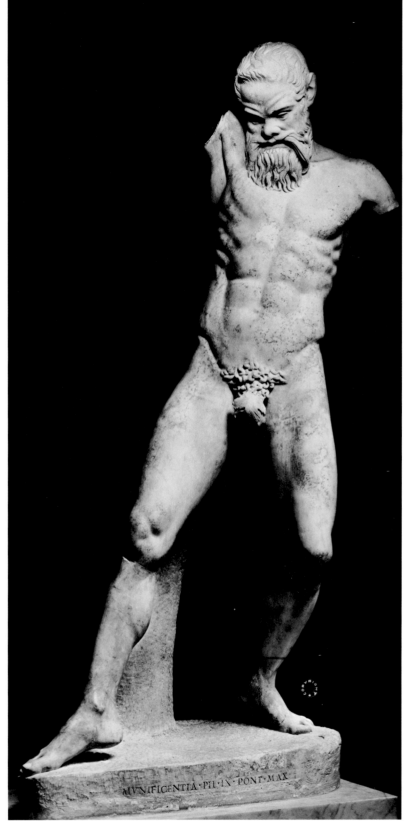

290–291 Athena and Marsyas attributed to Myron (Roman copies), orig-
inal ca. 450. Ht. 1.73 m, 1.59 m. Frankfurt and Rome.

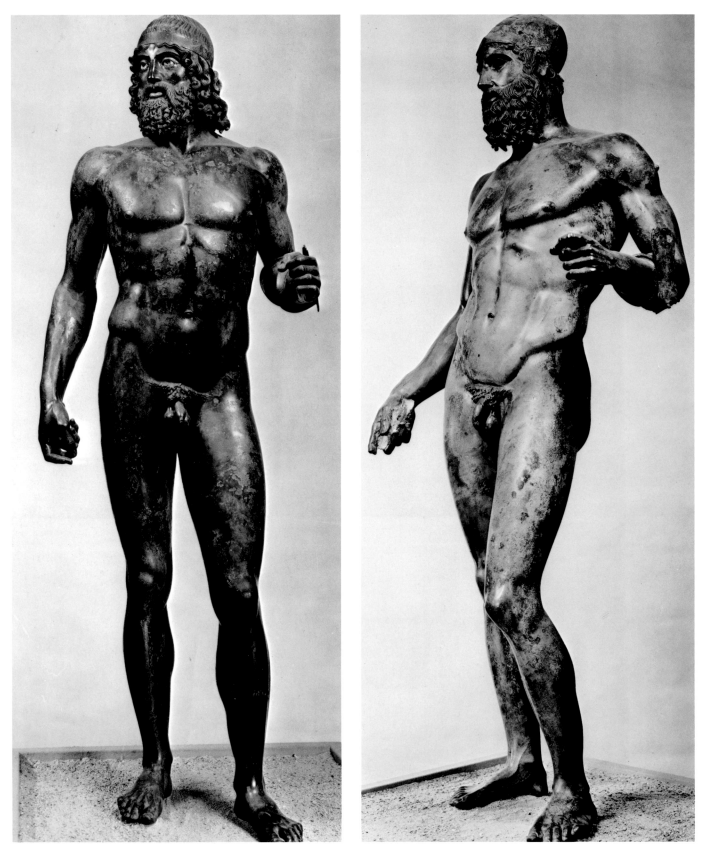

292–293 Warriors A and B from the sea off Riace Marina (Italy), ca. 460–
440. Bronze, ht. 1.98 m, 1.97 m. Reggio Calabria.

The Riace Bronzes
292–293

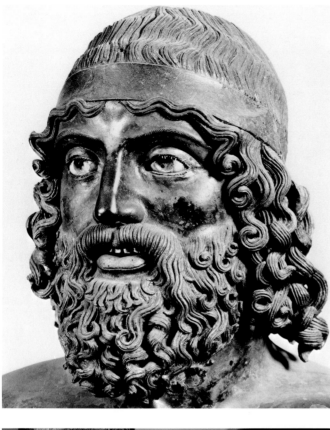

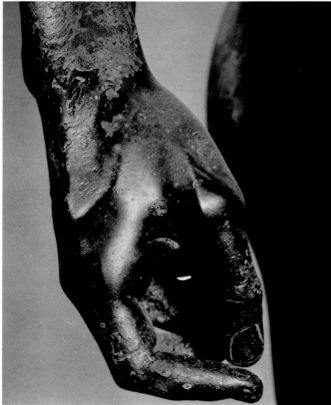

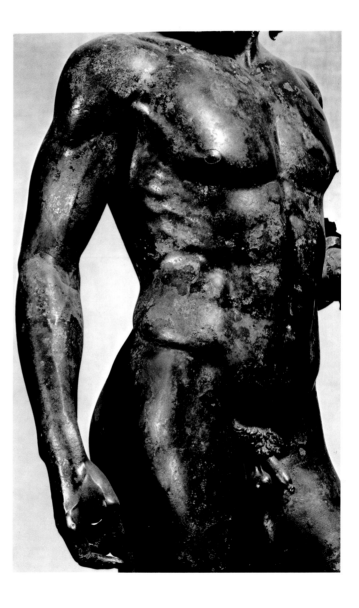

294–295 a and b Head, torso, and right hand of warrior A, fig. 292.

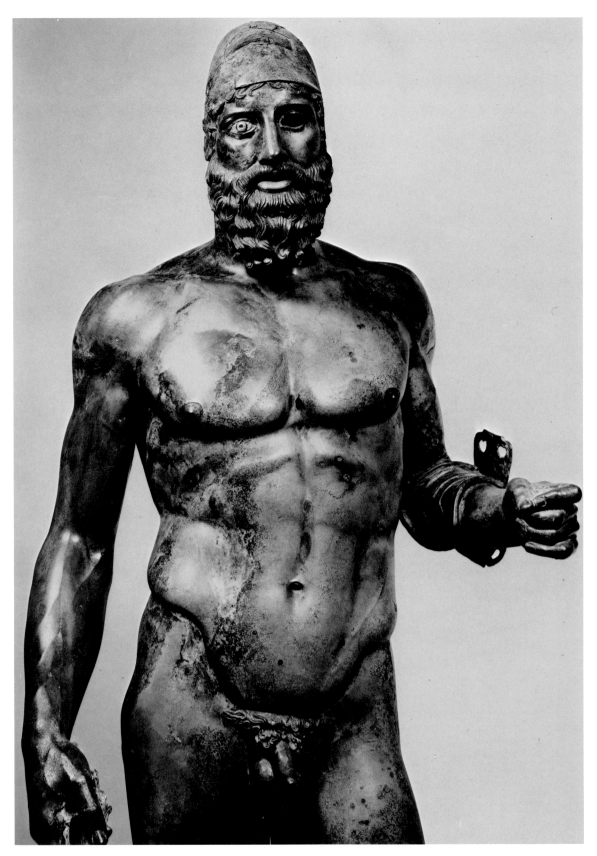

296 Head and torso of warrior B, fig. 293.

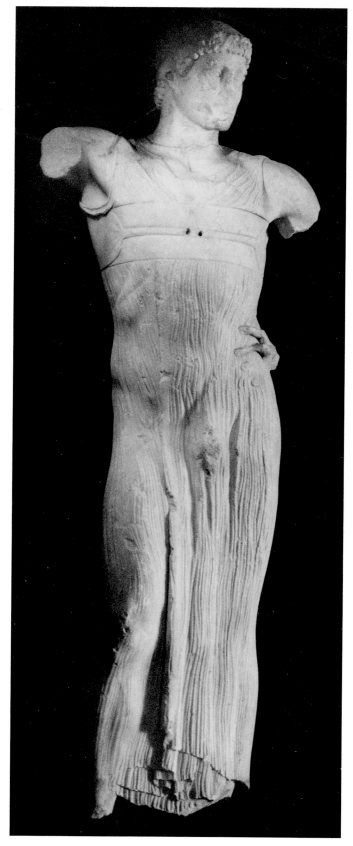

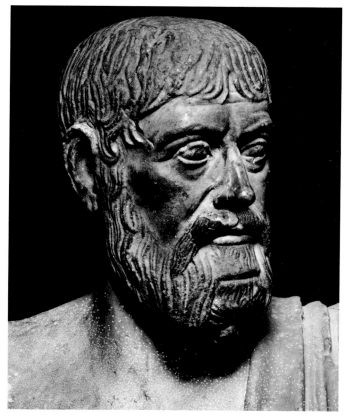

297–298 "Charioteer" from Motya (W. Sicily), ca. 470–450. Ht. 1.81 m. Marsala.

299 Herm of Pindar (Roman copy), original ca. 450. Ht. 54 cm. Formerly believed to be the Spartan general Pausanias, but identified as Pindar by an inscribed bust found at Aphrodisias in 1981.

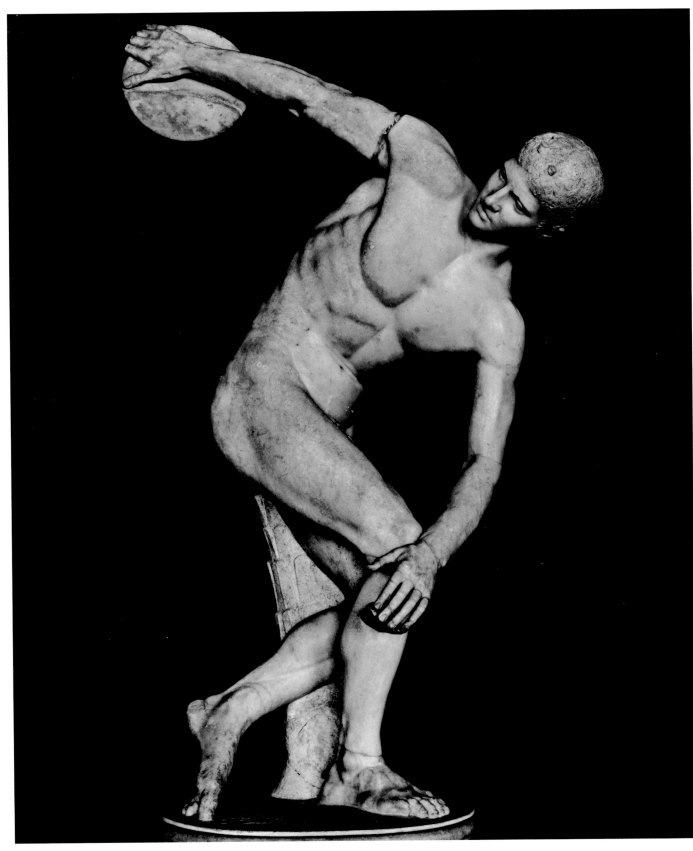

300 "Lancellotti" Diskobolos (Roman copy), original ca. 450. Ht. 1.55
m. Rome. Attributed to Myron.

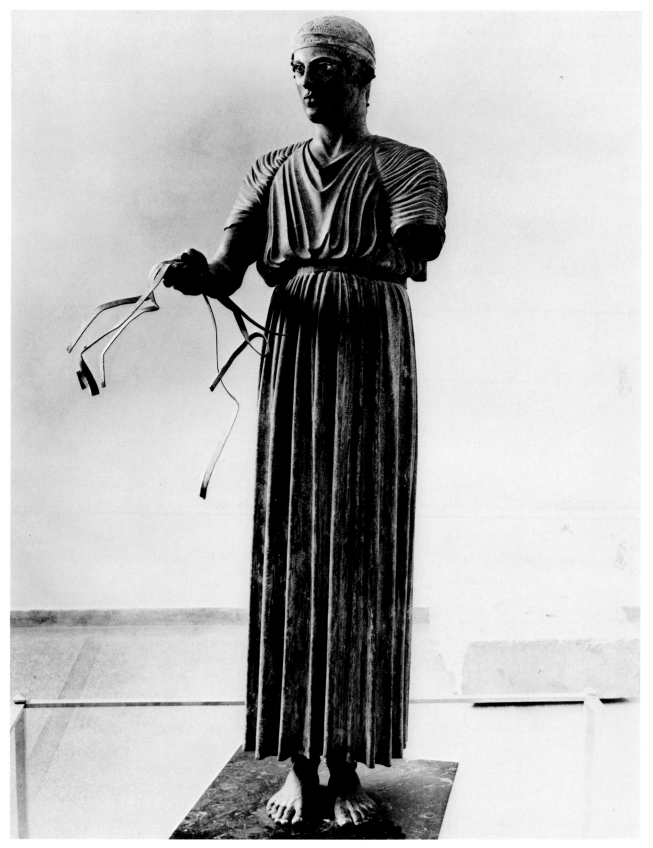

301 Charioteer from a chariot group dedicated by Polyzalos of Gela at
Delphi, for a victory either in 478 or in 474. Bronze, ht. 1.80 m.

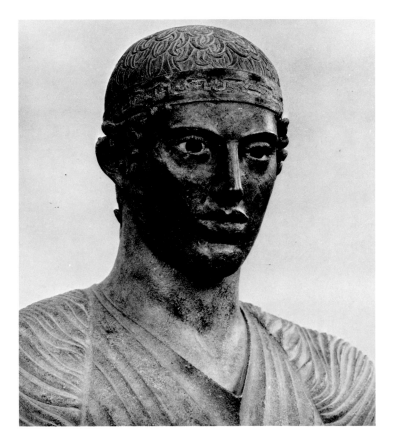

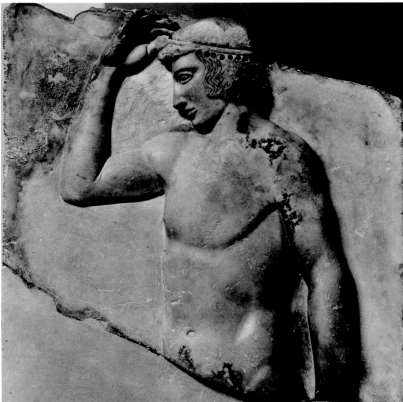

302 Head of the charioteer, fig. 301.

303 Stele of a youth crowning himself, from Sounion (Attica), ca. 470.
Ht. 48 cm. Athens. Found with the cache of kouroi, figs. 44–46, at
Sounion in 1915.

The Charioteer and Sounion Youth
302–303

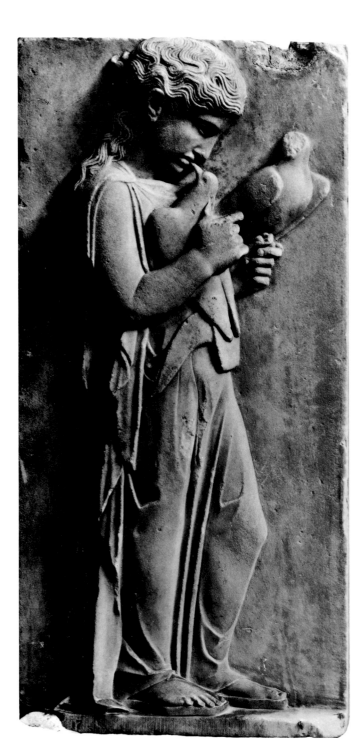

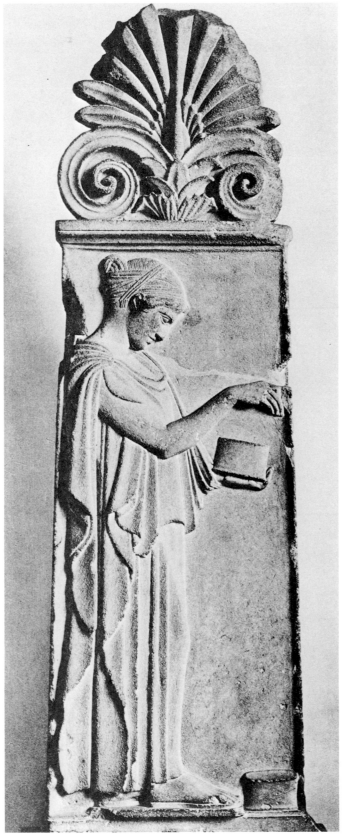

304 Grave stele of a young girl holding two doves, from Paros, ca. 460. Ht. 80 cm. New York.

305 Grave stele of a girl (the "Giustiniani stele"), perhaps from Paros, ca. 460–450. Ht. 1.43 m. Berlin. She lifts a necklace(?), originally rendered in paint, from a box.

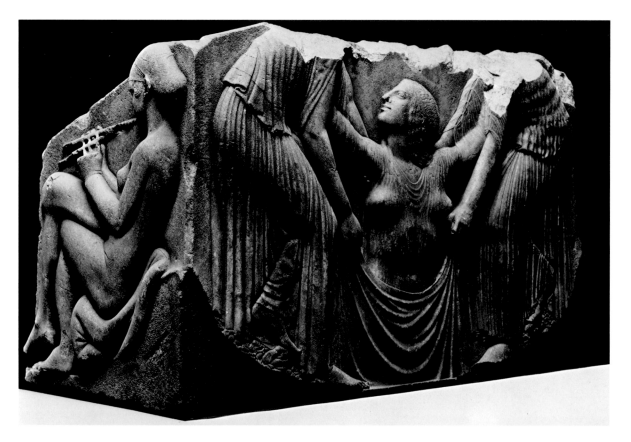

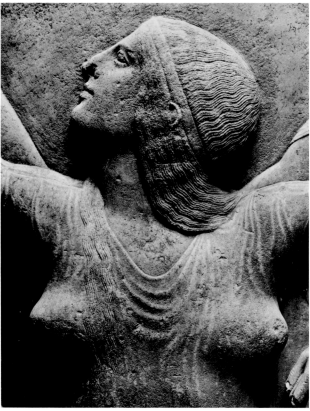

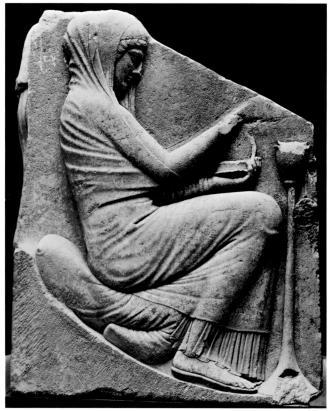

306–308 The "Ludovisi Throne," probably an altar, from Rome, ca. 460–
450. Two women help Aphrodite from the sea, flanked on the sides
by a flutegirl and an acolyte burning incense. Ht. 1.04 m.

The Ludovisi Throne
306–308

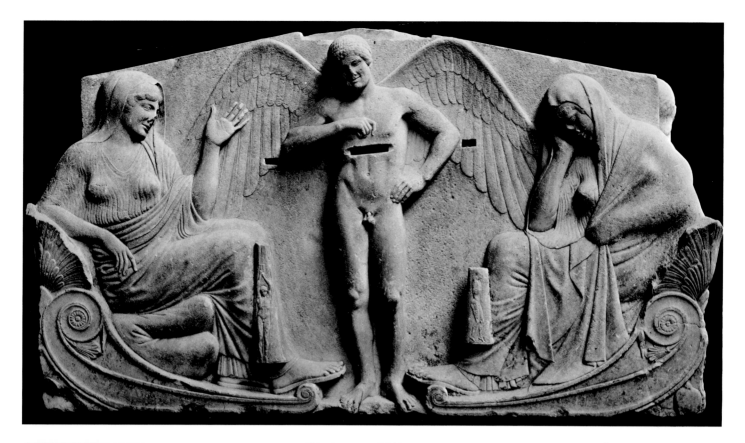

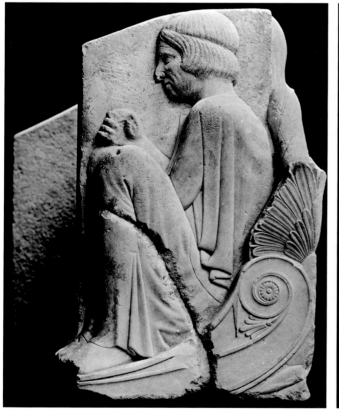

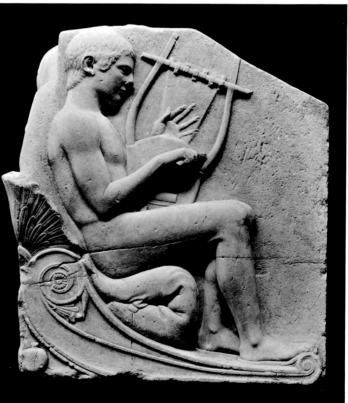

309–311 The "Boston Throne," acquired in Rome, purportedly a Greek
original of ca. 460–450. An Eros weighs souls in the presence of two
women (the left rejoicing, the right mourning), flanked on the sides
by an old woman spinning and a youth playing the lyre. Ht. 96 cm.
Boston. The reliefs were probably carved in the nineteenth century.

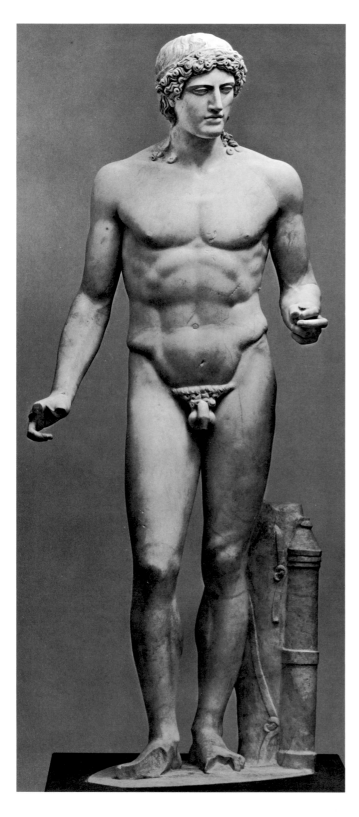

312 "Kassel" Apollo (Roman copy), original ca. 450. Ht. 1.97 m. Kassel.

313 Composite cast of a head in Bologna (fig. 314) and a torso in Dresden, both Roman copies, original ca. 450. Plaster, ht. 2.19 m. Rome, Museo delle Gessi. The association between the two parts and the identification as Pheidias's Athena Lemnia, made by Furtwängler in the nineteenth century, has recently been challenged (Hartswick 1983).

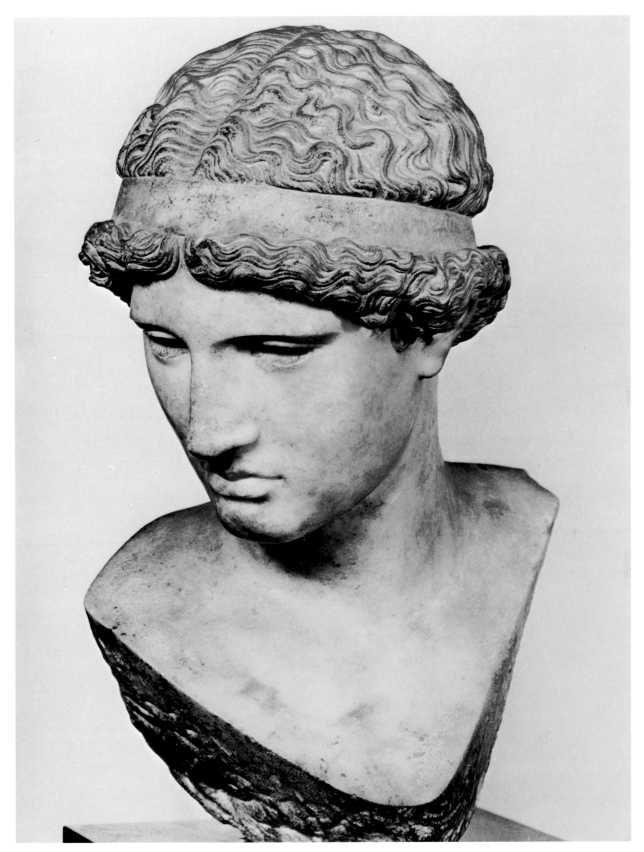

314 Head of the "Lemnian" Athena (Roman copy), original ca. 450. Ht.
ca. 60 cm. Bologna.

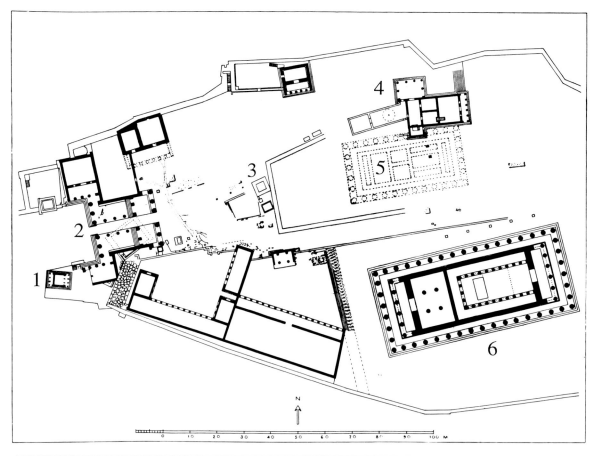

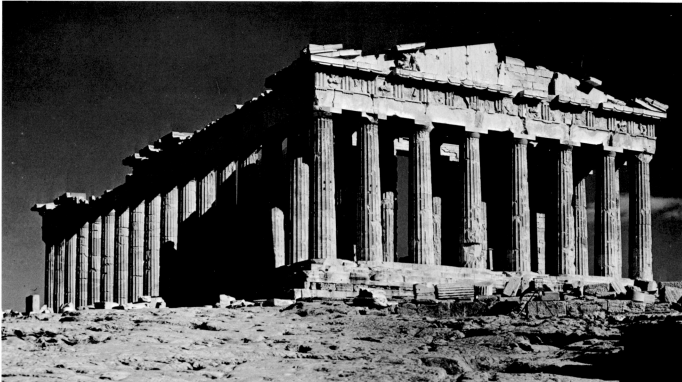

315 Plan of the Akropolis. Key: (1) Temple of Athena Nike; (2) Propylaia; 316 View of the Parthenon.
(3) Athena Promachos of Pheidias; (4) Erechtheion; (5) Old Temple
of Athena; (6) Parthenon.

The Parthenon
315–316

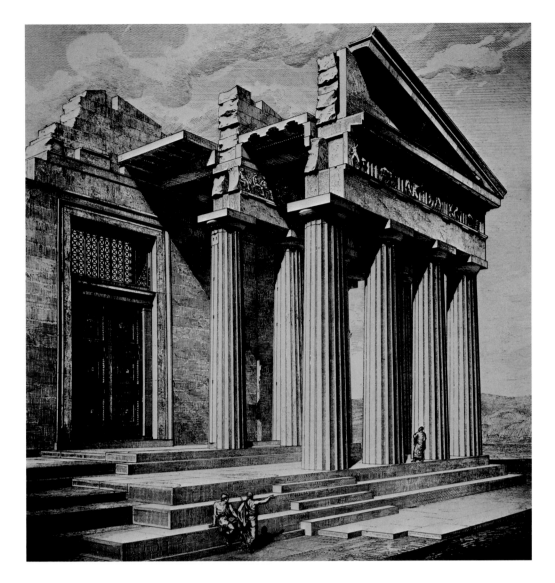

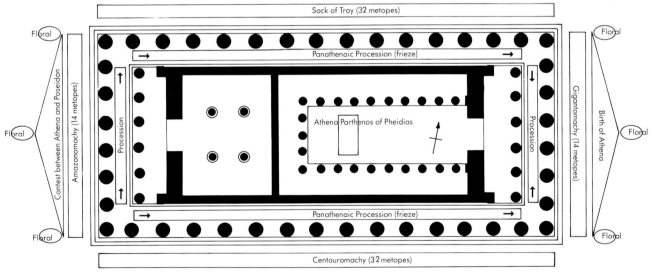

317 Cutaway of the Parthenon.

318 The sculptural program of the Parthenon.

The diagram labels in image 318 read:

Sack of Troy (32 metopes)

Floral

Floral

Floral

Contest between Athena and Poseidon

Amazonomachy (14 metopes)

Panathenaic Procession (frieze)

Procession

Athena Parthenos of Pheidias

Gigantomachy (14 metopes)

Birth of Athena

Floral

Floral

Floral

Procession

Panathenaic Procession (frieze)

Centauromachy (32 metopes)

The Sculptural Program of the Parthenon
317–318

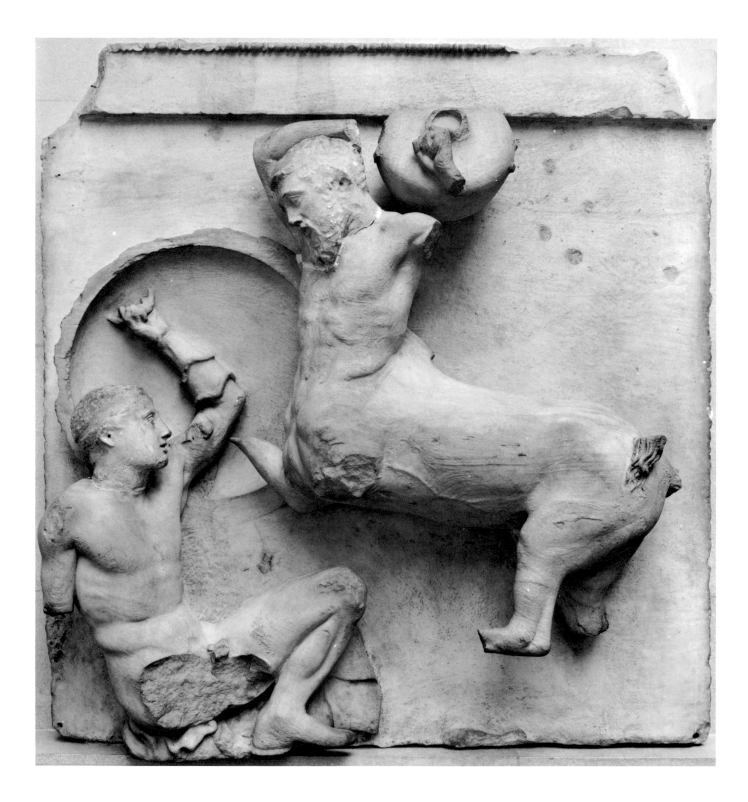

319 South metope 4, 447–442. Lapith and Centaur. Ht. 1.36 m. London.

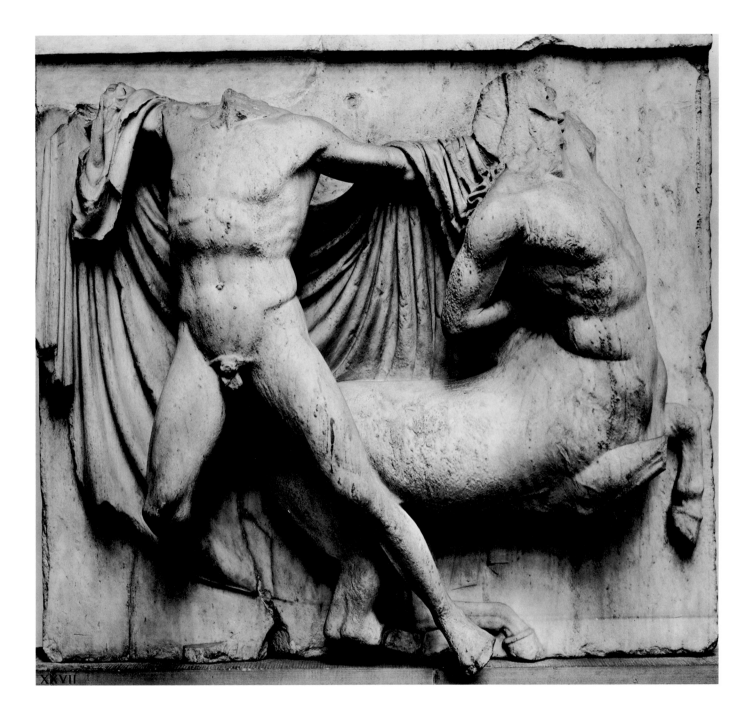

320 South metope 27, 447–442. Lapith and Centaur. Ht. 1.37 m. London.

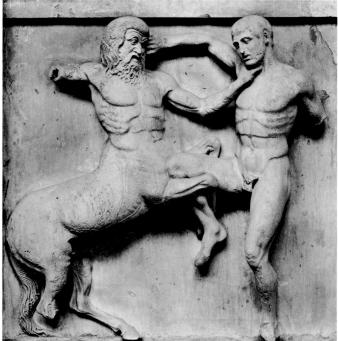

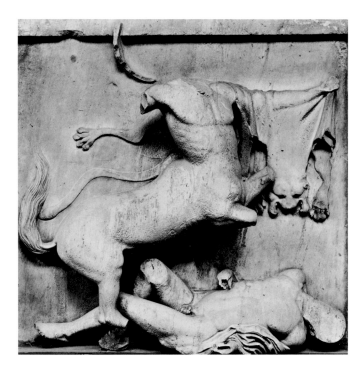

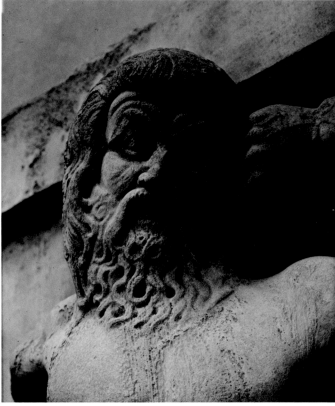

321 Torso of Lapith from metope 27, fig. 320.
322–323 South metopes 28, *bottom left,* and 31, *top right,* 447–442. Lapith and Centaur. Ht. 1.33 m. London.

324 Head of Centaur from metope 31, fig. 323.

Metopes of the Parthenon
321–324

325–326 South metopes 9–16 and 17–24. Drawings by Jacques Carrey, 1674. Paris.

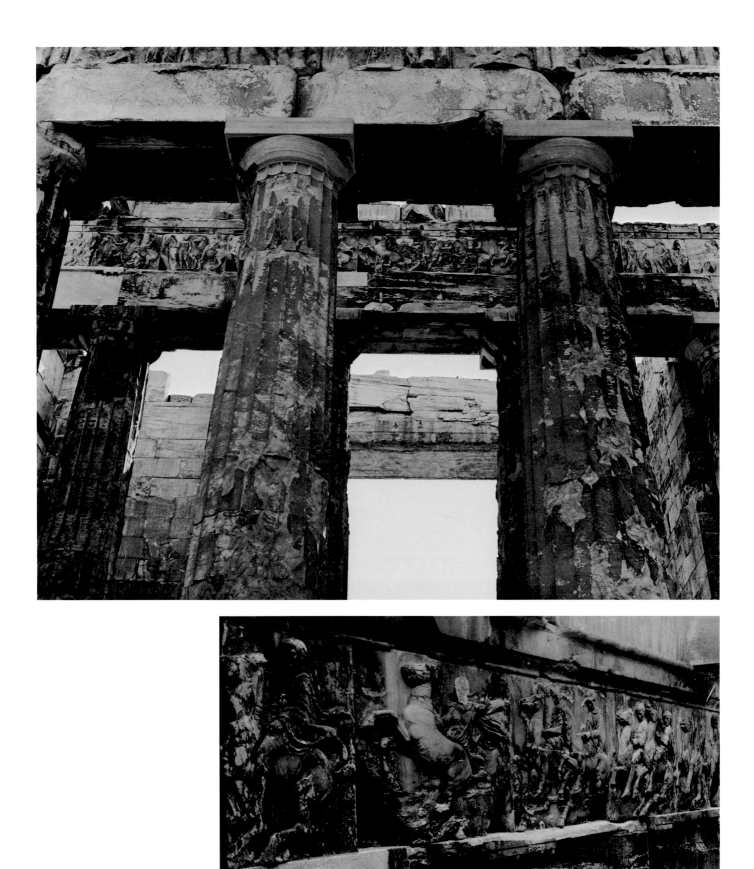

327–328 West frieze, 442–438. View from below and slabs vii–x in situ. Ht. of frieze, 1.06 m.

The Parthenon Frieze
327–328

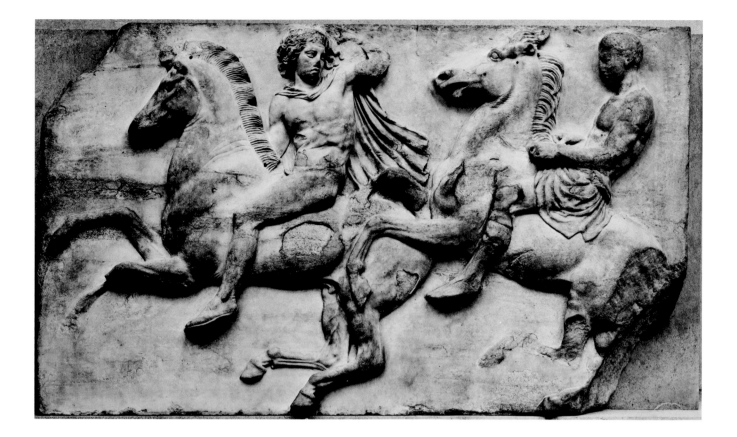

5

6

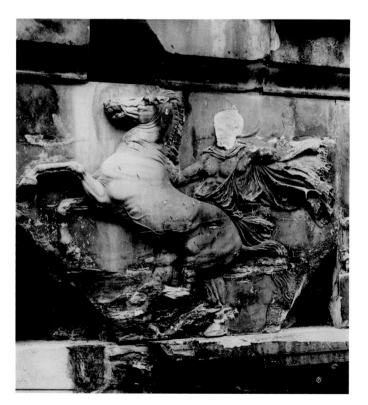

329 West frieze, 442–438. Two riders (ii.2, 3). Ht. 1.06 m. London.
330 West frieze: diagonal views.

331 West frieze, 442–438. Man restraining his horse (viii.15). Ht. 1.06 m.

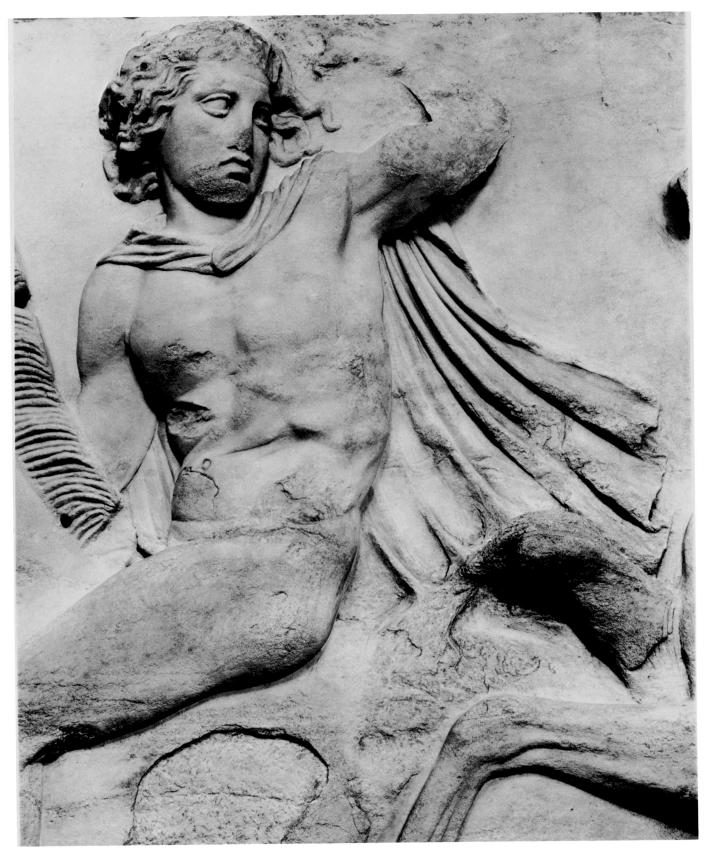

332 West frieze: detail of rider (ii.2), from fig. 329.

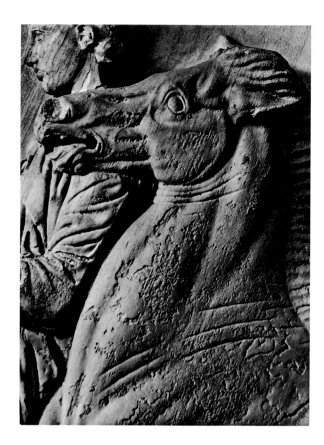

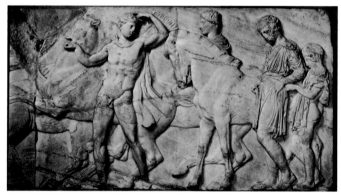

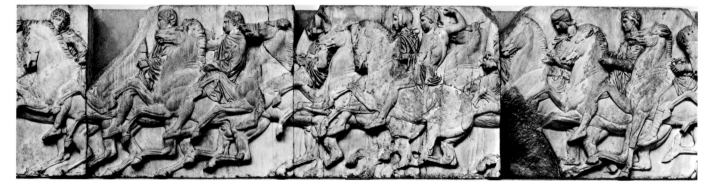

333–335 North frieze, 442–438. Riders preparing to mount (xlii.130–34), *top left*; detail of horse and rider (xxxix.122), *top right*; cavalcade (xxxvi–ix), *bottom*. Ht. 1.06 m. London.

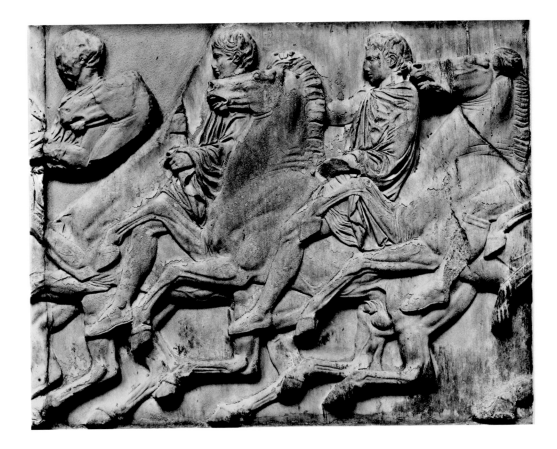

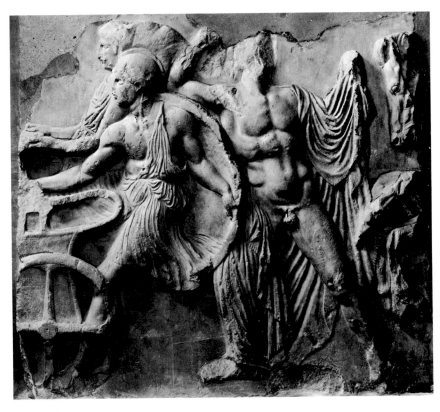

336–337 North frieze, 442–438. Detail of cavalcade, fig. 335 (xxxvii. 113–16); apobatai (xvii. 56–58). Ht. 1.06 m. London and Athens.

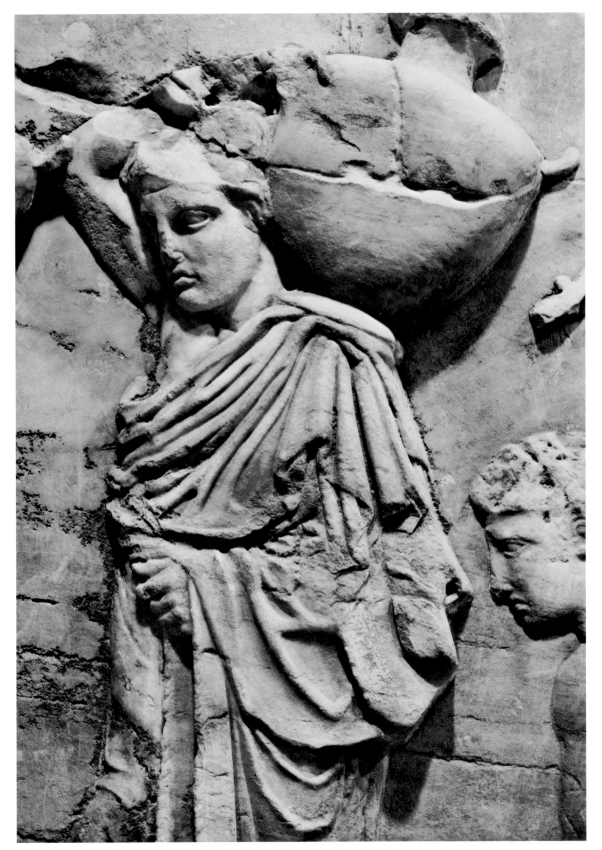

338 North frieze, 442–438. Detail of hydriaphoroi (vi.16–19). Ht. 1.06
m. London.

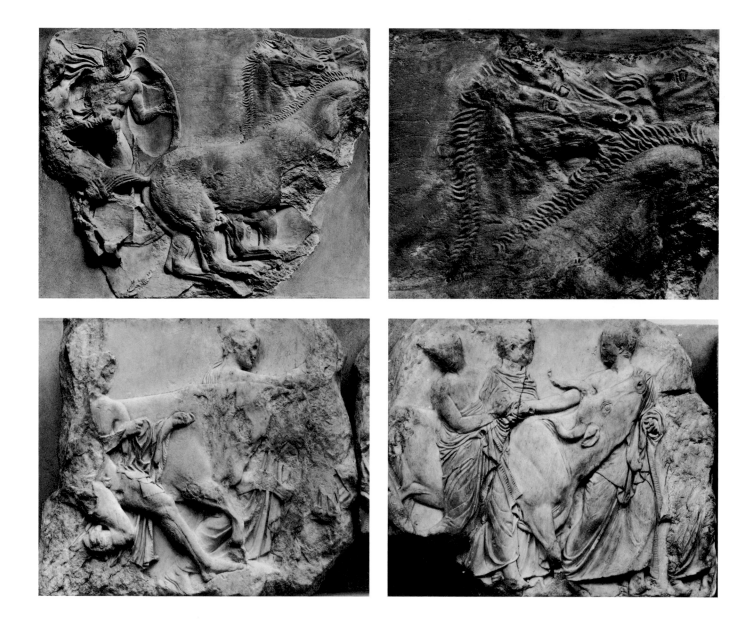

339–341 South frieze, 442–438. Chariot (xxx.73–74) with detail of horses, *top, left and right*; youths restraining a cow, and two youths leading a cow (xxxix–xl.109–18). Ht. 1.06 m. London.

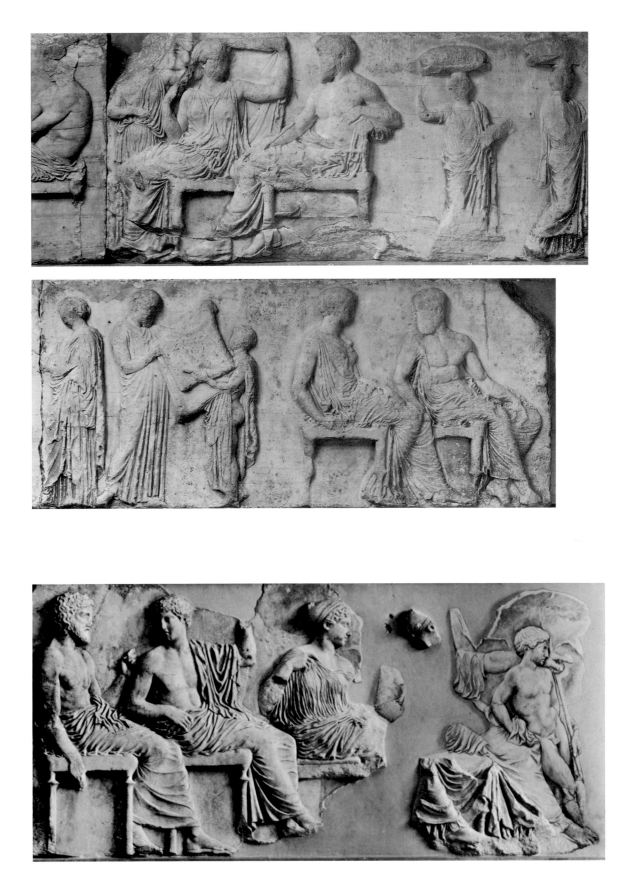

342 East frieze, central slab, 442–438. *Top*: Ares, Nike (or Iris), Hera, Zeus; two acolytes with stools. *Center*: the priestess of Athena receives the two acolytes with stools, while the Archon Basileus takes the peplos from another acolyte; Athena, Hephaistos (v.28–37). Ht. 1.06 m. London.

343 East frieze, *bottom*, 442–438: Poseidon, Apollo, Artemis, Aphrodite, and Eros (vi.38–42). Ht. 1.06 m. London.

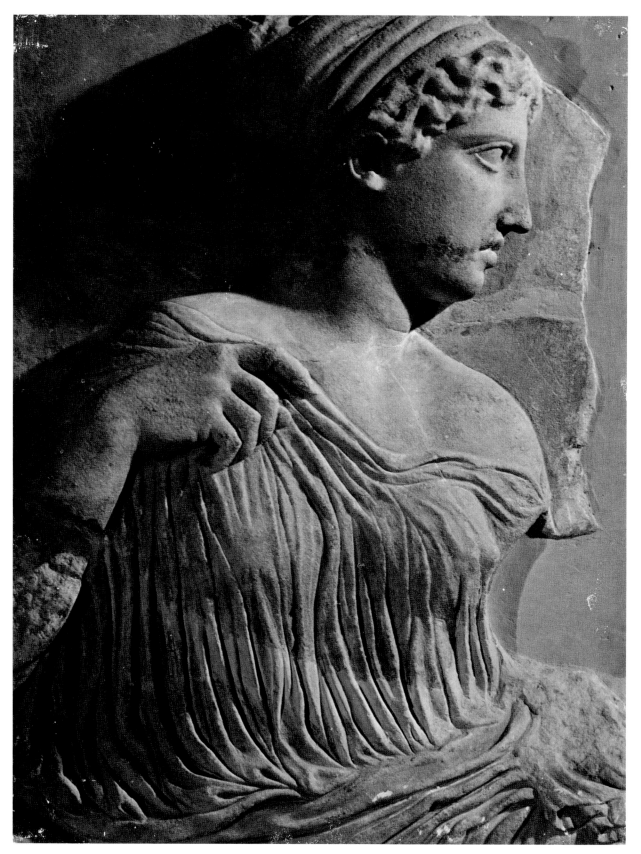

344 East frieze: detail of Artemis, fig. 343 (vi.40).

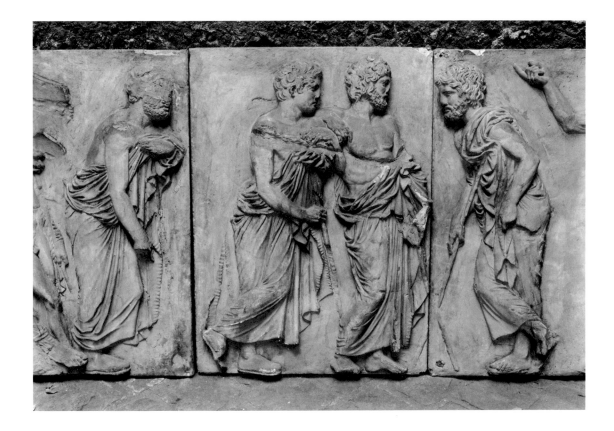

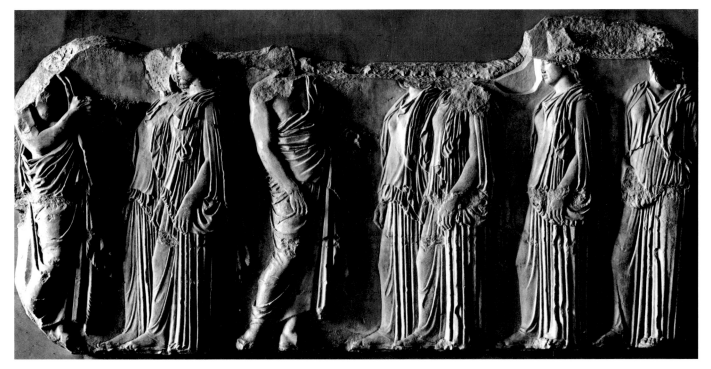

345–346 East frieze, 442–438. "Eponymous heroes" (vi.42–48); girls
(vii.49–56). Ht. 1.06 m. Fig. 345 is a plaster cast in Paris of the
severely damaged original in London; fig. 346 is in Paris.

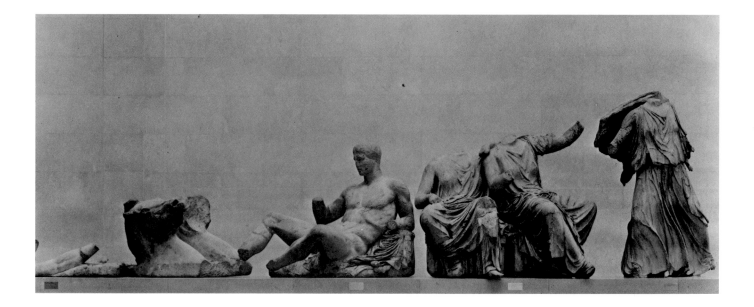

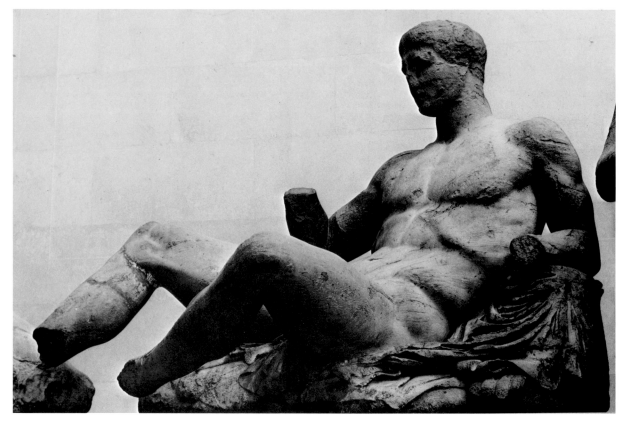

347–348 East pediment, 438–432. The birth of Athena: Helios (A-C),
Dionysos (D), Kore (E), Demeter (F), Artemis (G); detail of Dionysos
(D). Ht. of G, 1.73 m; of D, 1.21 m. London.

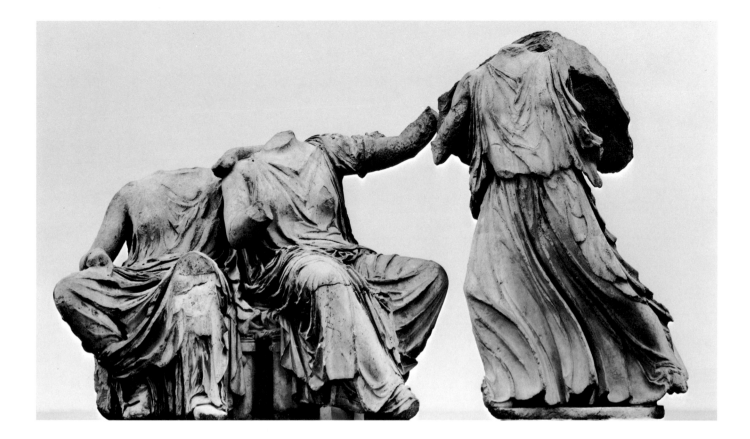

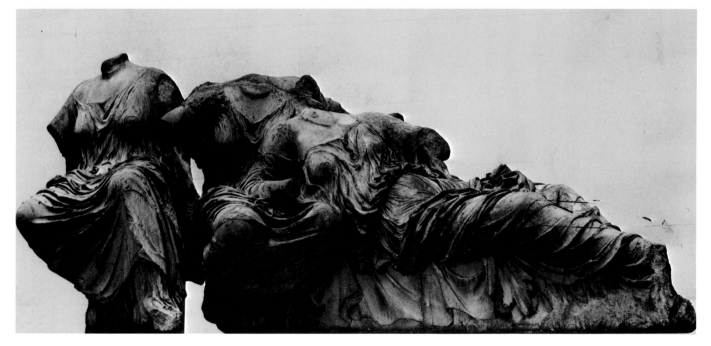

349–350 East pediment, 438–432. Kore (E), Demeter (F), Artemis (G);
 Hestia (K), Dione (or Themis) (L), and Aphrodite (M). Ht. of G,
 1.73 m; of K, 1.30 m. London.

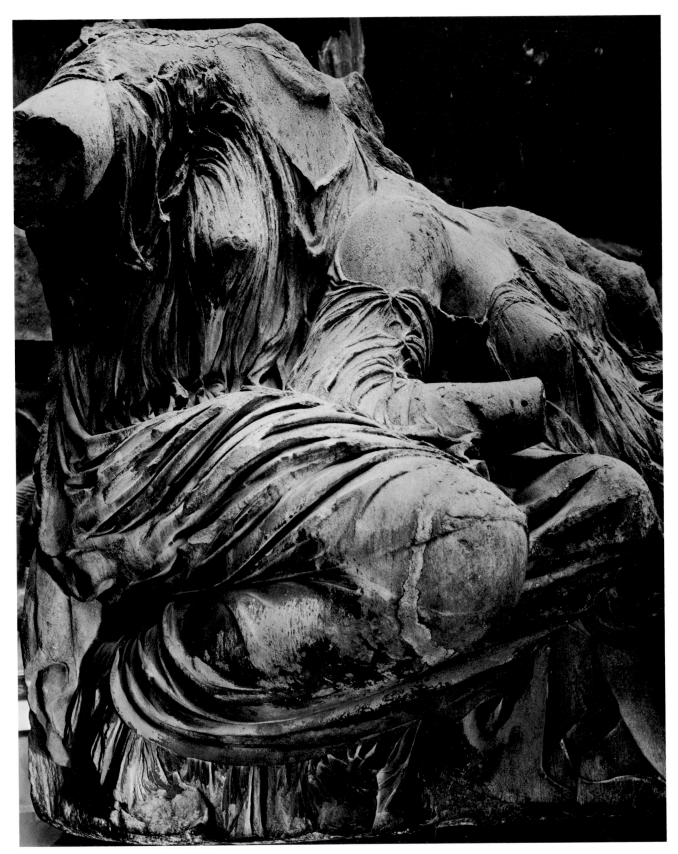

351 East pediment: detail of Dione/Themis (L) and Aphrodite (M), fig. 350.

The Pediments of the Parthenon
351

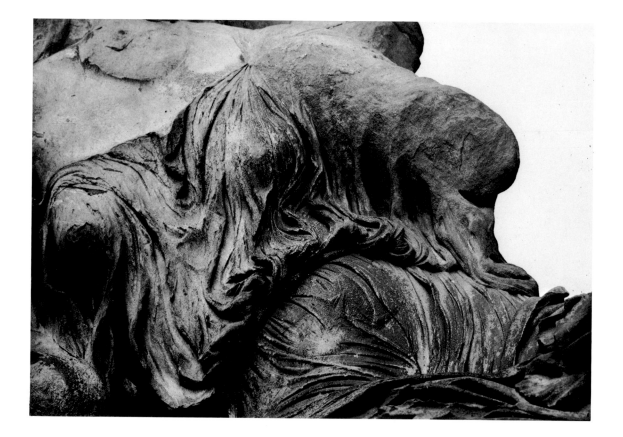

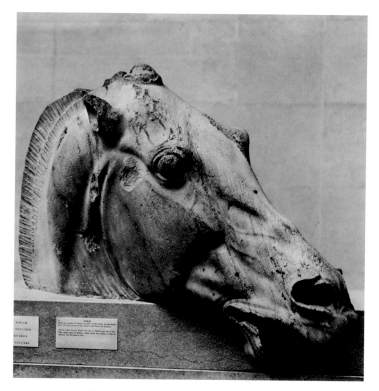

352 East pediment: detail of Aphrodite (M), fig. 350.

353 East pediment, 438–432. Horse from Selene's chariot (O). L. 82 cm. London.

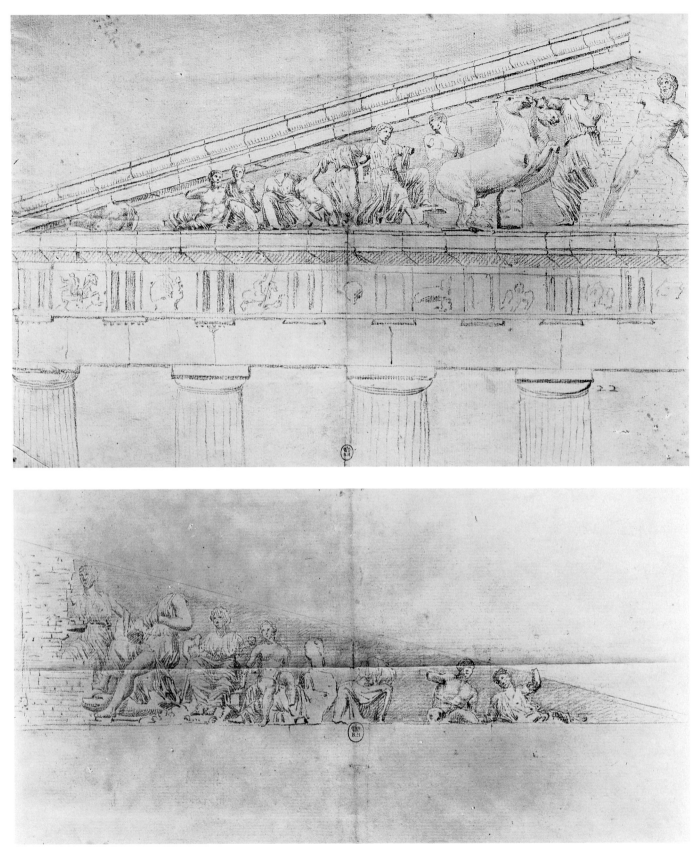

354–355 West pediment: The contest between Athena and Poseidon.
Drawings by Jacques Carrey, 1674. Paris.

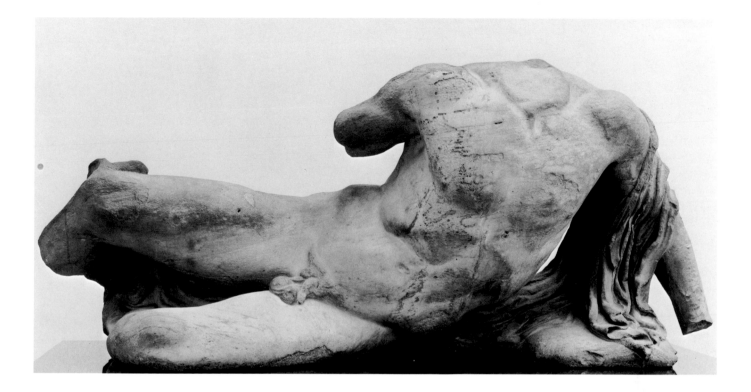

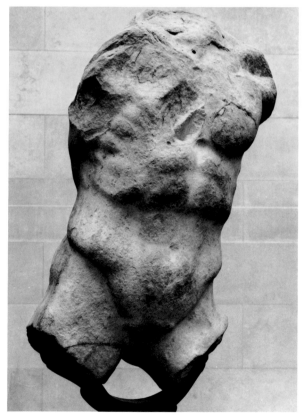

356–358 West pediment, 438–432. Reclining hero or divinity, perhaps the river Ilissos (A), *top*; Hermes (H), *bottom*. L. of A, 1.56 m; ht. of H, 1.15 m. London.

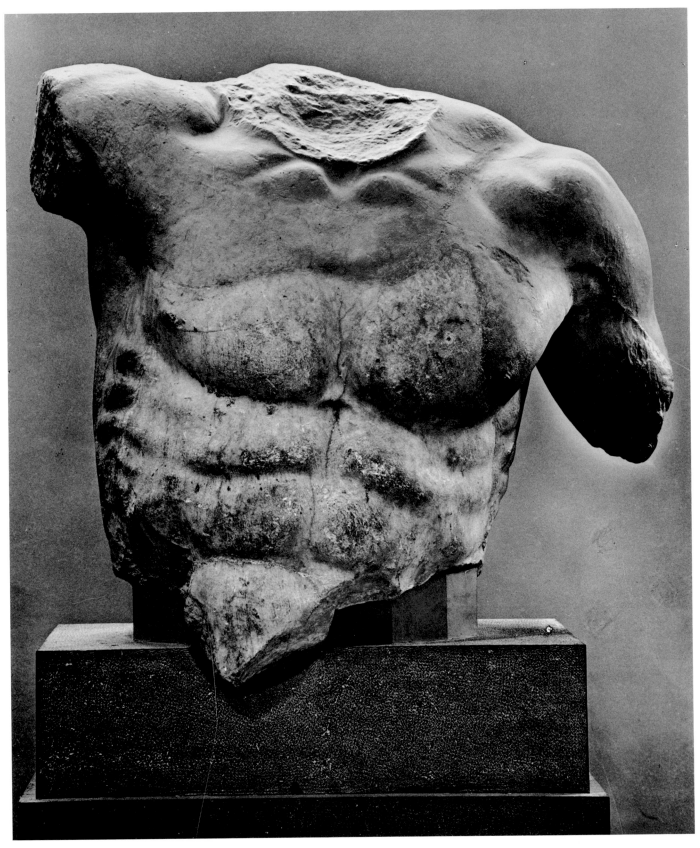

359 West pediment, 438–432. Poseidon (M). Ht. 83 cm. Athens. The
upper part is completed with a cast of the fragment in London.

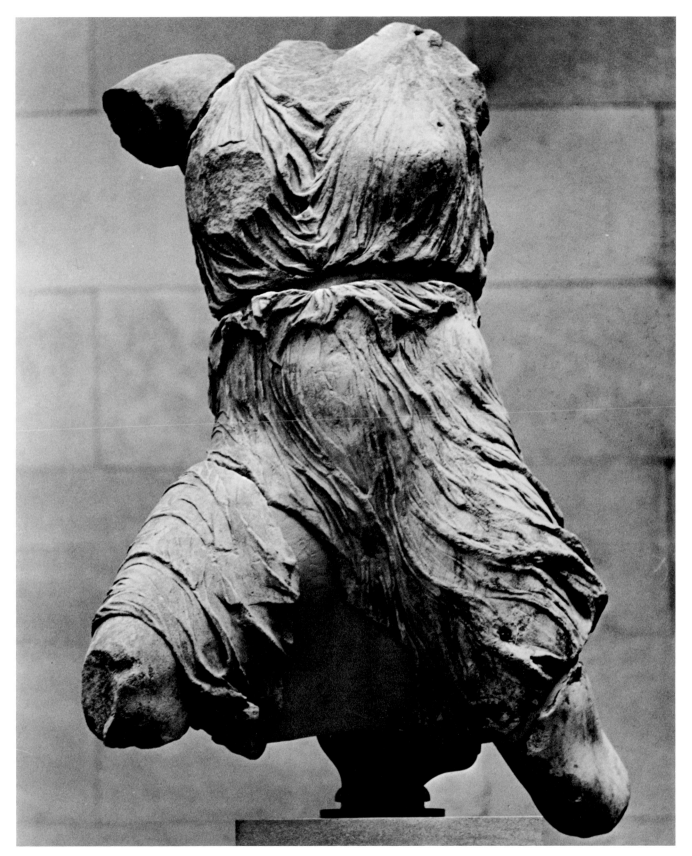

360 West pediment, 438–432. Iris (N). Ht. 1.35 m. London.

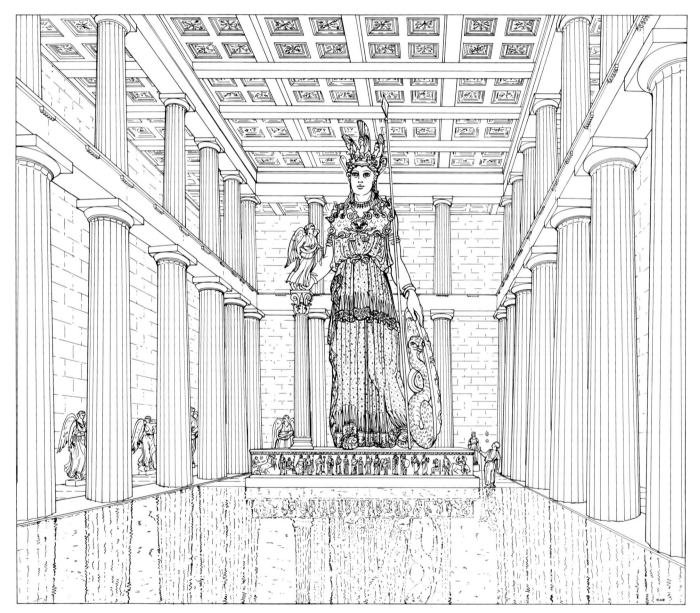

361 Reconstruction of the Parthenon's interior with statue of Athena Par-
 thenos.

The Athena Parthenos
361

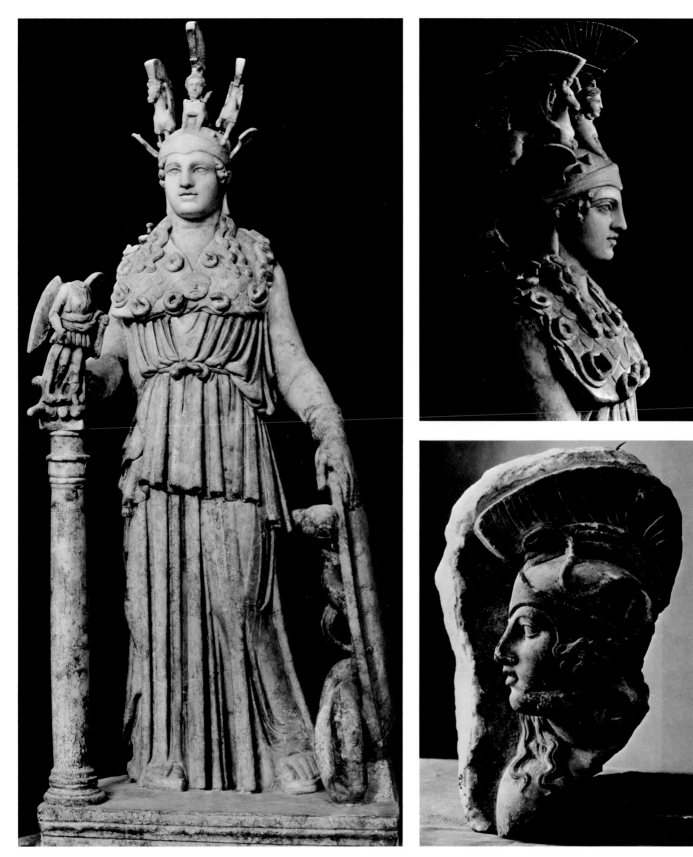

362–363 Small-scale replica of Athena Parthenos (the "Varvakeion Athena"; Roman copy), original 447–438. Ht. 1.045 m. Athens.

364 Neo-Attic relief excerpted from the shield of Athena Parthenos (Roman copy), from Piraeus harbor, original 447–438. Fighting Amazon. Ht. of fragment, 19 cm.

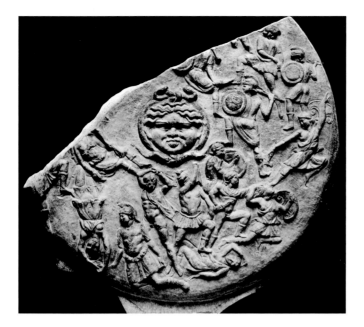

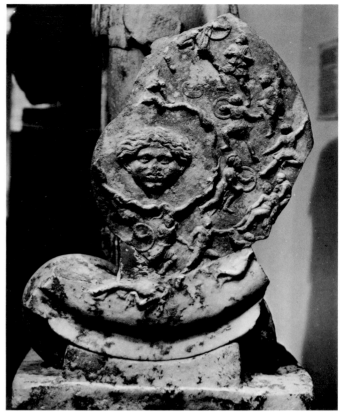

365–366 Shield of Athena Parthenos (the "Strangford Shield"; Roman copy), from Athens, original 447–438. Amazonomachy. D. 50 cm. London. The detail shows the supposed portraits of Pheidias and Perikles.

367 Shield of Athena Parthenos (Roman copy), from Patras, original 447–438. Amazonomachy. D. 45 cm.

368 Attic red-figure calyx-krater from Ruvo, ca. 400. Gigantomachy. Original ht. ca. 31 cm. Naples.

The Athena Parthenos
365–368

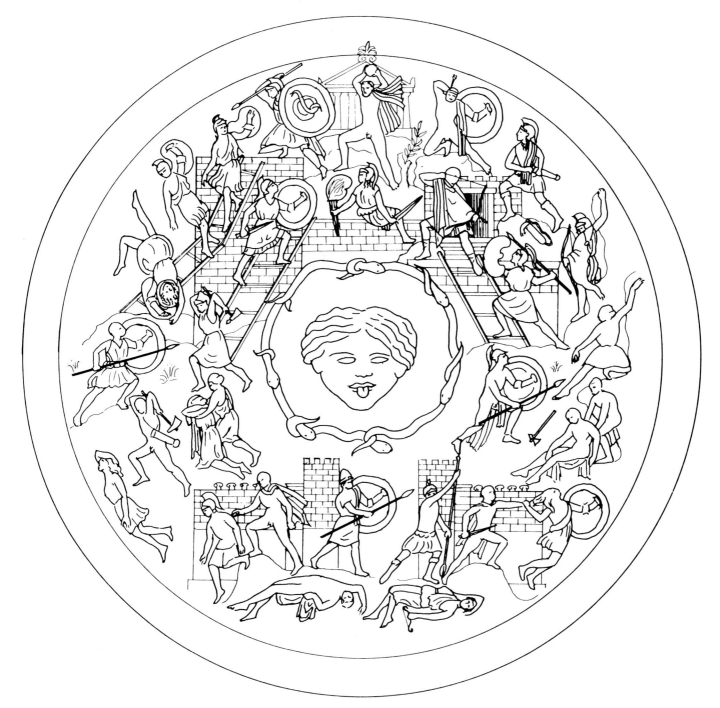

369 Reconstruction of the shield of the Athena Parthenos by Evelyn Harrison.

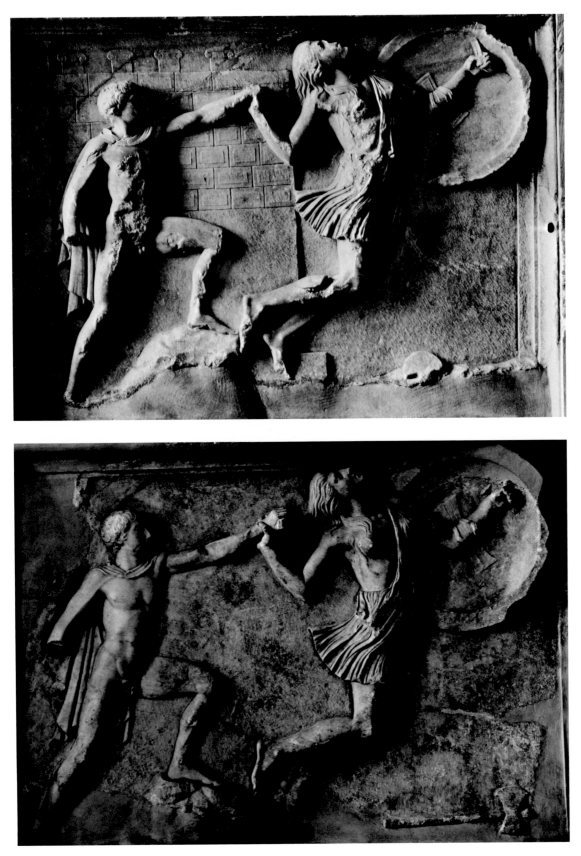

370–371 Neo-Attic reliefs excerpted from the shield of Athena Parthenos
(Roman copy), from Piraeus harbor, original 447–438. Greeks and
Amazons. Piraeus Museum. Ht. 90 cm. One has an architectural
background.

The Athena Parthenos
370–371

372 Hadrianic sestertii of Elis, AD 133. Zeus. Silver, d. 3 cm. Berlin and Florence.

373–374 Attic red-figured bell-krater from Baksy (South Russia), ca. 400. Above, Zeus on his throne (which is embellished with a Niobid frieze), flanked by Hera and Athena; below, two riders. Original ht. ca. 74 cm. Leningrad. The Zeus quotes the Zeus at Olympia, the arrangement of the Hera, Zeus, and Athena duplicates that of the east pediment of the Parthenon, and the two riders echo the pair from the west frieze of the Parthenon, fig. 329.

The Zeus at Olympia
372–374

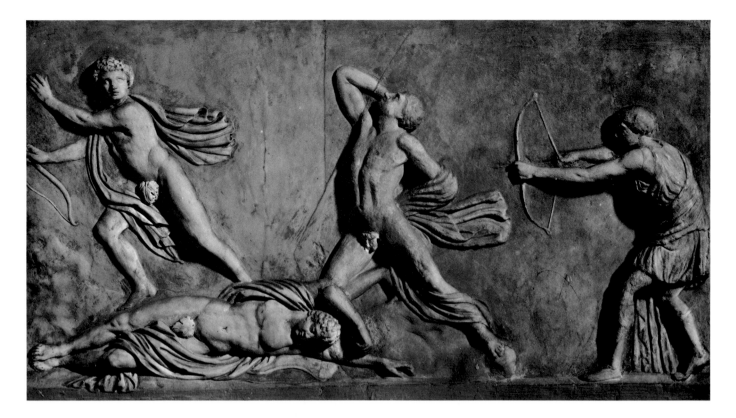

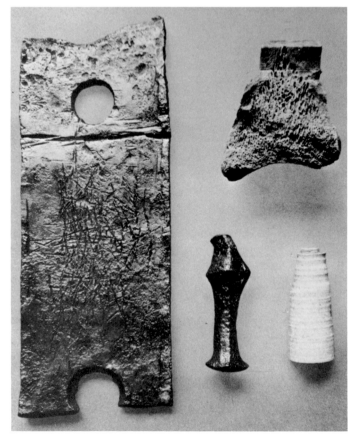

375 Frieze of Niobids (Roman copy), original ca. 430–420. Ht. 53 cm. Rome, Villa Albani. The left half of the relief and parts of the limbs of the figures to the right are restored.

376–377 Terracotta mold for drapery and bronze tools, from the workshop of Pheidias at Olympia, ca 430–420. Ht. of the mold, 32 cm.

The Zeus at Olympia and Pheidias's Workshop
375–377

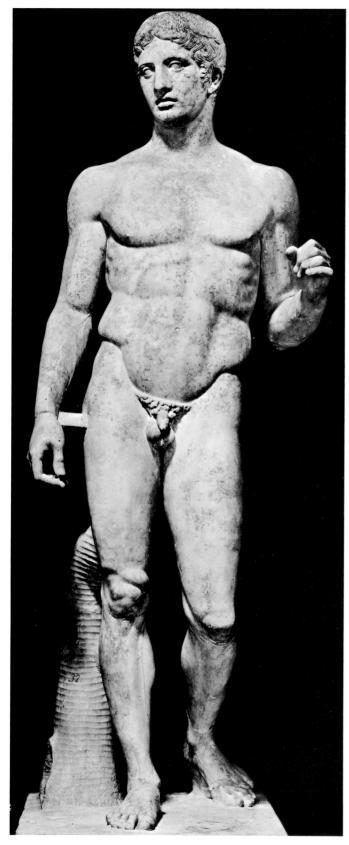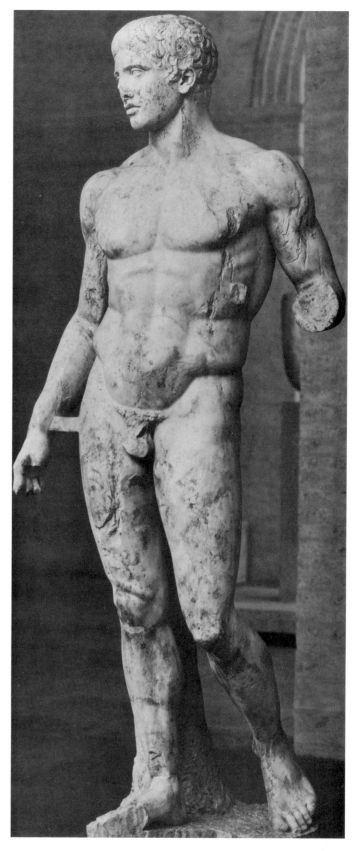

378–379 Doryphoros (Roman copies), from Pompeii and the sea off Italy, original ca. 440. Ht. 2.12 m, 1.98 m. Naples and Minneapolis.

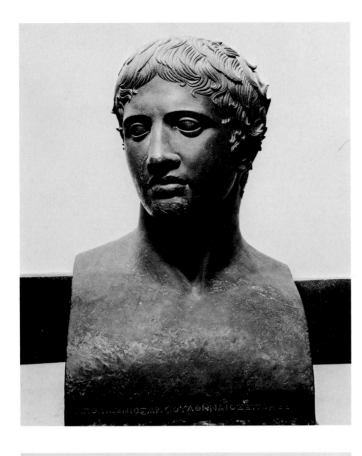

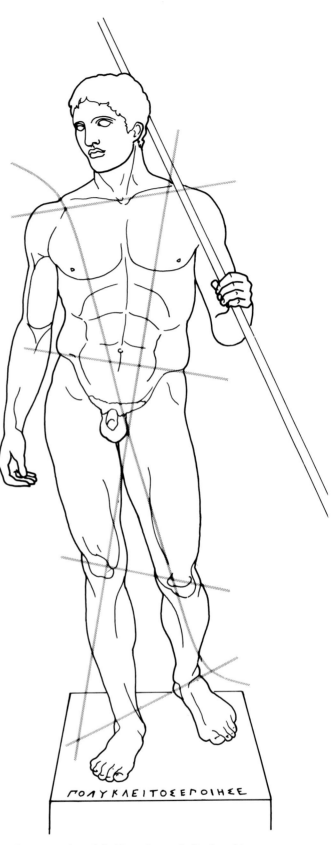

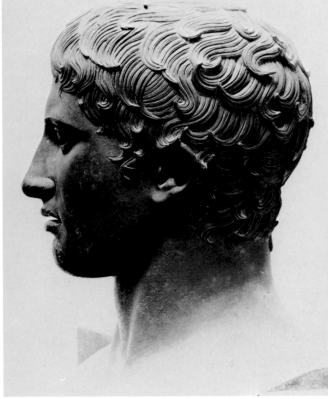

380–381 Herm of Doryphoros (Roman copy) signed by Apollonios son of Archias of Athens, from the Villa dei Papiri at Herculaneum, original ca. 440. Bronze, ht. 54 cm. Naples.

382 Reconstruction of the Doryphoros, indicating chiasmus.

Polykleitos of Argos
380–382

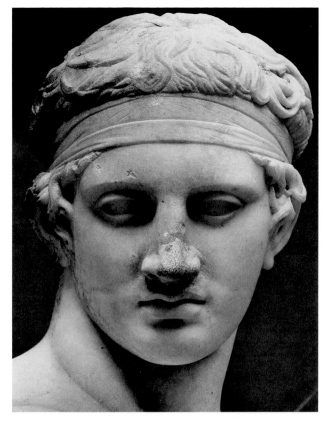

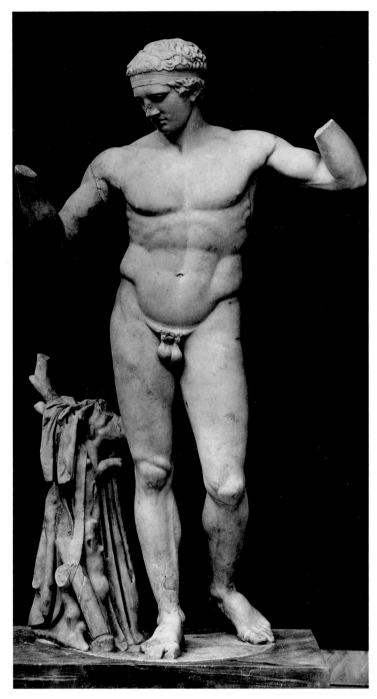

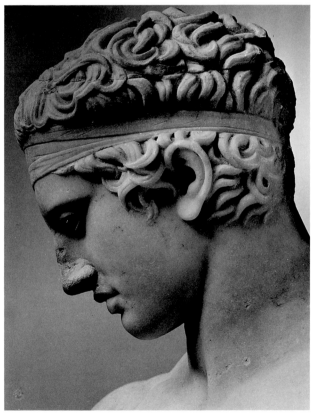

383–385 Diadoumenos (Roman copy), from Delos, original ca. 430. Ht.
1.86 m. Athens.

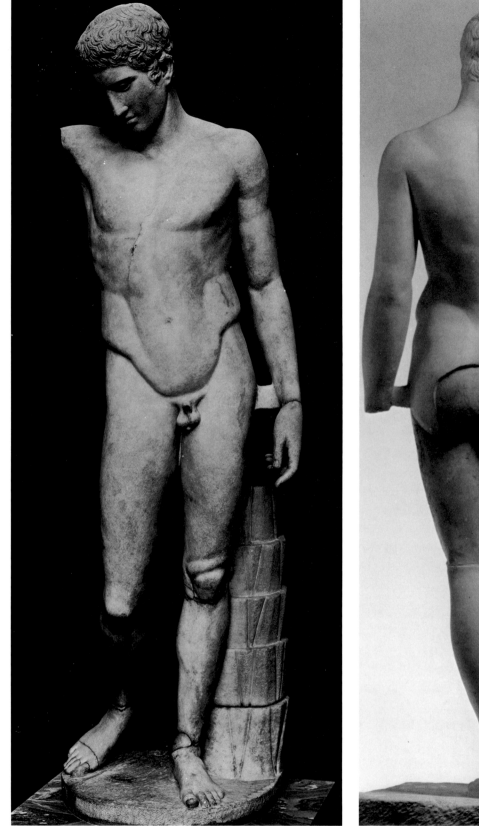

386 Athlete crowning himself (the "Westmacott boy"; Roman copy), original ca. 450–420. Ht. 1.49 m. London.

387 Cast of another Roman copy of the "Westmacott boy" with buttocks and thighs of the ancient cast from Baiae inserted; original ca. 450–430. Plaster, ht. 1.20 m. The Roman copy is in Castelgandolfo, the ancient cast in Baiae, the modern composite one in Basel.

The Westmacott Boy
386–387

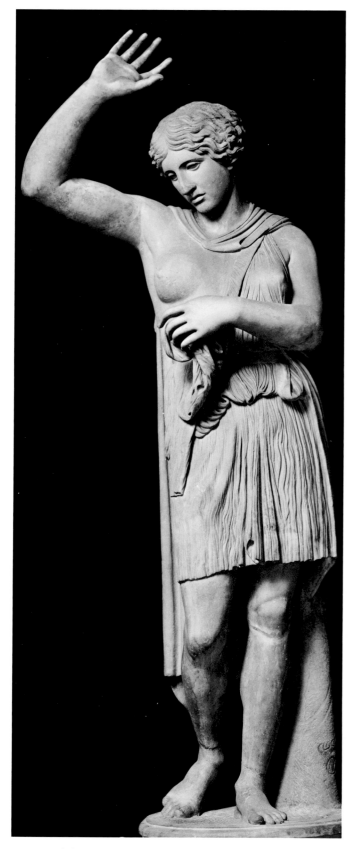

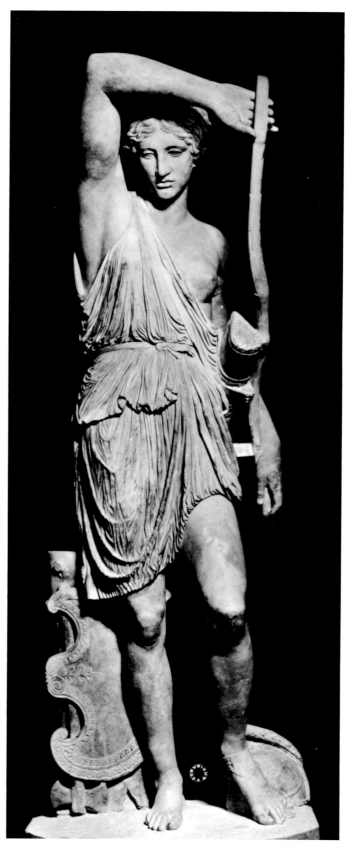

388 Wounded Amazon ("Sosikles Amazon"; Roman copy), original ca. 430. Ht. 2.02 m. Rome. Inscribed "Sosikles" on the support. The nose, right arm, lower left arm and hand, drapery curling away from the wound, and some drapery folds are restored.

389 Wounded Amazon ("Mattei" type; Roman copy), original ca. 430. Ht. 1.97 m. Rome. The head, from a replica of the "Sosikles" type, is alien; the right arm, upper left arm, bow, right foot, lower left thigh and knee, and plinth are restored.

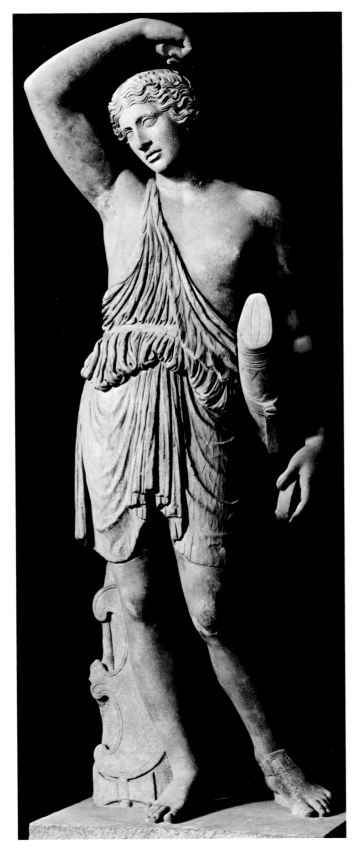

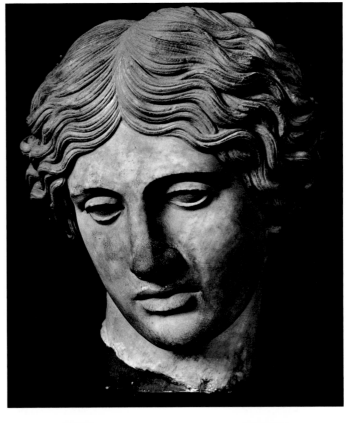

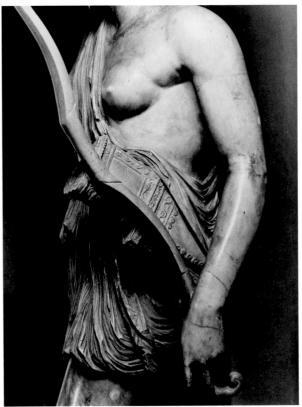

390 Wounded Amazon ("Sciarra" type; Roman copy), original ca. 430. Ht. 1.98 m. Rome. The nose, parts of the lips and neck, both arms, right leg, lower left leg, quiver, tree-trunk, and plinth are restored.

391 Head of "Sosikles Amazon" type (Roman copy), original ca. 430. Ht. 31 cm. Rome. The tip of the nose is restored.
392 Quiver of the "Mattei" Amazon, fig. 389.

The Amazons
390–392

393 Cast of the girdle and adjacent area of the chiton of the "Mattei" Amazon, from Baiae (Italy), original ca. 430. Plaster, ht. 16 cm.
394 Detail of the girdle area of the "Mattei" Amazon, fig. 389.

395 Cast of the right foot of the "Mattei" Amazon, from Baiae (Italy), original ca. 430. Plaster, l. 11 cm.
396 Detail of the right foot of a copy of the "Mattei" Amazon. Rome.

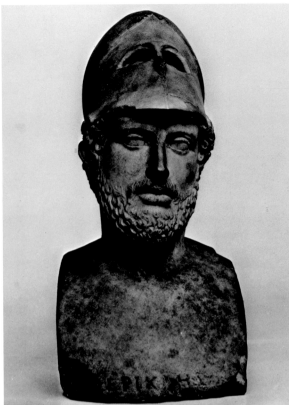

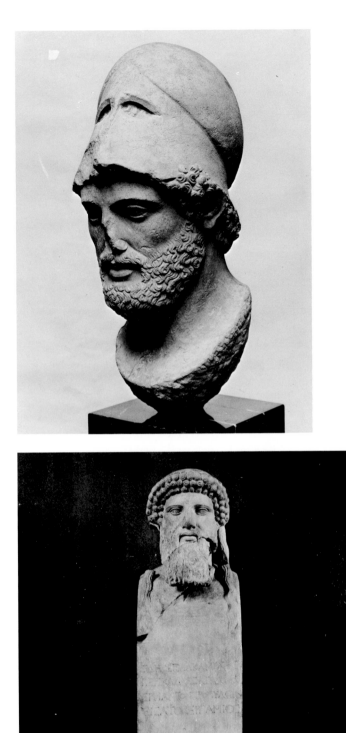

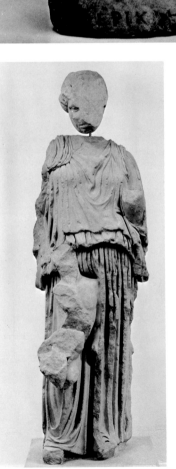

397 Perikles (Roman copy), original ca. 425. Ht. 48 cm. London. In-
scribed "Perikles." The nose is restored.
399 Prokne and Itys dedicated by Alkamenes, from the Akropolis, ca.
430–420. Ht. 1.63 m.

398 Perikles (Roman copy), original ca. 425. Ht. 54 cm. Berlin.
400 Hermes Propylaios by Alkamenes (Roman copy), from Pergamon:
original ca. 430–420. Ht. 1.19 m. For the inscription, see T 73a.

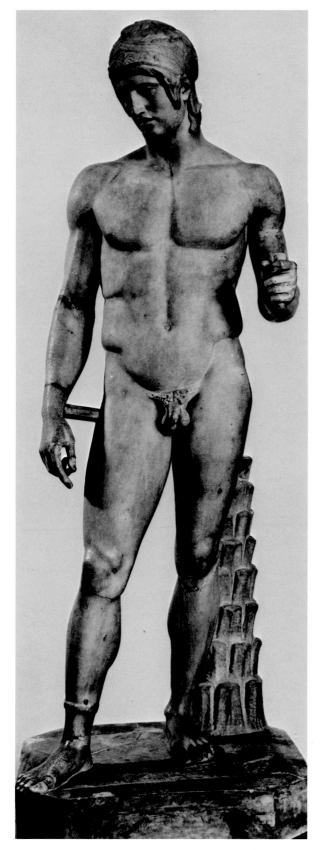

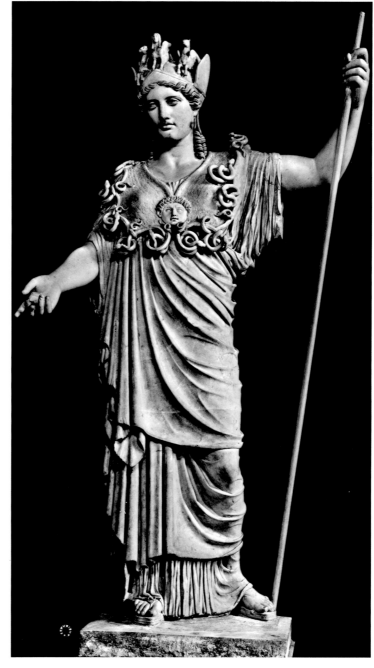

401 "Borghese Ares" (Roman copy), original ca. 420–400. Ht. 2.11 m. Paris.

402 "Farnese Athena" (Roman copy), original ca. 420–400. Ht. 2.24 m. Naples. The arms and the animals on the helmet are restored.

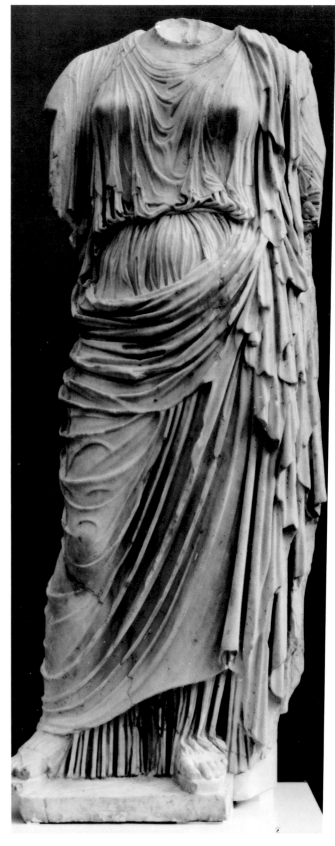

403 Reconstruction by G. I. Despinis of the Nemesis of Rhamnous by
Agorakritos of Paros, ca. 430–420. Ht. 4.5 m, with base, 5.4 m.

404 Nemesis of Rhamnous (Roman copy, reduced in size), original ca.
430–420. Ht. 1.85 m. Copenhagen.

The Nemesis of Agorakritos
403–404

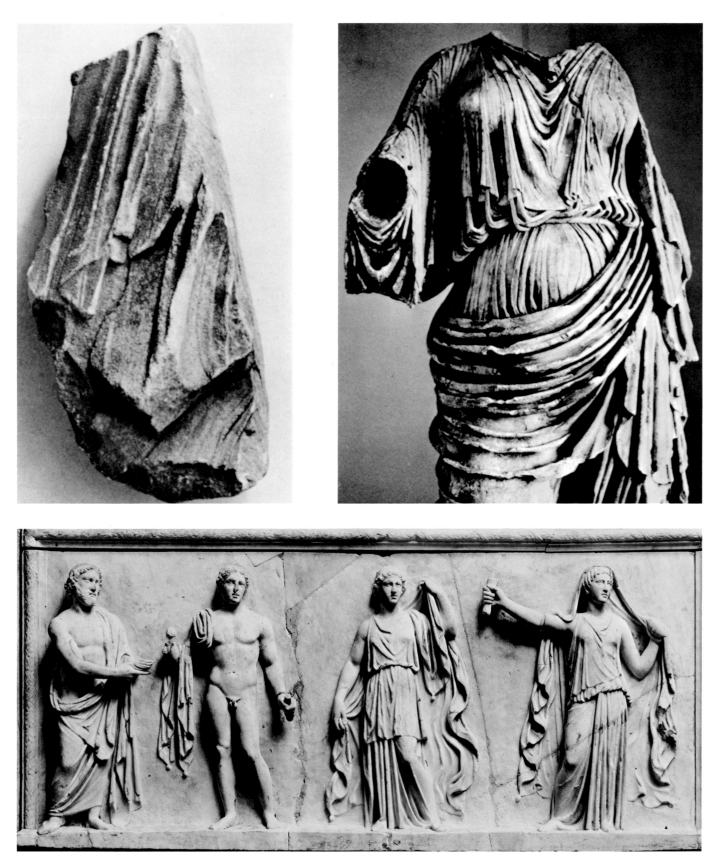

405 Fragment from the right side of the chiton overfold of the Nemesis, ca. 430–420. Ht. 49.5 cm. Athens.

406 Another reduced copy of the Nemesis, from Athens. Ht. of the copy, 1.9 m.

407 Relief with figures excerpted from the base of the Nemesis, fig. 403 (Roman copy), original ca. 430–420. Ht. 54 cm. Stockholm. The right forearm of the right-hand figure and other minor details are restored.

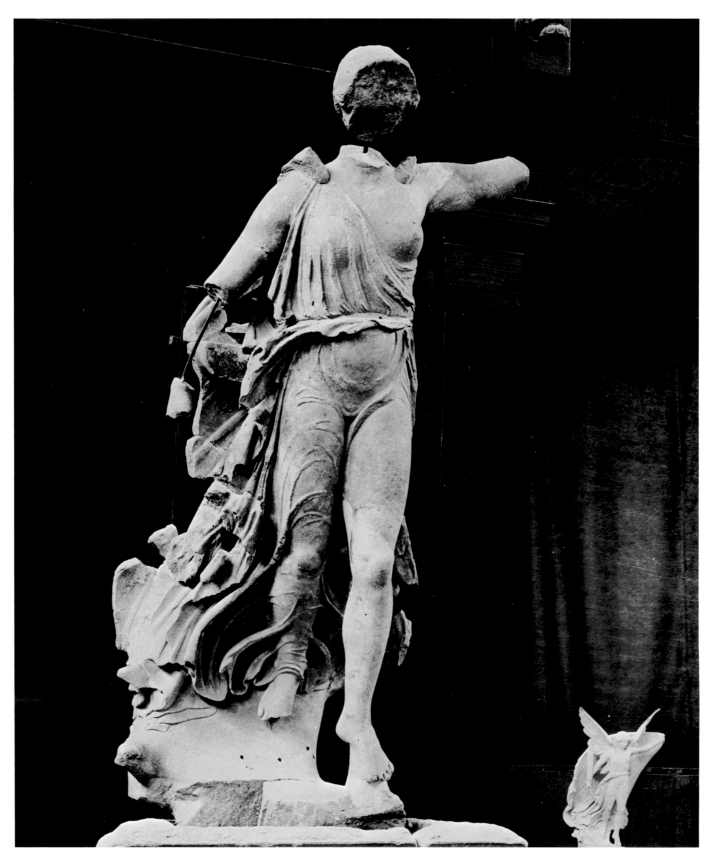

408 Nike of Paionios from Olympia, ca. 420. Ht. 1.95 m. For the inscription, see T 81.

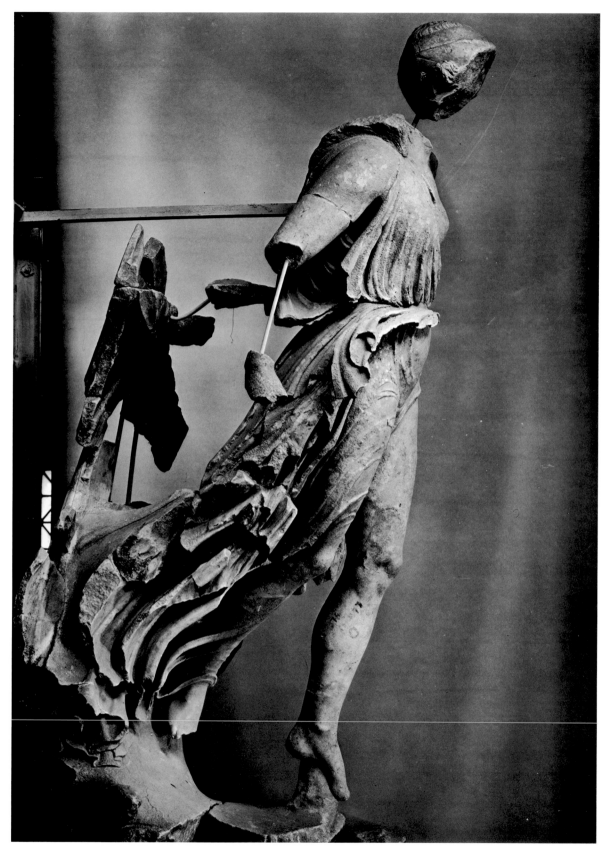

409 Right profile of the Nike, fig. 408.

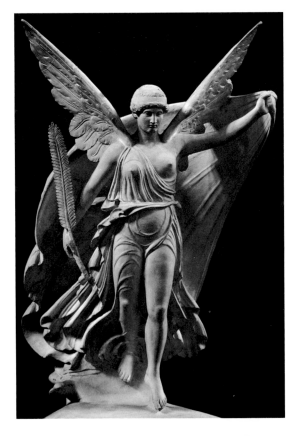

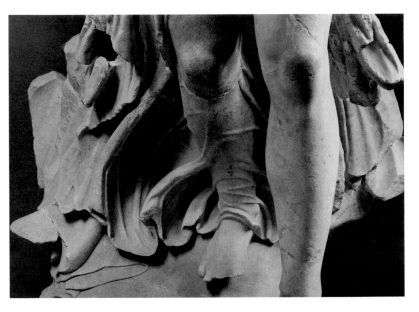

410 Model of the Nike, fig. 408, on its 9-meter high pillar. Olympia.

411 Detail of the Nike of Paionios, fig. 408.
412 Attic red-figured hydria attributed to the Meidias painter, ca. 410. Rape of the Leukippidai. Ht. 52.1 cm. London.

The Nike of Paionios
410–412

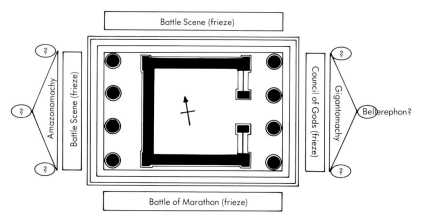

Battle Scene (frieze)

Amazonomachy | Battle Scene (frieze)

Council of Gods (frieze) | Gigantomachy

Bellerophon?

Battle of Marathon (frieze)

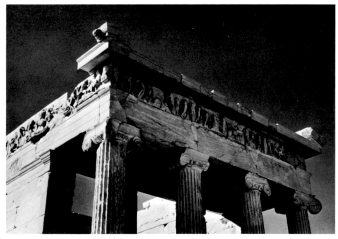

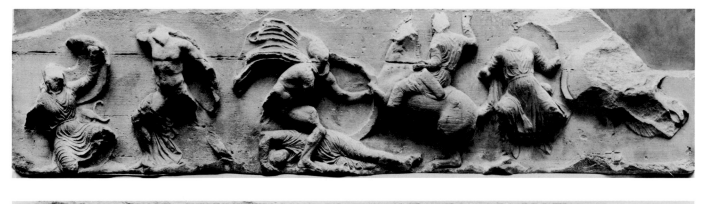

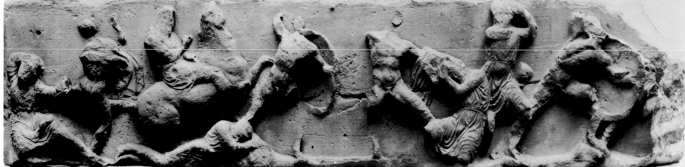

413 View of the temple of Athena Nike, showing east and south friezes, ca. 420. Assembly of the gods and battle between Greeks and Persians (Marathon?). Ht. of friezes, 45 cm. The south frieze is a concrete cast of the original in the British Museum.

414 The sculptural program of the temple of Athena Nike, *top right*.
415–416 South frieze, ca. 420. Center of the battle; the Persian defeat. Ht. 45 cm. London.

The Temple of Athena Nike
413–416

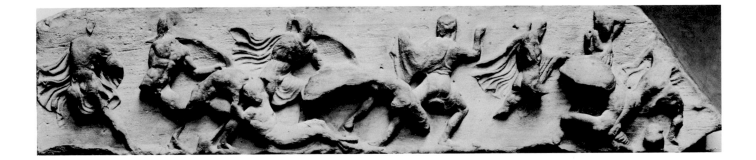

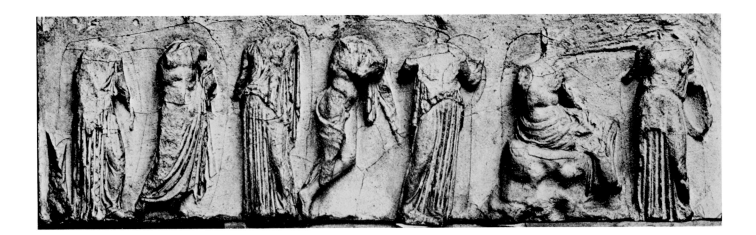

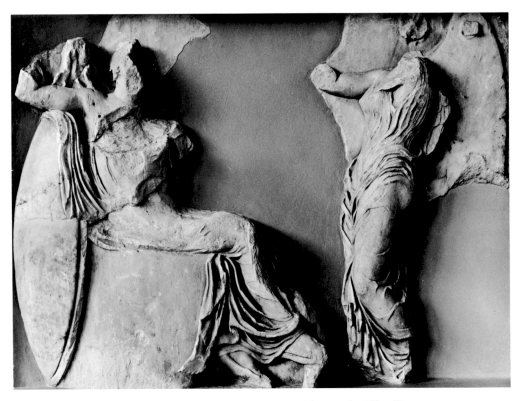

417 West frieze, ca. 420, *top*: Greeks fight Greeks. Ht. 45 cm.

418 East frieze, ca. 420, *center*: Assembly of the gods (at far right, Poseidon and Athena). Ht. 45 cm. Plaster cast.

419 Parapet, ca. 420–400. Athena and a Nike. Ht. 1.01 m.

The Temple of Athena Nike
417–419

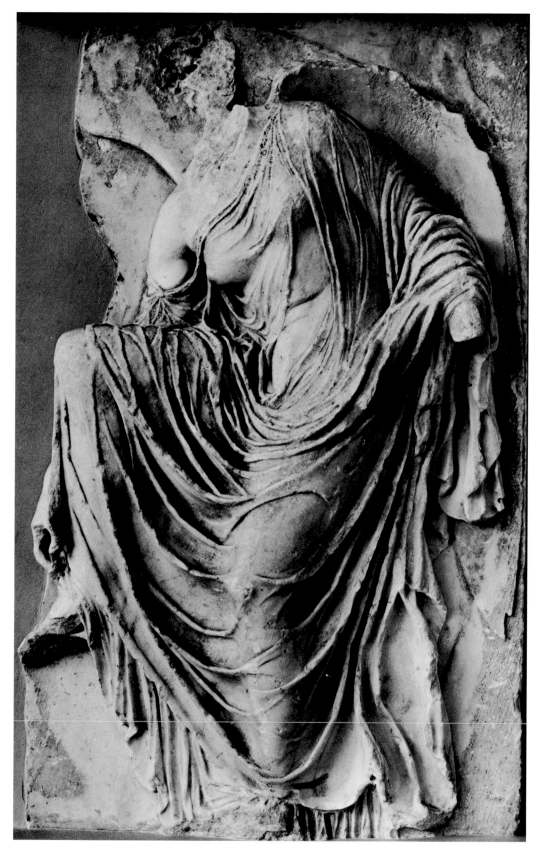

420 Nike binding her sandal, ca. 420–400. Ht. 1.01 m.

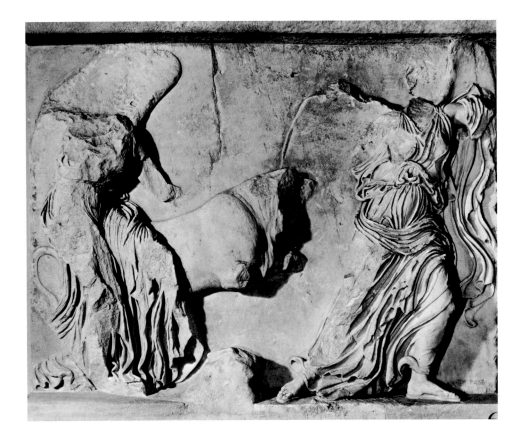

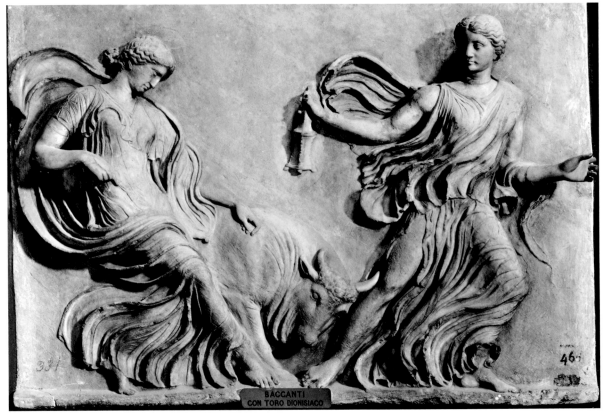

421 Nikai and bull, ca. 420–400. Ht. 1.01 m.

422 Roman version of a slab of the parapet: two women and a bull. Ht. 68 cm. Florence.

The Nike Temple Parapet
421–424

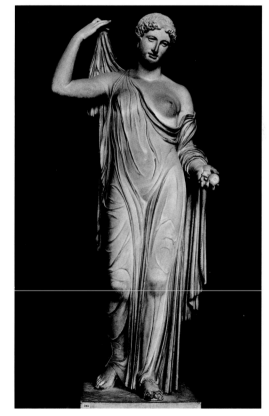

423 Detail of the right-hand Nike, fig. 421.
425 Aphrodite from the Agora, ca. 420. Ht. 1.83 m.

424 Standing Nike, ca. 420–400. Ht. 1.01 m.
426 "Fréjus/Genetrix" Aphrodite (Roman copy), original ca. 410. Ht. 1.65 m. Paris. The neck is restored.

Two Aphrodites
425–426

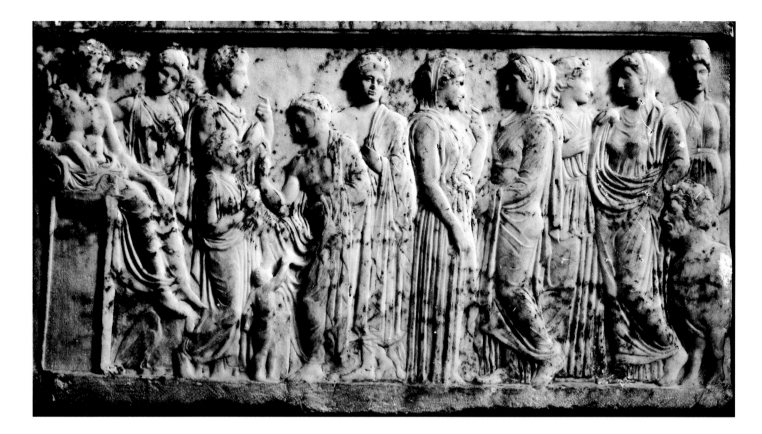

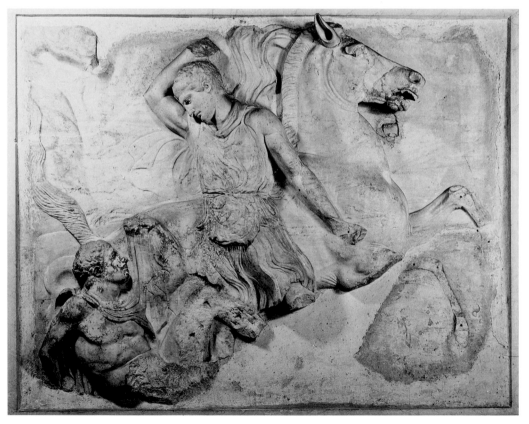

427 Votive relief dedicated by Xenokrateia to the river god Kephisos, from 428 Grave relief (the "Albani" relief), ca. 420–410. Ht. 1.80 m. Rome.
New Phaleron (near Athens), ca. 410. Ht. 57 cm. Athens.

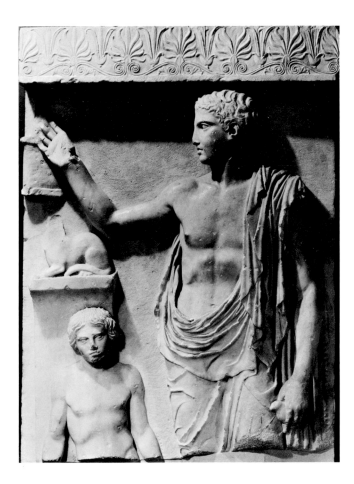

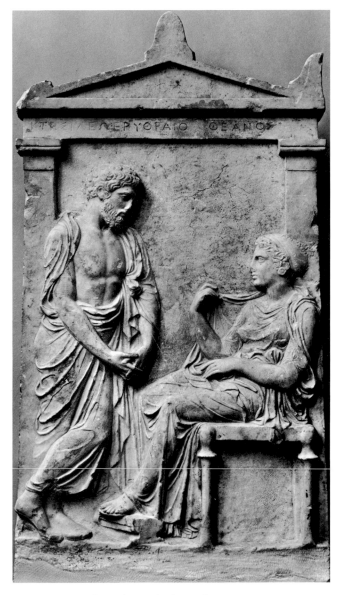

429 Grave relief (the "cat" stele), supposedly from Aegina or Salamis, ca. 420. Ht. 1.04 m. Athens.

430 Gravestone of Ktesileos and Theano from Athens, ca. 410–400. Ht. 93 cm.

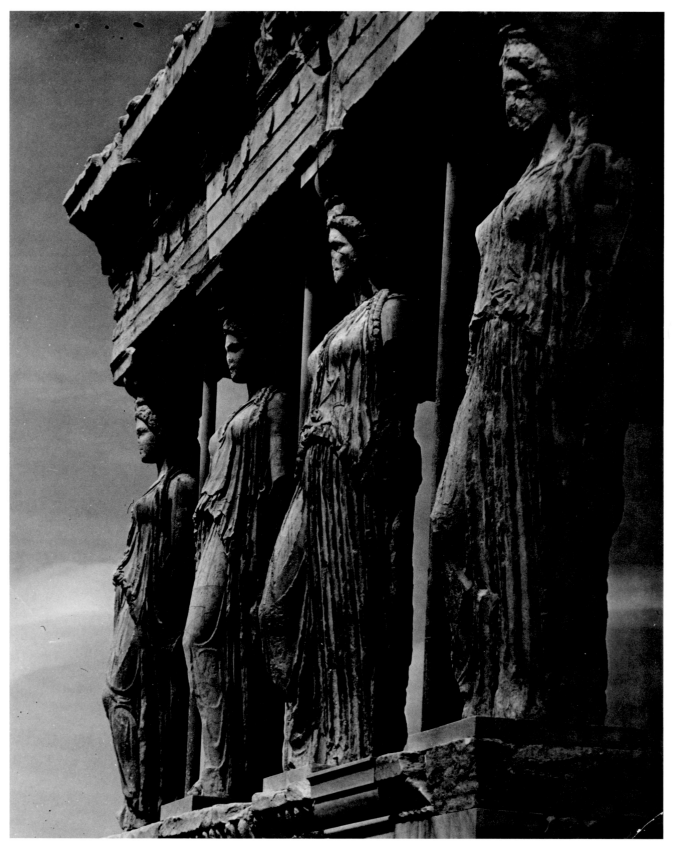

431 The Erechtheion on the Athenian Akropolis, ca. 420–406. Three-
quarter view of south porch. Ht. of korai (Caryatids), 2.31 m. Since
this photograph was taken, the korai have been removed to the Ak-
ropolis Museum and replaced with concrete casts.

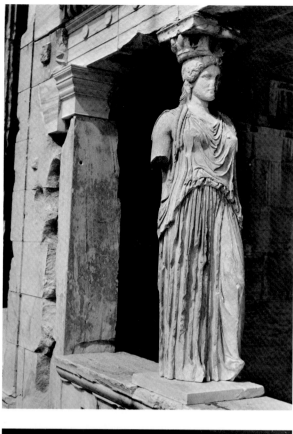

432 Kore (Caryatid) from the south porch of the Erechtheion, ca. 420–410, *top left*. Ht. 2.31 m. Now removed to the Akropolis Museum.

433–435 Frieze fragments from the Erechtheion, 409–406. Ht. of frieze, 49 cm.

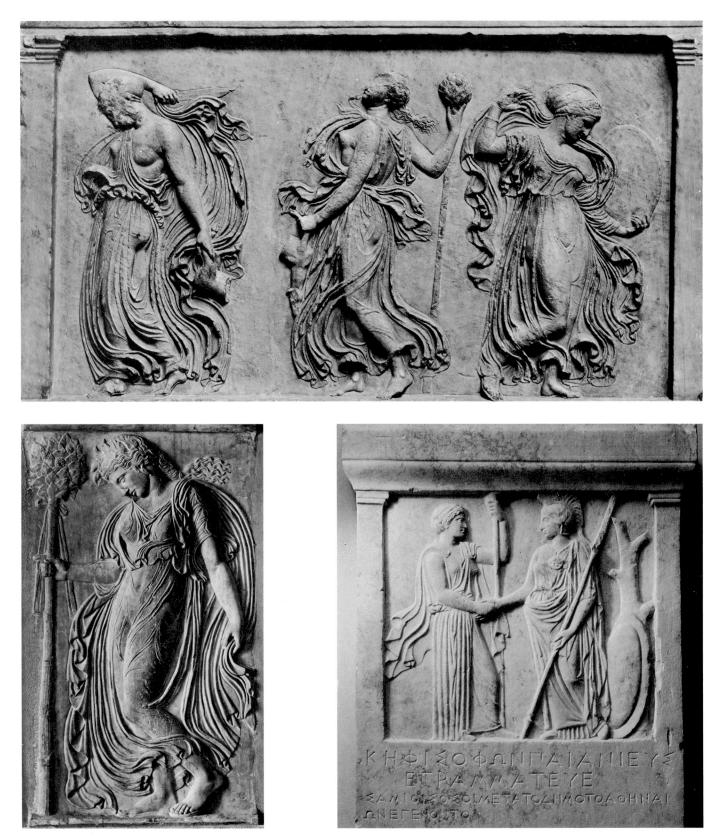

436–437 Reliefs of dancing maenads (Roman copies), originals ca. 410–400. Ht. 1.43 m, 1.41 m. Rome and Madrid.

438 Document relief from the Akropolis, for a decree honoring Samos, 403, *bottom right*. Ht. 1.13 m.

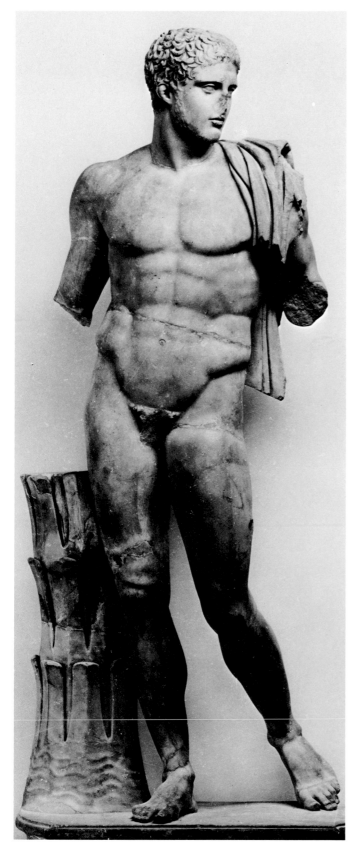

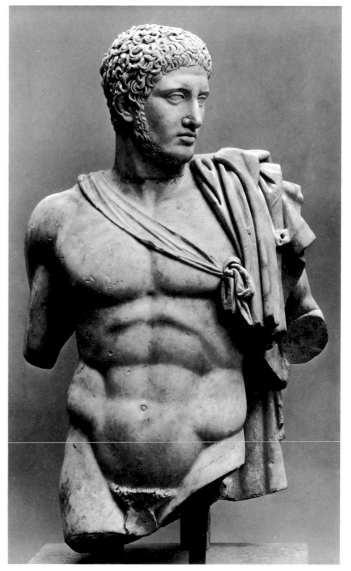

439 Diomedes (Roman copy), original, ca. 420. Ht. 1.77 m. Naples.

440 Another copy of the Diomedes, fig. 439. Ht. 1.02 m. Munich.

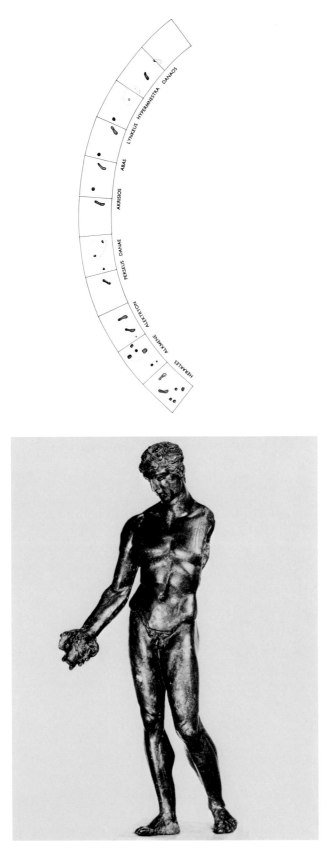

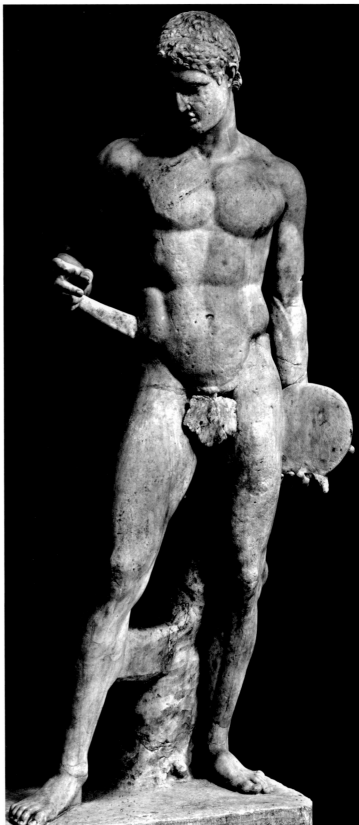

441 Base of the (now lost) dedication of the Argives at Delphi, by Antiphanes of Argos, ca. 370–360, *top left*. Herakles and the kings of Argos. D. 13.7 m.

442 Diskobolos (Roman copy) sometimes attributed to Naukydes of Argos, original, ca. 400. Ht. 1.66 m. Paris. The head does not belong, and the legs are restored.

443 Statuette of Phrixos holding the ram's head, perhaps after an original by Naukydes of Argos, ca. 400, *bottom left*. Bronze, ht. 17.5 cm.

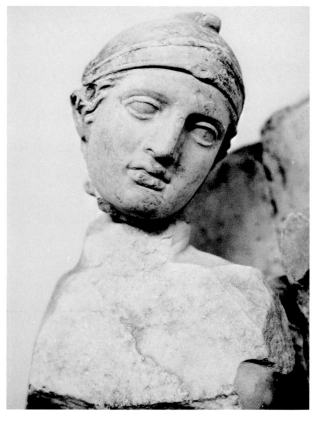

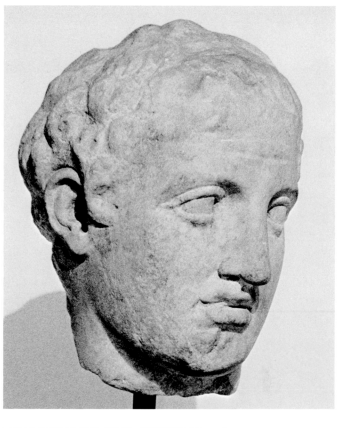

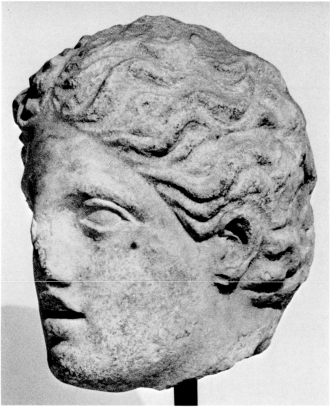

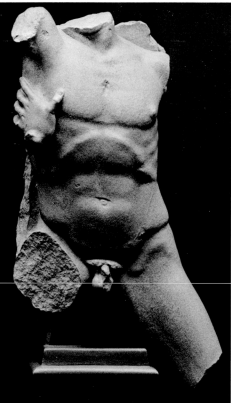

444–446 Heads of Greeks and Amazons from the metopes of the Argive Heraion, ca. 420–400. Ht. 17 cm, 15 cm, 16 cm. Athens.

447 Greek from the metopes of the Argive Heraion, ca. 420–410. Ht. 55 cm. Plaster cast in the Museum of Classical Archaeology, Cambridge, from original marble in Athens.

(6 metopes)
Rape of Leukippidai

Amazonomachy

Centauromachy

(6 metopes)
Return of Apollo

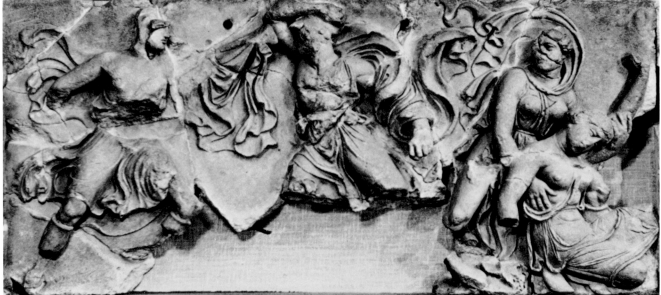

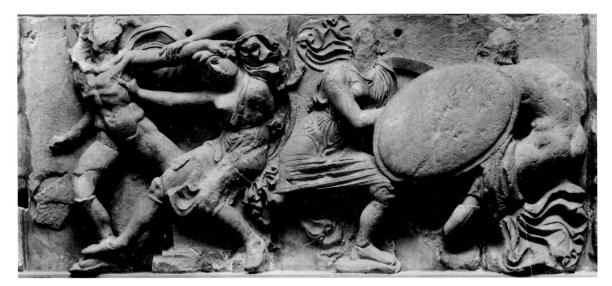

448 Program of the temple of Apollo at Bassai/Phigaleia.

449–450 Amazonomachy from the temple of Apollo at Bassai/Phigaleia, ca. 400. Ht. 64 cm. London.

The Temple of Apollo at Bassai/Phigaleia
448–450

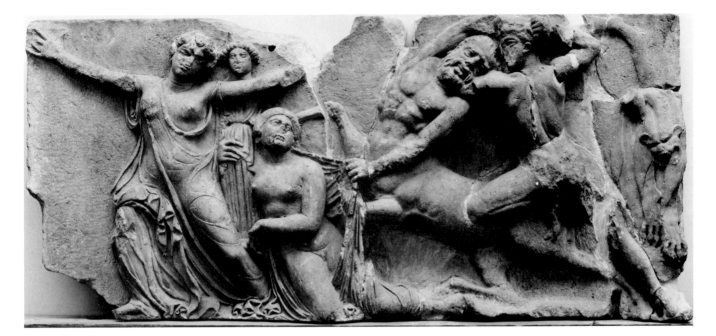

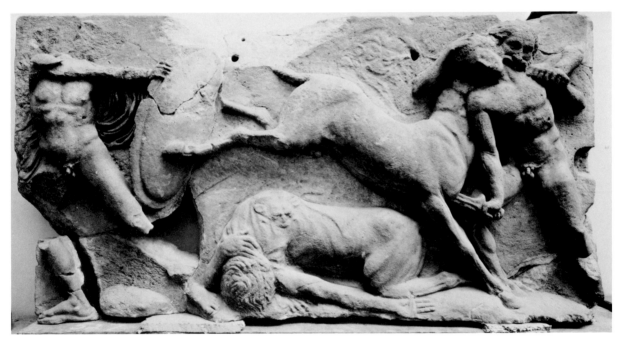

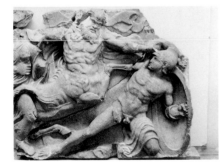

451–453 Centauromachy from the temple of Apollo at Bassai/Phigaleia, ca. 400. Ht. 64 cm. London.

454 Metope from the temple of Apollo at Bassai/Phigaleia, ca. 400. Rape scene. Ht. 41.9 cm. London.

The Temple of Apollo at Bassai/Phigaleia
451–454

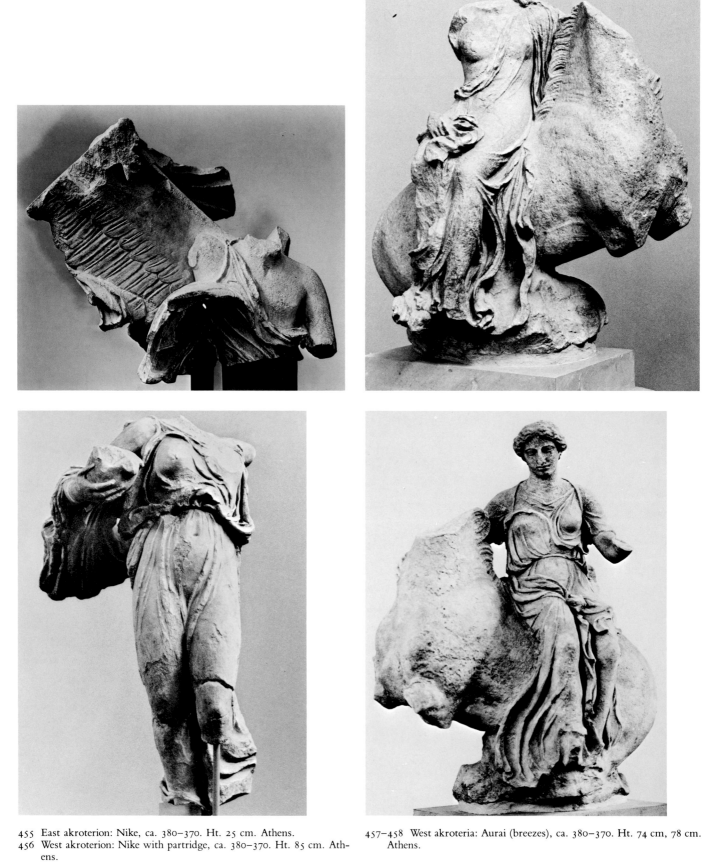

455 East akroterion: Nike, ca. 380–370. Ht. 25 cm. Athens.
456 West akroterion: Nike with partridge, ca. 380–370. Ht. 85 cm. Athens.

457–458 West akroteria: Aurai (breezes), ca. 380–370. Ht. 74 cm, 78 cm. Athens.

The Temple of Asklepios at Epidauros
455–458

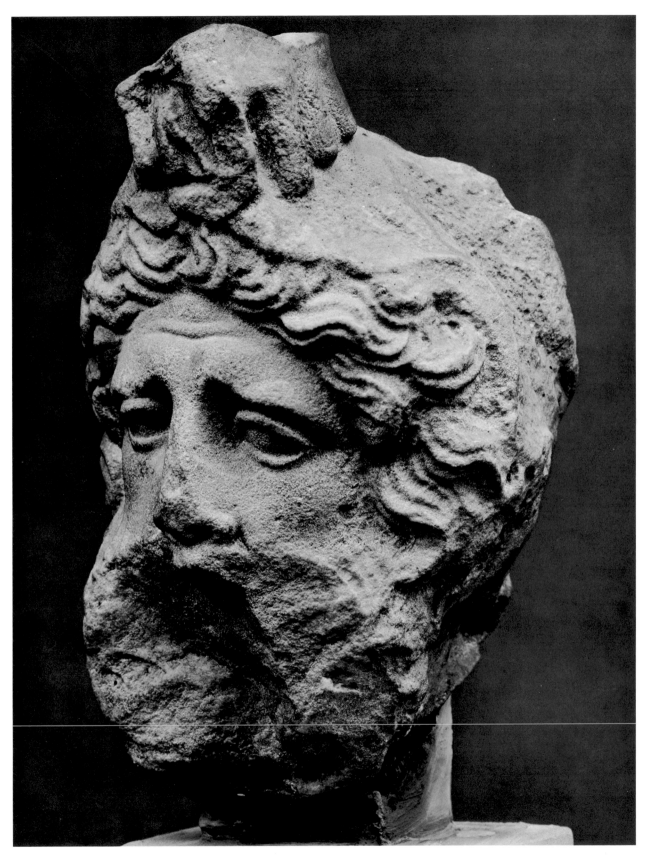

459 East pediment (Ilioupersis), ca. 380–370. Priam. Ht. 15 cm. Athens.

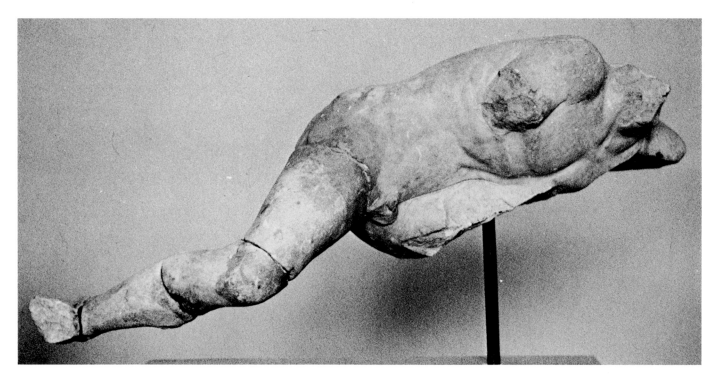

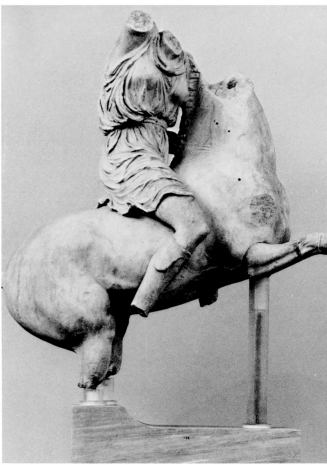

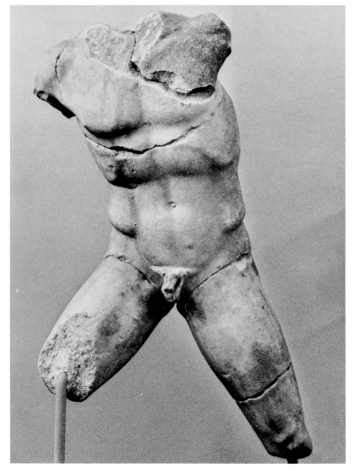

460 East pediment (Ilioupersis), ca. 380–370. Lunging youth. L. 97 cm. Athens.

461 West pediment (Amazonomachy), ca. 380–370. Penthesilea. Ht. 90 cm. Athens.

462 West pediment (Amazonomachy), ca. 380–370. Achilles. Ht. 70 cm. Athens.

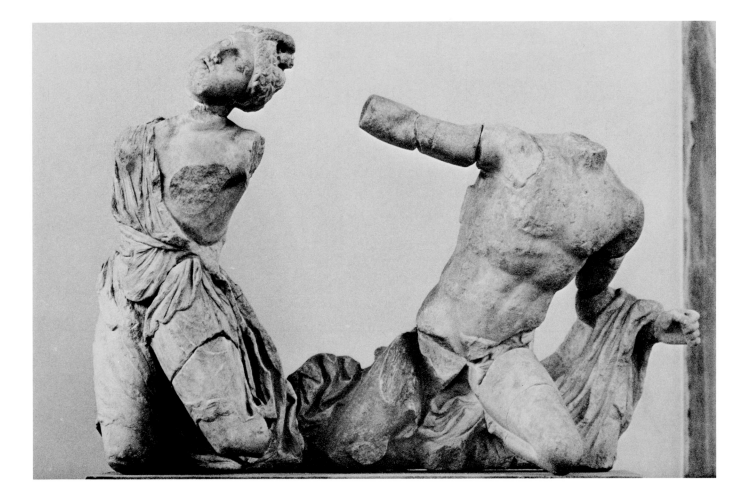

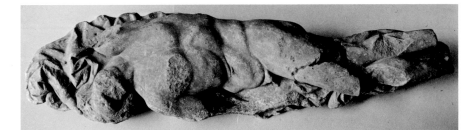

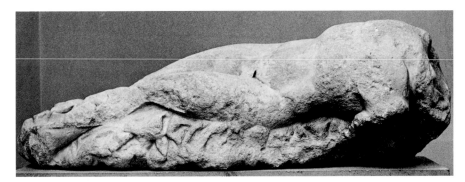

463 West pediment (Amazonomachy), ca. 380–370. Amazon and Greek. Ht. 55 cm. Athens.

464–465 West pediment (Amazonomachy), ca. 380–370. Dead Greeks. L. 91 cm, 97 cm. Athens.

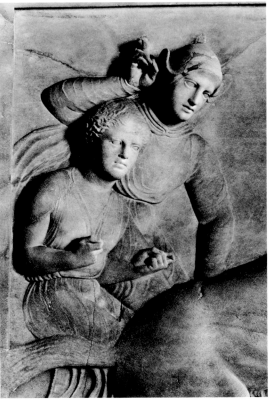

466–467 The "Lycian Sarcophagus" from Sidon, ca. 400–375. Ht. of friezes, 1.34 m. Istanbul.

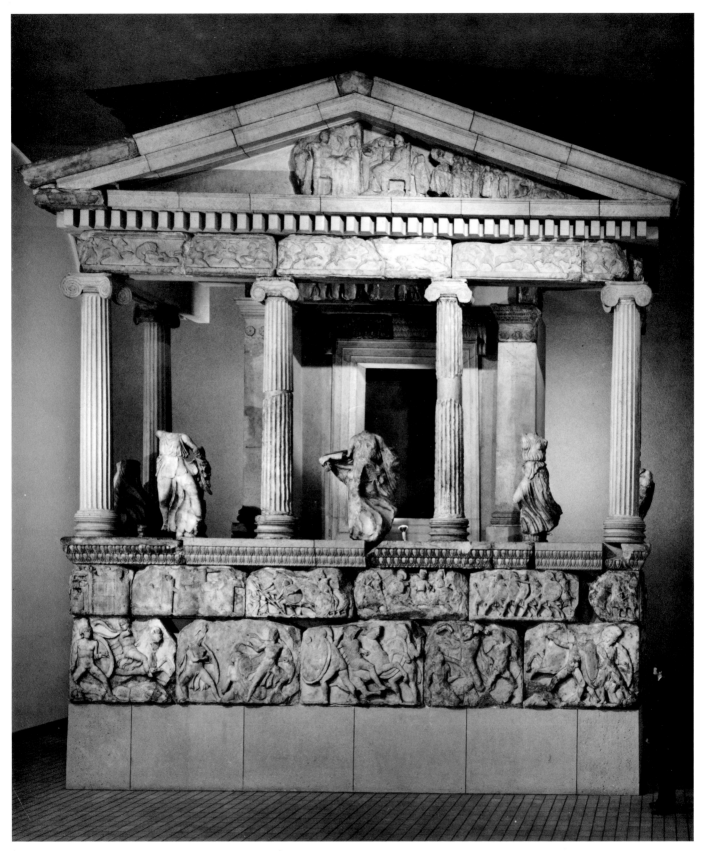

468 The "Nereid Monument" (tomb of Erbbina?), from Xanthos, ca.
 390–380. Ht. 8.07 m. London.

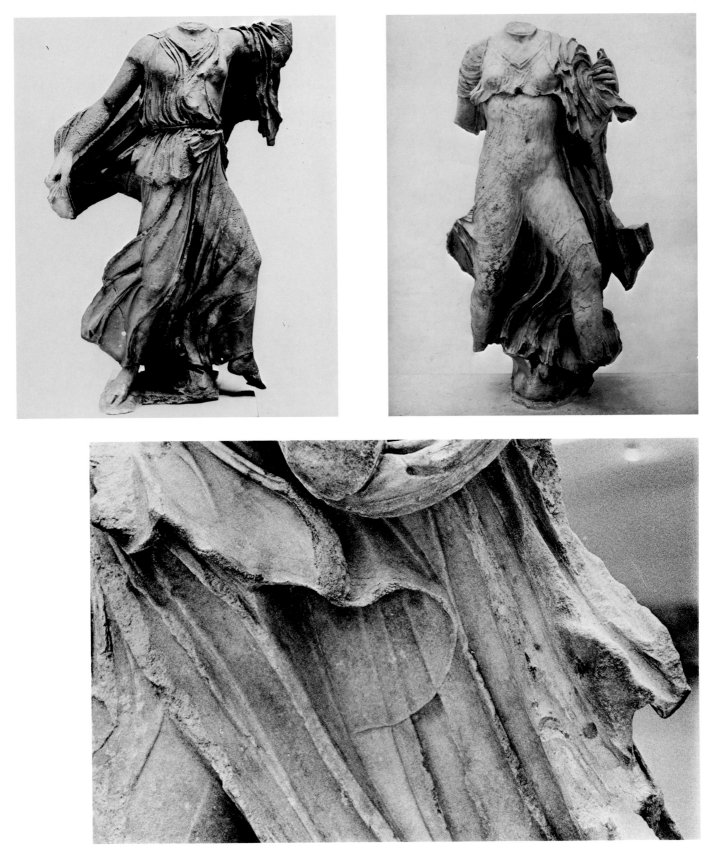

469–471 Details of the tomb, fig. 468: Nereids. Ht. 1.42 m, 1.40 m, 1.44 m. London.

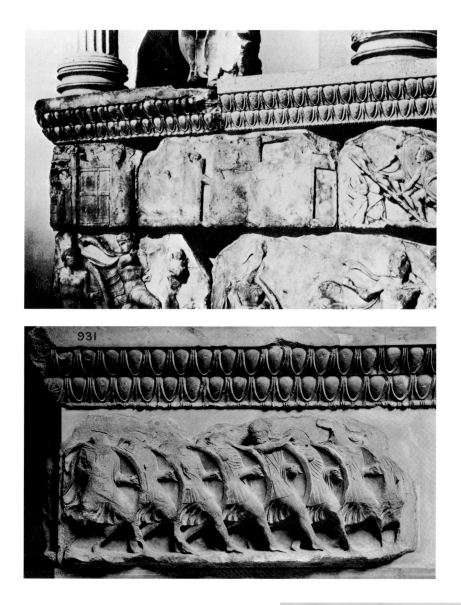

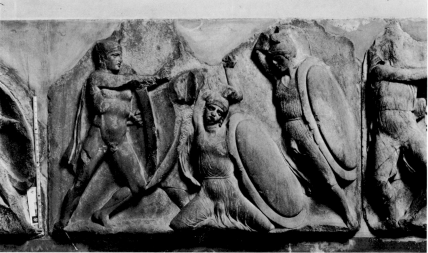

472–473 Frieze II from the tomb, fig. 468: city-siege and the Lycian phal-anx. Ht. of frieze, 63 cm. London.

474 Frieze I from the tomb, fig. 468: battle. Ht. of frieze, 1.01 m. London.

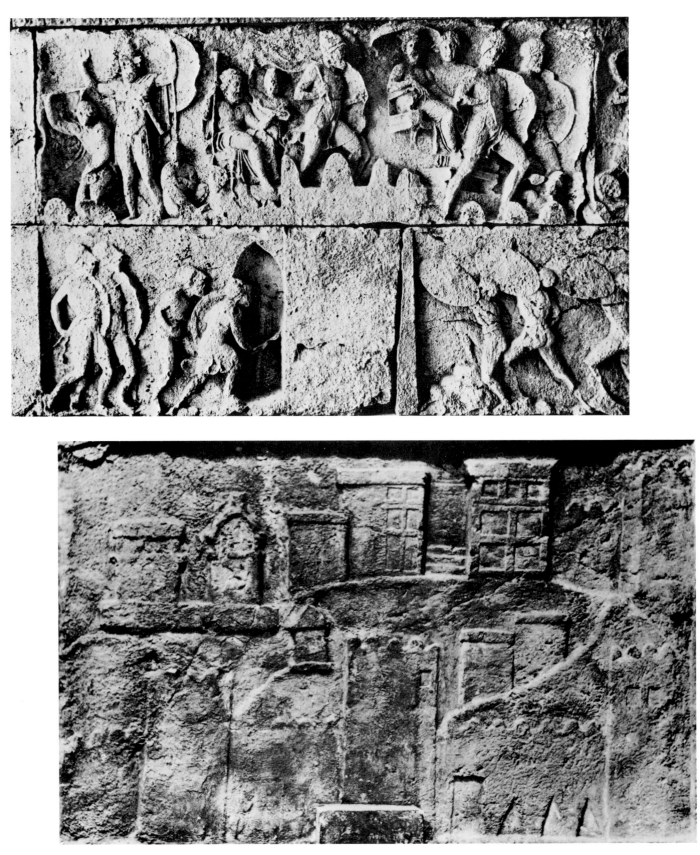

475 Heroon at Trysa (Lycia), ca. 370. City-siege, with sacrifice (top left), rulers enthroned on the battlements, and attackers below. Limestone, ht. of friezes, 1.1 m. Vienna.

476 Landscape tomb at Pinara, ca. 370–360. Panel D with representation of city. Rock relief, ht. 86.3 cm. Plaster cast in London of original still in situ.

Tombs at Trysa and Pinara
475–476

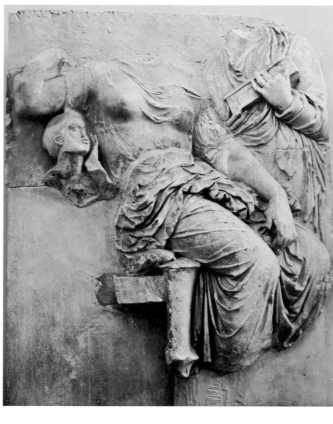

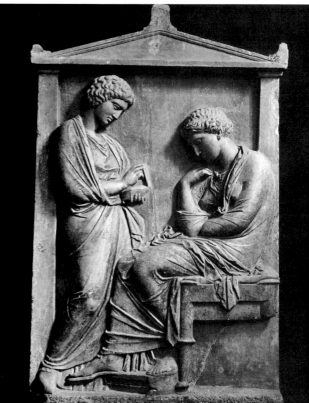

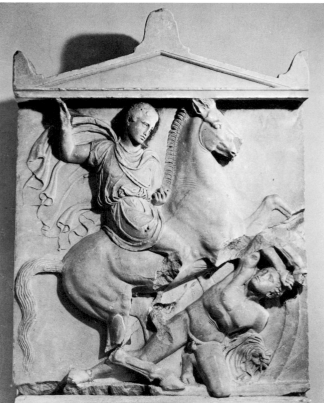

477 Grave stele of Hegeso from the Kerameikos, Athens, ca. 400. Ht. 1.58 m.

478 Grave relief from the Piraeus, ca. 380. Ht. 1.21 m. Athens.

479 Grave stele ("Telauges Mnema"), ca. 370. Ht. 1.375 m.

480 Grave relief of Dexileos from Athens, 394–393. Ht. 1.40 m. For the epitaph see chapter 1.2.

481 Athenian strategos (the "Pastoret" head), sometimes identified as Konon (Roman copy), original ca. 400–375. Ht. 34 cm. Copenhagen.

482 Head from a wreck off Porticello (Italy), ca. 400. Bronze, ht. 42 cm. Reggio Calabria.

483 Head of Sokrates ("type A"; Roman copy), original ca. 390–370. Ht. 37 cm. Naples.

484 Krater by the Pronomos painter from Ruvo, ca. 400. Actors holding masks for a satyr play. Ht. 75 cm. Naples.

Attic and Other Portraits
481–484

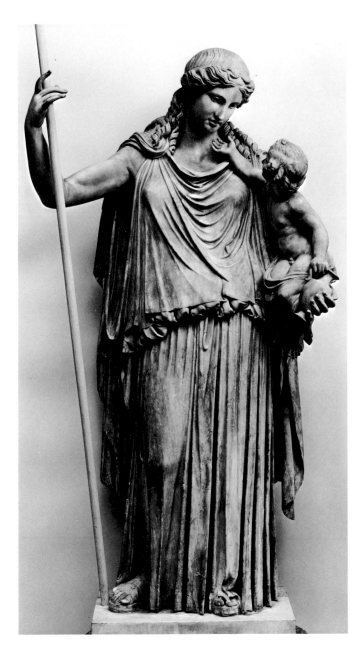

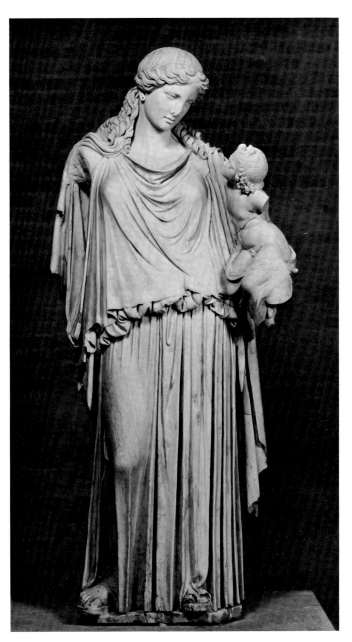

485–486 Eirene and Ploutos by Kephisodotos (Roman copy), original ca.
375–370. Ht. 2.01 m. Munich. Shown with and without the resto-
rations.

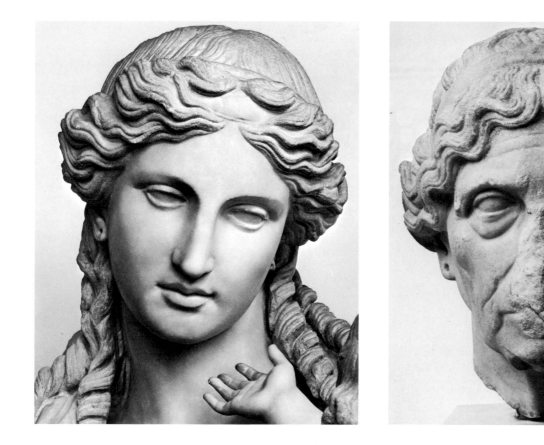

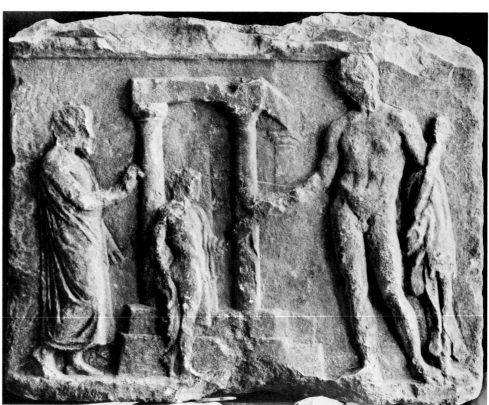

487 Head of the Eirene, fig. 486.

488 Head of an old woman ("Lysimache"; Roman copy), original, ca. 400–375. Ht. 30 cm. London.

489 Votive relief to Herakles from Marousi, ca. 400–375. Ht. 47 cm. Athens.

The Eirene and Other Attic Sculpture
487–489

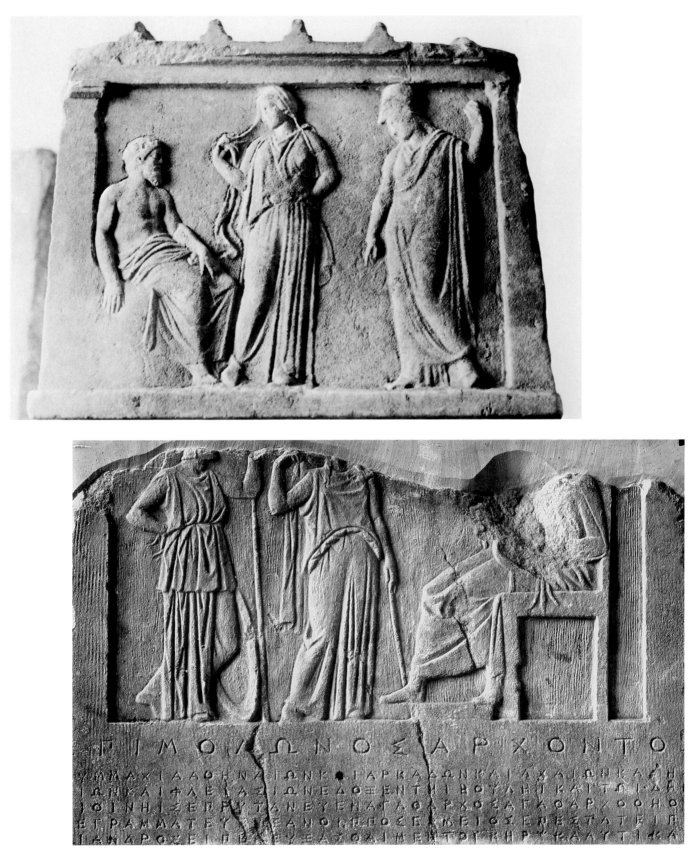

490 Document relief commemorating the treaty between Athens and Kerkyra (Corfu), from Athens, 375/74. Ht. 95 cm.

491 The decree relief of Molon, from Athens, 362/61. Ht. 46 cm.

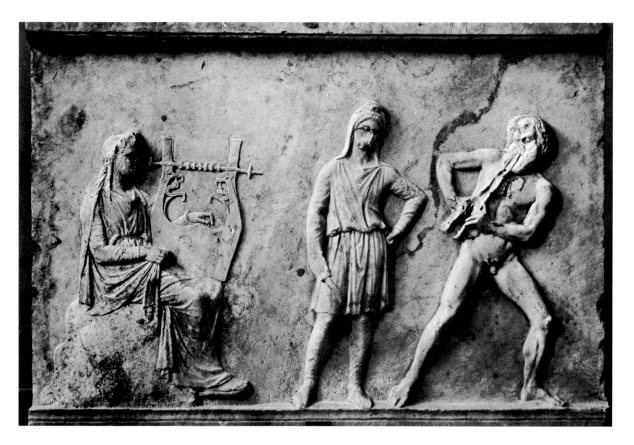

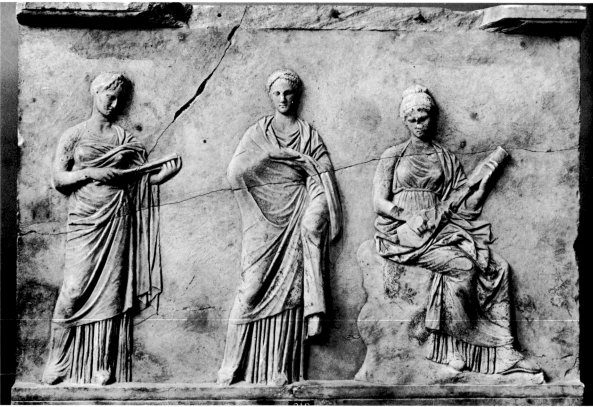

492–493 Statue base from Mantineia (Arkadia), ca. 330–320. Apollo,
 Skythian, and Marsyas; three Muses. Ht. 98 cm. Athens.

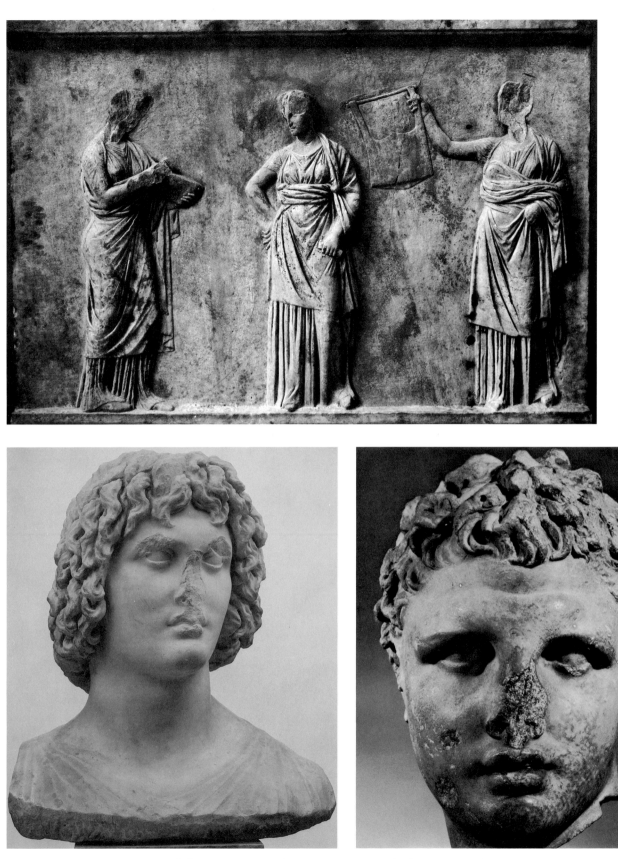

494 Statue base from Mantineia (Arkadia), ca. 330–320. Three Muses. Ht. 98 cm. Athens.

495 Bust of a youth, perhaps Eubouleus, from the Ploutonion at Eleusis, ca. 330. Ht. 47 cm. Athens. The figure was cut down to a bust in antiquity, the hair and drapery were retooled, and the face was re-polished.

496 "Aberdeen" Herakles from Greece, ca. 350–330. Ht. 29 cm. London.

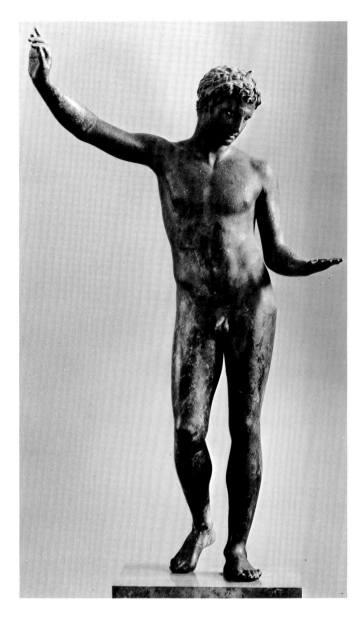

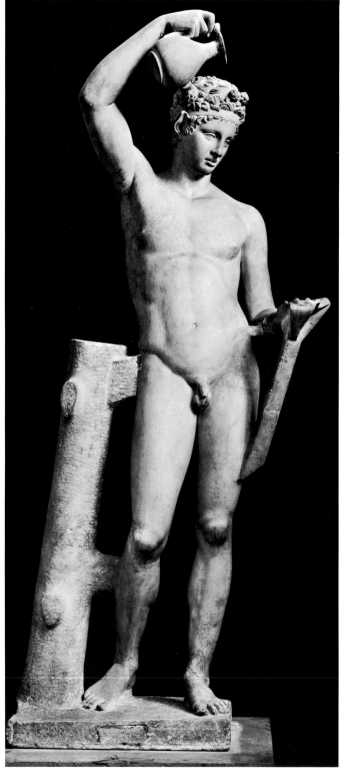

497 Youth from the sea off Marathon, ca. 330. Bronze, ht. 1.3 m. The arms were restored in antiquity.

498 Satyr pouring wine (Roman copy), original ca. 370. Ht. 1.53 m. Palermo.

Praxiteles
497–498

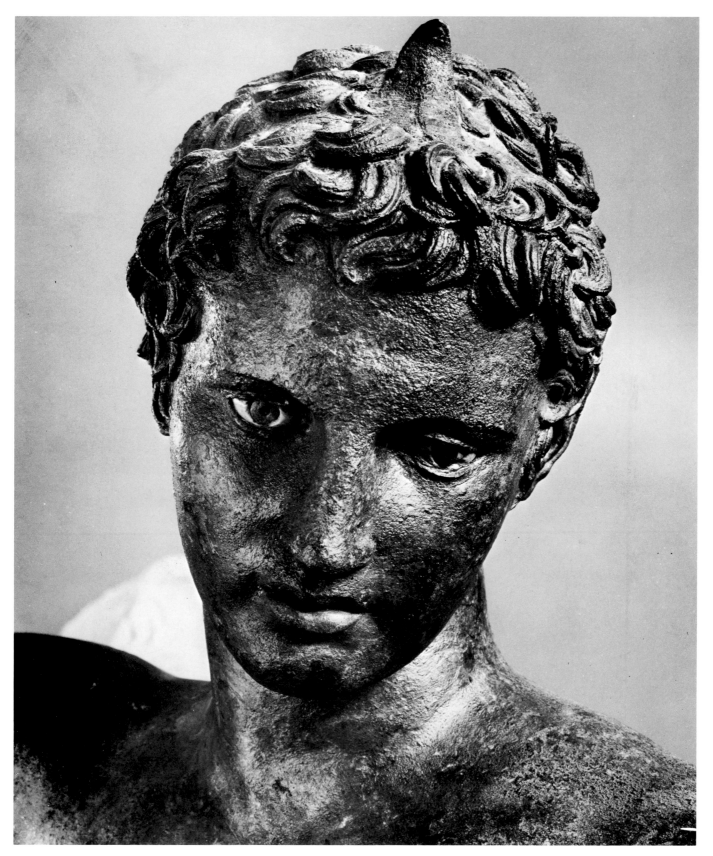

499 Head of the youth, fig. 497.

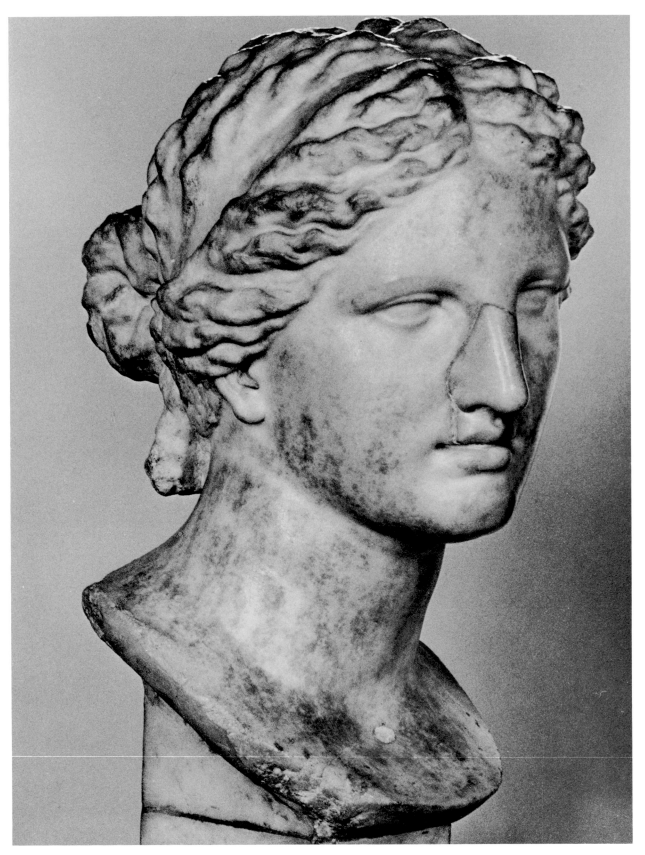

500 The "Leconfield" Aphrodite, ca 330. Ht. 41 cm. Petworth (England).
 The nose and part of the upper lip are restored.

Praxiteles
500

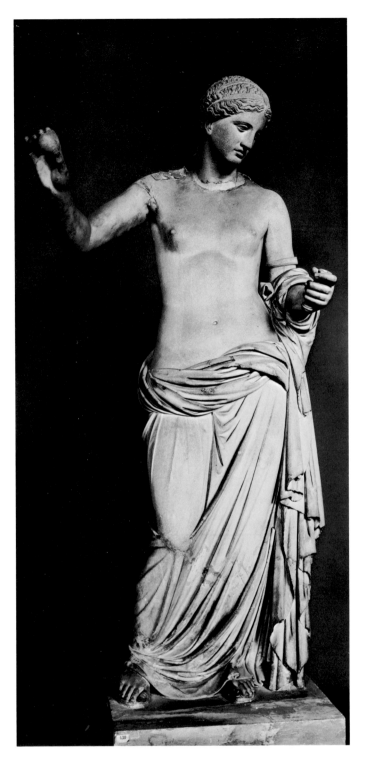

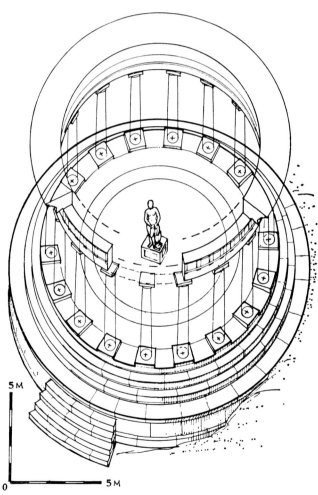

501 Aphrodite from Arles (Roman copy), original ca. 370–350. Ht. 1.94 m. The head (which does not join break-on-break) was reset on the body, the arms were restored, and the entire body smoothed down by François Girardon in 1685.

502 Reconstruction by Iris Love of the temple of Aphrodite Euploia at Knidos.

5 M

0 5 M

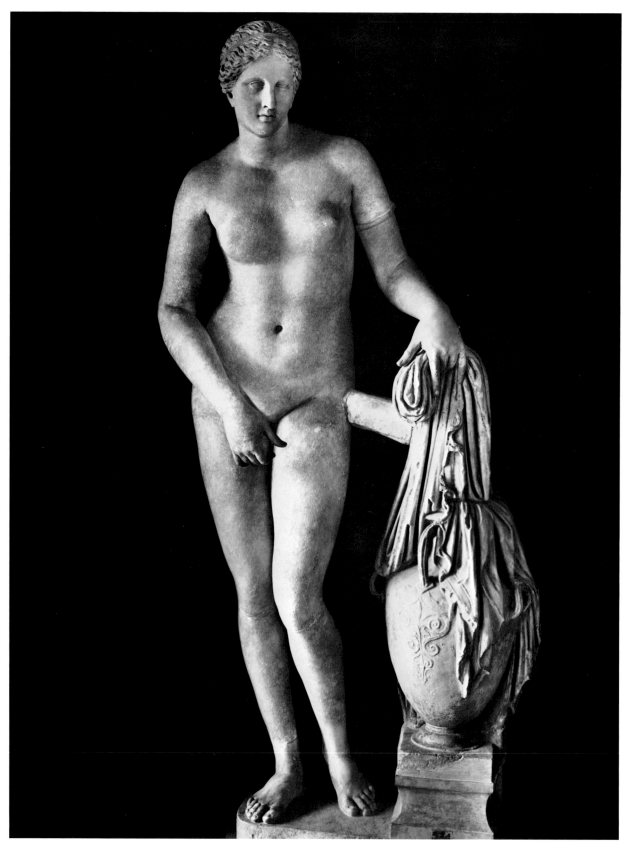

503 Aphrodite of Knidos ("Venus Colonna"; Roman copy), original ca.
350–340. Ht. 2.04 m. Rome. The neck, right forearm and hand, left
arm from below the armband to the fingers, right foot and ankle, left
leg below the knee, and plinth are restored.

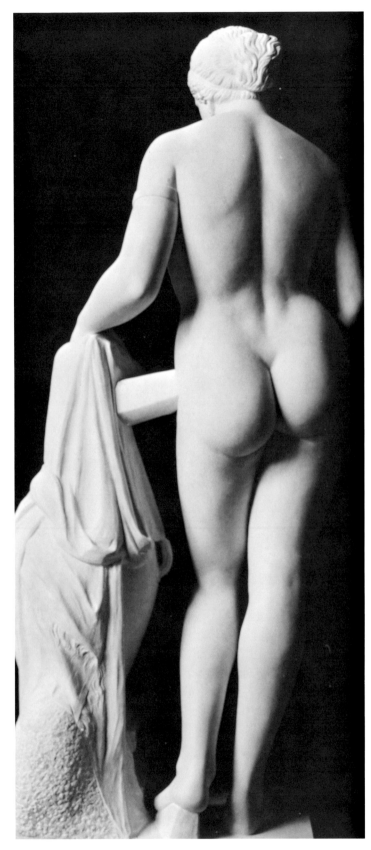

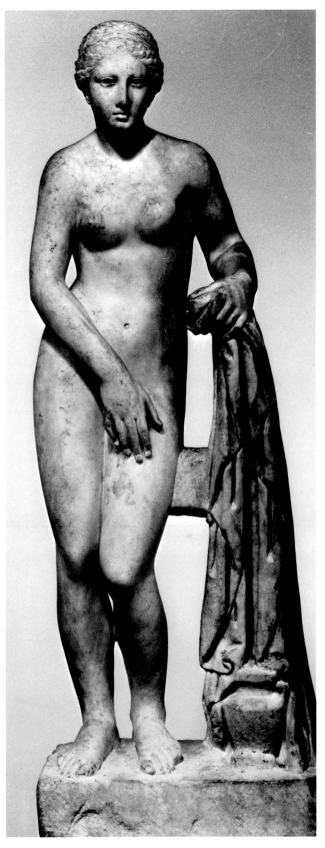

504 Back view of the Aphrodite, fig. 503.

505 Aphrodite of Knidos (Roman statuette), original ca. 350–330. Ht. 97 cm. Malibu.

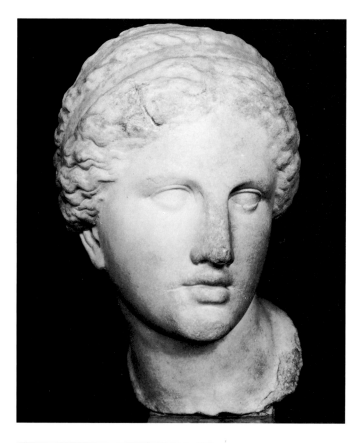

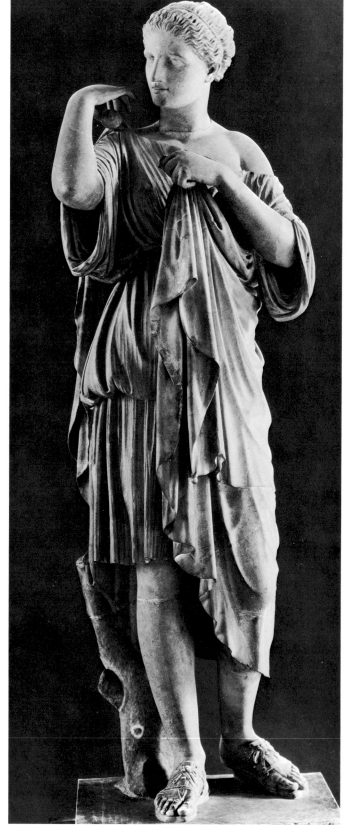

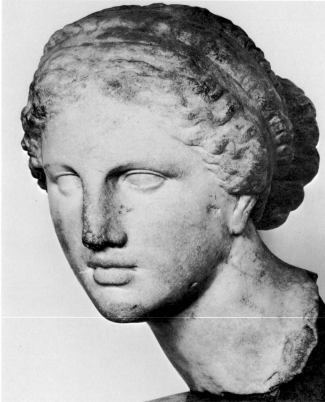

506–507 "Kaufmann" head of the Knidian Aphrodite (Hellenistic copy), from Tralleis (Turkey), original ca. 350–340. Ht. 35 cm. Paris.

508 Artemis from Gabii (Roman copy), original ca. 340. Ht. 1.65 m. Paris. The right hand, parts of the left arm and hand, the right leg, and some drapery folds are restored.

Praxiteles
506–508

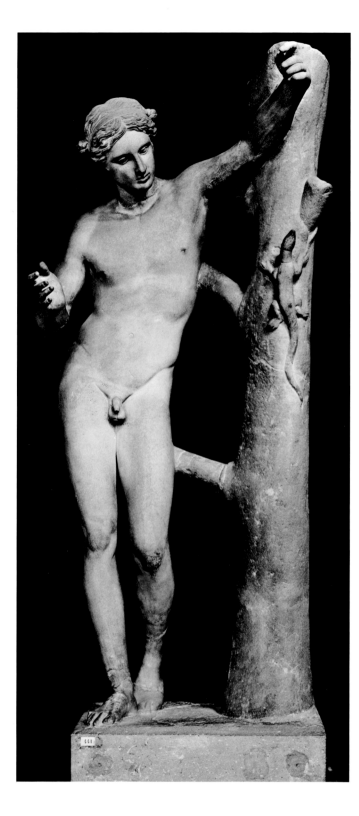

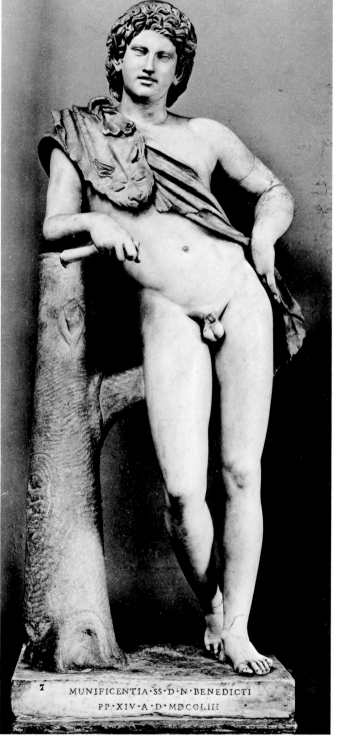

509 Apollo Sauroktonos (Roman copy), original ca. 350. Ht. 1.49 m. Paris. The neck and parts of the arms are restored.

510 Resting Satyr (Roman copy), original ca. 350–330. Ht. 1.7 m. Rome. The nose, left arm, and head of the panther skin are restored.

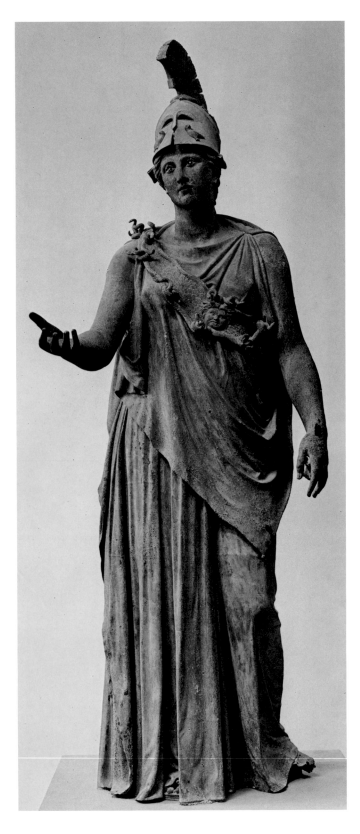

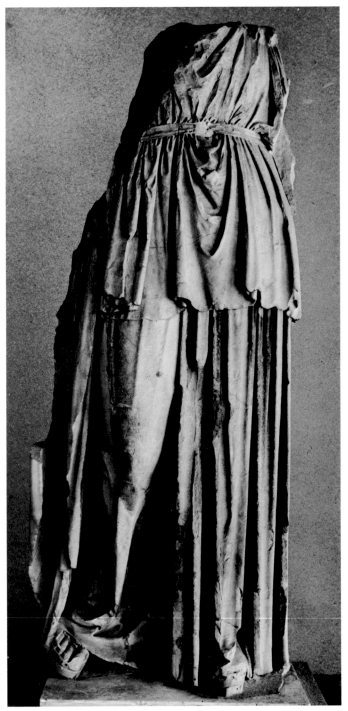

511 Athena from the Piraeus, ca. 350, if not a late Hellenistic copy. Bronze, ht. 2.35 m.

512 Apollo Kitharoidos, probably the Apollo Patroos of Euphranor, from the Metroon in the Athenian Agora, ca. 340–330. Ht. 2.54 m. Fragments of a kithara were found with the statue.

Other Athenian Sculptors
511–512

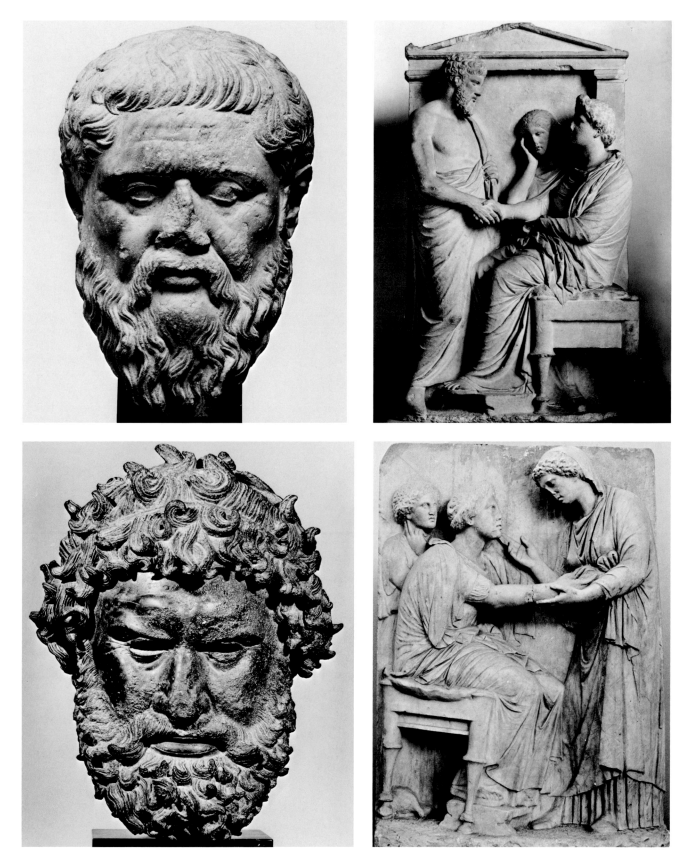

513 Plato, attributed to Silanion (Roman copy), original ca. 340. Ht. 35 cm. Switzerland.
514 Boxer from Olympia, ca. 330. Bronze, ht. 28 cm.

515 Grave relief of Thraseas and Euandria, from the Kerameikos, Athens, ca. 350. Ht. 1.60 m. Berlin.
516 Grave relief ("Grands Adieux"), from the Kerameikos, Athens, ca. 340. Ht. 1.7 m.

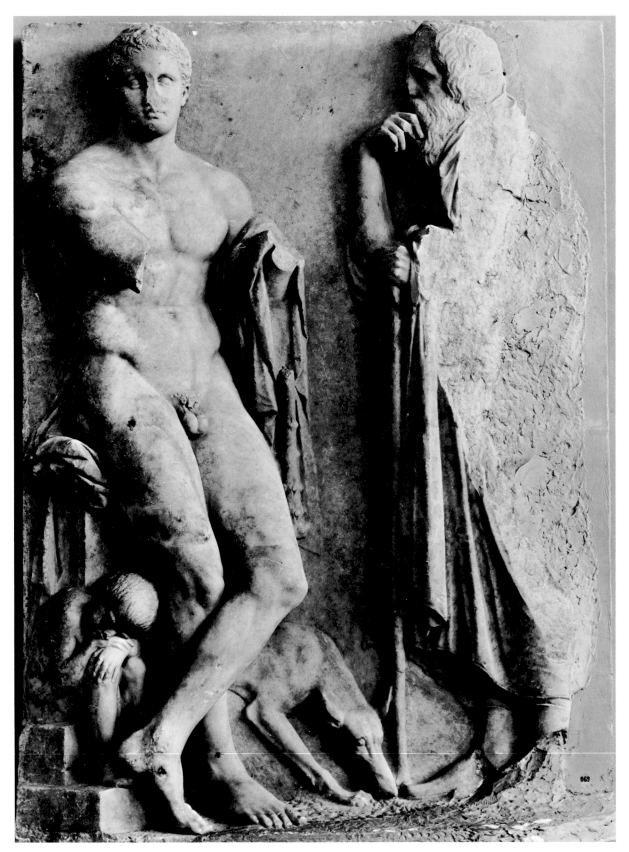

517 Grave relief of a young hunter from the river Ilissos, Athens, ca. 330.
Ht. 1.68 m.

The Ilissos Stele
517–519

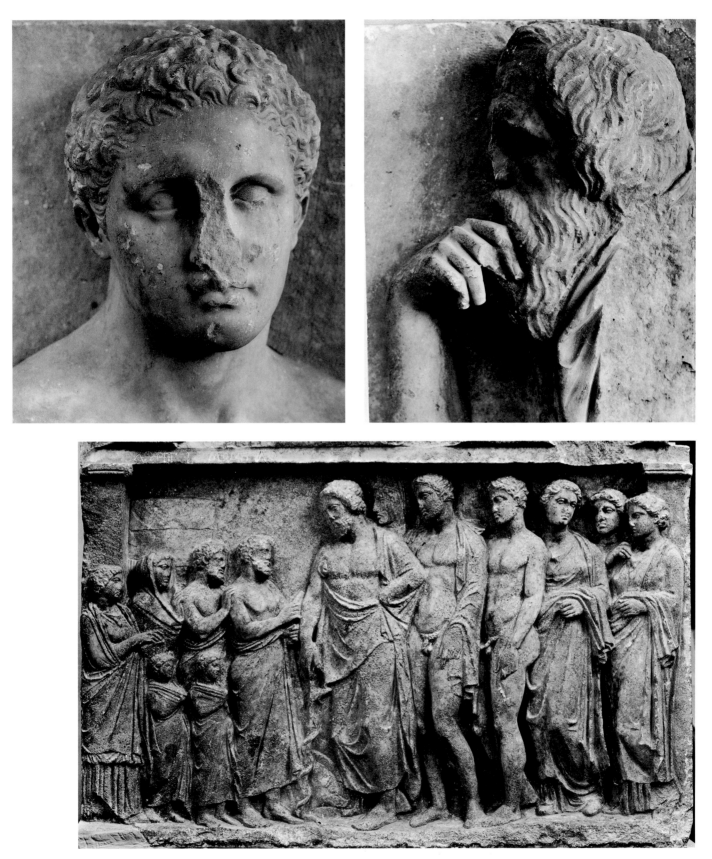

518–519 Heads of the hunter and the old man, fig. 517.

520 Votive relief to Asklepios and his family, from Loukou (Attica), ca. 375–350. Ht. 53 cm. The inscription is modern.

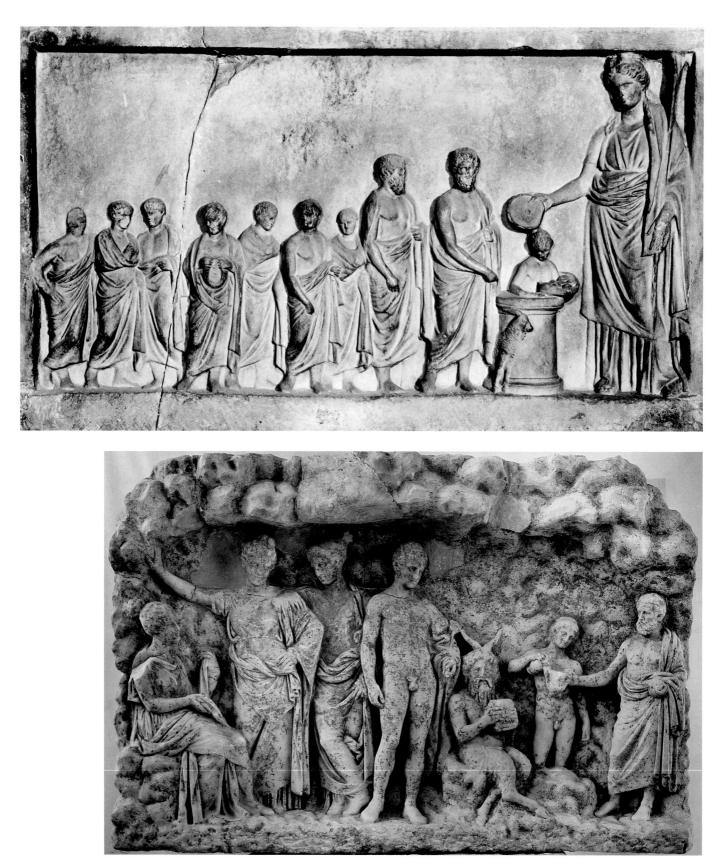

521 Votive relief to Demeter, from Athens, ca. 350–330. Ht. 66 cm. Paris.

522 Votive relief dedicated by Agathemeros to the Nymphs, with Hermes and Pan, from a cave on Mt. Pendeli, near Athens, ca. 330–300. Ht. 1.74 m; of the relief, 70 cm. Athens.

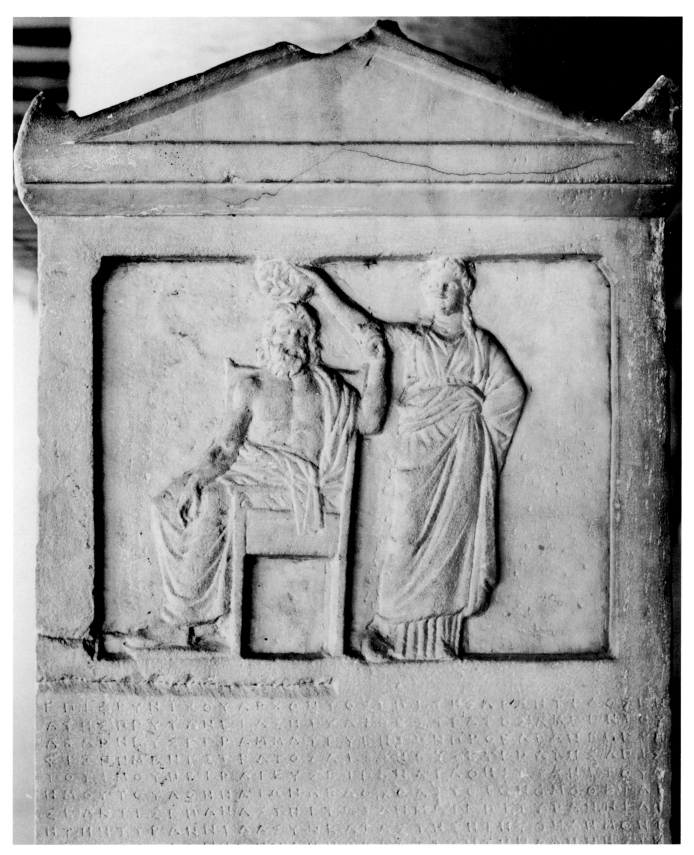

523 Document relief from the Athenian Agora, 336. Demos crowned by
Demokratia. Ht. of stele, 1.57 m.

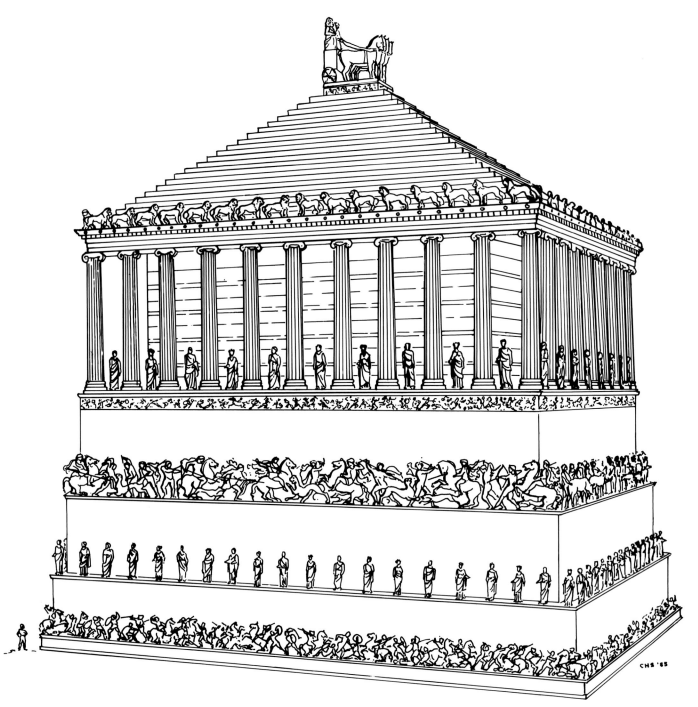

524 Reconstruction.

The Mausoleum at Halikarnassos
524

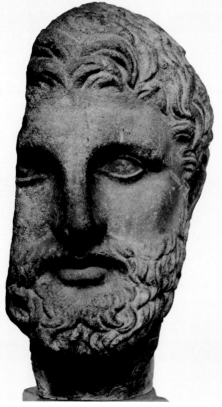

525 Head of Apollo, ca. 360–350. Ht. 42 cm. London.
526 Bearded male, ca. 360–350. Ht. 35 cm. London.

527 Persian rider, ca. 360–350. L. 2.15 m. London.
528 Panther, ca. 360–350. L. 1.0 m. London.

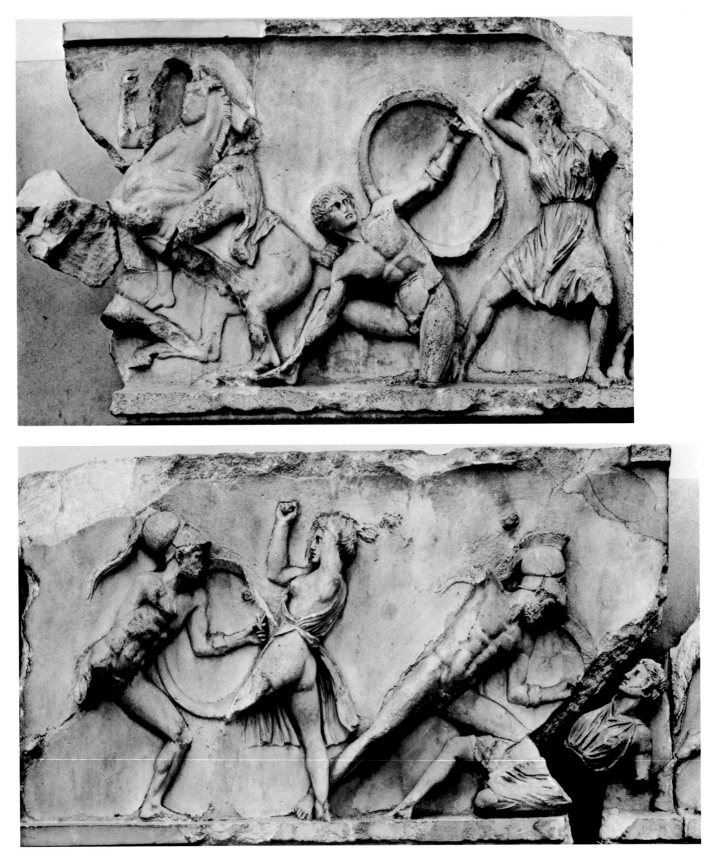

529–530 Amazon frieze, ca. 360–350. Ht. 90 cm. London.

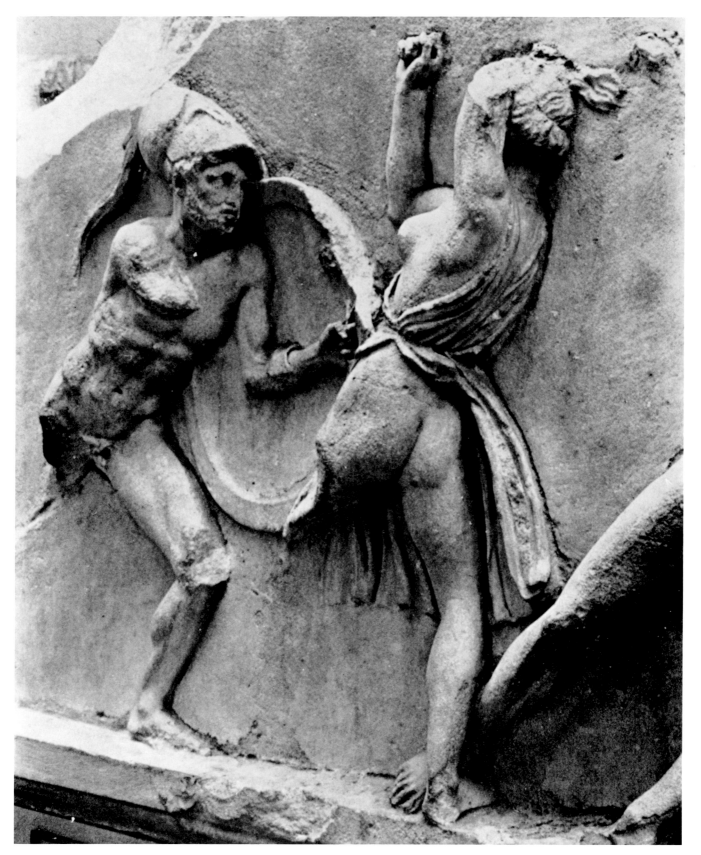

531 Detail of the Amazon and Greek, fig. 530.

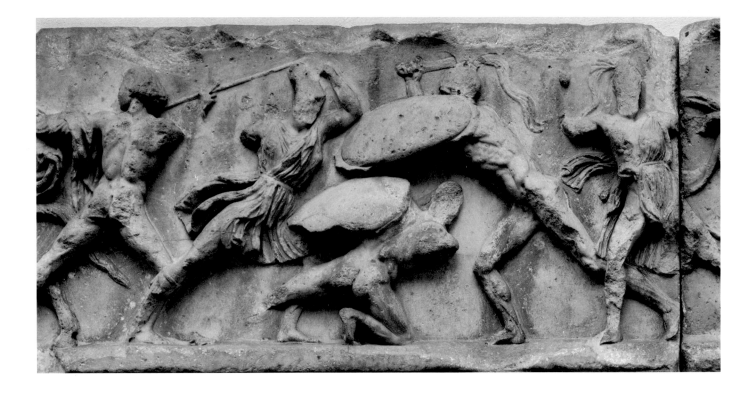

532–533 Amazon frieze, ca. 360–350. Ht. 90 cm. London.

534 Amazon frieze, ca. 360–350. Fragment of a dying Amazon. Ht. 40 cm. London.

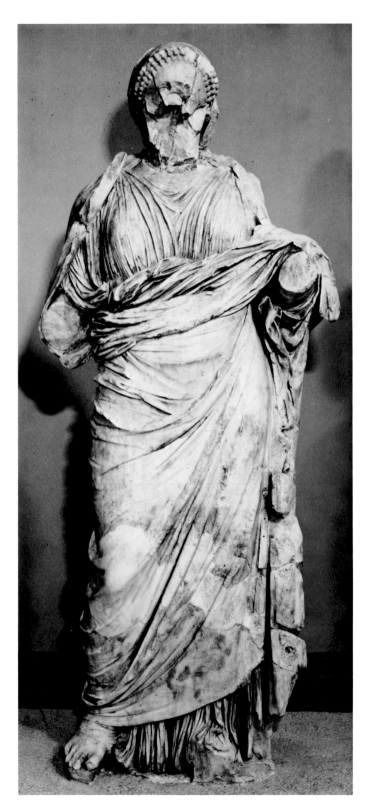

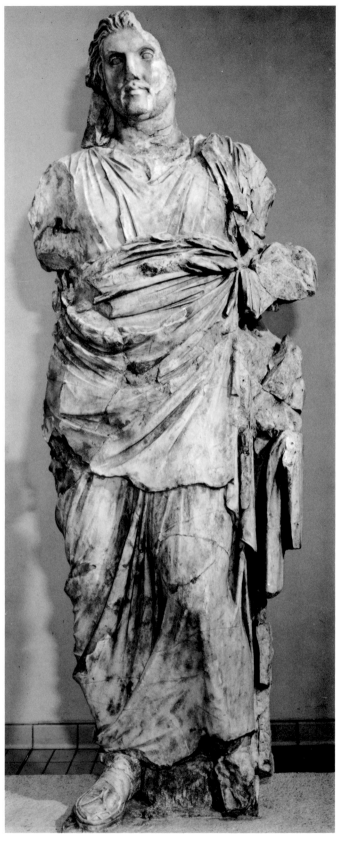

535 Carian lady and nobleman ("Artemisia" and "Maussolos"), ca. 360–350. Ht. 2.67 m, 3 m. London.

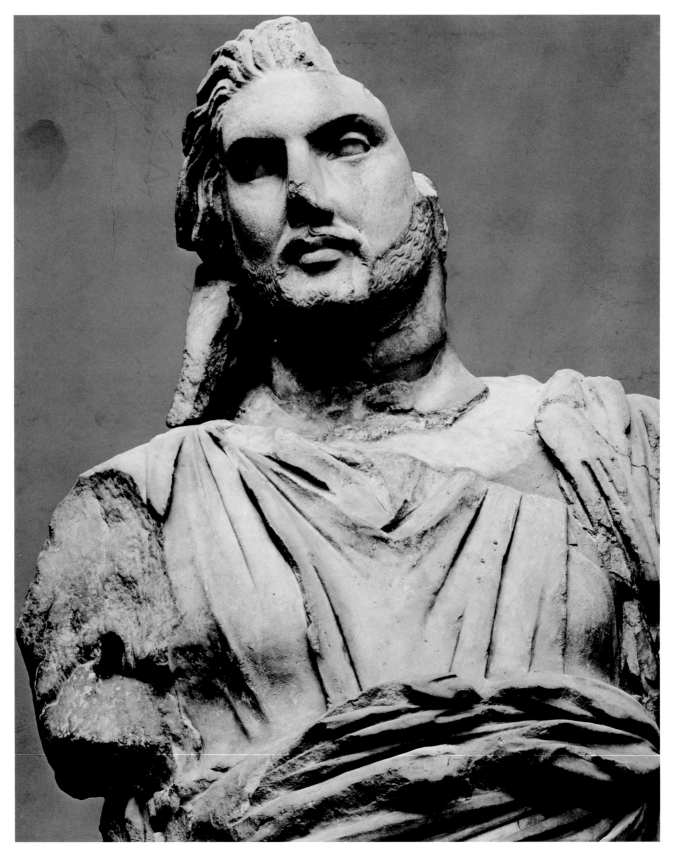

536 Detail of the man, fig. 535.

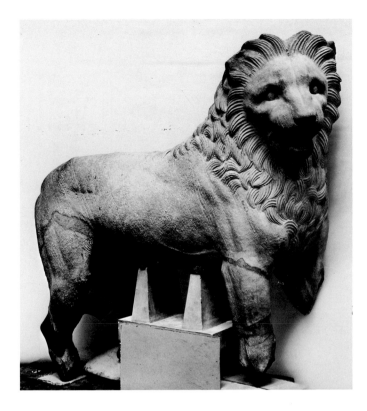

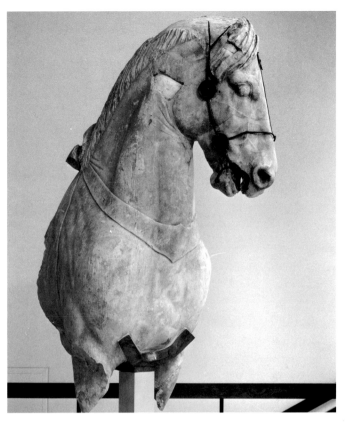

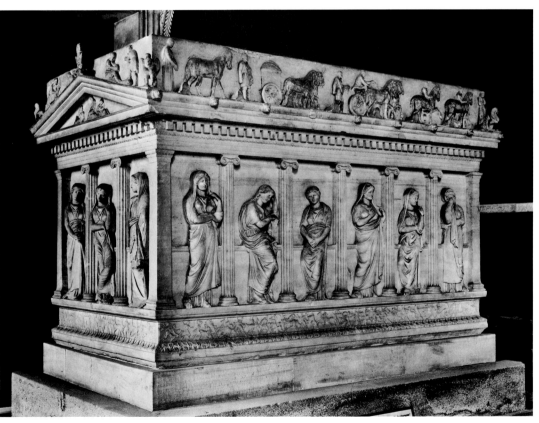

537 Lion, ca. 360–350. L. 1.5 m. London.

538 Horse from the chariot group, ca. 360–350, *top right*. Ht. 2.33 m. London.

539 "Mourning Women" sarcophagus from the royal nekropolis at Sidon, ca. 360–340. Ht. 1.8 m. Istanbul.

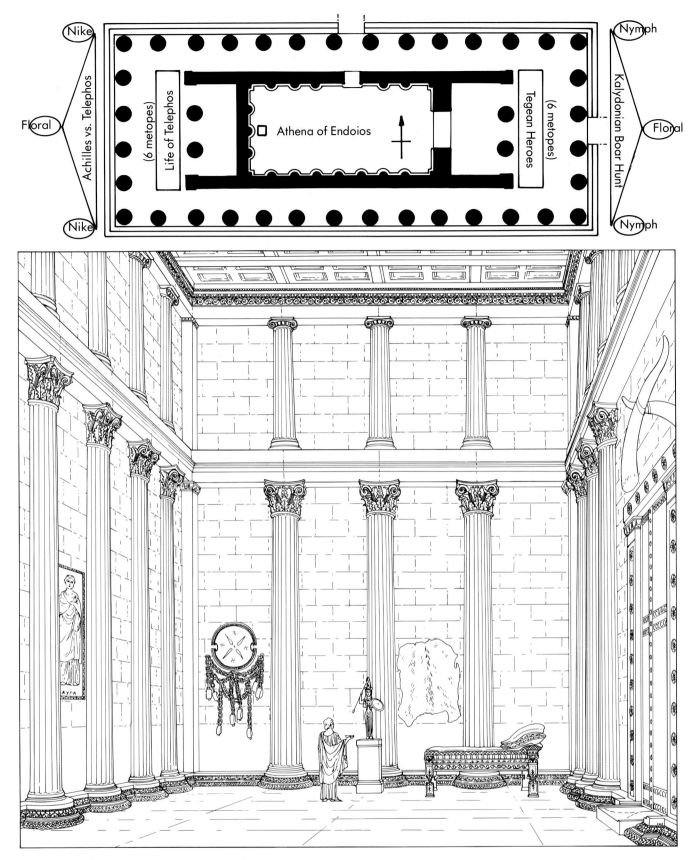

Nike

Achilles vs. Telephos

Floral

Nike

(6 metopes) Life of Telephos

Athena of Endoios

(6 metopes) Tegean Heroes

Nymph

Kalydonian Boar Hunt

Floral

Nymph

540–541 Temple of Alea Athena, Tegea: the sculptural program and reconstructed interior.

Skopas of Paros
540–541

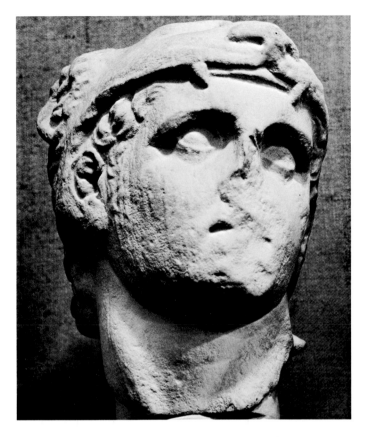

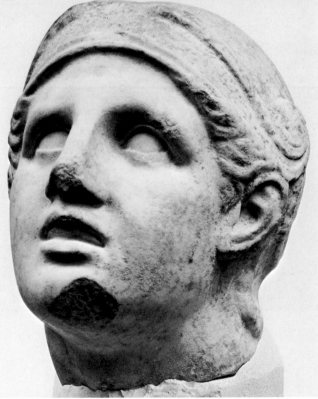

542 Head of Telephos from the west pediment, ca. 340. Ht. 31.4 cm.

543–544 Head of a warrior from the west pediment, ca. 340, *bottom left and top right*. Ht. 32.6 cm. Athens. From a cast taken before the right side of the face was in-filled with plaster.

545 Head supposedly from Tegea. Ht. 30 cm. Malibu. Modern forgery after the head, figs. 543–544.

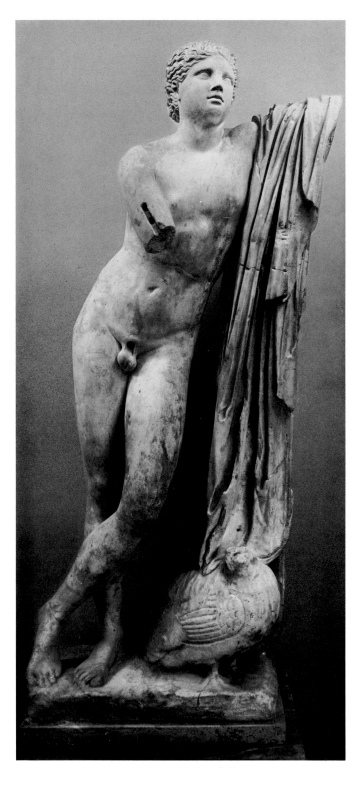

546 Pothos (Roman copy), original ca. 330. Ht. 1.80 m. Rome.

547 Statuette of a maenad (Roman copy), original ca. 360. Ht. 45 cm. Dresden.

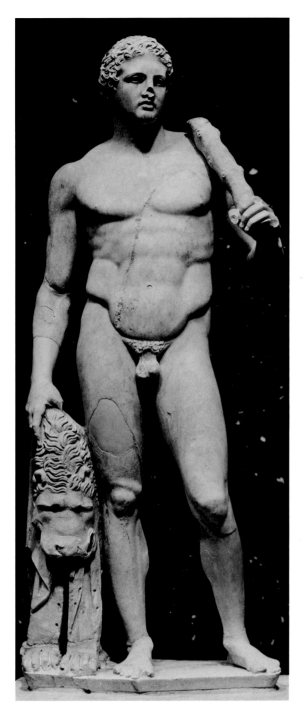

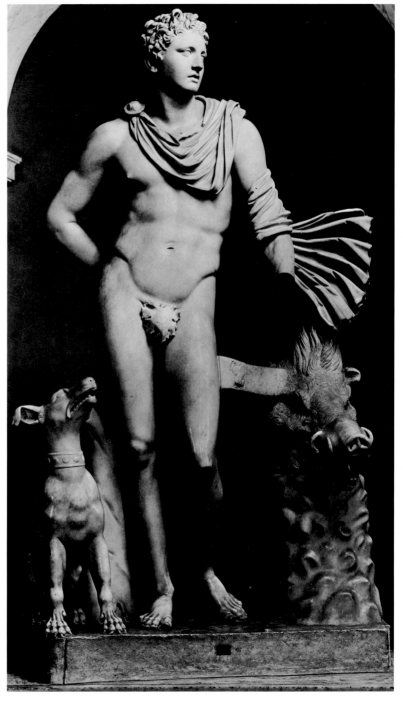

548 "Lansdowne" Herakles (Roman copy), original ca. 360. Ht. 1.93 m. Malibu.

549 Meleager (Roman copy), original ca. 340. Ht. 2.10 m. Rome. The left hand held a boar spear vertically against the shoulder.

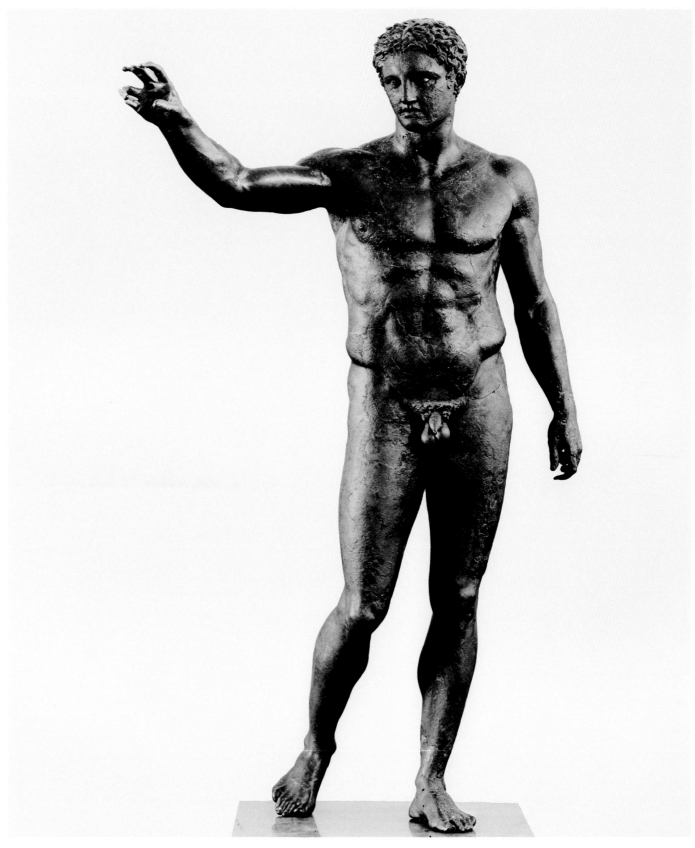

550 Perseus from a wreck off Antikythera (Greece), ca. 350–330. Bronze,
ht. 1.94 m. Athens.

The Last Generation of the Polykleitan School
550

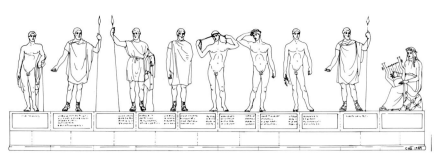

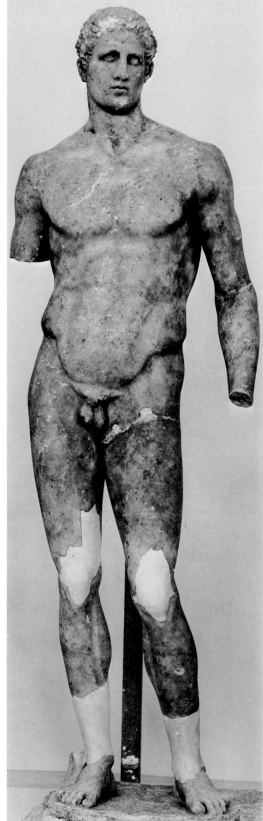

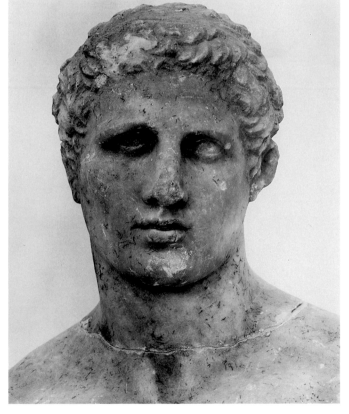

551 Daochos monument at Delphi, 337/36–333/32. L. 11.6 m.

552–553 Agias from the Daochos monument, 337/36–333/32. Ht. 2 m. His ankles and knees are restored.

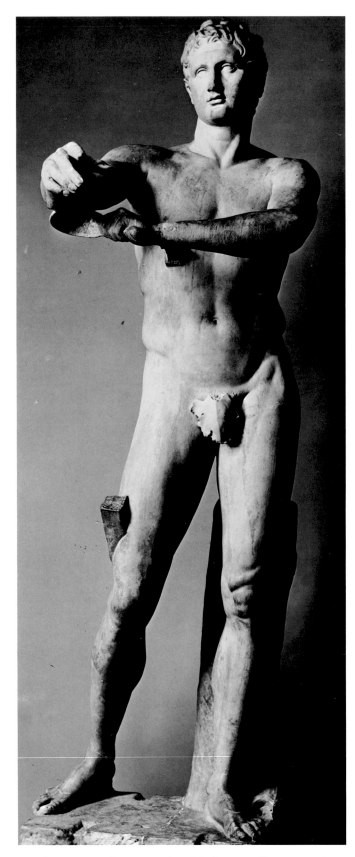

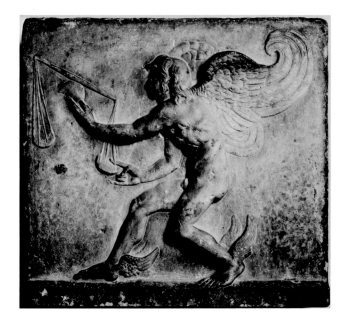

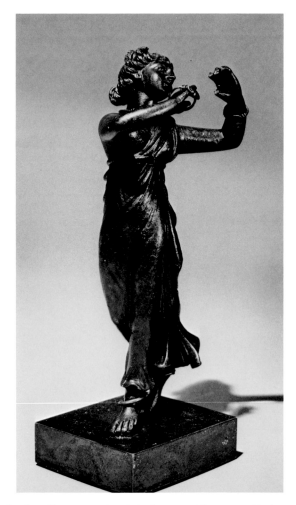

554 Apoxyomenos (Roman copy), original ca. 320. Ht. 2.05 m. Rome. Most of the nose, the left ear, and parts of the fingers, strigil, and toes are restored.

555 Relief of Kairos (Roman copy), original ca. 330. Ht. 60 cm. Turin.

556 Statuette of a dancing flutegirl (Roman copy), original ca. 330–320. Bronze, ht. 16.2 cm. Santa Barbara.

Lysippos
554–556

557 Head of Sokrates ("type B"; Roman copy), original ca. 340–320. Ht. 35.5 cm. Rome. The tip of the nose and the left part of the upper lip are restored.

558 Statuette of Sokrates ("type B"; Hellenistic or Roman copy) from Alexandria, original ca. 340–320. Ht. 27.5 cm. London.

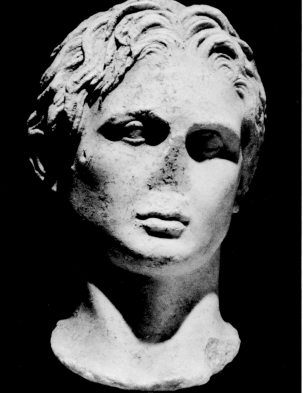

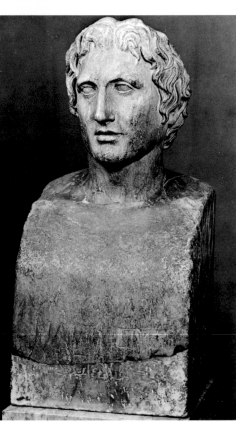

559 Tetradrachm of Lysimachos of Thrace, 306–281. Alexander with diadem and Ammon's horns. Silver, d. 2.9 cm. London.

560 Head of Alexander from the Akropolis, ca. 340–335, if not a later copy. Ht. 35 cm.

561 "Schwarzenberg" Alexander (Roman copy), original ca. 335–320. Ht. 37 cm. Vienna.

562 "Azara" Alexander (Roman copy), original ca. 335–320. Ht. 68 cm. Paris. The face has been smoothed over, and the lips, nose, and eyebrows restored.

Lysippic and Other Alexanders
559–565

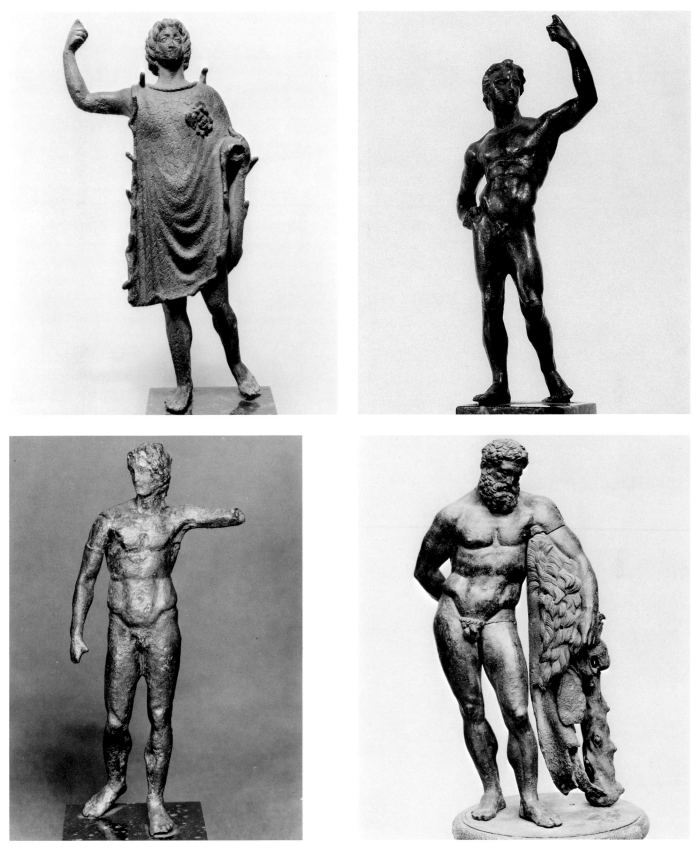

563 Statuette of Alexander Aigiochos (Roman copy), from Alexandria, original ca. 330–310. Bronze, ht. 31 cm. London.

564 "Fouquet" Alexander (Roman copy), from Alexandria, original ca. 335–320. Bronze, ht. 16.5 cm. Paris.

565 "Nelidow" Alexander (Roman copy), original ca. 335–320. Bronze, ht. 10 cm. Original, ca. 335–320. Cambridge (Mass.). The legs are restored below the knee.

566 Herakles ("Farnese" type; Roman copy), original ca. 320. Bronze, ht. 42.5 cm. Paris.

567 Charging Herakles (Roman copy), original ca. 330–320. Ht. 1.74 m. Rome. The nose is restored.

568 Statuette of Zeus, ca. 330–300, if not Roman. Bronze, ht. 24.5 cm. New York.

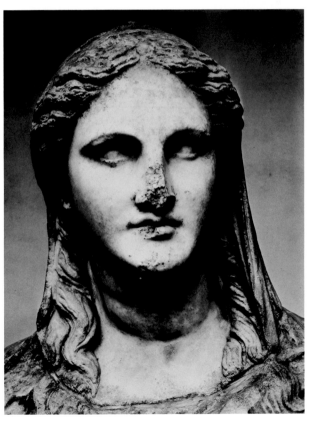

569–570 Artemis from the Piraeus, ca. 330–320. Bronze, ht. 1.95 m. 571 Head of the Demeter of Knidos, fig. 572.

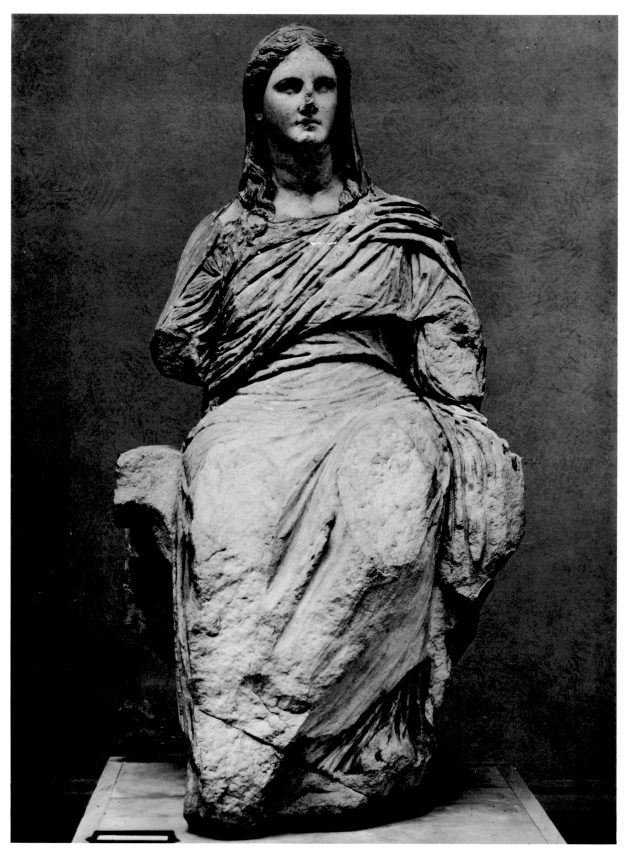

572 Demeter, cult statue of the sanctuary of Demeter at Knidos, ca. 340–
330. Ht. 1.47 m. London.

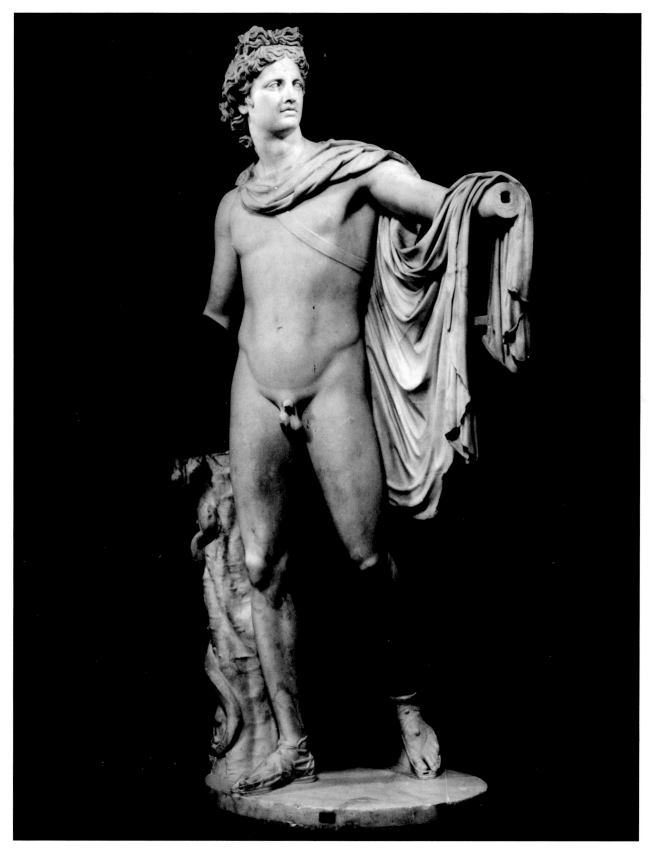

573 "Belvedere" Apollo (Roman copy), original ca. 330. Ht. 2.24 m.
Rome.

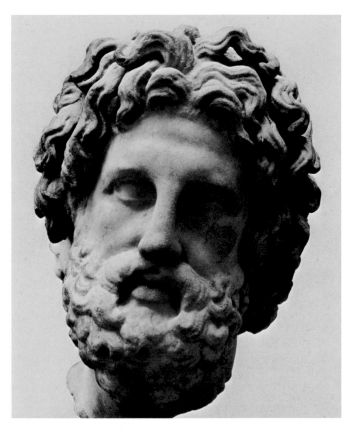

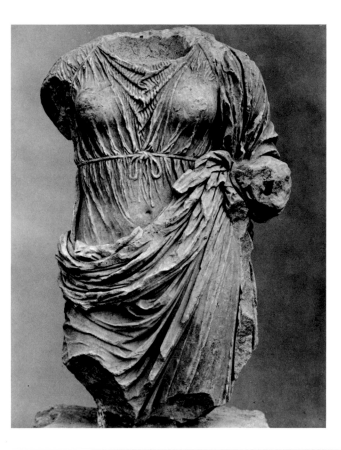

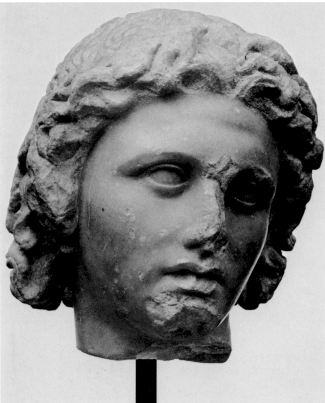

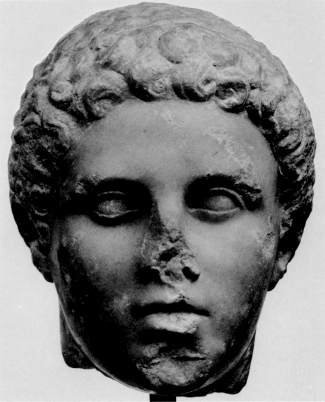

574 "Blacas" Asklepios from Melos, ca. 330. Ht. 58.4 cm. London.

576 Head of Alexander, reportedly from Megara, ca. 320. Ht. 28 cm.
Malibu. Acquired with numerous other fragments presumably from
the same monument; the hair was recut in antiquity.

575 Colossal female torso, perhaps of Demokratia, from the Stoa Basileos
in the Athenian Agora, ca. 330–300. Ht. 1.54 m.

577 Head of a youth, perhaps Alexander's companion Hephaistion, from
the same ensemble as the head, fig. 576; ca. 320. Ht. 26 cm. Malibu.
The hair was recut in antiquity.

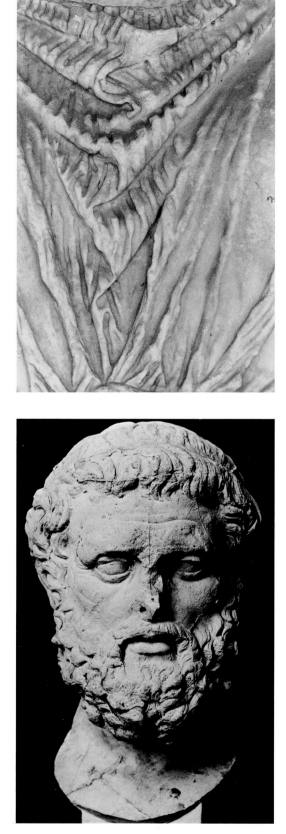

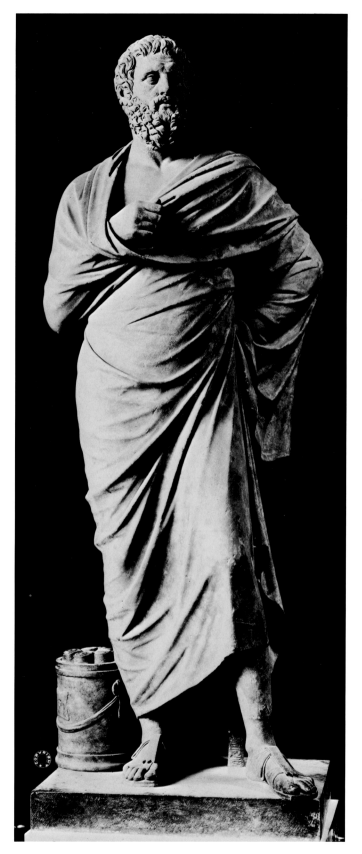

578 Detail of the torso of "Demokratia," fig. 575.

579 Sophokles (Roman copy), original probably 338–324. Ht. 2.04 m.
Rome. Extensively reworked in the nineteenth century.
580 Cast of the head of the Sophokles, fig. 579, taken before restoration,
bottom left.

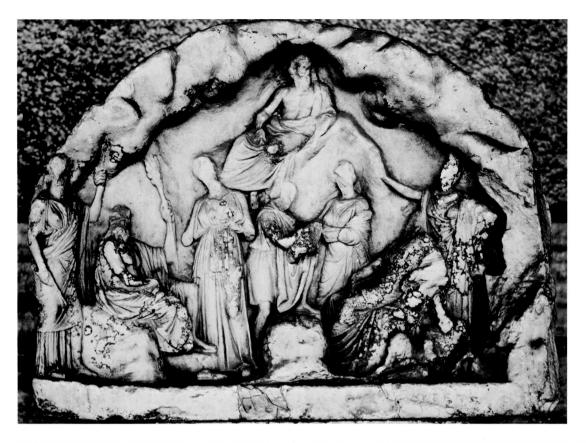

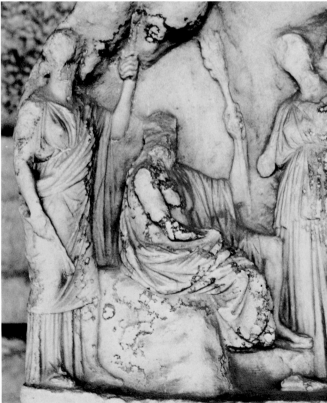

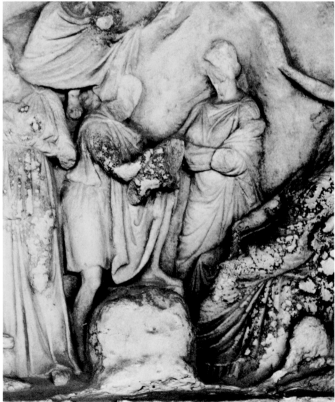

581–583 Votive relief dedicated by Neoptolemos of Melite, from the Athenian Agora, ca. 330–320. Zeus presides over an assembly of divinities (*left,* Demeter, Apollo, Artemis; *right,* two Nymphs, Pan, and Acheloos), while Hermes delivers the infant Dionysos to a Nymph at center. Ht. 64.5 cm.

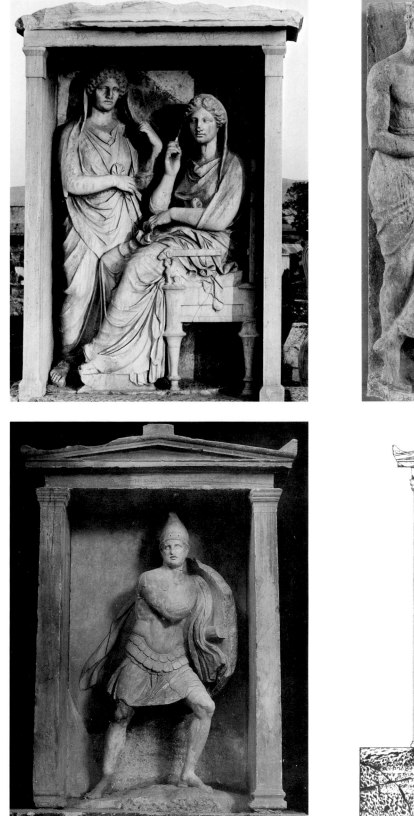

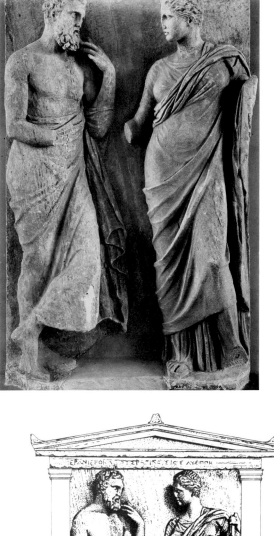

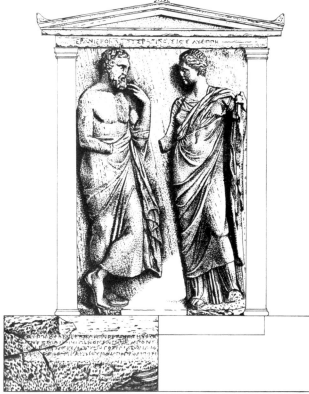

584 Grave relief of Demetria and Pamphile, from the Kerameikos, Athens, ca. 330–317. Ht. 2.15 m.

585 Grave relief of Aristonautes, from the Kerameikos, Athens, ca. 330–317. Ht. 2.91 m; of figure, 2 m.

586–587 Grave relief of Hieron and Lysippe from Rhamnous, ca. 330–317. Ht. 1.81 m. Athens.

The Latest Attic Gravestones
584–587

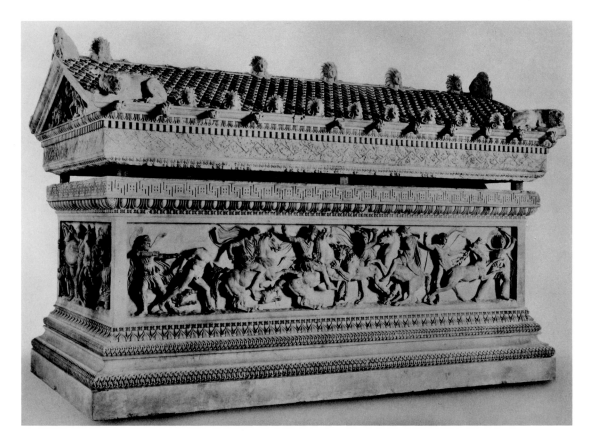

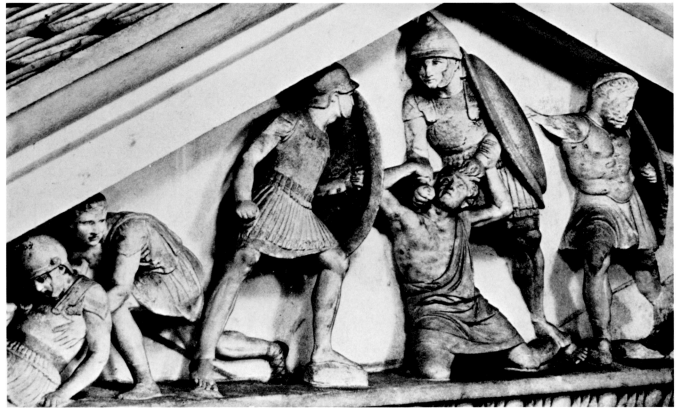

588 The "Alexander" sarcophagus (probably the sarcophagus of King Ab-
dalonymos of Sidon), from the royal nekropolis of Sidon, ca. 320–
310. Ht. of friezes, 69 cm. Istanbul. For the polychromy, see chapter
16.3.

589 Pediment relief from the sarcophagus, fig. 588: murder of Perdikkas
in 321?

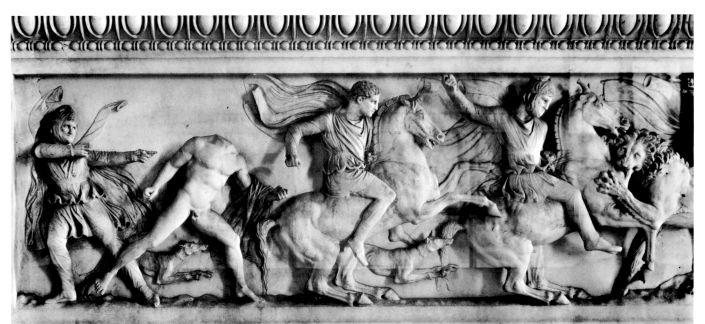

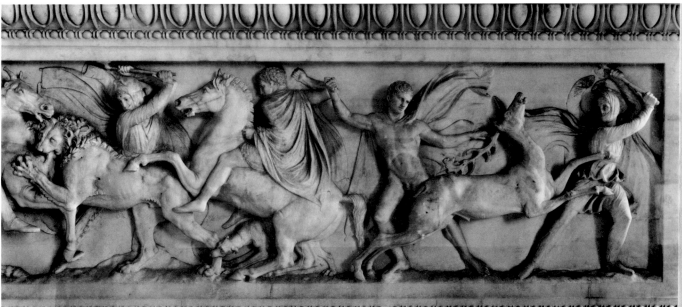

590–591 Hunt on the long side of the sarcophagus, fig. 588: Alexander
 hunting in the Persian royal park at Sidon in 332?

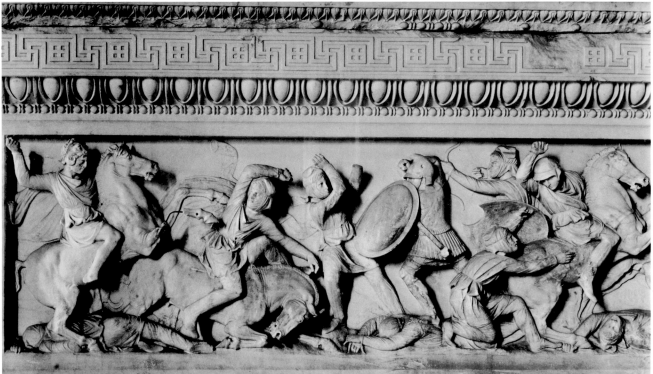

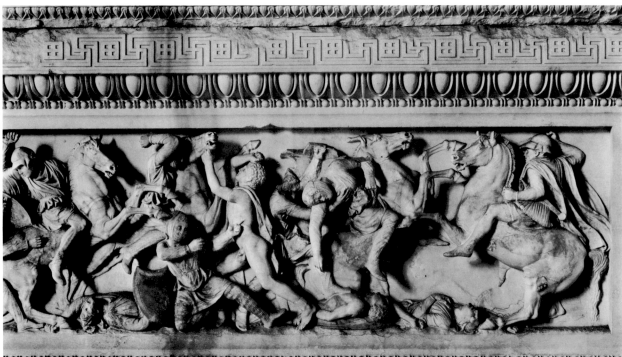

592–593 Battle on the long side of the sarcophagus, fig. 588. Alexander
at the battle of the Issos in 333.

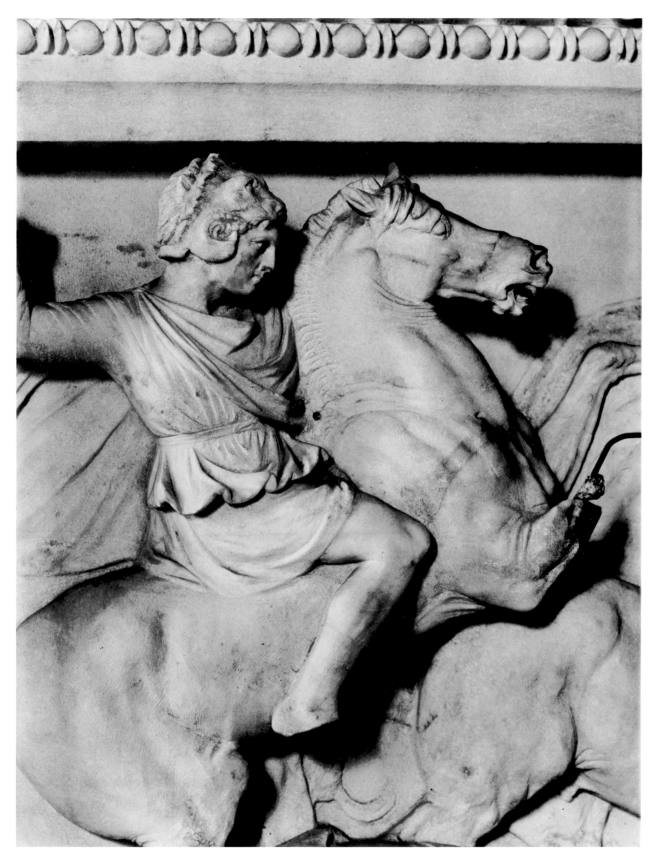

594 Detail of the battle, fig. 588: Alexander.

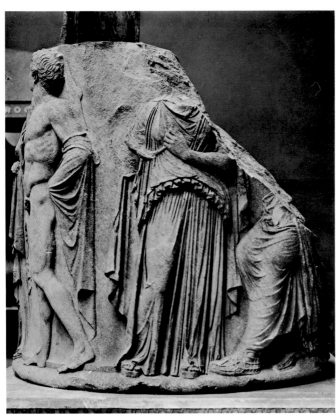

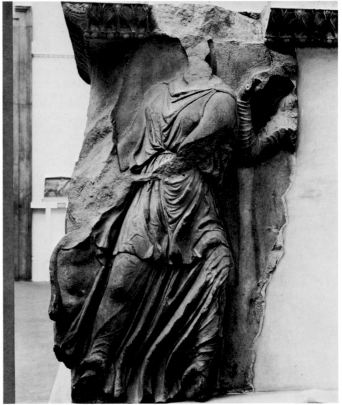

595–596 Column drum from the temple of Artemis at Ephesos, ca. 330–310. Thanatos, Iphigeneia (?), and Hermes Psychopompos; Hermes, Klytemnestra (?) and Kalchas (?). Ht. 1.82 m. London.

597 Plinth from the temple of Artemis at Ephesos, ca. 330–310. Fight (Herakles and a giant?). Ht. 1.85 m. London.

598 Plinth from the temple of Artemis at Ephesos, ca. 330–310. Unexplained subject (seated man and two women). Ht. 1.85 m. London.

The Temple of Artemis at Ephesos
595–598

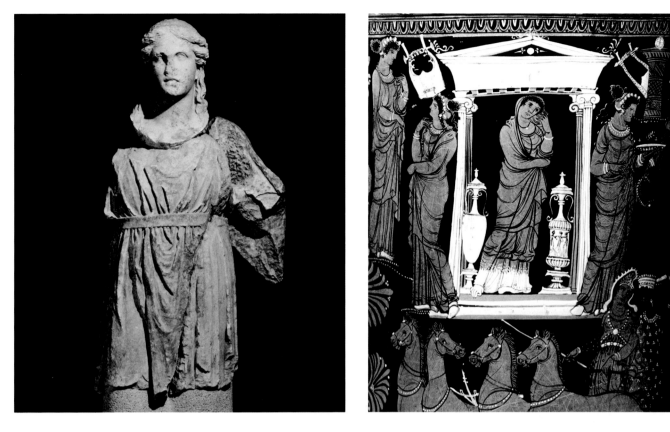

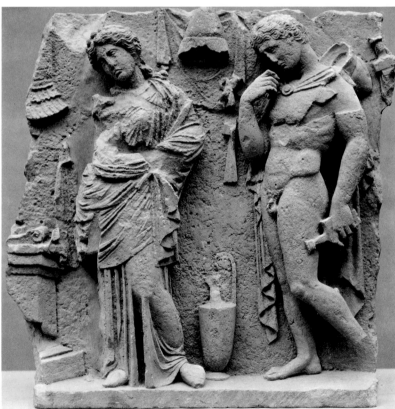

599 Dionysos by Praxias or Androsthenes of Athens, from the west pediment of the temple of Apollo at Delphi, ca. 330. Ht. 1.5 m. The god held a kithara in the crook of his left arm.

600 Apulian red-figure loutrophoros, ca. 330. Ht. 98 cm. Malibu.

601 Relief from a Tarentine funerary monument, ca. 320–300. Orestes and Elektra at the tomb of Agamemnon? Limestone, ht. 58.5 cm. New York.

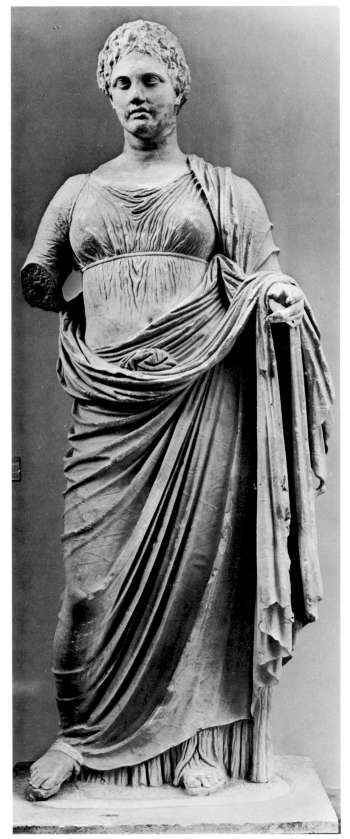

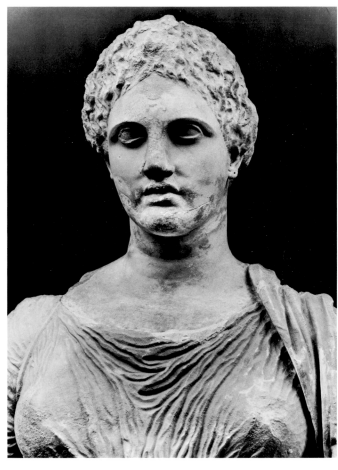

602–603 Themis from Rhamnous (Attica), dedicated by Megakles and carved by Chairestratos, both of Rhamnous, ca. 300. Ht. 2.22 m. Athens.

The Themis of Chairestratos
602–603

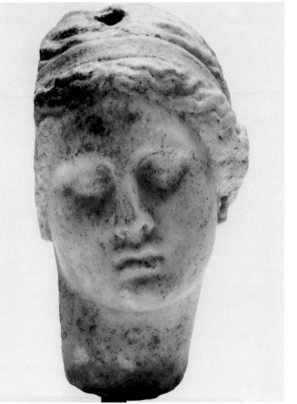

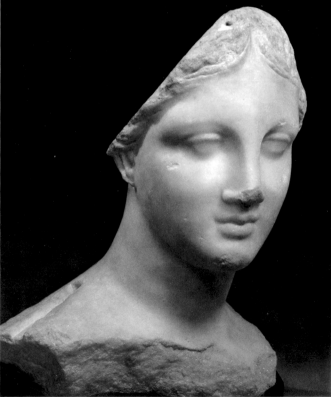

604 Statuettes from the Asklepieion at Cos, ca. 300–275. Ht. 55 cm, 63 cm. Istanbul.

605 Head of a statuette from the Asklepieion at Cos. Ht. 20 cm. Stuttgart.

606 Head of a woman from Chios, ca. 320–300. Ht. 36 cm. Boston.

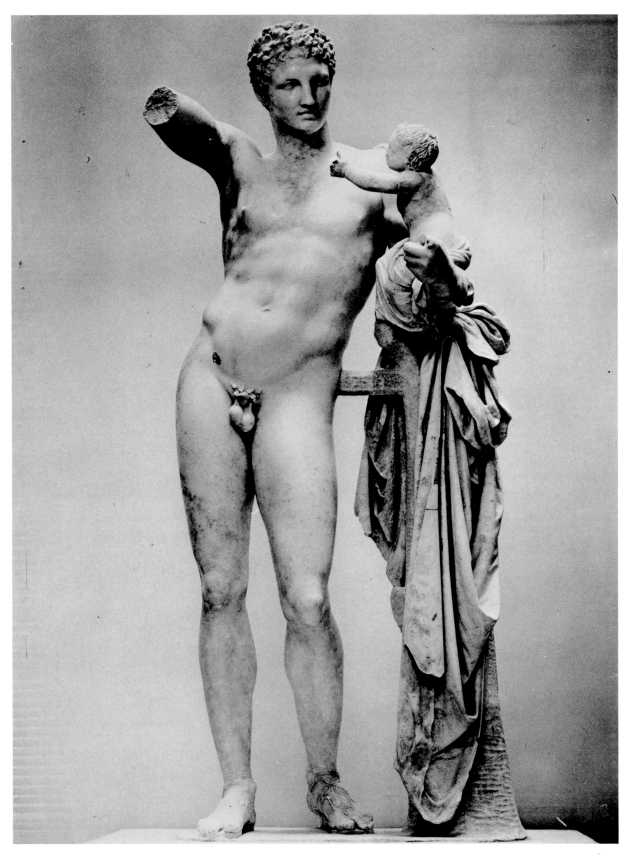

607 Hermes and the infant Dionysos, from the Heraion at Olympia, ca.
300–250 (?). Ht. 2.15 m. Attributed by Pausanias (T 93) to Praxiteles.
The entire left leg below the knee and the right leg from knee to ankle
are restored.

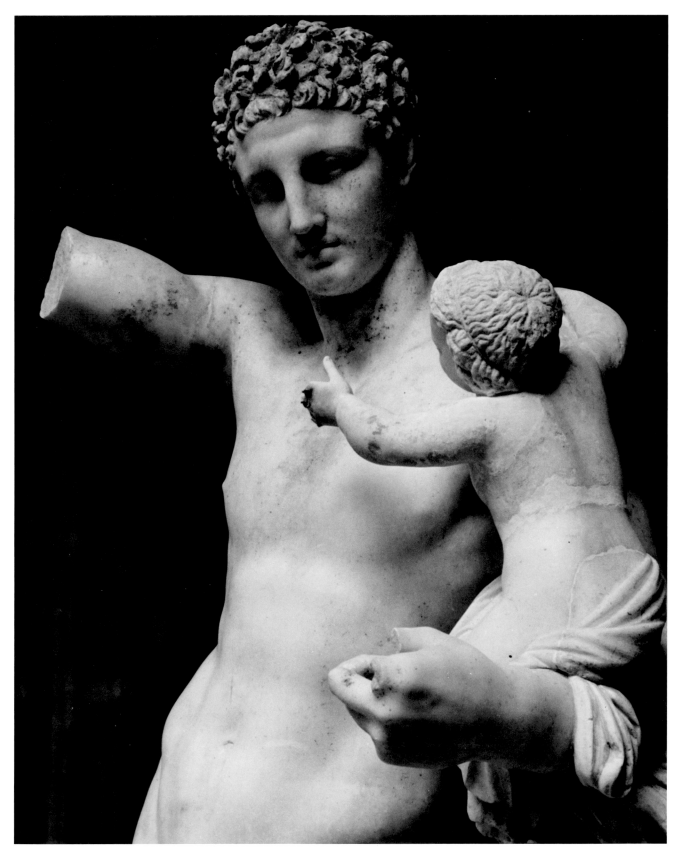

608 Detail of the Hermes, fig. 607.

609 Fresco in the Casa del Naviglio at Pompeii: Hermes and the infant Dionysos.

610 Inscribed bust of Menander attributed to the sons of Praxiteles (Roman copy), original ca. 300. Bronze, ht. 17 cm. Malibu.

611 Epikouros, from a double herm of Epikouros and Metrodoros (Roman copy), original ca. 270. Ht. 60 cm. Rome.

612 Statuette of Hermarchos (Roman copy), original ca. 270. Ht. 1.07 m. Florence.

The Sons and Followers of Praxiteles
609–612

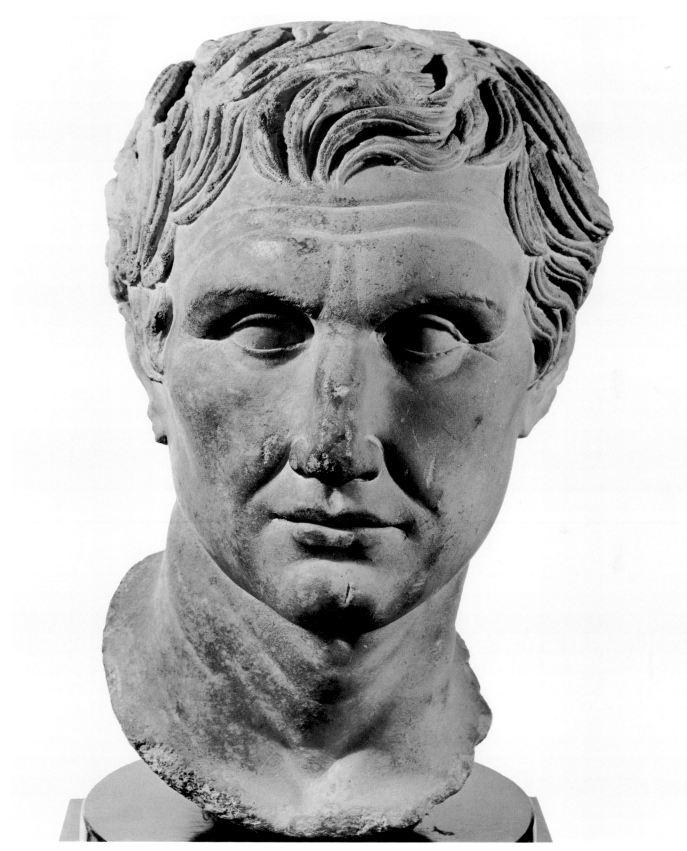

613 Head of Menander attributed to the sons of Praxiteles (Roman copy),
original ca. 300. Ht. 34 cm. Dumbarton Oaks.

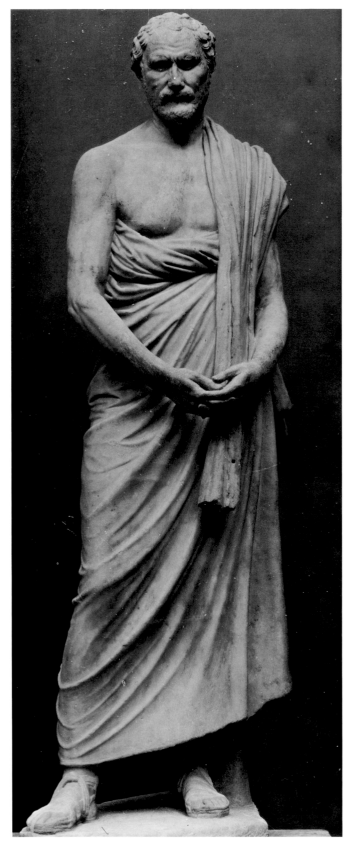
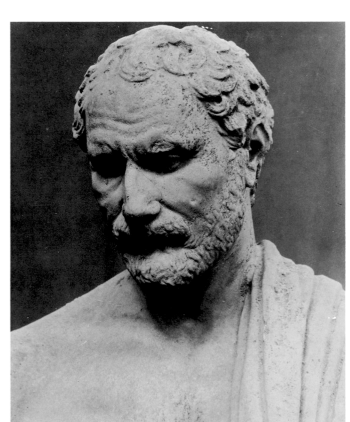
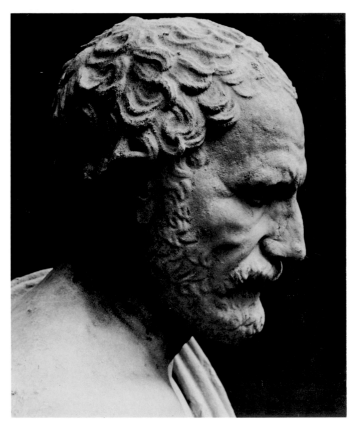

614–616 Demosthenes (Roman copy), original 280/79. Ht. 2.02 m. Copenhagen.

The Demosthenes of Polyeuktos
614–616

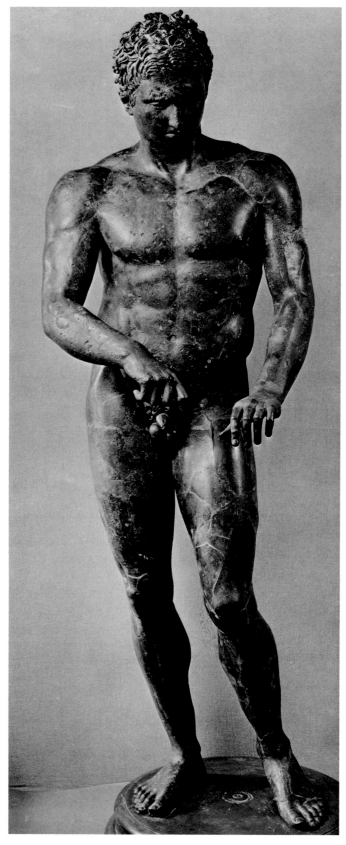

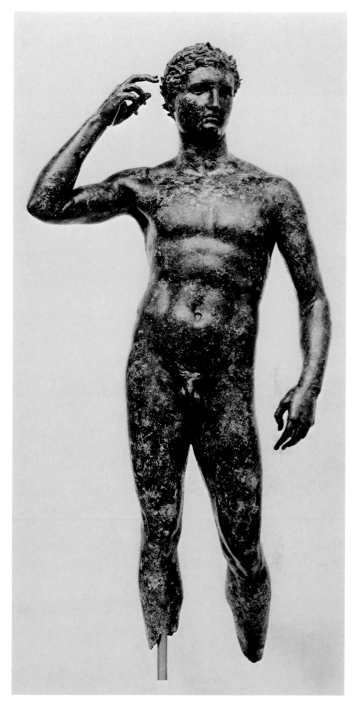

617 Athlete cleaning his strigil, from Ephesos, ca. 300, if not a Roman overcasting. Bronze, ht. 1.92 m. Vienna.

618 Athlete adjusting his crown (the "Getty Bronze"), from the Adriatic Sea, ca. 300. Bronze, ht. 1.51 m. Malibu.

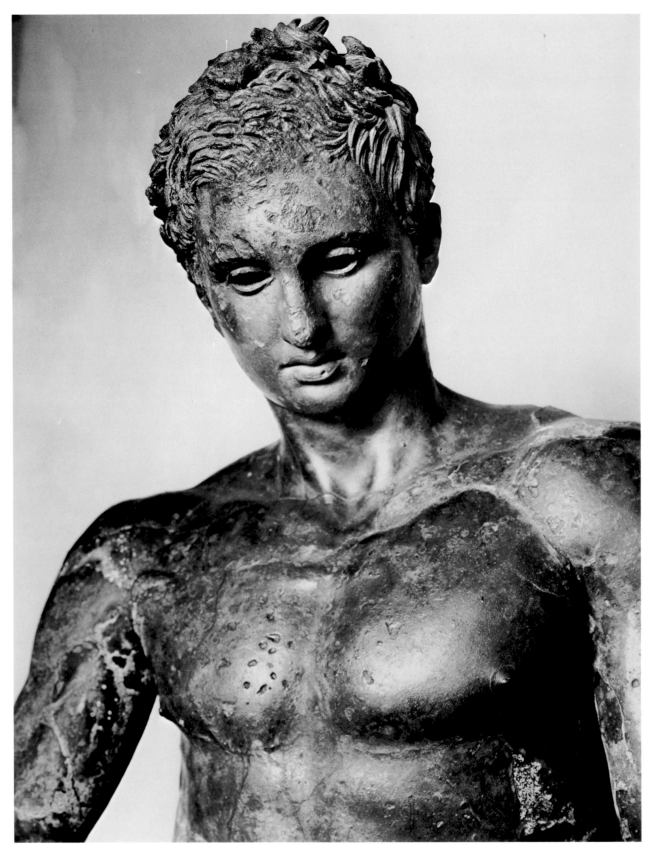

619 Head of the athlete from Ephesos, fig. 617.

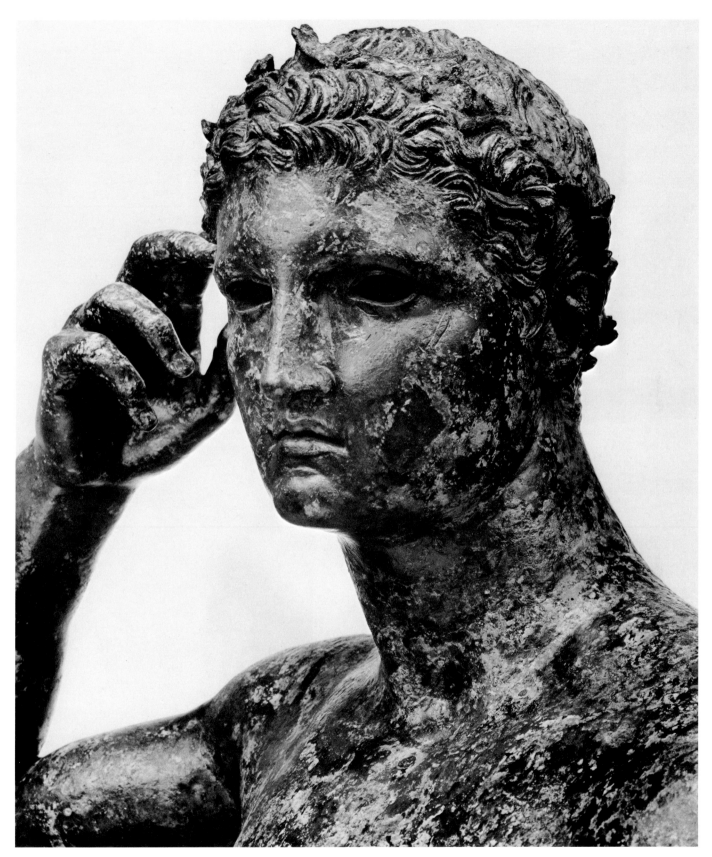

620 Head of the Getty athlete, fig. 618.

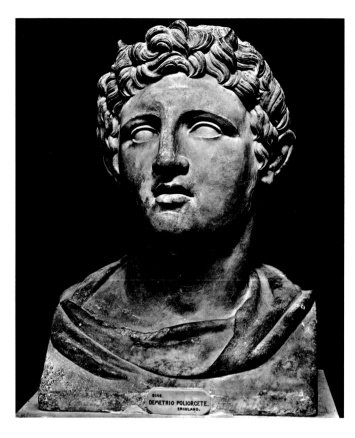

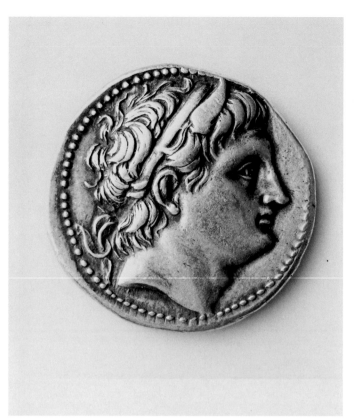

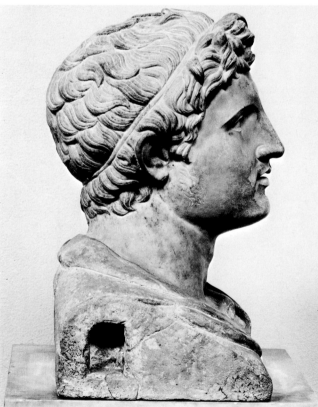

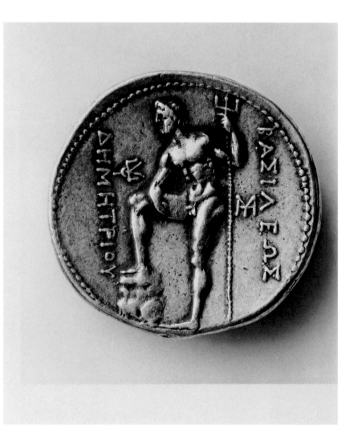

621–622 Herm identified as King Demetrios Poliorketes (Roman copy), from the Villa dei Papiri at Herculaneum, original probably 306–283. Ht. 43.5 cm. Naples.

623 Tetradrachm of King Demetrios Poliorketes, 306–283: Demetrios with the diadem and bull's horns (obverse); Poseidon (reverse). Silver, d. 2 cm. London.

The School of Lysippos
621–623

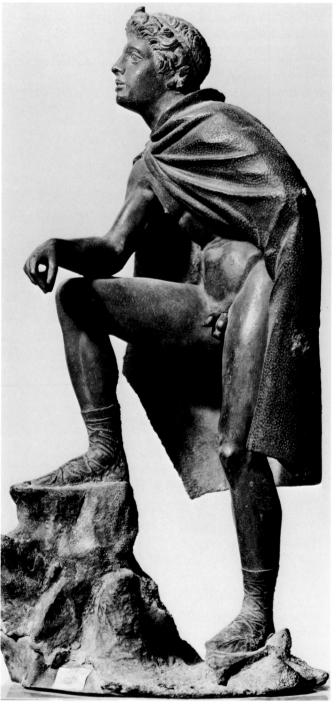

624 Colossal head identified as King Demetrios Poliorketes, from the steps of the Dodekatheon at Delos, ca. 306–301(?). Ht. 55 cm. Two cuttings for marble horns are present in the hair.

625 Statuette identified as King Demetrios Poliorketes (Roman copy), original ca. 306–283. Bronze, ht. 30 cm. Naples.

626 Statuette of the Tyche (Fortune) of Antioch by Eutychides (Roman copy), original ca. 300–290. Ht. 89 cm. Rome. The head, though ancient, is from another statue.

627 Statuette of the Tyche (Fortune) of Antioch by Eutychides (Roman copy), original ca. 300–290. Ht. 47 cm. Budapest.

628 Coin of Volusianus, minted in Antioch, AD 251–53. The Tyche in her portable shrine. Bronze, d. 2.8 cm. Paris.

629 Tetradrachm of King Antiochus IV of Syria, 175–164. The Apollo Mousagetes of Bryaxis at Daphne. Silver, d. 1.8 cm.

630 Bust identified as King Seleukos I Nikator of Syria (Roman copy),
from the Villa dei Papiri at Herculaneum, original probably 306–281.
Bronze, ht. 50 cm. Naples.

631 Tetradrachm of Philetairos of Pergamon, 283–264. King Seleukos I
Nikator of Syria. Silver, d. 1.8 cm. Private collection.
632 Statuette of Sarapis (Roman copy), original ca. 286–278. Ht. 24 cm.
Ostia.

633 Head of Sarapis (Roman copy), original ca. 286–278. Ht. 22 cm.
Cambridge (England).
634 Roman gem showing Sarapis in his temple. D. 1.4 cm. London.

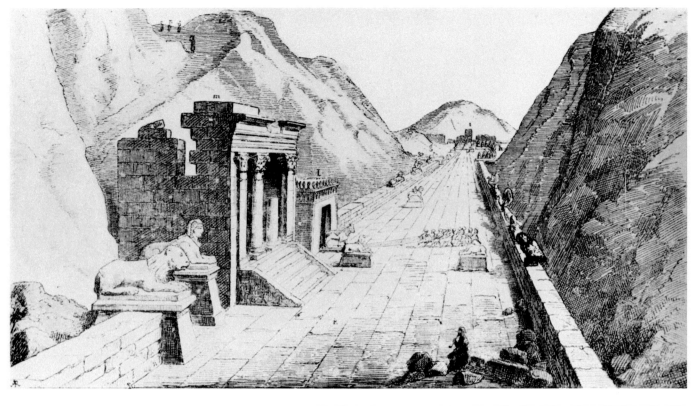

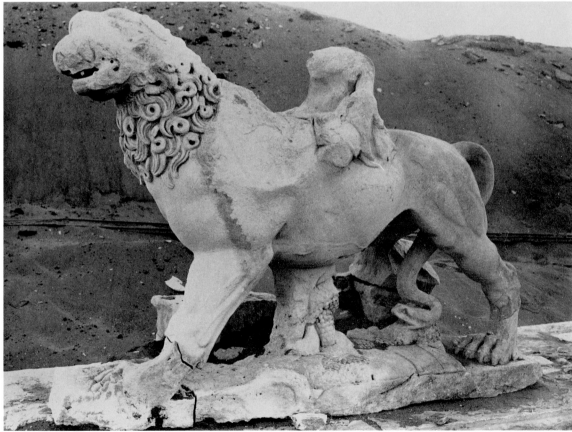

635 The Sarapeion at Memphis in the nineteenth century.

636 The baby Dionysos riding Kerberos, from the Sarapeion at Memphis, ca. 250. Limestone, ht. 1.80 m.

637 Dionysos (now missing) riding a peacock, from the Sarapeion at Memphis, ca. 250. Limestone, ht. 1.80 m.

638 Pindar, from the semicircle of sages, fig. 635, ca. 250–150 (?). Limestone, ht. 1.85 m.

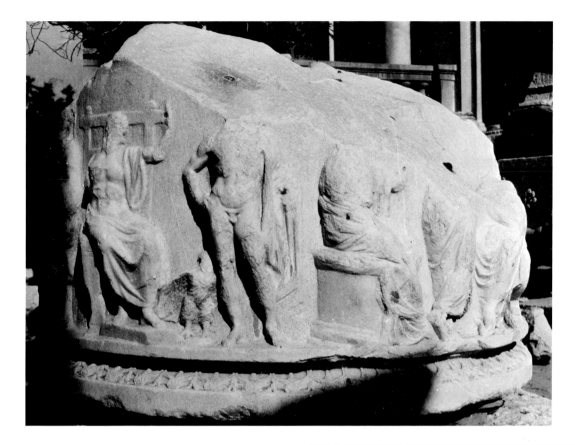

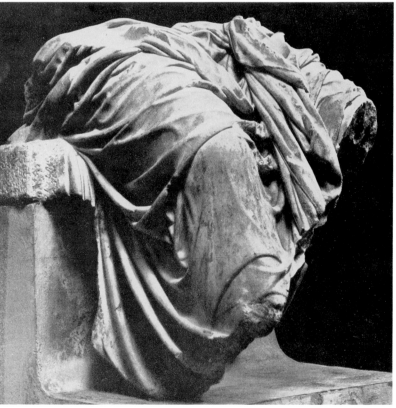

639 Column drum or altar base from Azerita (Alexandria), ca. 250–150. From left, Hera, Zeus (enthroned), Hermes, Hestia(?), Asklepios(?), Aphrodite(?). Ht. ca. 1 m.

640 Draped torso from Alexandria, ca. 300–250. Ht. 75 cm.

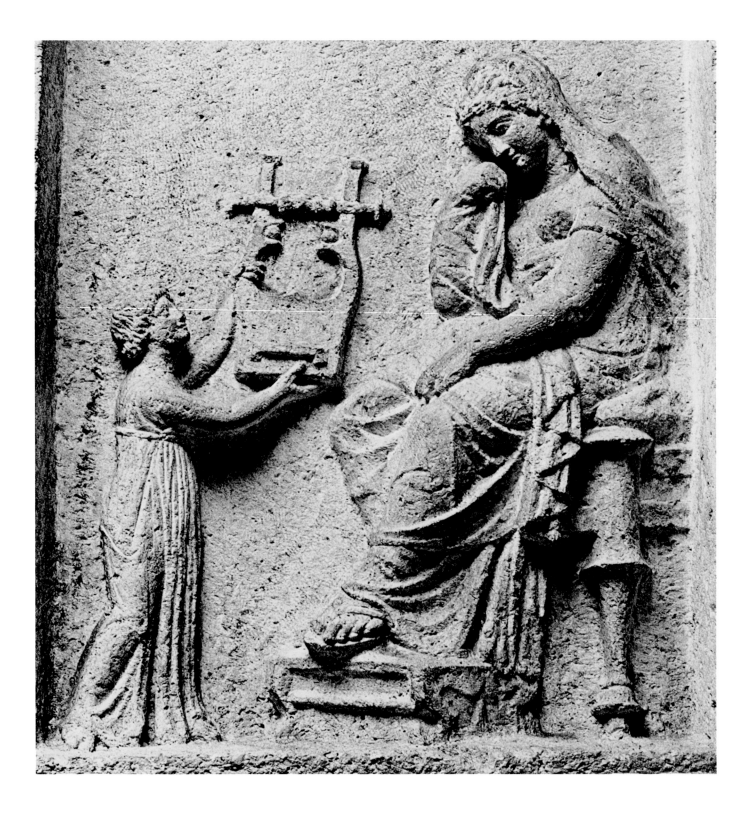

641 Gravestone of Niko, from Alexandria, ca. 250. Limestone, ht. (in-
cluding base, not shown) 69 cm. Cairo.

The Gravestone of Niko
641

642 Tetradrachm of Ptolemy I, 306–282. Head of Ptolemy, diademed. Silver, d. 1.8 cm. Private collection.

644 Head of a Ptolemy, perhaps Ptolemy III Euergetes, ca. 250–200. Reportedly from Egypt. Ht. 34.5 cm. Switzerland.

643 King Ptolemy I Soter, supposedly from Greece or Asia Minor, ca. 300–275. Ht. 24 cm. Paris. Only the face is antique.

645 Ptolemaic Queen or Aphrodite, ca. 275–225. Ht. 30 cm. Formerly Munich art market.

646 Black boy, ca. 300–200. Bronze, ht. 18 cm. New York.

647 Grotesque phallic dancer, ca. 300–200. Faience, ht. 6.3 cm. Baltimore.

648 The "Baker Dancer," from Egypt, ca. 250–220. Bronze, ht. 21 cm. New York.

649 Black boy ("Black Orpheus") playing a small harp, from Chalons-sur-Saône (France), ca. 250–200 or perhaps first century AD. Bronze, ht. 20.2 cm. Paris.

650–651 Metopes from the temple of Athena at Ilion, ca. 300–280. Helios; defeated giant. Ht. 85 cm. Berlin and Çanakkale.

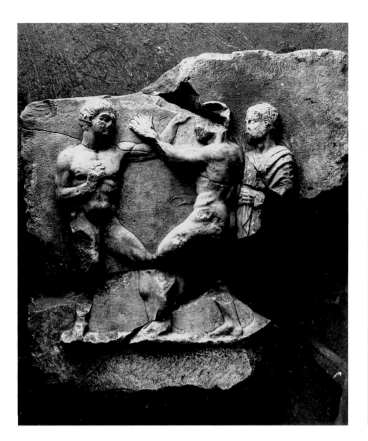

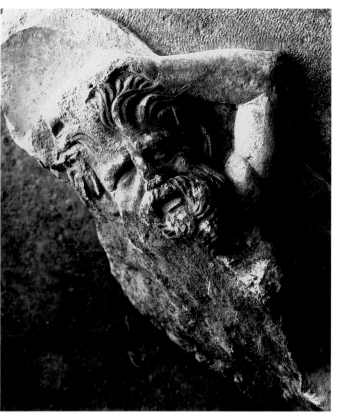

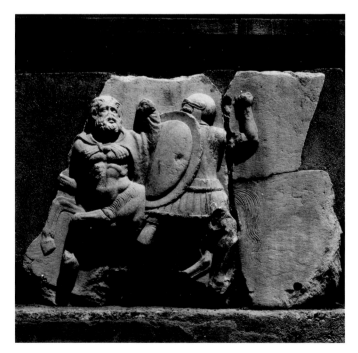

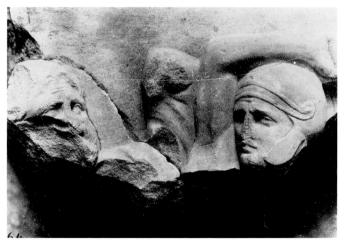

652–655 Coffer reliefs from the Mausoleum at Belevi, near Ephesos, ca. 300–280. Boxing match, *top left*; Centauromachy. Ht. of coffers, 1.13 m. Izmir.

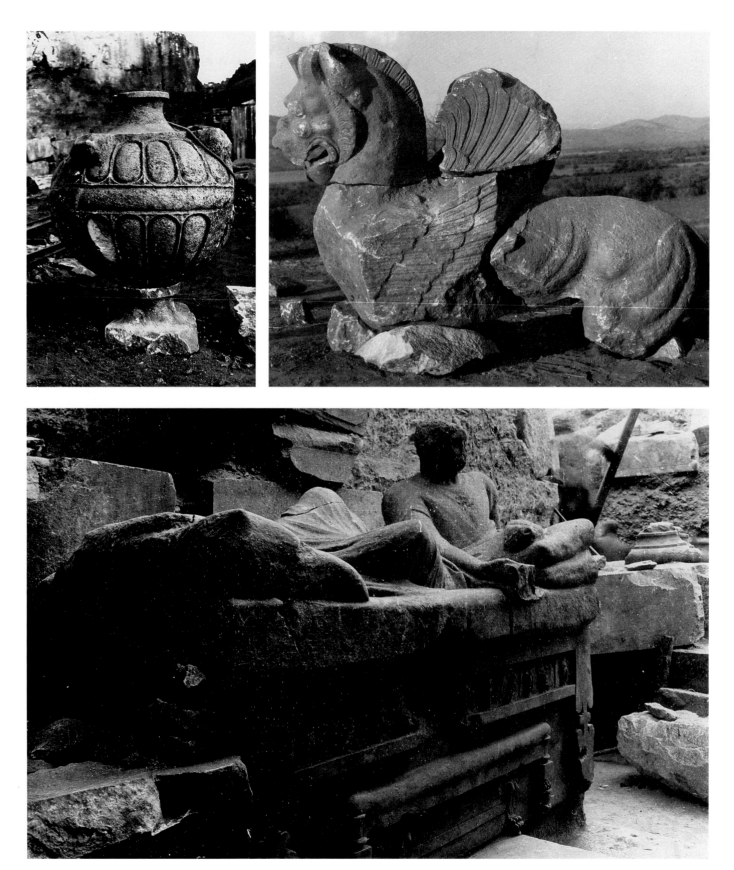

656 Griffin and vase, roof decoration of the Mausoleum at Belevi, near Ephesos, perhaps ca. 246–240. Ht. of griffins, 1.4 m; of vase, 1.07 m. Izmir.

657 King (Antiochos II Theos of Syria?) on a couch, from the tomb chamber of the Mausoleum at Belevi, near Ephesos, perhaps ca. 246–240. Ht. 2.11 m. Selçuk.

The Mausoleum at Belevi
656–657

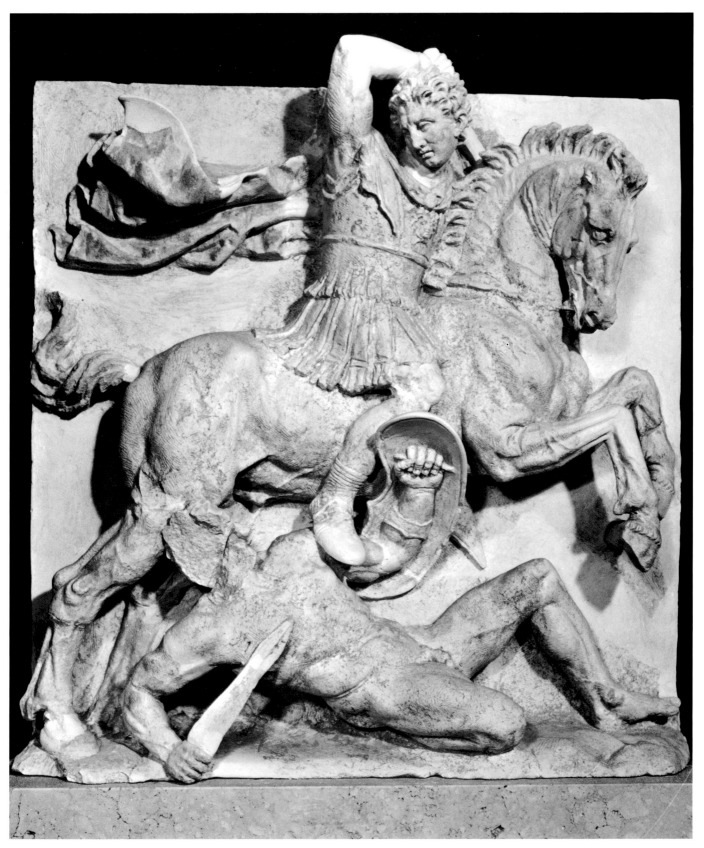

658 Metope from a funerary naiskos on the Via Umbria at Taranto, ca.
275–250: warrior and barbarian. Limestone, ht. 43 cm.

659 Reconstruction of a funerary naiskos on the Via Umbria at Taranto, ca. 275–250. Limestone, original ht. ca. 7 m.

660–661 Barbarian from the metopes of the naiskos, fig. 659. Limestone, ht. 39.2 cm.

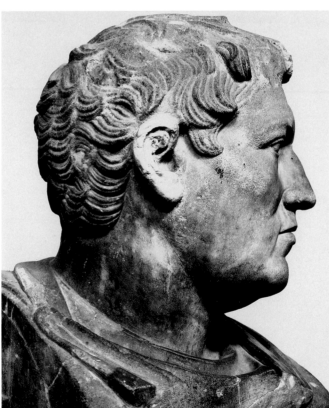

662–663 Herm of Philetairos of Pergamon (Roman copy), from the Villa dei Papiri at Herculaneum, original ca. 275–250. Ht. 40 cm. Naples.

664 Tetradrachm of King Attalos I of Pergamon, 241–197. Philetairos. Silver, d. 1.6 cm. Private collection.

665 Tetradrachm of Pergamon (detail), probably 181 or 177. Athena Polias Nikephoros. Silver, d. 1.6 cm. Copenhagen.

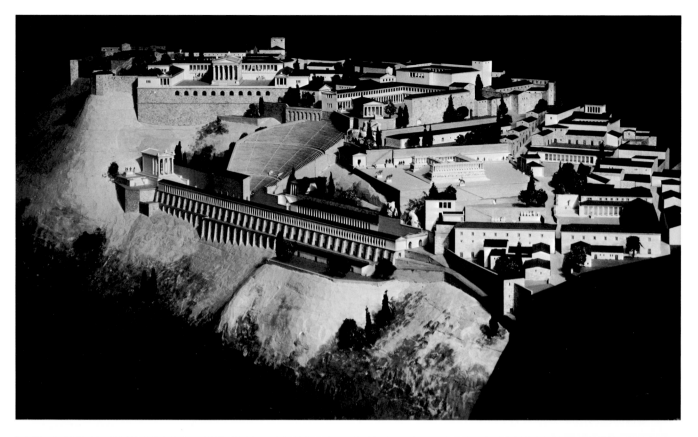

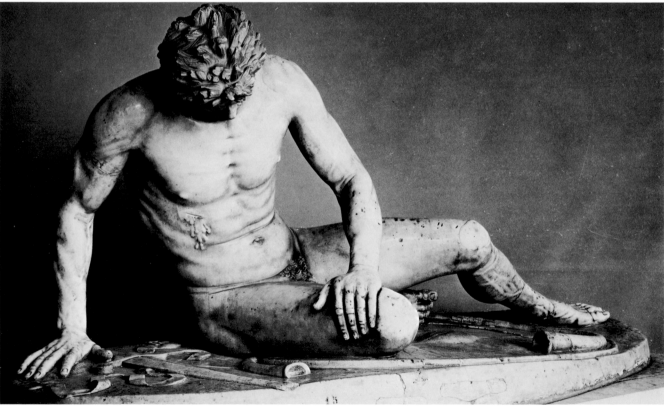

666 Model of the Akropolis at Pergamon. Berlin.

667 Dying Celtic Trumpeter (Roman copy), original ca. 220. Ht. 93 cm. Rome. The right arm and right side of the plinth up to the trumpeter's body are restored.

The Victory Dedications of Attalos I
666–667

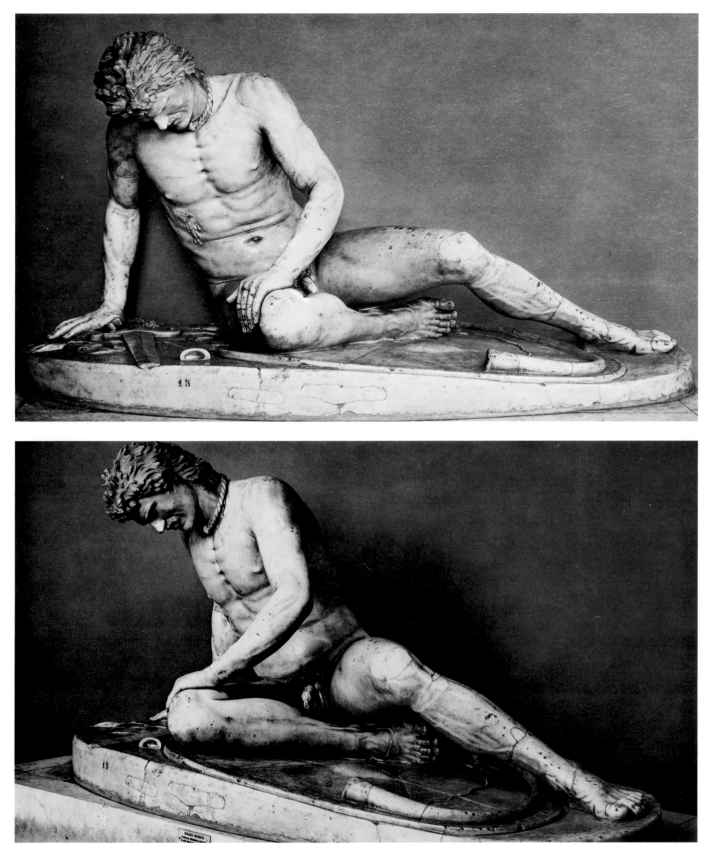

668–669 Views of the trumpeter, fig. 667.

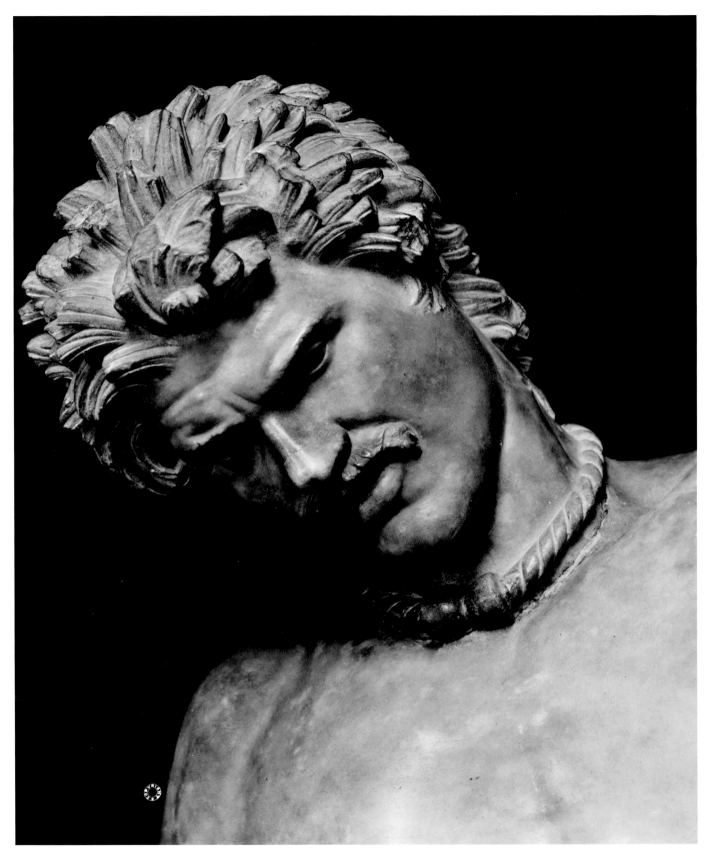

670 Head of the trumpeter, fig. 667.

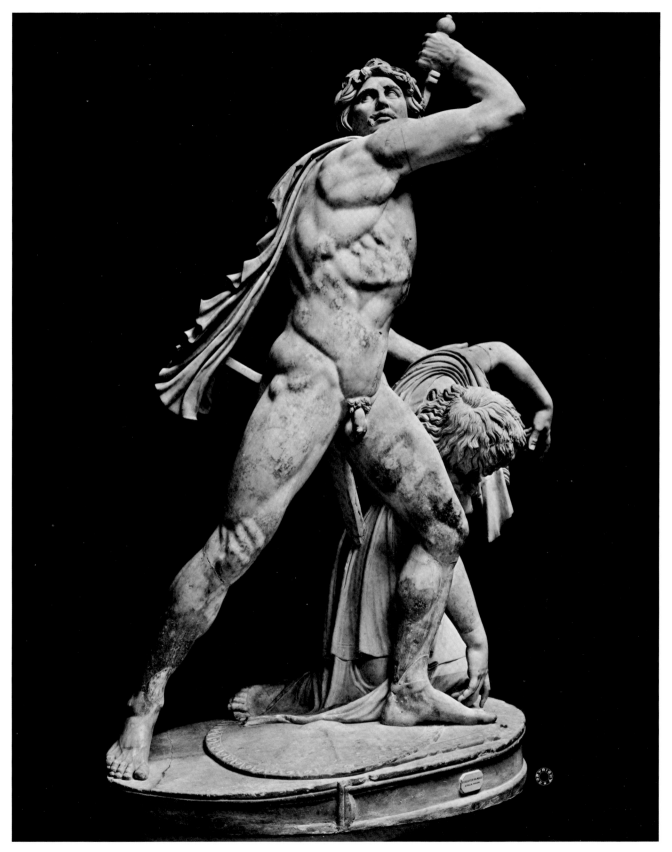

671 Suicidal Celt ("Ludovisi Gaul"; Roman copy), original ca. 220. Ht.
2.11 m. Rome. Restorations include the Celt's right arm with the
sword-hilt, the left forearm, the fluttering end of the cloak, and the
woman's nose, left arm, and lower right arm.

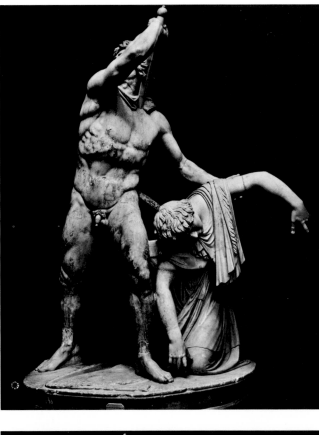

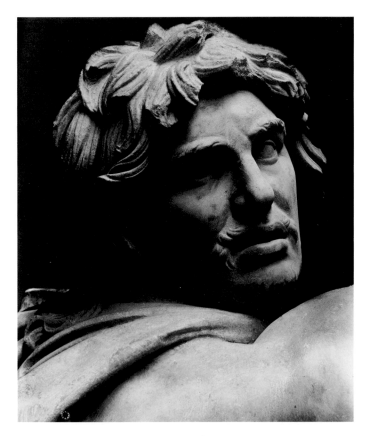

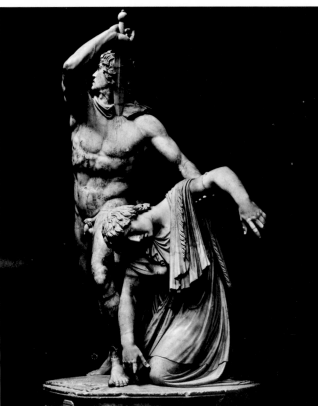

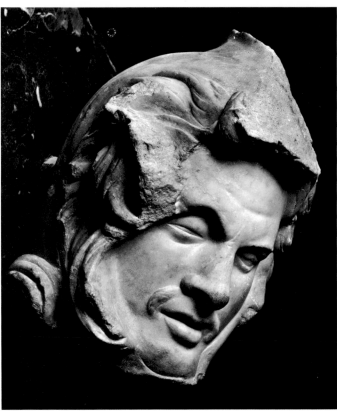

672–674 Details of the Celt, fig. 671.

675 Dying Iranian (Roman copy), original ca. 220. Ht. 33.5 cm. Rome.

The Victory Dedications of Attalos I
672–675

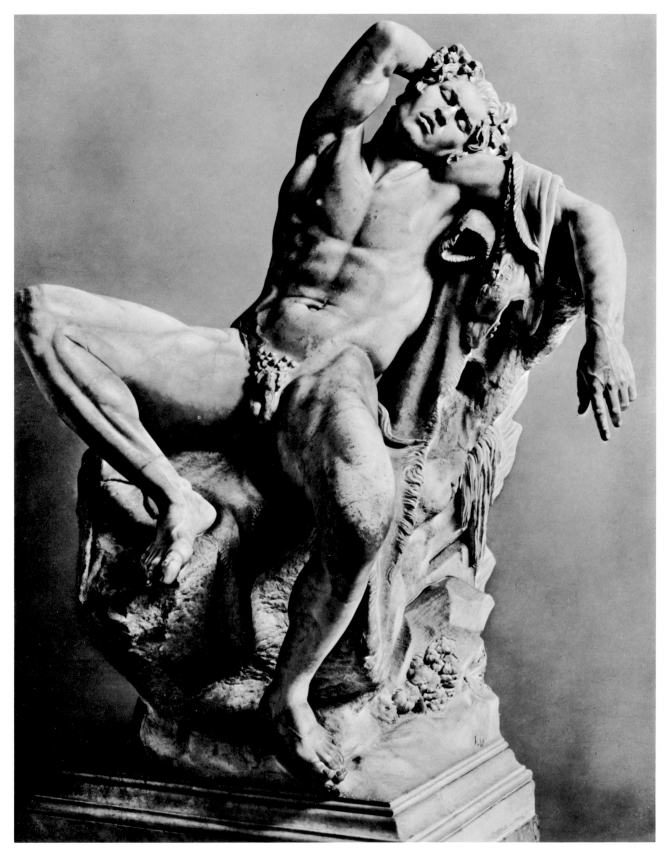

676 Drunken satyr ("Barberini Faun"), ca. 230–200. Ht. 2.15 m. Mu-
nich. The legs and pendant left arm are restored; the right leg is too
high, and its foot should rest on the point of the rock.

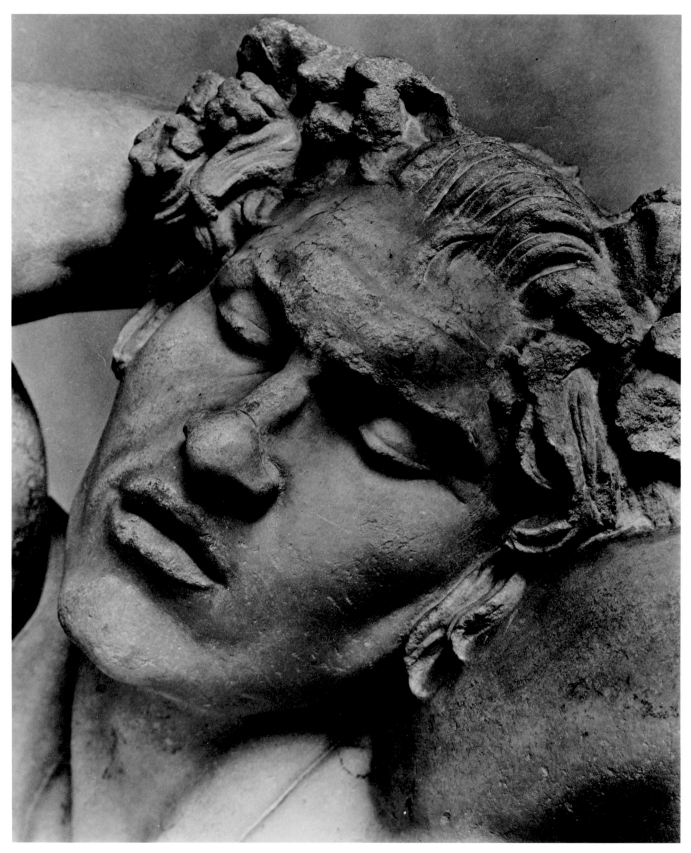

677 Head of the satyr, fig. 676.

The Barberini Faun
677

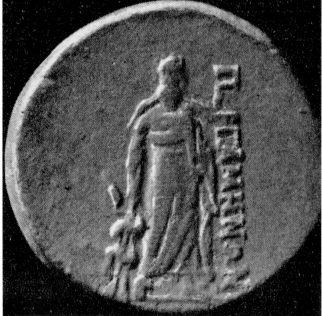

678 Inscribed herm of Antisthenes (Roman copy), original ca. 250–220. Ht. 56 cm. Rome. The nose is restored.

679 Coins of Pergamon showing the Asklepios of Phyromachos, ca. 190–150. Bronze, d. 1.9 cm, 2.5 cm. Berlin.

680–682 Head identified as Attalos I, from Pergamon, ca. 240–200. Ht. 39.5 cm. Berlin. The head was recut in antiquity, presumably after Attalos declared himself king ca. 237, to receive the plaster wig and diadem.

683 "Wild Man" (perhaps the Centaur Cheiron) from the Asklepieion at Pergamon, ca. 220–180. Ht. 48 cm. Bergama.

684 Another view of the "Wild Man," fig. 683.

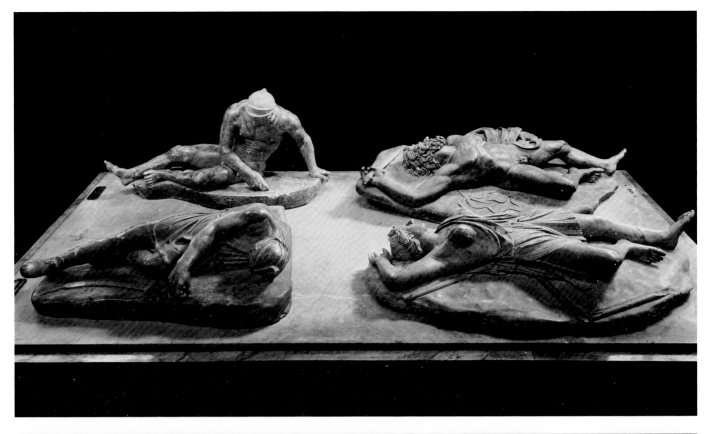

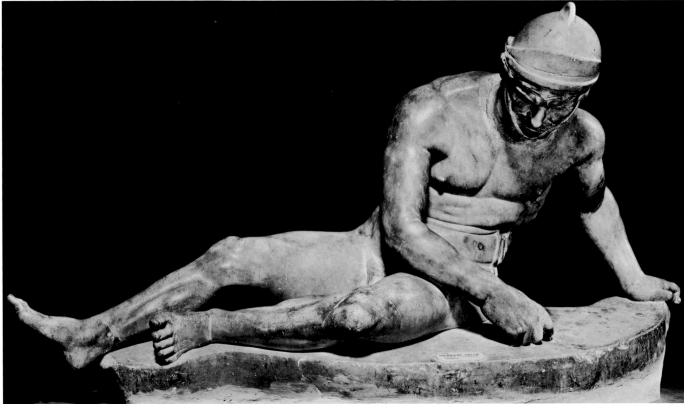

685 Four figures (Roman copies) attributed to the "Small Pergamene Dedication" on the Athenian Akropolis, originals ca. 200–150. *Clockwise from lower left*: dead Persian, dying Celt, dead Giant, and dead Amazon. L. 1.25–1.37 m. Naples. Both arms of the Persian, the left arm of the Celt, and minor parts of the limbs of the other figures are restored, together with their noses and other details.

686 Dying Celt (Roman copy) from the group in fig. 685.

The Small Pergamene Dedication
685–686

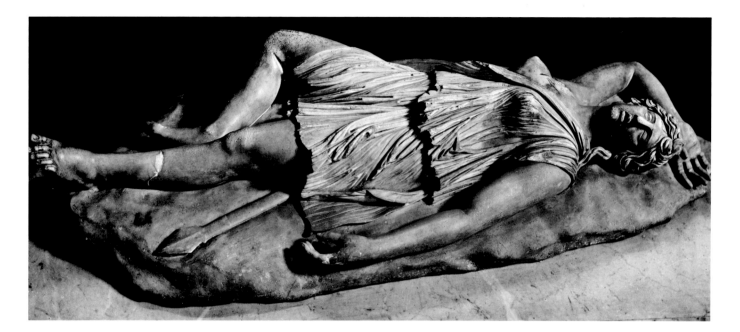

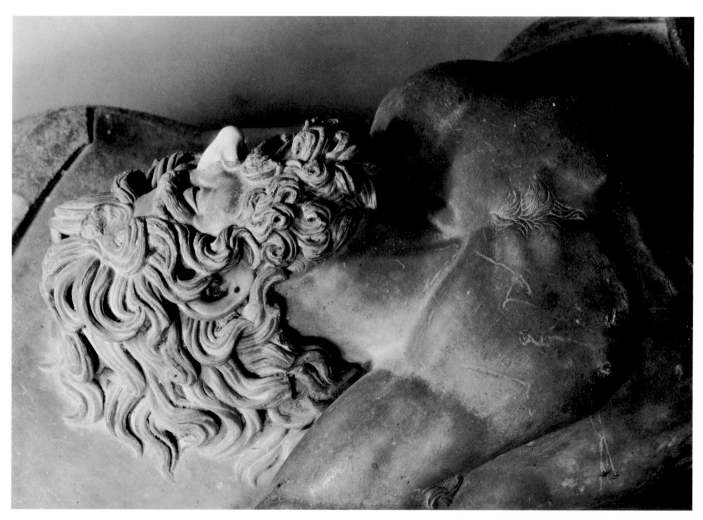

687–688 Dead Amazon and head of the dead Giant (Roman copies) from
the group, fig. 685.

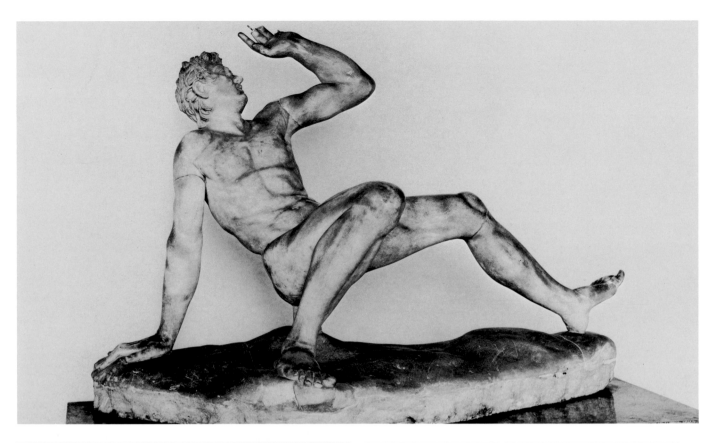

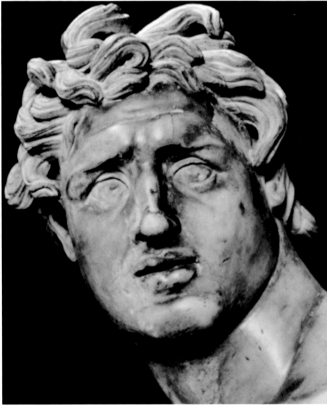

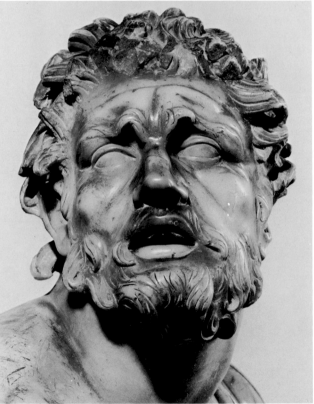

689 Falling Celt attributed to the group in fig. 685 (Roman copy), original ca. 200–150. Ht. 78 cm. Venice. The left arm and parts of the other limbs are restored.

690–691 Heads of defeated Celts attributed to the group in fig. 685 (Roman copies), originals ca. 200–150. Ht. of figures, 83 cm, 75 cm. Paris and Venice.

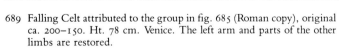

The Small Pergamene Dedication
689–691

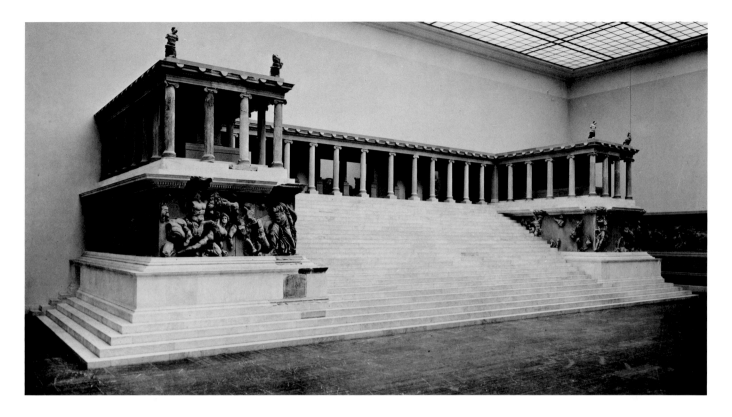

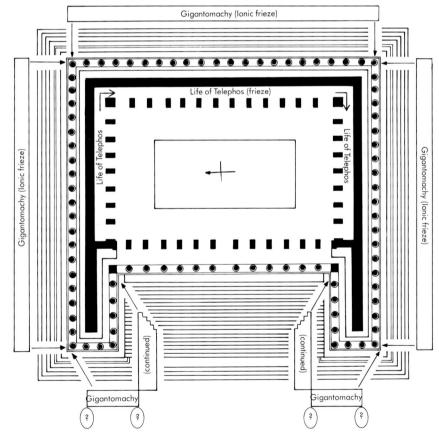

692–693 View and sculptural program of the "Great Altar," as reconstructed in the Pergamon Museum, Berlin, ca. 180–150. Ht. of monument, 5.6 m; of Gigantomachy frieze, 2.28 m; of Telephos frieze, 1.58 m.

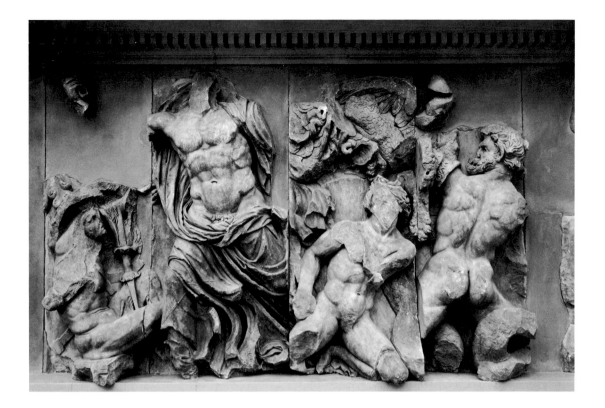

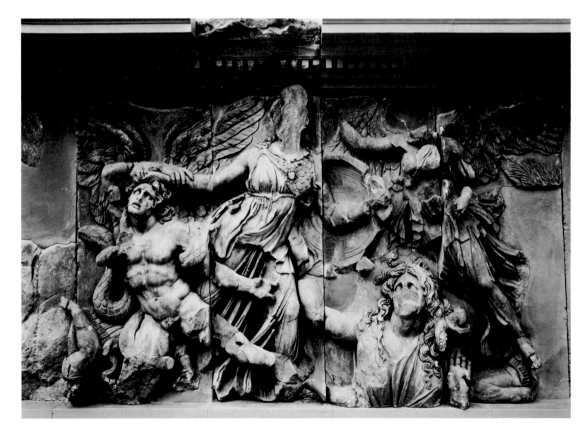

694–695 East frieze: Porphyrion, Zeus (name inscribed), and two other
 giants; Alkyoneus, Athena (name inscribed), Ge (name inscribed),
 and Nike. Berlin.

The Great Altar of Pergamon
694–695

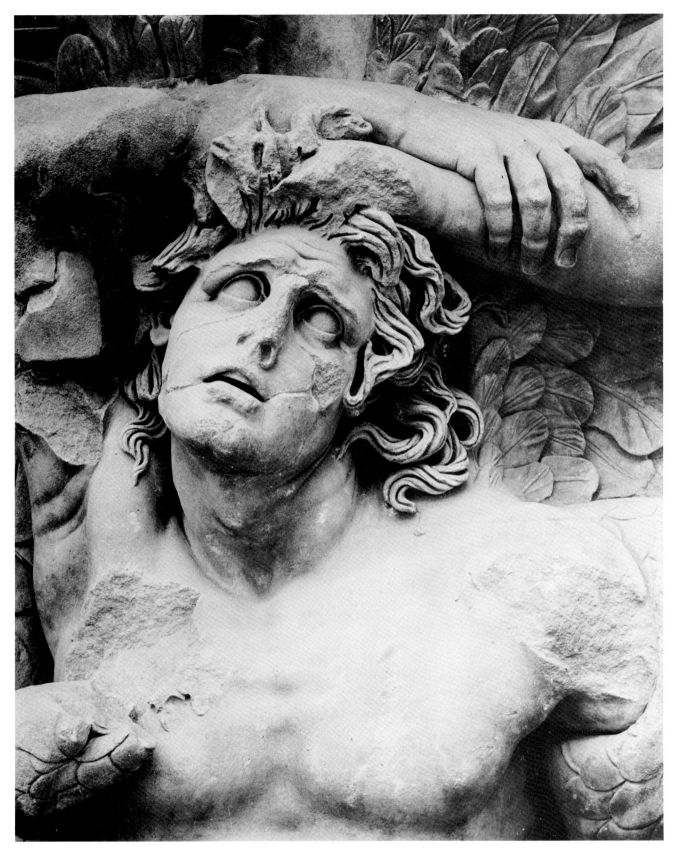

696 Head of Alkyoneus from the east frieze, fig. 695. Berlin.

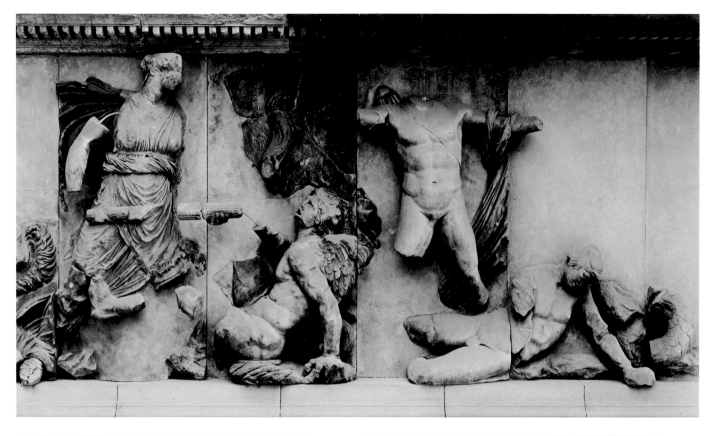

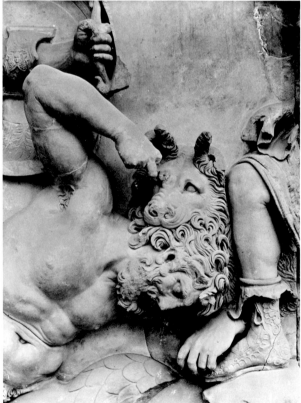

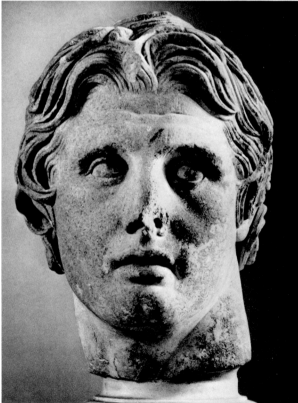

697–698 East frieze: Leto (name inscribed) and Apollo; head of Artemis's opponent. Berlin.

699 Head of Alexander (?) from Pergamon, perhaps from the Gigantomachy of the "Altar." Ht. 42 cm. Istanbul.

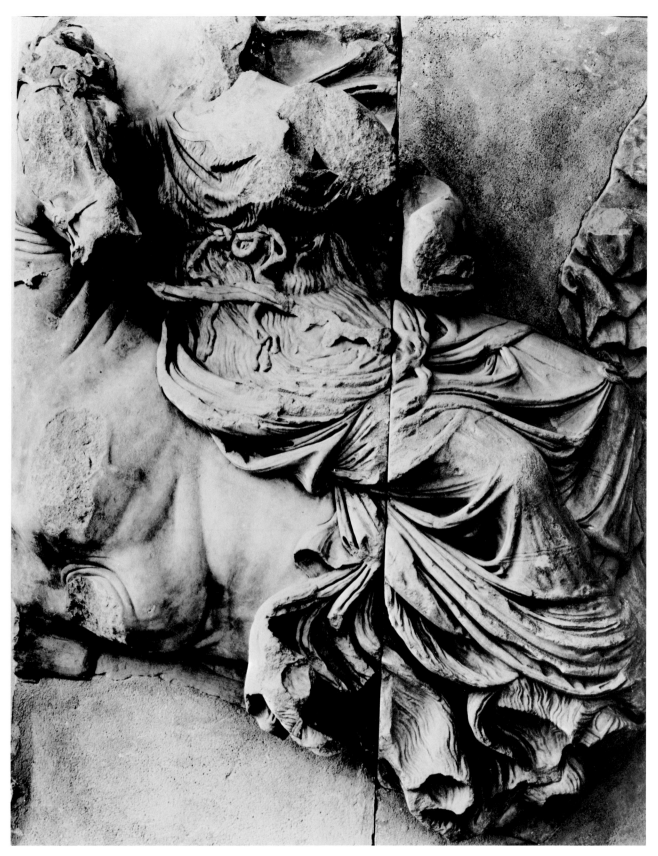

700 South frieze: a goddess, probably Eos. Berlin.

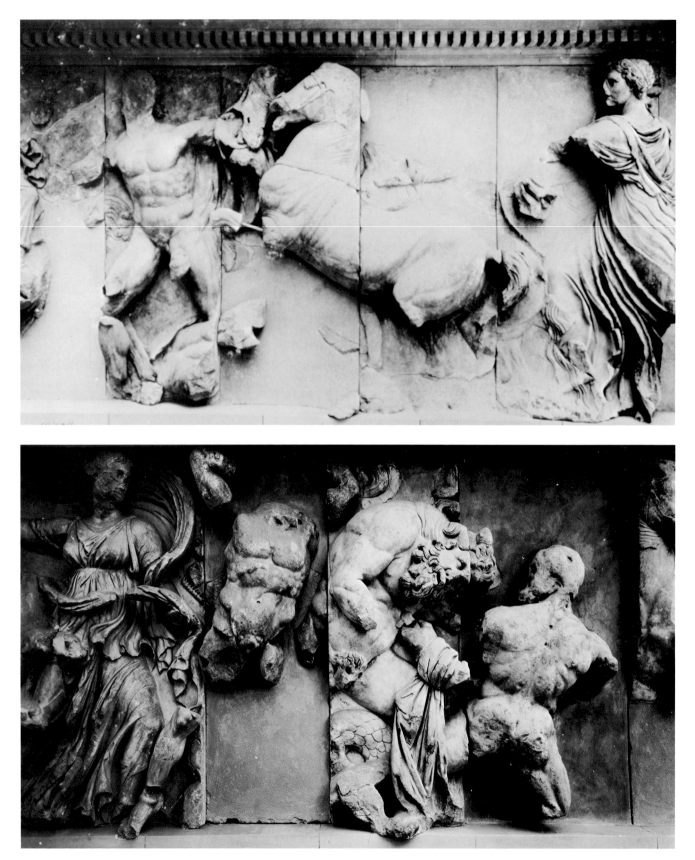

701–702 South frieze: Helios; unidentified goddess and steer-giant. Berlin.
 The giant to the right of fig. 702 is a cast of the marble found at
 Worksop, England.

The Great Altar of Pergamon
701–702

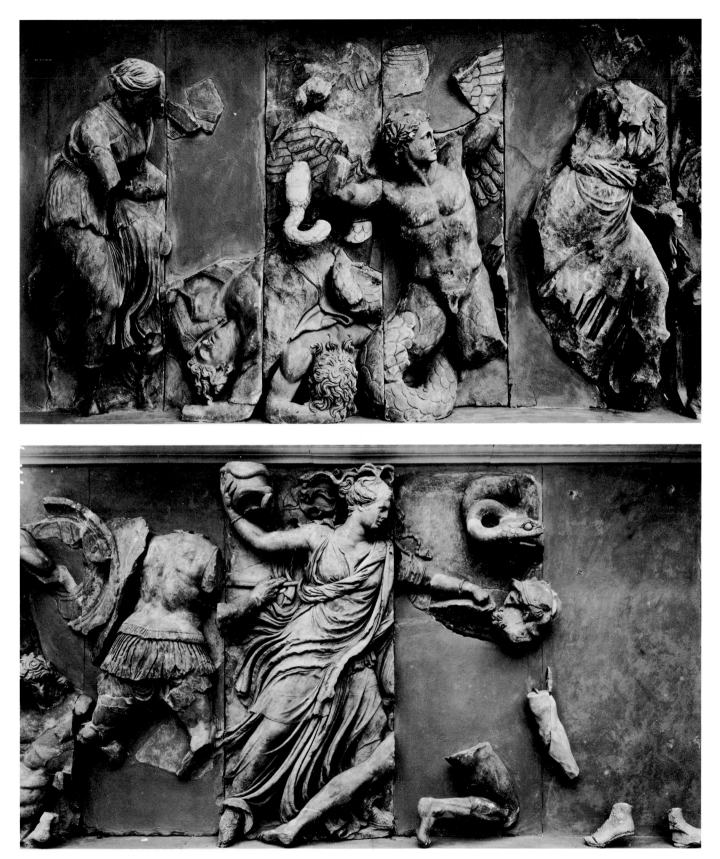

703–704 North frieze: Aphrodite (name inscribed) and Eros; "Nyx"
(probably Persephone). Berlin.

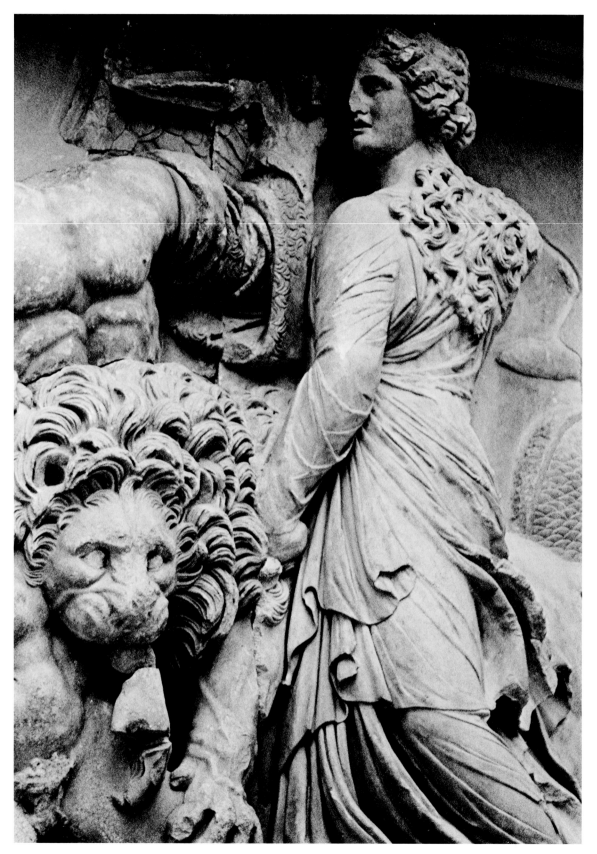

705 North frieze: Lion-goddess. Berlin.

The Great Altar of Pergamon
705

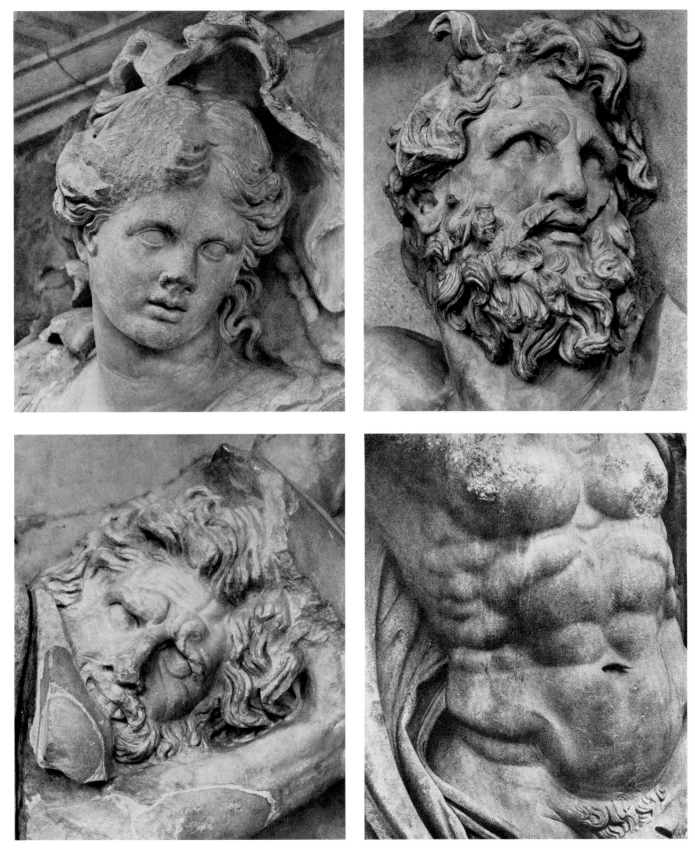

706 North frieze: head of "Nyx"/Persephone, fig. 704.
707 North frieze: head of the "biting Giant." Berlin.

708 East frieze: head of Hekate's opponent. Berlin.
709 East frieze: torso of Zeus. Berlin.

The Great Altar of Pergamon
706–709

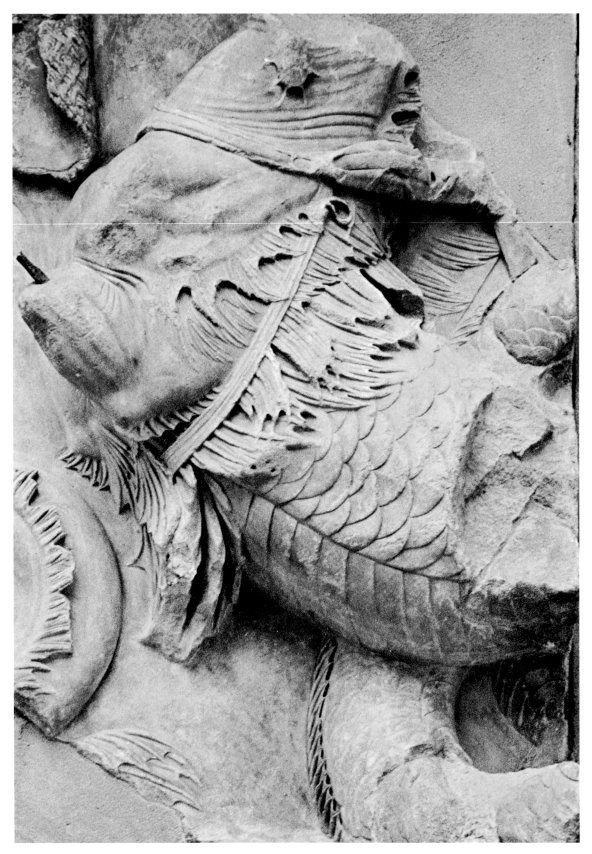

710　North frieze: hippocamp from Poseidon's chariot. Berlin.

The Great Altar of Pergamon
710

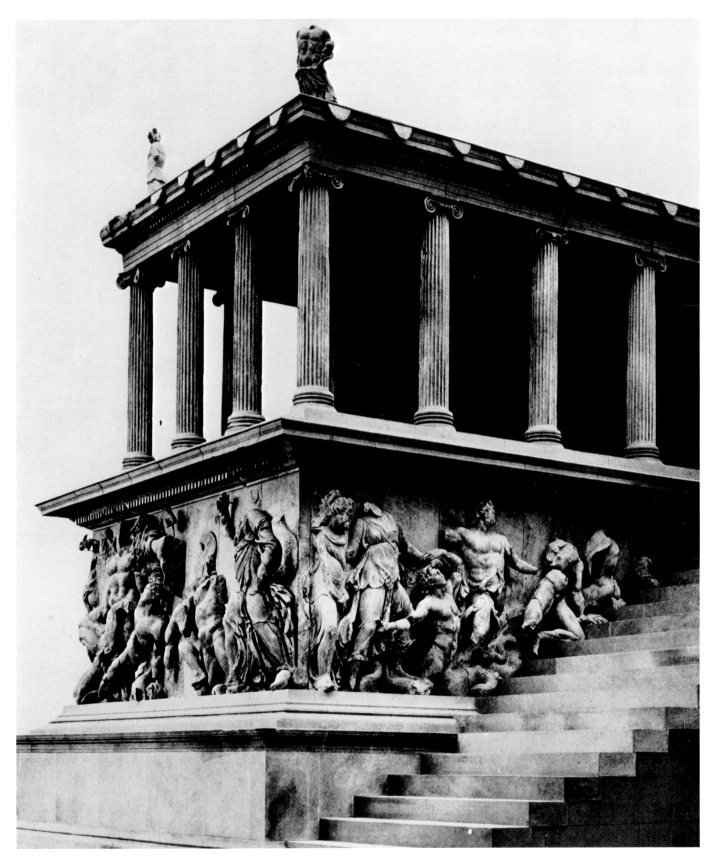

711 West frieze: left projection with Triton and Amphitrite (names inscribed); stair-frieze with Nereus (name inscribed) and Doris. Berlin.

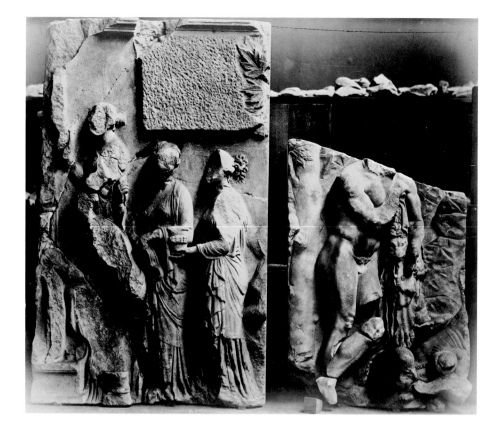

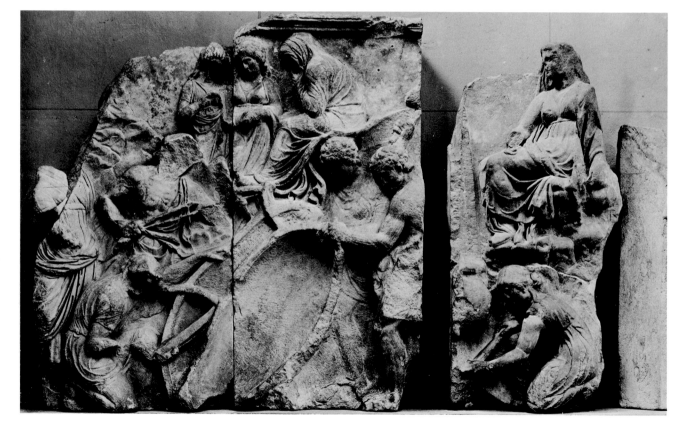

712–713 Telephos frieze: sacrifice at a shrine, and Herakles finding Tele-
phos on Mt. Parthenion; building the box for Auge. Berlin. The plane-
tree at the top of the relief is unfinished.

The Great Altar of Pergamon
712–713

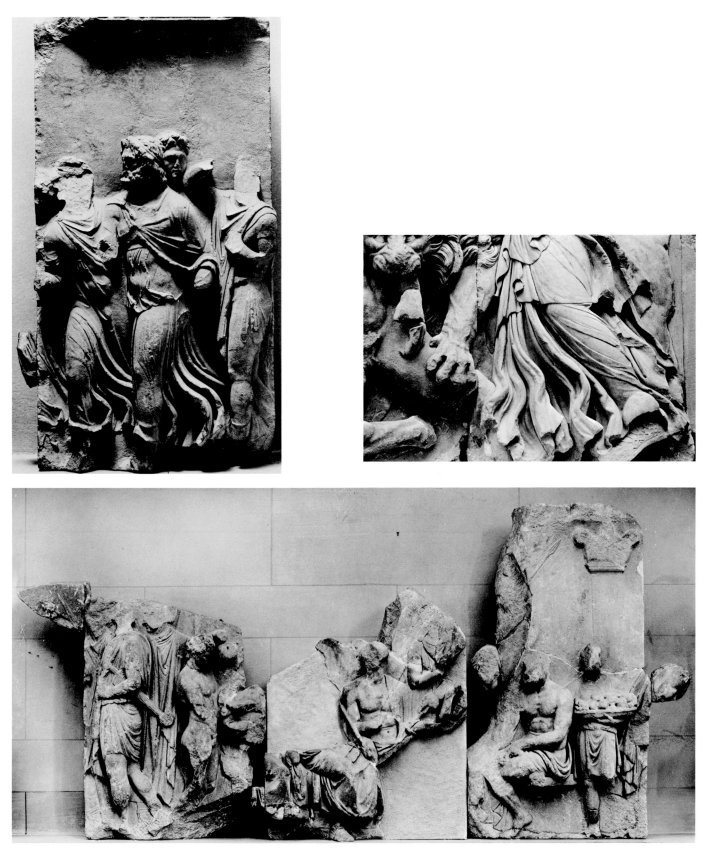

714 Telephos frieze: Teuthras, king of Mysia, hastens to meet Auge. Berlin.

715 Gigantomachy frieze: detail of the lion-goddess, fig. 705, top right. Berlin.

716 Telephos frieze: Telephos and the Argive princes. Berlin.

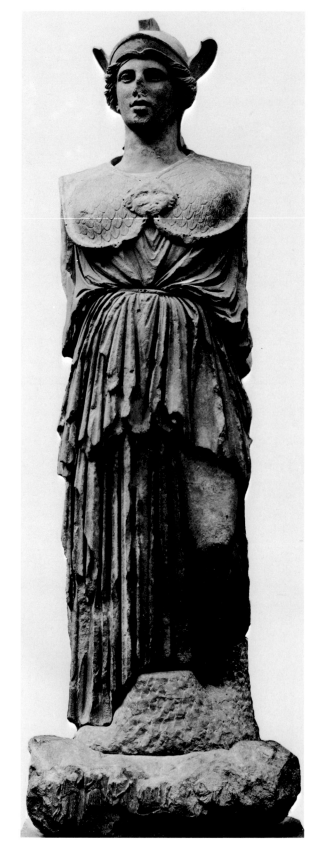

717 Tragedy, from Pergamon, ca. 190–160. Ht. 1.80 m. Berlin. 718 Athena Parthenos, from Pergamon, ca. 190. Ht. 3.51 m. Berlin.

Pergamene Freestanding Sculpture
717–718

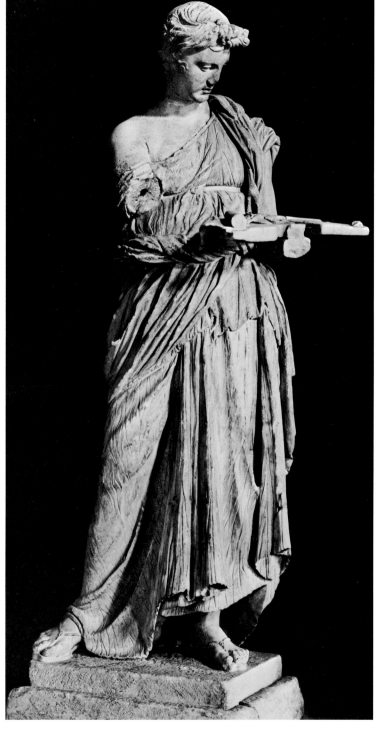

719–720 "Crouching Aphrodite" (Roman copies), original ca. 200–150. Ht. 1.13 m, 1.02 m. Naples and Rome. The forearm, left hand, and the soles of the feet of fig. 719 are restored, together with Eros's lower legs, his arms, and parts of his wings.

721 Girl preparing a sacrifice, from Anzio (Italy), ca. 200–150. Ht. 1.74 m. Rome.

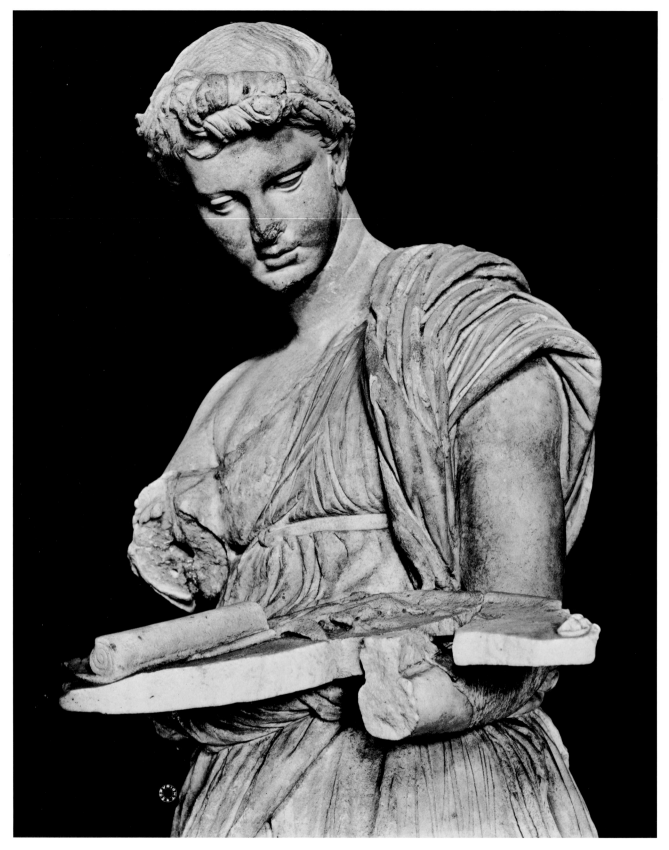

722 Head of the girl, fig. 721.

The Anzio Girl
722

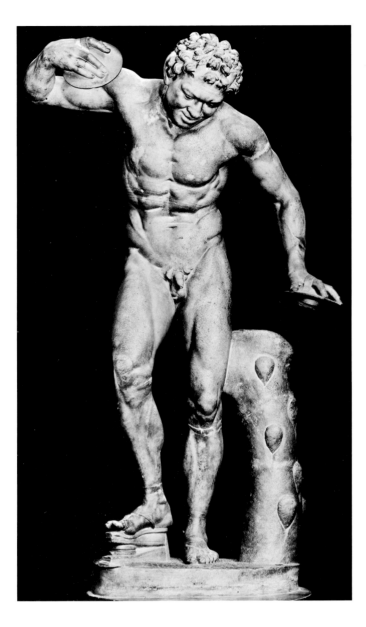

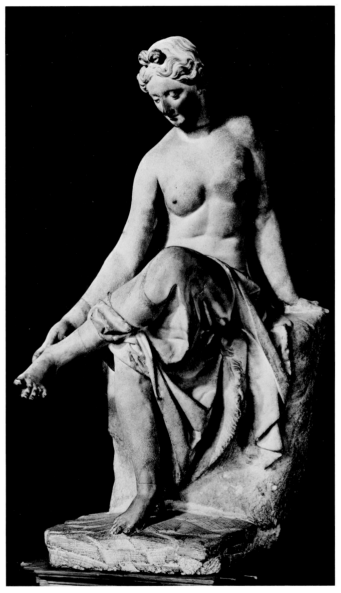

723–724 Satyr and nymph from the "Invitation to the Dance" (Roman copy), original ca. 200–150(?). Ht. 1.43 m, 1.01 m. Florence. The heads and parts of the arms and legs of both figures are restored.

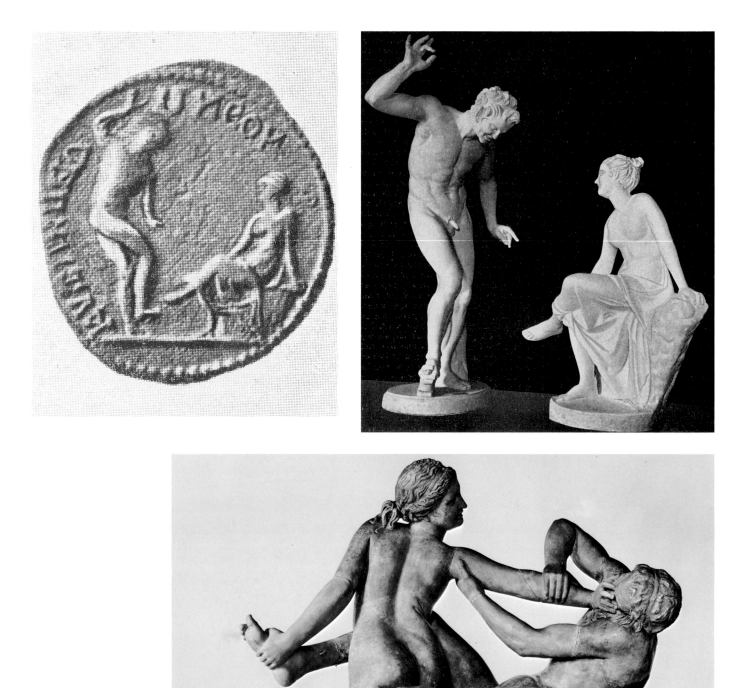

725 Coin of Kyzikos depicting the group in fig. 723–724.

726 Reconstruction of the group by W. Klein.

727 Satyr and hermaphrodite (Roman copy), original ca. 150(?). Ht. 91 cm. Dresden. Restorations include much of the arms of both figures, the left foot of the hermaphrodite, and the lower legs of the satyr.

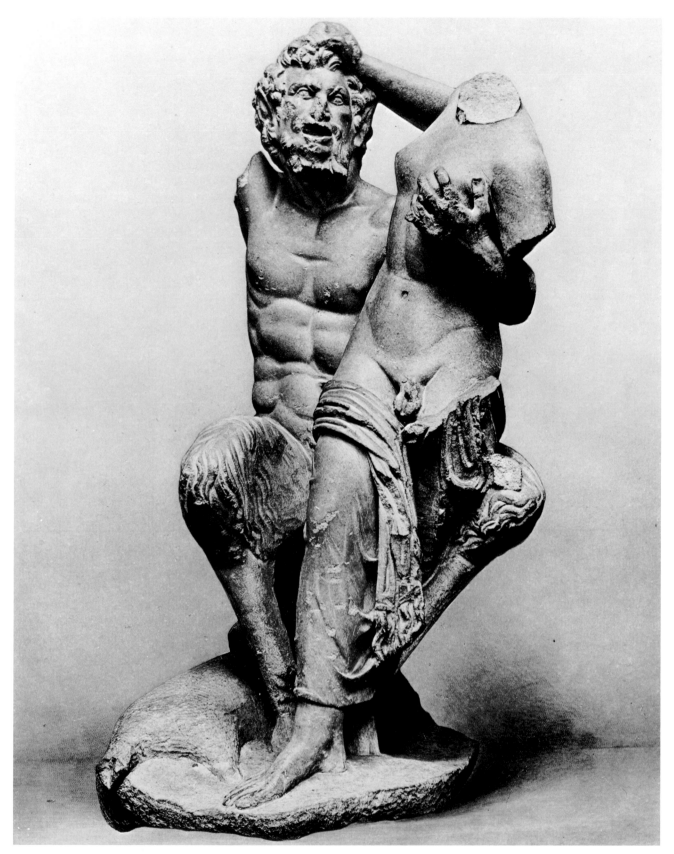

728 Satyr and hermaphrodite (Roman copy), original ca. 150 (?). Ht.
unknown. Once Geneva market, present location unknown.

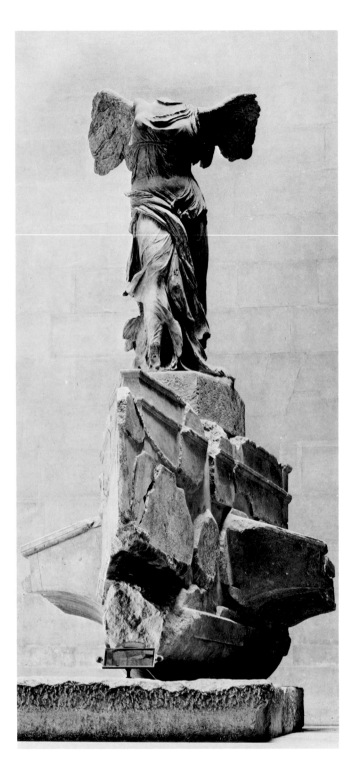
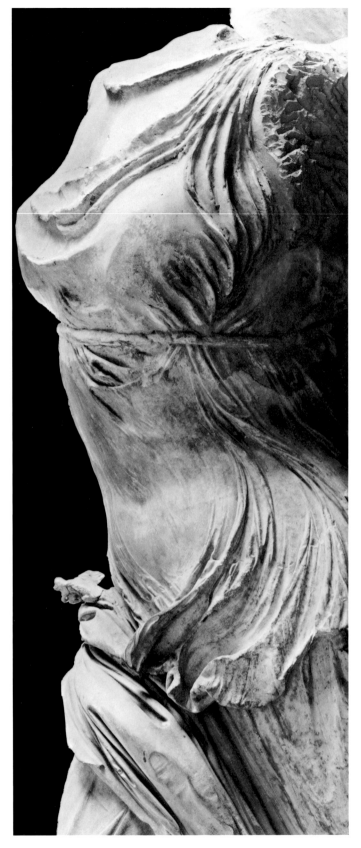

729–730 Nike from Samothrace, ca. 190. Ht. of figure, ca. 2 m. Paris.

The Nike of Samothrace
729–730

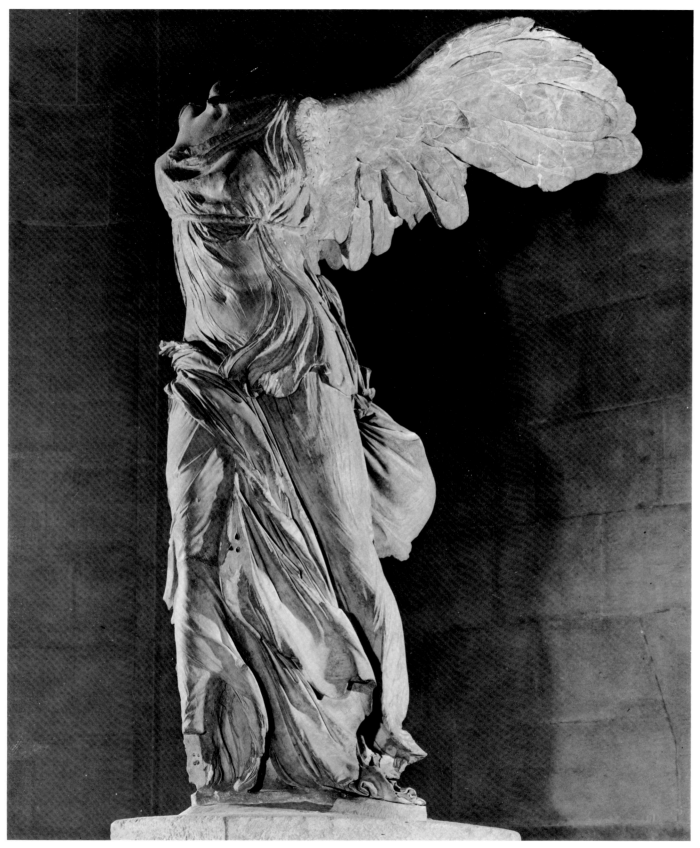

731 Side view of the Nike, fig. 729.

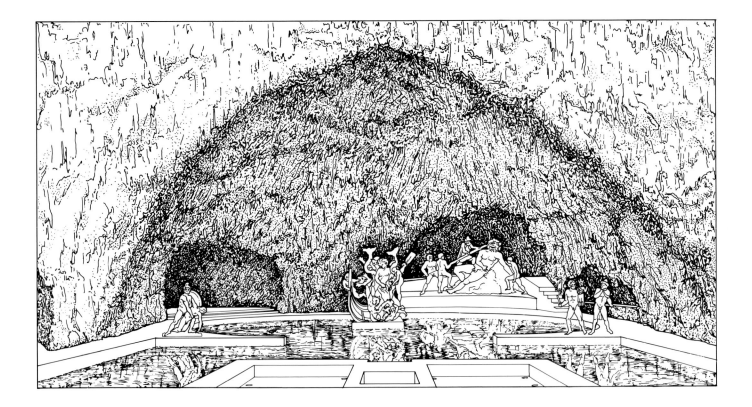

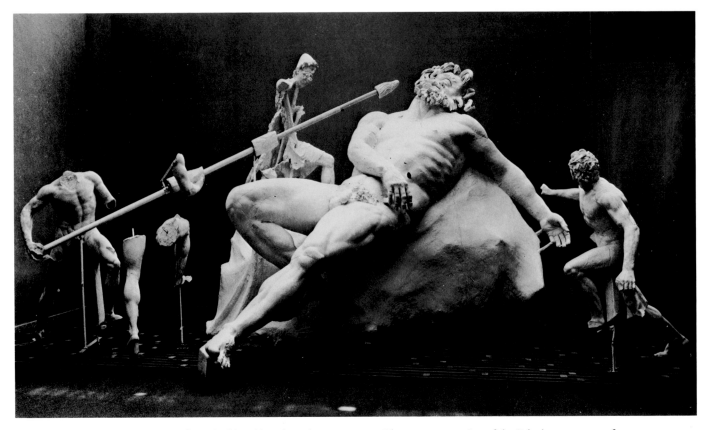

732 Reconstruction of the cave at Sperlonga (Italy), with sculptural groups signed by Hagesandros, Athanodoros, and Polydoros of Rhodes, ca. 20 BC to AD 20(?), after originals of the mid-second century. At front, Odysseus with the body of Achilles (left), and with Diomedes and the Trojan Palladion (right); at center, Odysseus fighting Skylla; at right rear, Odysseus and companions blinding Polyphemos. Ht. of human figures, 2.0–2.2 m; of Polyphemos, ca. 3.5 m.

733 Plaster reconstruction of the Polyphemos group, fig. 732.

The Sperlonga Sculptures
732–733

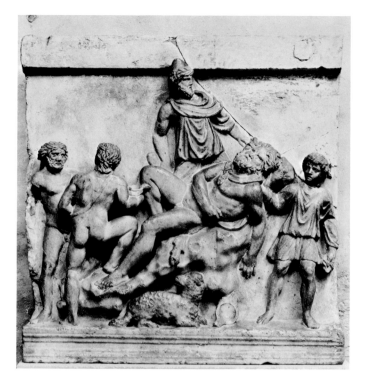

734 Roman sarcophagus relief with the blinding of Polyphemos, ca. AD 180. Ht. 73 cm. Catania.

735–736 Polyphemos group, fig. 732: "third companion."

737 Polyphemos group, fig. 732: foot of Polyphemos.

738 Polyphemos group, fig. 732: Odysseus.

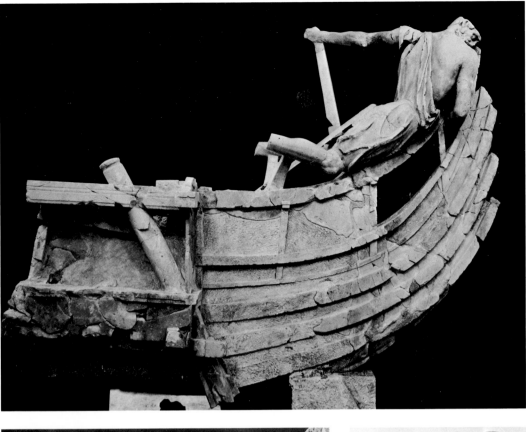

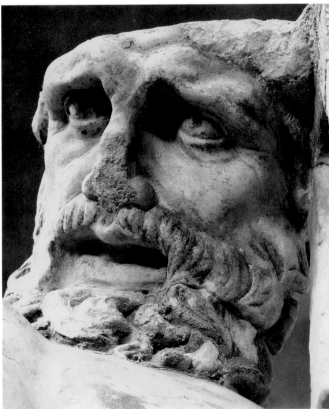

739 Skylla group, fig. 732: Odysseus's ship and helmsman.
740 Skylla group, fig. 732: head of helmsman.

741 Palladion group, fig. 732: Diomedes grasping the Palladion.

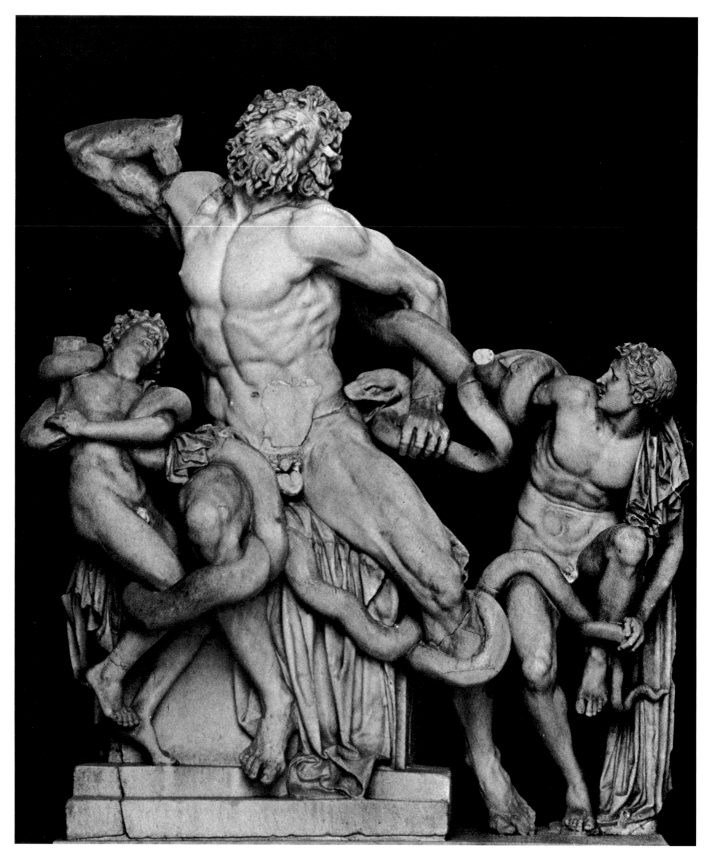

742 Laokoon and his sons, by Hagesandros, Athanodoros, and Polydoros
of Rhodes, from the substructures of the Baths of Trajan at Rome,
ca. 20 BC to AD 20(?), perhaps after an original of the mid-second
century. Ht. 1.84 m.

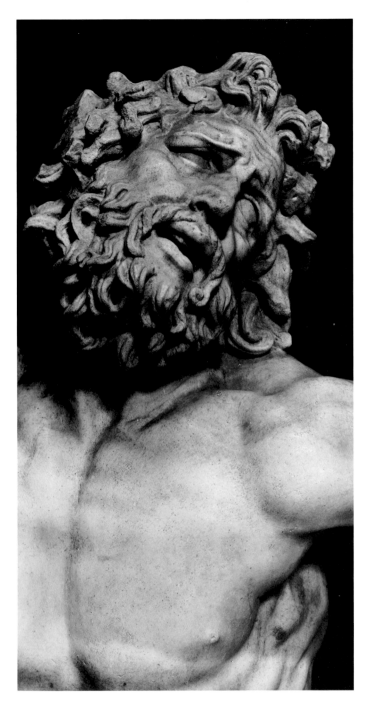

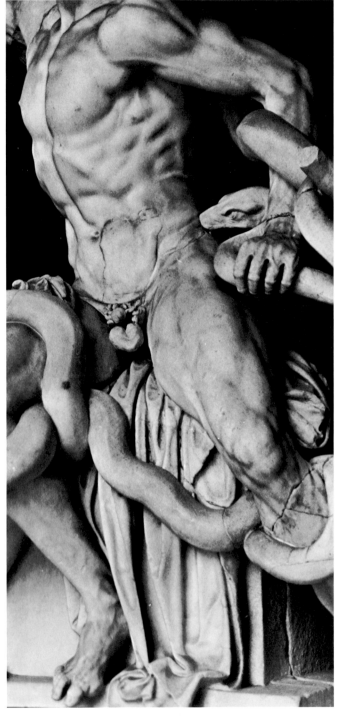

743–744 Details of Laokoon from the group, fig. 742.

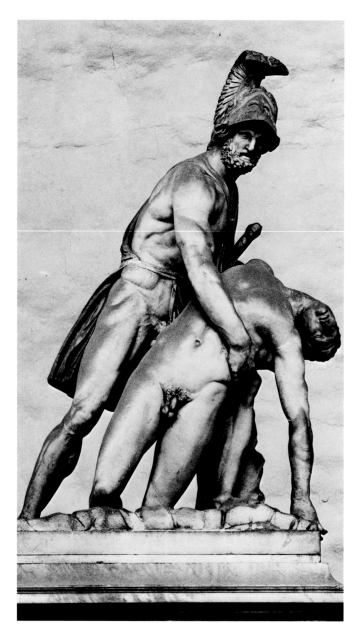

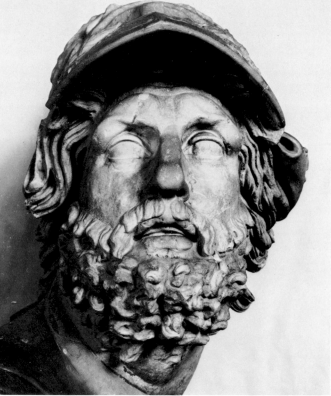

745 Menelaos with the body of Patroklos (?) (Roman copy), original ca. 150–125. Ht. 2.2 m. Florence. Parts of "Patroklos" and the torso of "Menelaos" are restored.

746 Menelaos with the body of Patroklos (?) ("Pasquino"; Roman copy), original ca. 150–125. Ht. 1.92 m. Rome, on the wall of the Palazzo Braschi, overlooking the Piazza Pasquino.

747 Head of "Menelaos" from another copy of the group, figs. 745–746. Ht. 47 cm. Rome. The nose, parts of the lips, and eyes, details of the hair, and the bust are restored.

The Pasquino Group
745–747

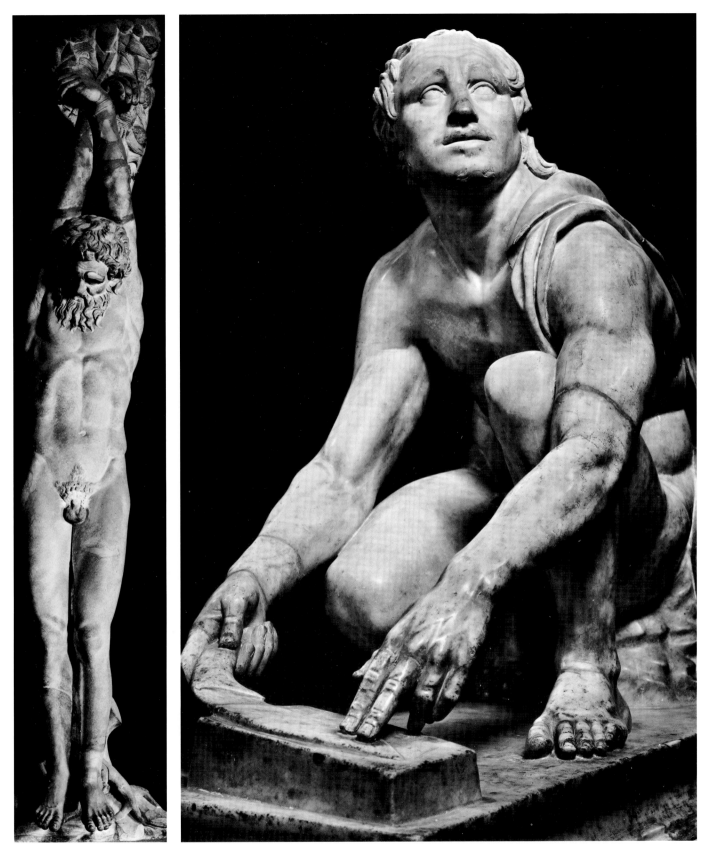

748 Marsyas ("red" type; Roman copy), original ca. 200–150. Ht. 2.43 m. Florence. Parts of the arms, legs, and the nose are restored.

749 Scythian knife-grinder (Roman copy), original ca. 200–150. Ht. 1.06 m. Florence. The tip of the nose, some of the fingers, and parts of the drapery are restored, and the surface has been repolished.

The Flaying of Marsyas
748–749

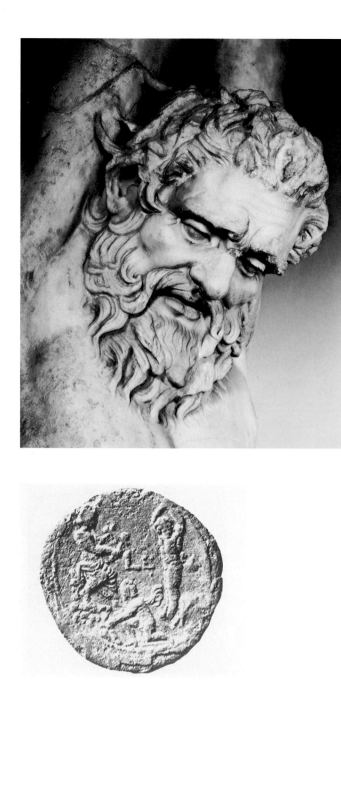

750 Head of another copy ("white" type) of the Marsyas, fig. 748. Ht. 2.56 m. Paris.

751 Antonine coin of Alexandria, AD 138–60. Marsyas group, with Apollo. Bronze, d. 2 cm. Florence.

752 Roman engraved gem showing the Marsyas group, with Apollo. Carnelian, d. 1.4 cm. Private collection.

753 Drunken old woman (Roman copy), original ca. 225–200. Ht. 92 cm. Munich.

The Flaying of Marsyas
750–752

754 Head of the old woman, fig. 753.

755 Old fisherman (Roman copy), original ca. 200. Ht. 1.6 m. Rome. Restorations (by Algardi) include the nose, chin and lower lip, the right hand, the left forearm and hand, the feet, the lower part of the support, and the plinth.

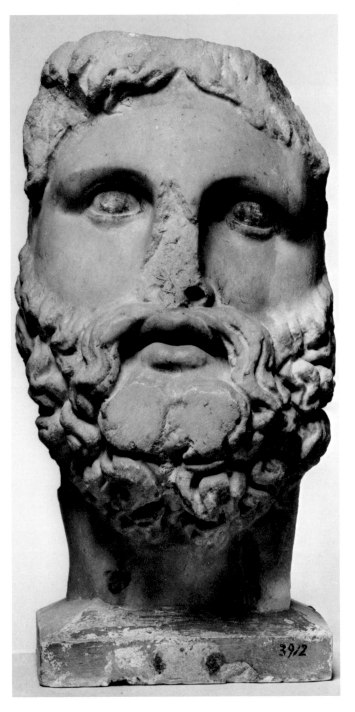

756 Ptolemy IV Philopator from the Sarapeion at Alexandria, ca. 217–204. Ht. 35 cm. Paris.

757 Sarapis, from the Sarapeion at Alexandria, ca. 217–204. Ht. 53 cm.

A Ptolemaic Cult Group from the Alexandrian Sarapeion
756–758

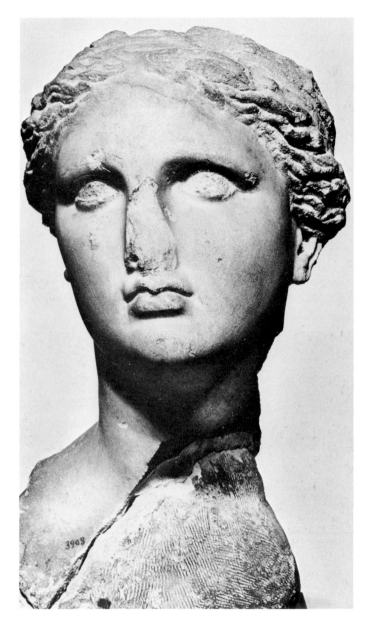

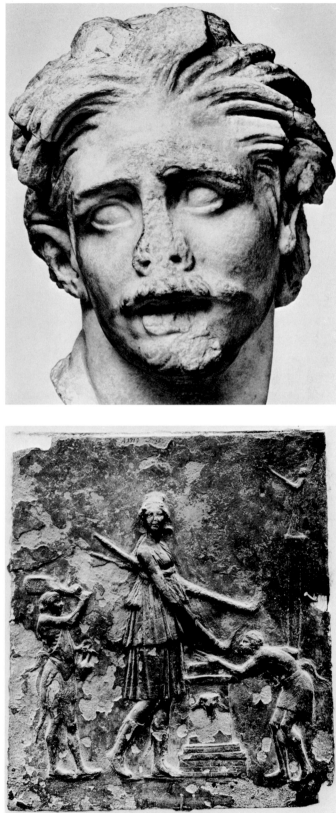

758 Arsinoe III, from the Sarapeion at Alexandria, ca. 217–204. Ht. 46 cm.

759 Celt, from the Fayum, ca. 175–150. Ht. 37 cm. Cairo.
760 Relief from the Minoe fountain on Delos, ca. 200. Arsinoe II sacrificing, acompanied by satyrs. Bronze, ht. 50 cm.

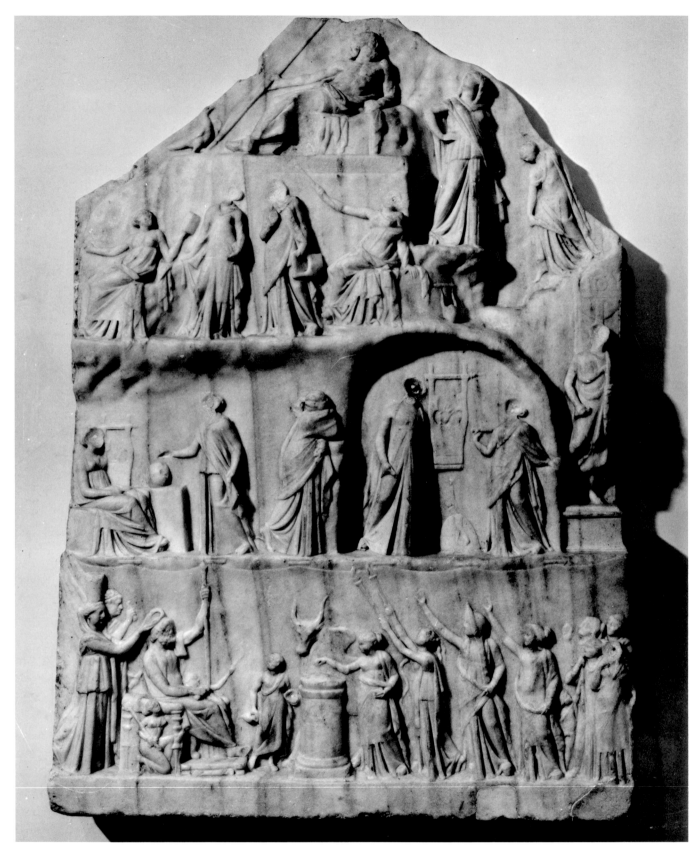

761 Relief signed by Archelaos of Priene, from Bovillae (Italy), ca. 200–
150. Apotheosis of Homer, with the Muses, Apollo, a poet, and Zeus
above. Ht. 1.18 m. London.

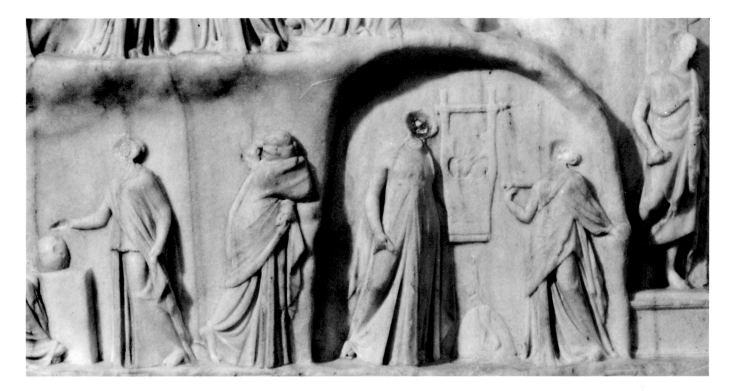

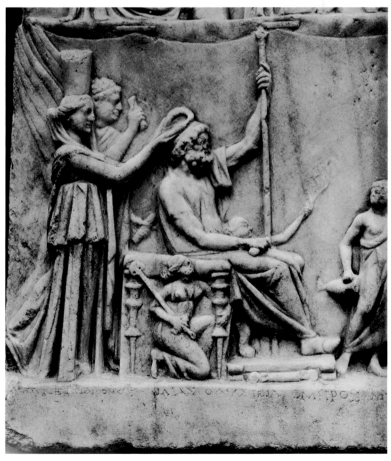

762–763 Details of the Archelaos relief, fig. 761: Apollo and the Muses,
with the poet standing by the Delphic tripod at far right; Oikoumene
and Chronos crown Homer, whose throne is attended by Iliad and
Odyssey, with Myth at far right.

The Archelaos Relief
762–763

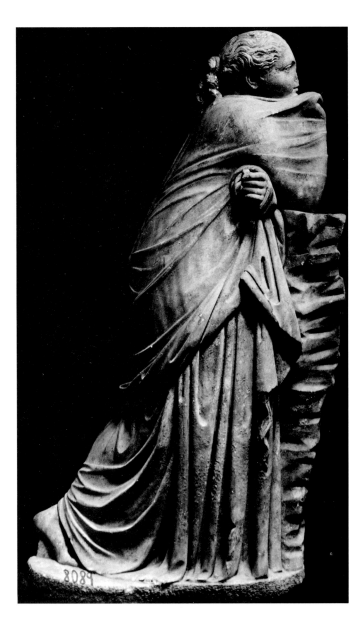

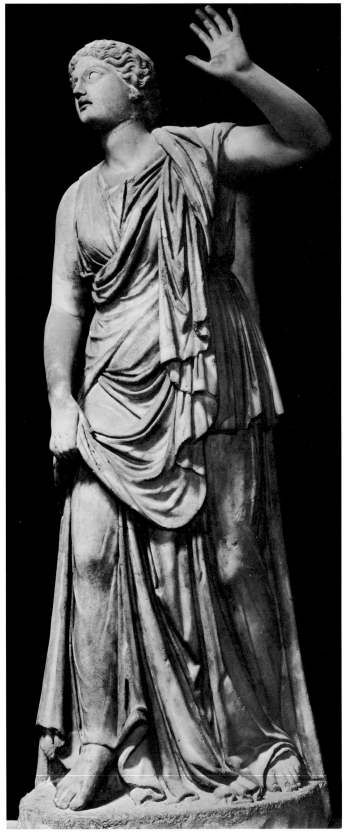

764 "Polyhymnia" (Roman copy), from Rome, original, ca. 230–150. Ht. 1.50 m.

765 Dancing Muse (Roman copy), original ca. 230–150. Ht. 1.53 m. Florence. The left arm and adjacent drapery, most of the right arm and part of the drapery held in the hand, and the neck are restored; the head is ancient, but some doubt whether it belongs; the crown of the head, nose, and lips are restored; the surface has been repolished.

The Muses
764–766

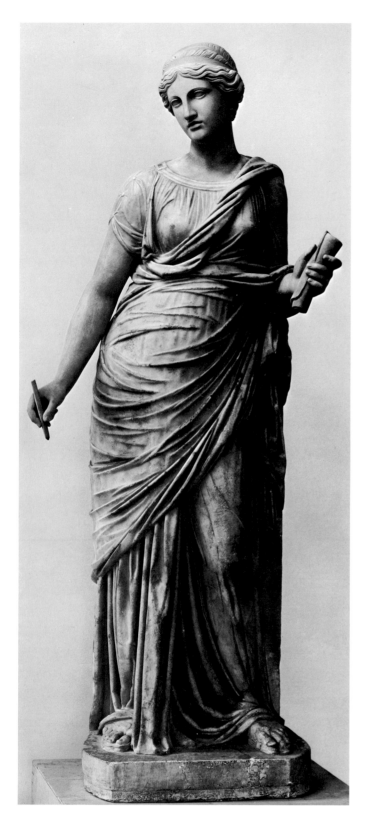

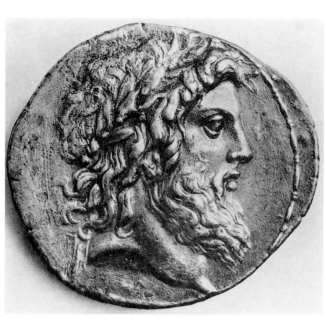

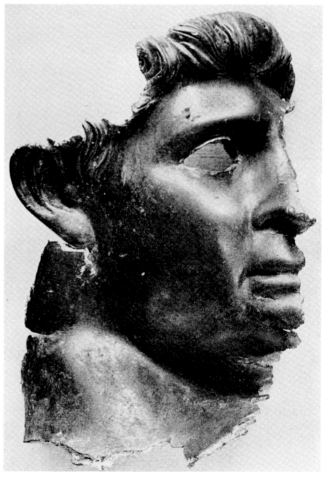

766 "Klio" (Roman copy), original ca. 230–150. Ht. 1.66 m. Munich. The head, neck, right arm, left forearm, and the pillar are restored.

767 Tetradrachm of Antiochos IV Epiphanes of Syria, 168. Zeus. Silver, d. 1.9 cm. Paris.

768 Head of a ruler, either Antiochos IV Epiphanes of Syria or (more probably) Antiochos VII Sidetes, from Shami (Southern Iran), ca. 170 or 130/129. Bronze, ht. 26.7 cm. Teheran.

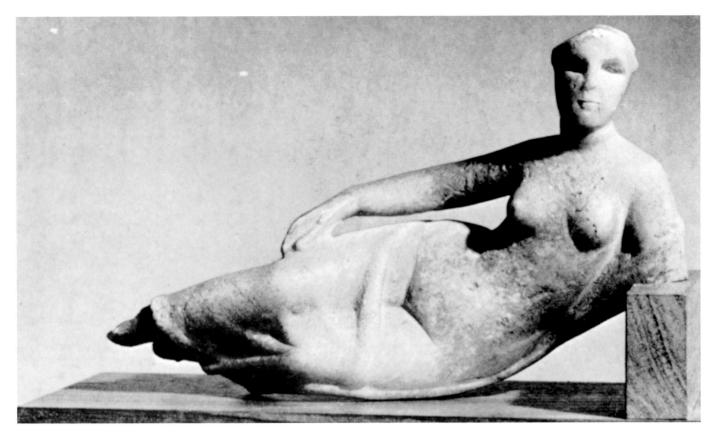

769 Statuette of a reclining woman (Anahita?) from Iran, ca. 150–100. Alabaster, l. 17.4 cm. New York.

770 Portrait head, perhaps King Euthydemos I of Baktria (Roman copy), ca. 230–200. Ht. 33 cm. Rome. The tip of the nose is restored.

771 Colossal foot from a cult statue (of Zeus?) at Ai Khanoum in Baktria (Afghanistan), ca. 200–140. Kabul Museum.

772 Statuette of a woman from the temple at Ai Khanoum in Baktria (Afghanistan), ca. 200–140. Ht. 1 m. Kabul.

773 Statuette of a goddess from Ai Khanoum in Baktria (Afghanistan), ca. 200–140. Bone, ht. 16.2 cm. Kabul.

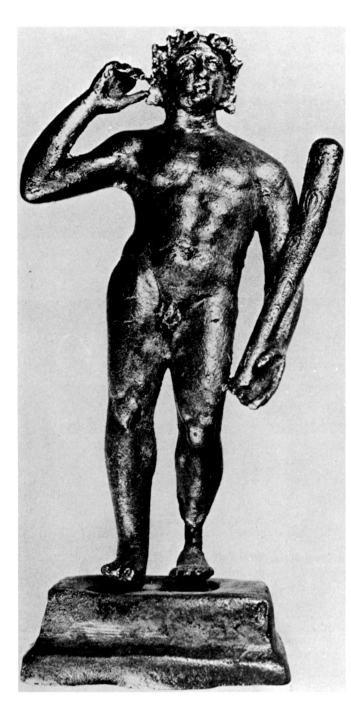

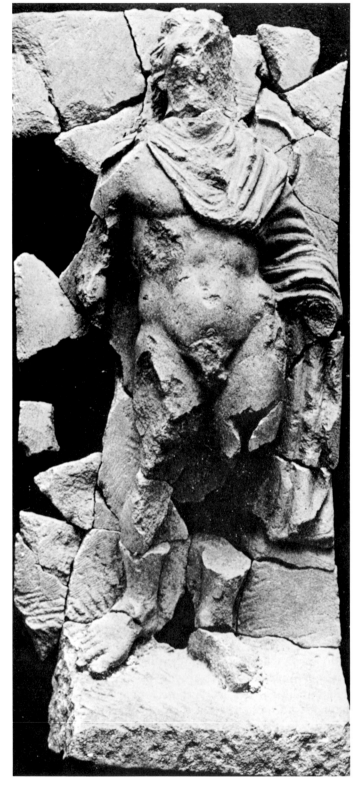

774 Statuette of Herakles from Ai Khanoum in Baktria (Afghanistan), ca. 200–140. Bronze. Kabul.

775 Gravestone of a youth from Ai Khanoum in Baktria (Afghanistan), ca. 200–140. Ht. 57 cm. Kabul.

Ai Khanoum
774–775

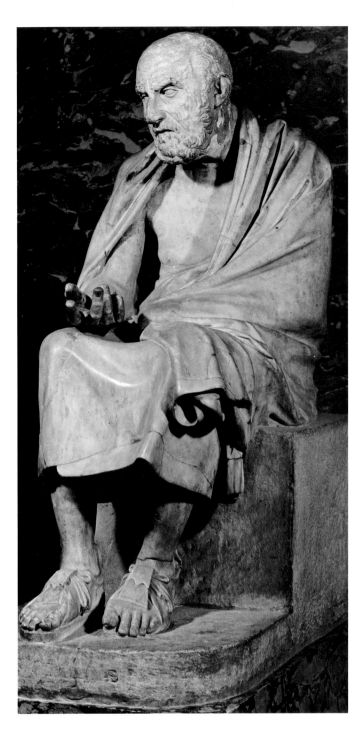

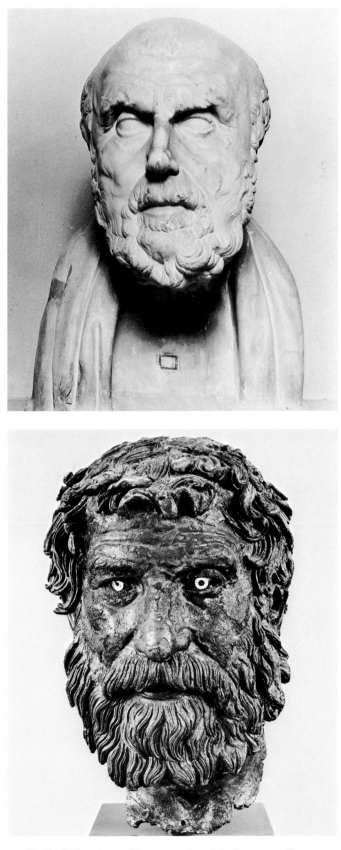

776 The Stoic philosopher Chrysippos, reconstruction using a Roman copy of the body and a cast of the head in the British Museum; original ca. 200. Marble and plaster (the head), ht. 1.2 m. Paris.

777 Head of Chrysippos (Roman copy), original ca. 200. Ht. 43 cm. Naples. The nose is restored.

778 Head of a philosopher, from a wreck off Antikythera (Greece), ca. 230–170. Bronze, ht. 29 cm. Athens.

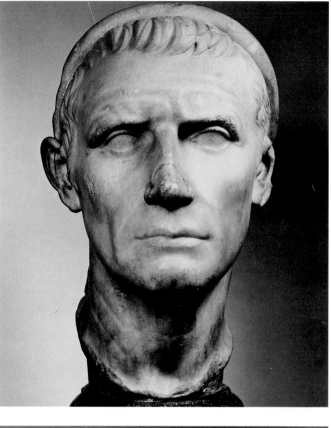

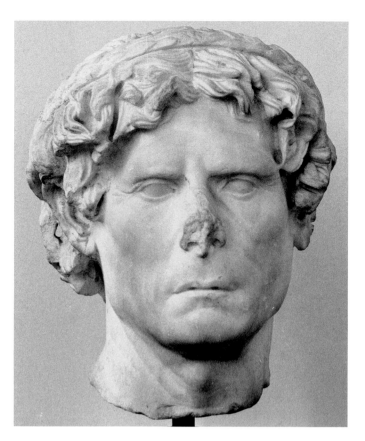

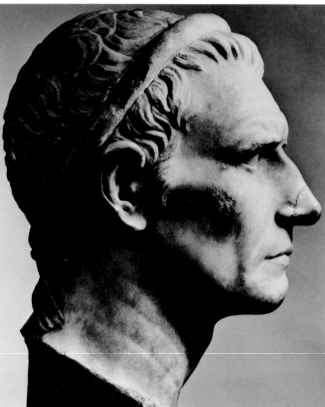

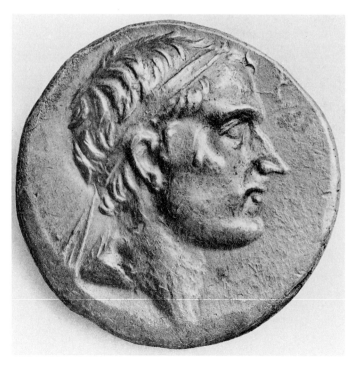

779–780 Head of Antiochos III (Roman copy), original ca. 200. Ht. 35 cm. Paris. The tip of the nose is restored.

781 Head of a priest, from Athens, ca. 200. Ht. 31 cm.

782 Tetradrachm of Antiochos III, minted in Ekbatana ca. 205. Antiochos, diademed; Apollo on omphalos. Silver, d. 2 cm.

An Attic Portrait of Antiochos III of Syria
779–782

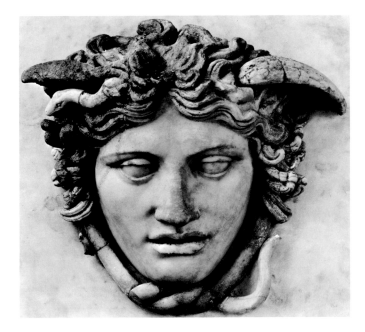

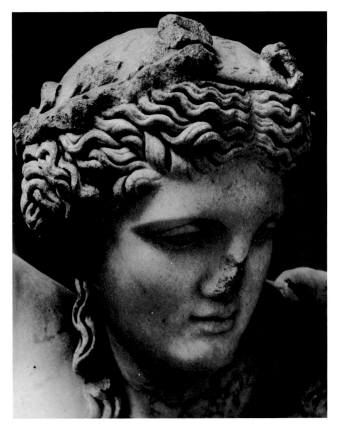

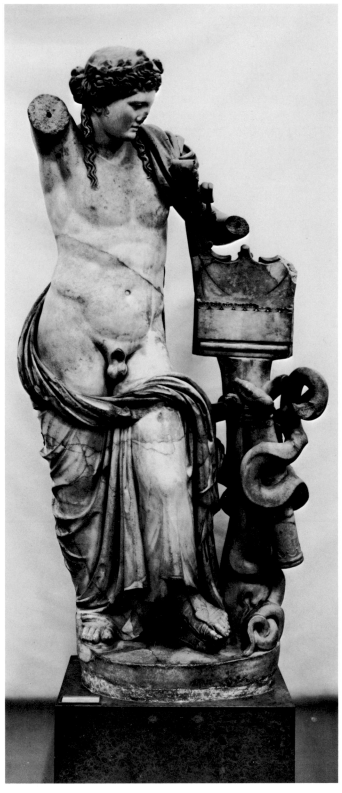

783 "Medusa Rondanini" (Roman copy), original ca. 200–170, *top left*. Ht. 40 cm. Munich. The left wing is restored.

784–785 Apollo Kitharoidos (Roman copy), original ca. 200–150. Ht. 2.29 m. London.

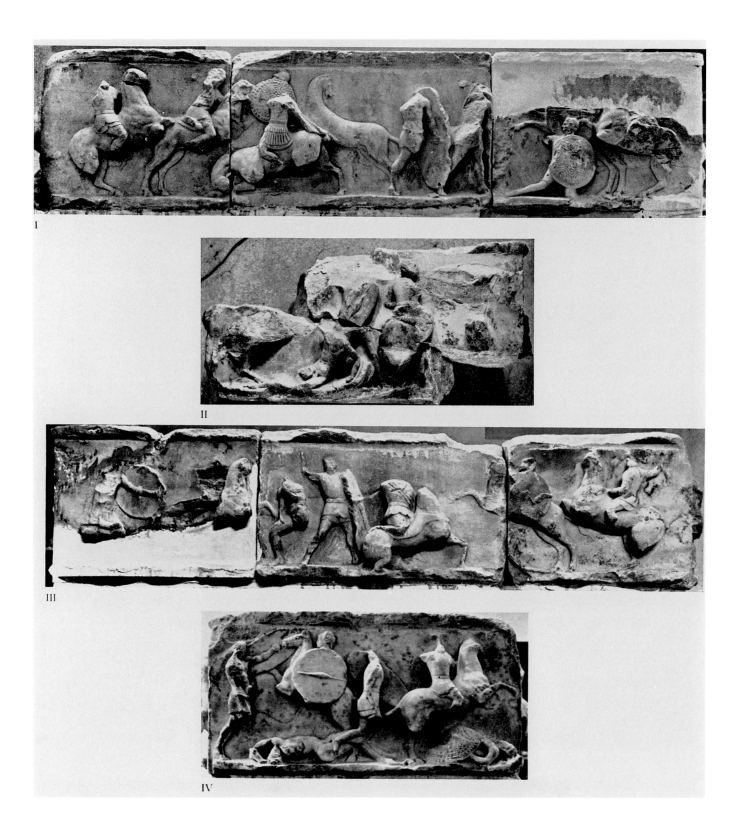

I

II

III

IV

786 Frieze from the base of the victory monument of Aemilius Paullus at
Delphi, 168 or shortly after. The battle of Pydna. Ht. 31 cm.

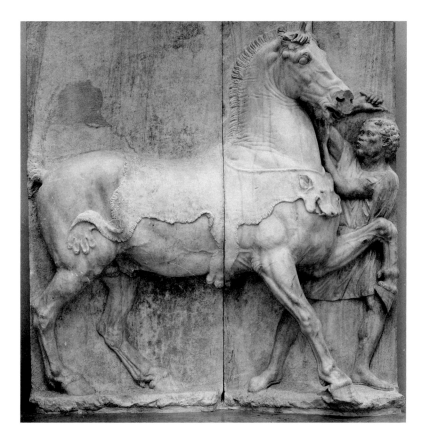

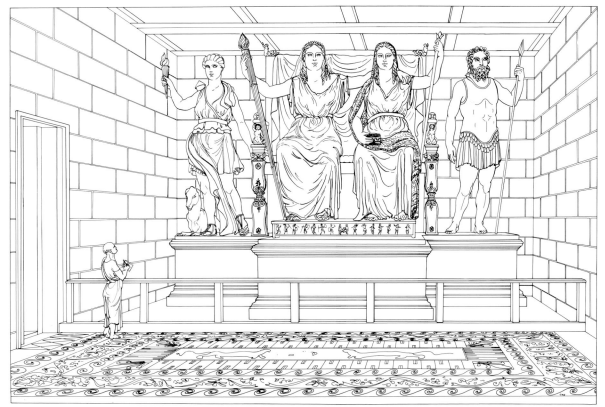

787 Black boy restraining a horse, from Athens, ca. 150–125. Ht. 2 m.

788 Reconstruction of the sanctuary of Despoina at Lykosoura in Arkadia, ca. 175–150. From left, Artemis, Demeter, Despoina, Anytos. Ht. of ensemble, ca. 5.7 m. Lykosoura and Athens.

An Attic Relief/Damophon of Messene at Lykosoura
787–788

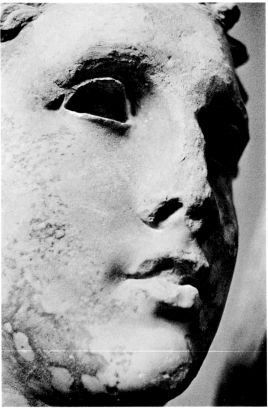

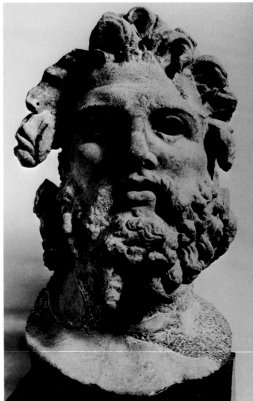

789 Heads of Artemis, Demeter, and Anytos from Lykosoura, ca. 175–150. Ht. of heads, 46 cm, 67 cm. Athens.

790–791 Heads of Artemis and Anytos, fig. 789. Most of the right side of Artemis's face is restored.

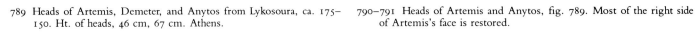

Damophon of Messene at Lykosoura
789–792

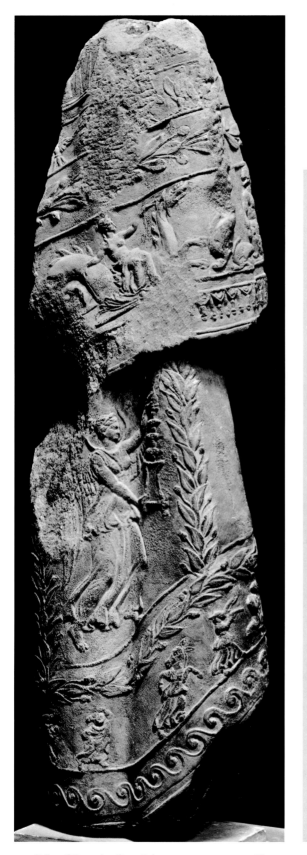

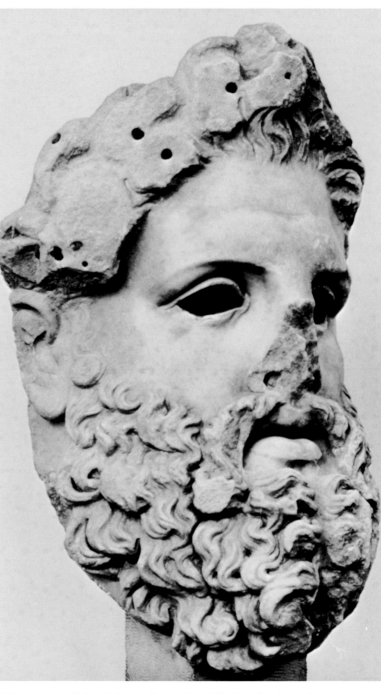

792 Robe of Despoina from Lykosoura, ca. 175–150. Ht. 1.13 m. Athens.

793 Colossal head of Zeus by Eukleides of Athens, from Aigeira in Achaea, ca. 150. From an akrolith, ht. 87 cm. Athens.

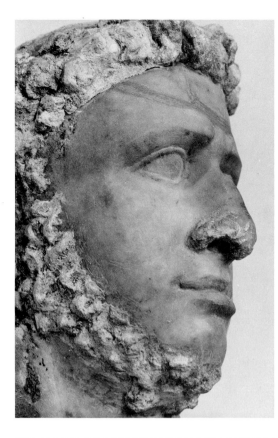

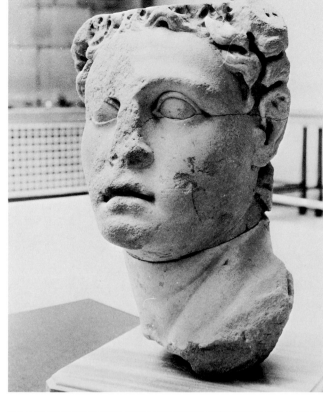

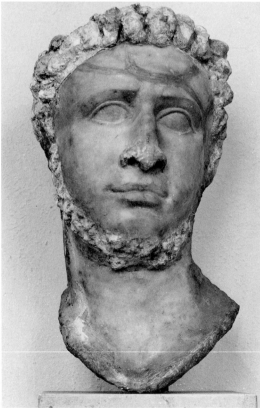

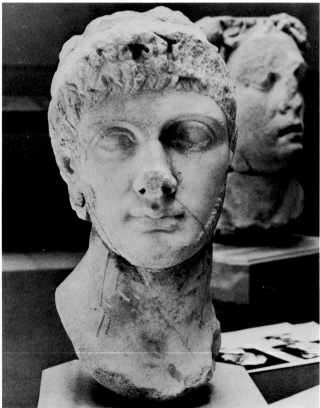

794–795 Colossal head of King Ptolemy IX Soter II of Egypt, from Memphis, ca. 100–80. Ht. 64 cm. Recut in antiquity, presumably from a portrait of the usurper Ptolemy X Alexandros I, who ousted Soter in 107 but was killed in 88.

796 Colossal head of King Seleukos I Nikator of Syria, from near Iskenderun (Turkey), ca. 100. Ht. 53.5 cm. Antakya.

797 King Antiochos IX of Syria, from near Iskenderun (Turkey), ca. 114–95. Ht. 43.1 cm. Antakya.

Ptolemaic and Seleukid Kings
794–797

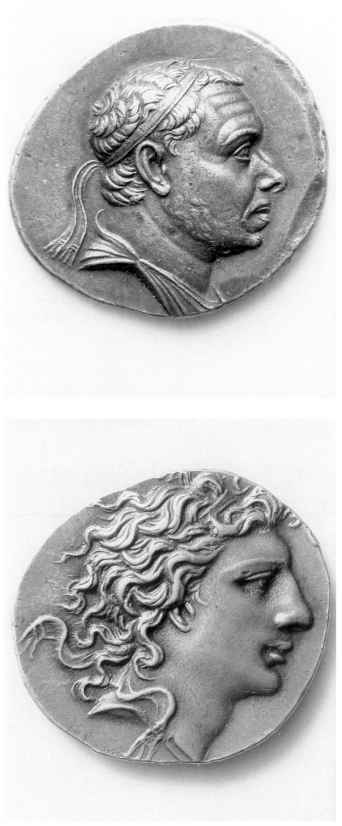

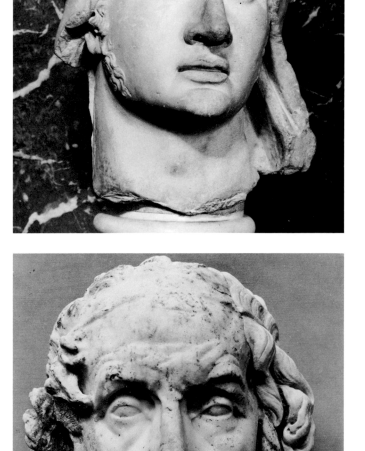

798–799 Tetradrachms of King Mithradates III and VI of Pontos, ca. 246–
190 and 100–63. Silver, d. 1.8 cm. London.

800 King Mithridates VI Eupator of Pontos (Roman copy), original ca.
100–75. Ht. 35 cm. Paris. Much of the nose is restored, together
with parts of the lips and chin.

801 Homer (Roman copy), original ca. 150–100. Ht. 54 cm. Paris. The
tip of the nose and some details of the beard and hair are restored.

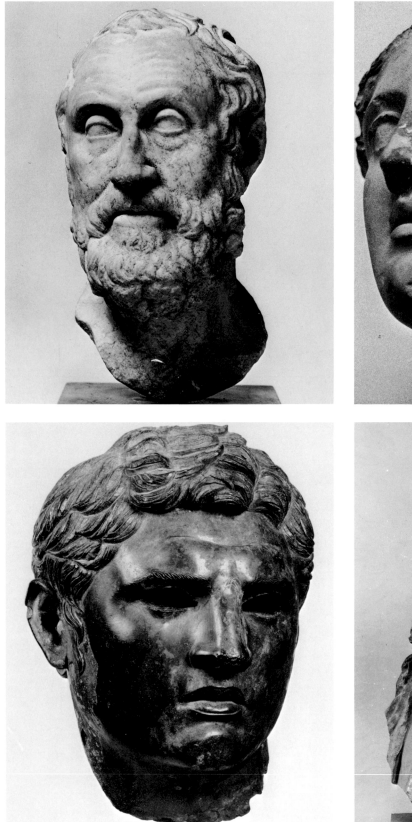

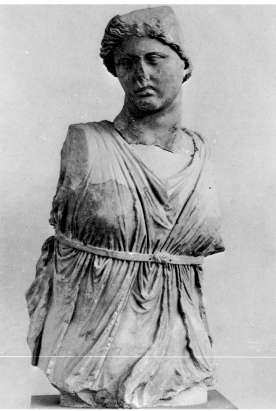

802 Karneades (Roman copy), original ca. 140. Ht. 35 cm. Basel.
803 Portrait ("Sulla"), reportedly from Asia Minor, ca. 100–75. Bronze, ht. 28 cm. Malibu.

804 Colossal Athena attributed to Euboulides of Athens, from Athens, ca. 100. Ht. 60 cm.
805 Nike by Euboulides of Athens, from Athens. Ht. 1.23 m. The right shoulder and adjacent parts of the chest and neck are restored.

Attic Neoclassicism and a Roman General
802–805

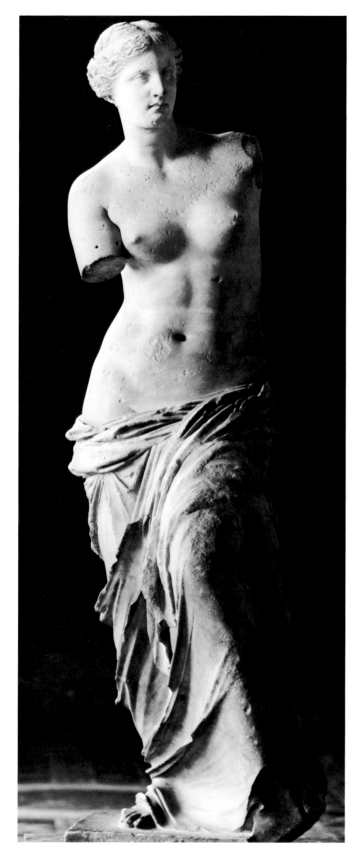

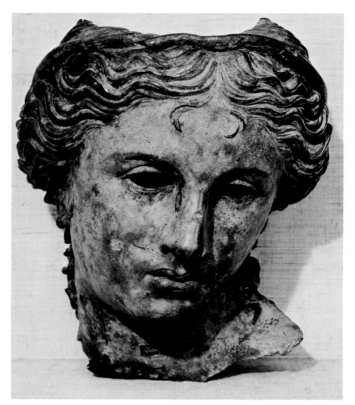

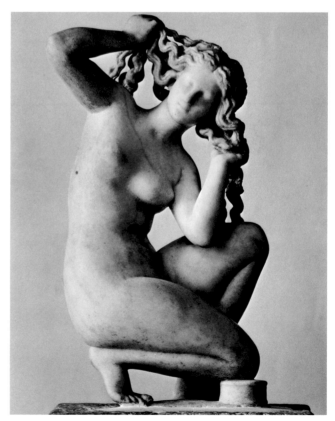

806 Aphrodite from Melos (the Venus de Milo), ca. 100. Ht. 2.04 m. Paris. Associated with a base (now lost) signed by [Alex]andros of Antioch on the Maeander.

807 Aphrodite from Satala in Armenia, ca. 100–75. Bronze, ht. 38 cm. London.

808 Aphrodite from Rhodes, ca. 100. Ht. 49 cm.

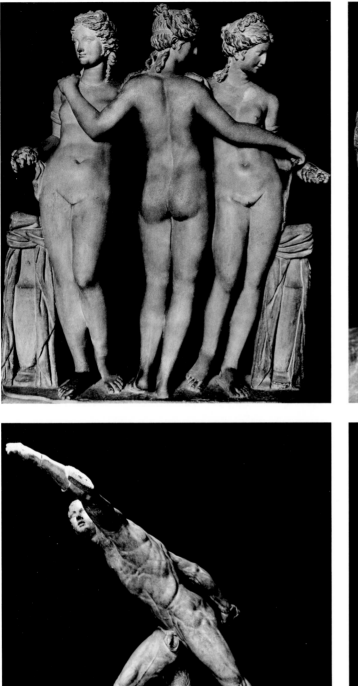

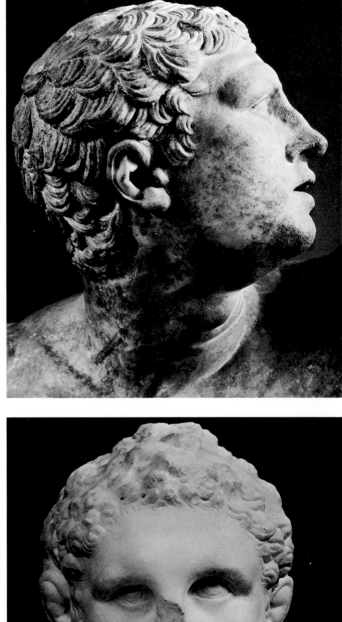

809 The Three Graces (Roman copy), original ca. 100–50. Ht. 1.05 m.
All three heads are restored.
810–811 "Borghese Warrior" signed by Agasias of Ephesos (Roman
copy), original ca. 100–75. Ht. 1.99 m. Paris. The arms are restored.

812 Head of a statue of Herakles, reportedly from Alexandria, ca. 150–
100. Ht. 58 cm. The eyes and hair were slightly recut in the second
century AD. Malibu.

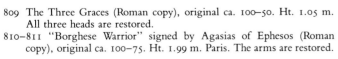

The Three Graces/The Borghese Warrior
809–811

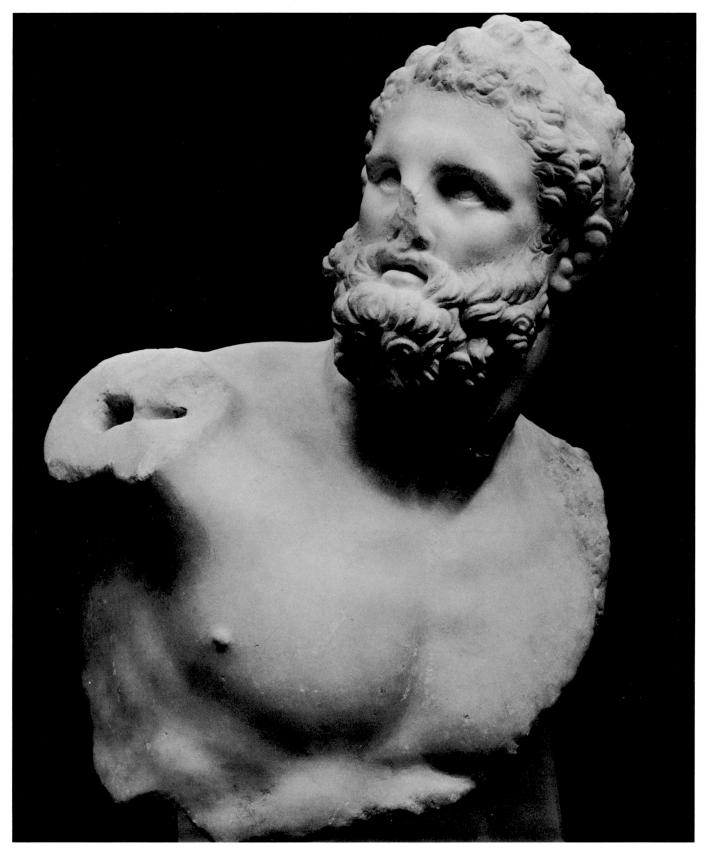

813 The Herakles, fig. 812, complete.

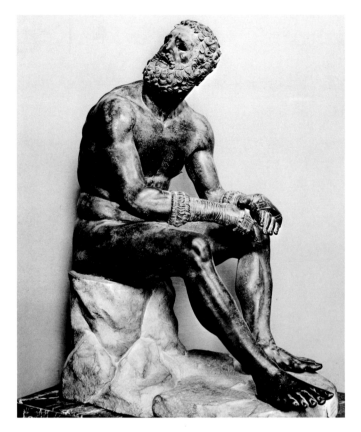

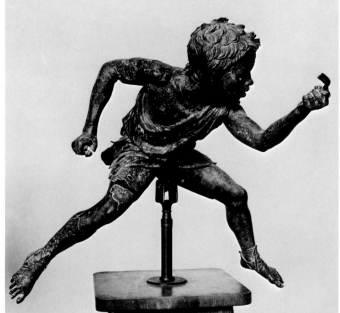

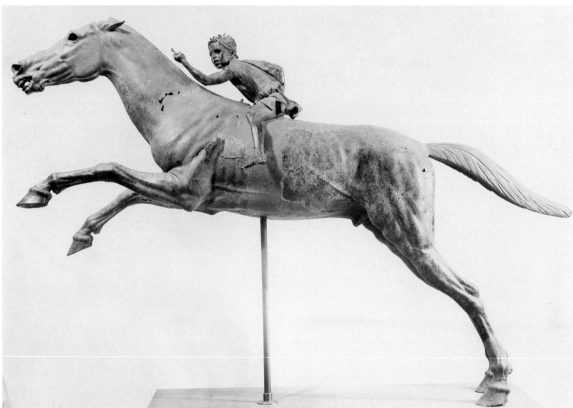

814 Boxer from Rome, ca. 100–50. Bronze, ht. 1.28 m.

815–816 Horse and jockey from a wreck off Cape Artemision (Greece), ca. 150–125. Bronze, ht. of jockey, 84 cm., l. of horse, 2.5 m. Athens. The horse's tail is restored, with parts of its body.

Late Hellenistic Athletic Sculpture
814–816

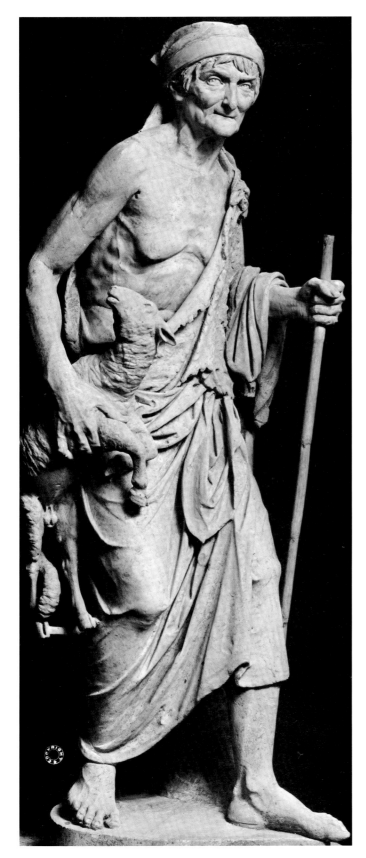

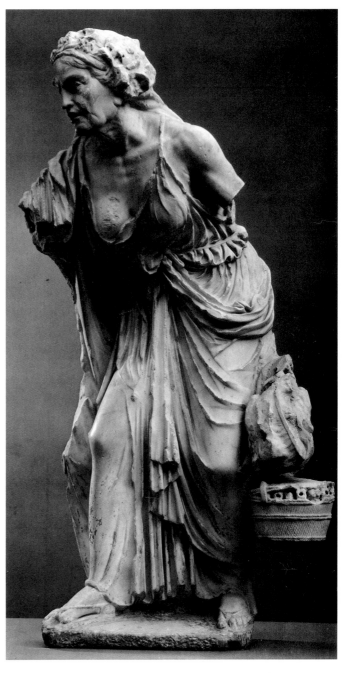

817 Old shepherdess (Roman copy), original ca. 150. Ht. 1.15 m. Rome. The head is restored.

818 "Old market woman" (Roman copy), original ca. 150–100. Ht. 1.26 m. New York. The face is partly restored.

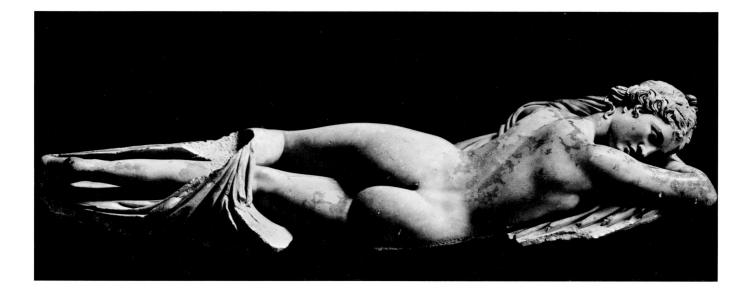

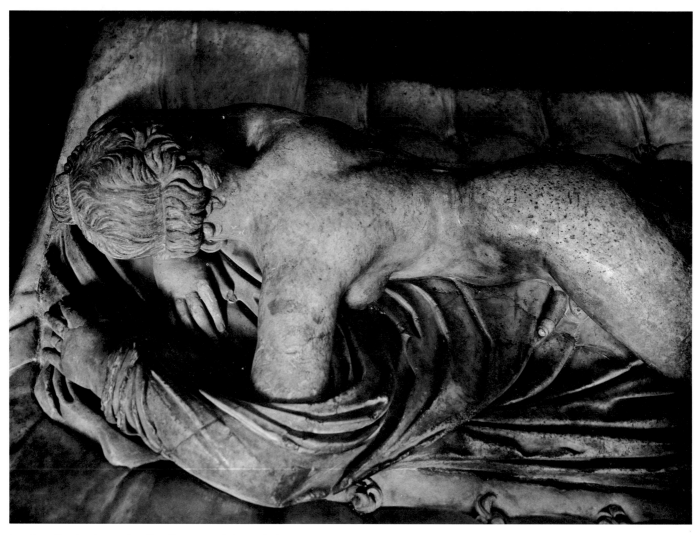

819–820 Sleeping hermaphrodites (Roman copies), original ca. 150–100.
L. 1.48 m. Rome and Paris. The mattress in fig. 820 is seventeenth-
century.

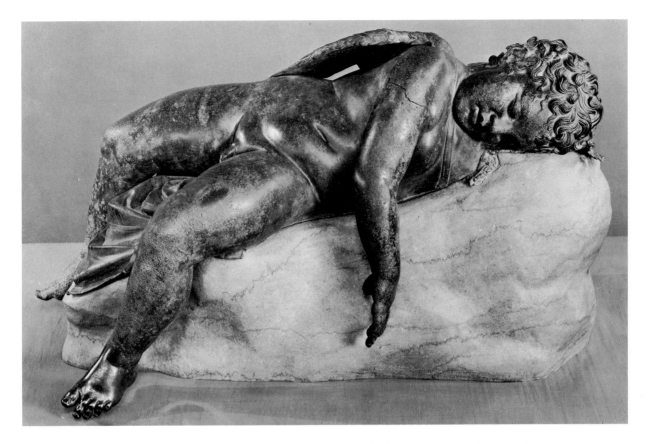

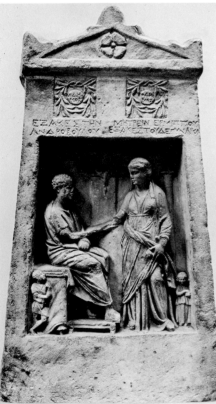

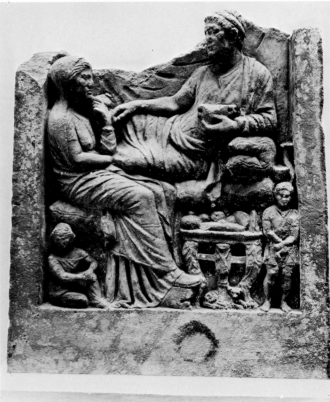

821 Sleeping Eros from Rhodes, ca. 150–100. Bronze, l. 78 cm. New York.

822 Gravestone of Exakestes and Metreis, probably from Smyrna (Turkey), ca. 200–100. Ht. 77 cm. London.

823 Gravestone with funerary banquet, from Asia Minor, ca. 200–100. Ht. 55 cm. London.

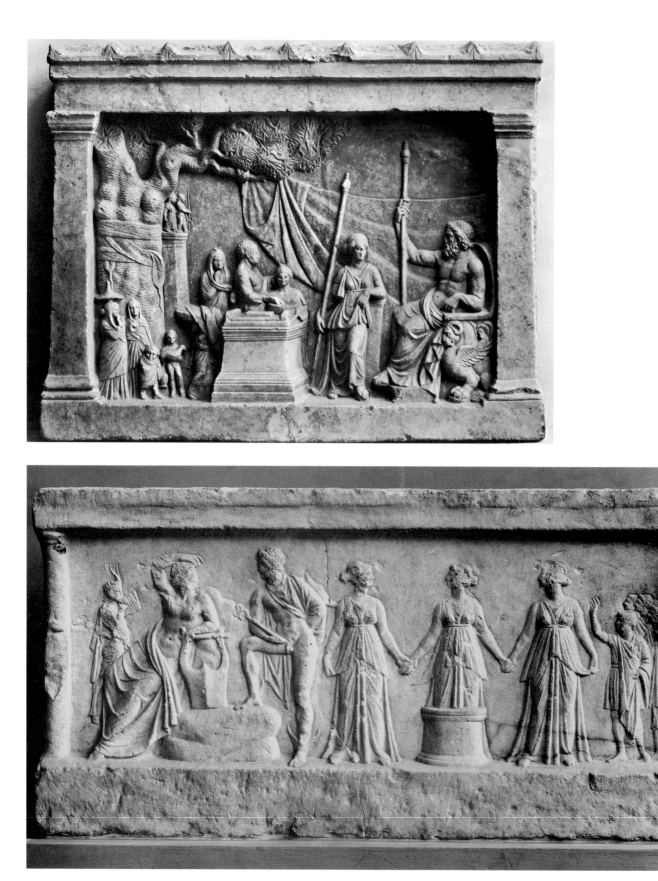

824 Votive relief, allegedly from Corinth, but probably Attic, ca. 150–100. The divinities may be Asklepios and Hygieia, Dionysos and Ariadne, or Isis and Sarapis/Osiris. Ht. 61 cm. Munich.

825 Votive relief with Pan, Apollo, Hermes, and the Nymphs, from the south side of the Akropolis at Athens, ca. 100. Ht. 39 cm.

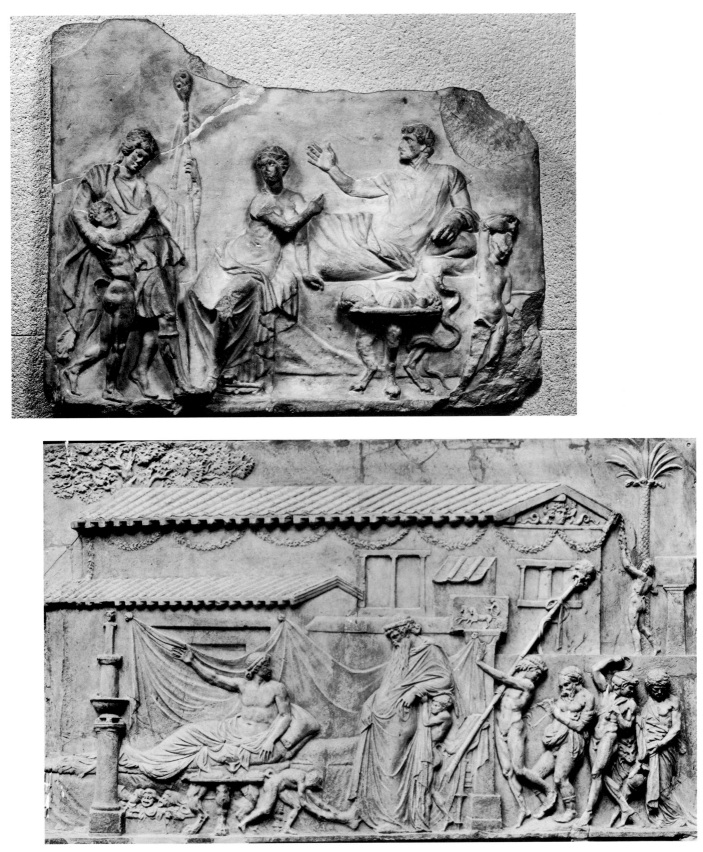

826 Votive relief from Piraeus, ca. 150–125. Dionysos visits a poet. Ht. 55 cm. Paris.

827 Relief with Dionysos visiting a poet (Roman copy), original, late first century BC. Ht. 91 cm. London. Many details restored.

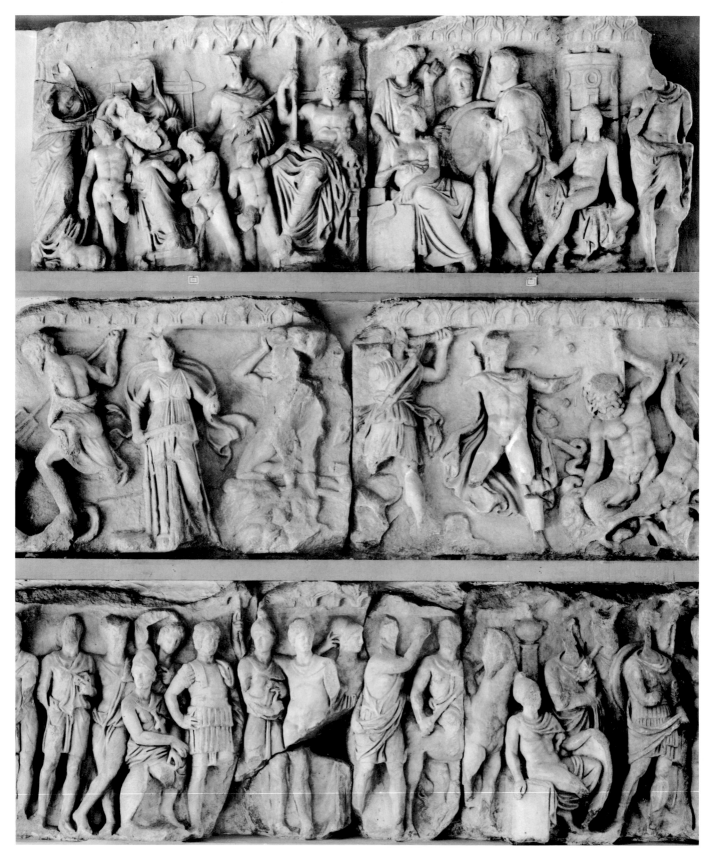

828 Frieze of the temple of Hekate at Lagina in Caria (Turkey), ca. 130–
100. *Top*: south frieze with assembly of Carian gods; *center*: west frieze
with Gigantomachy; *bottom*: north frieze with treaty between Roma
and the Carian cities. Ht. 93 cm. Istanbul.

The Temple of Hekate at Lagina
828

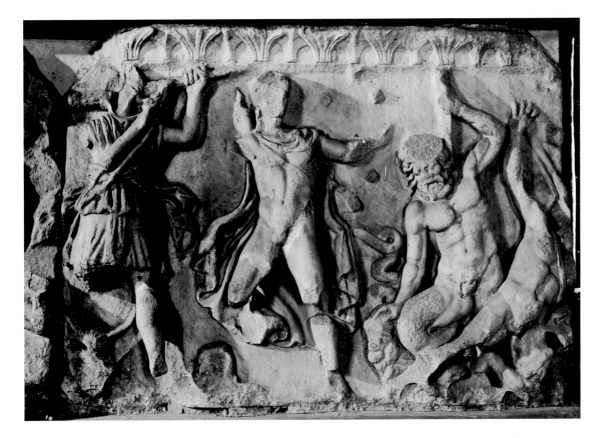

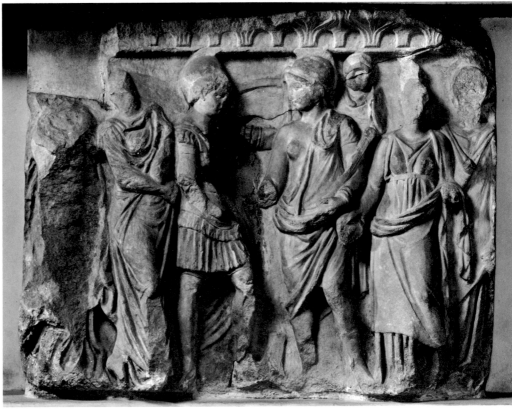

829–830 Details of the west and and north frieze at Lagina, fig. 828. Artemis, Apollo and the Giants; treaty between Roma and the Carian cities. Istanbul.

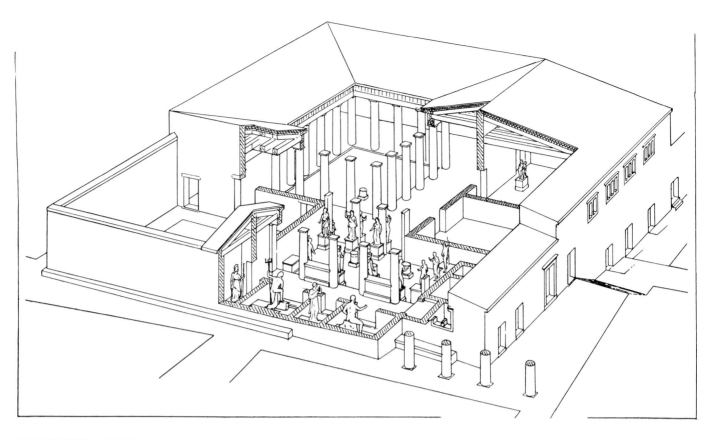

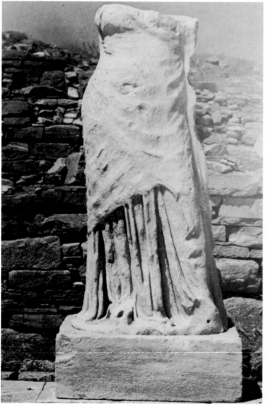

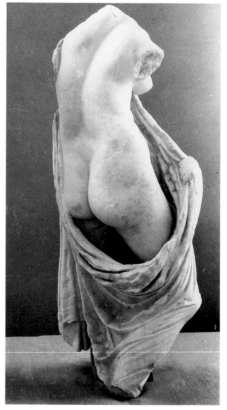

831 Reconstruction of the Establishment of the Poseidoniasts of Berytos
 (Beirut), ca. 150–125.
832 The goddess Rome (Thea Roma Euergetis), on a base signed by Melas
 son of Menandros of Athens, ca. 110. Ht. 1.54 m.

833 Nymph being disrobed by a satyr, ca. 100. Ht. 73 cm.

The Establishment of the Poseidoniasts at Delos
831–833

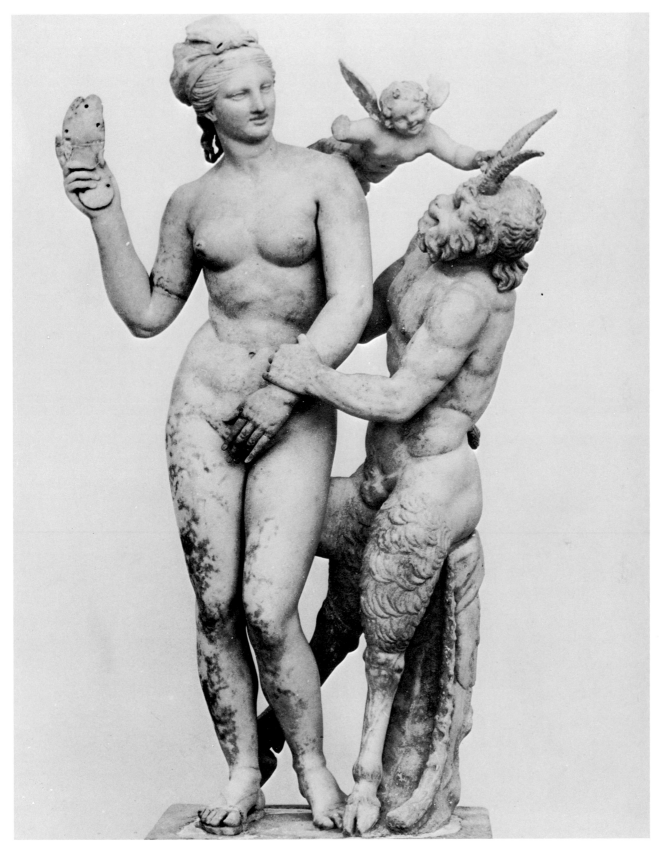

834 Aphrodite, Pan, and Eros dedicated by Dionysios of Berytos to his
native gods, from the Establishment of the Poseidoniasts of Berytos
(Beirut), ca. 100. Ht. 1.32 m. Athens.

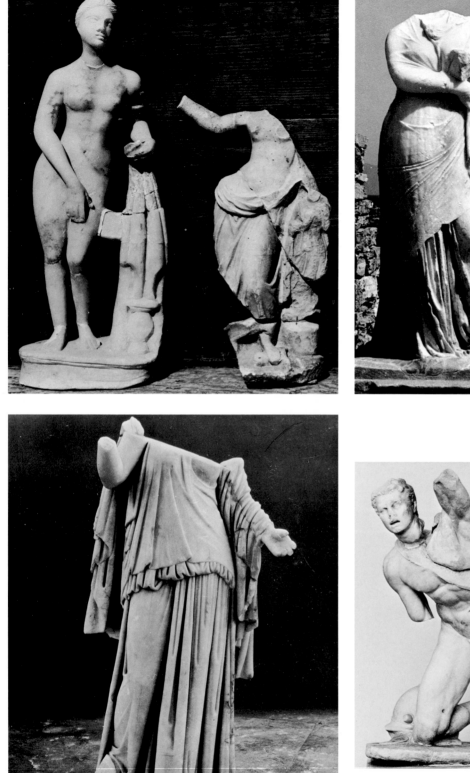

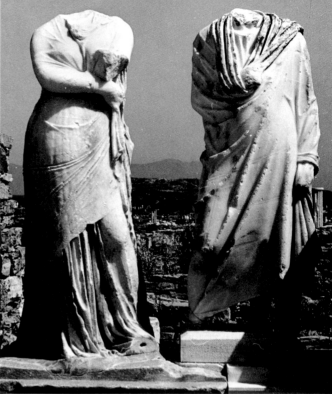

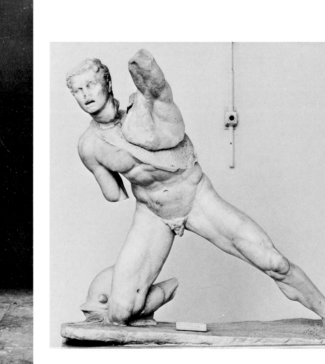

835 Statuettes of the Knidian Aphrodite of Praxiteles and another Aphrodite leaning on a statuette, from Delos, ca. 100. Ht. 45 cm, 37 cm.

836 Statuette recalling the Eirene of Kephisodotos, from Delos, ca. 100. Ht. 1.09 m.

837 Kleopatra and Dioskourides, in their house on Delos, 138/37. Ht. 1.67 m.

838 Fallen Celt, from the Agora of the Italians on Delos, ca. 100. Ht. 93 cm. Athens. The head, allegedly found on Mykonos, probably does belong to this statue.

Delian Copies, Portraits, and Dedications
835–838

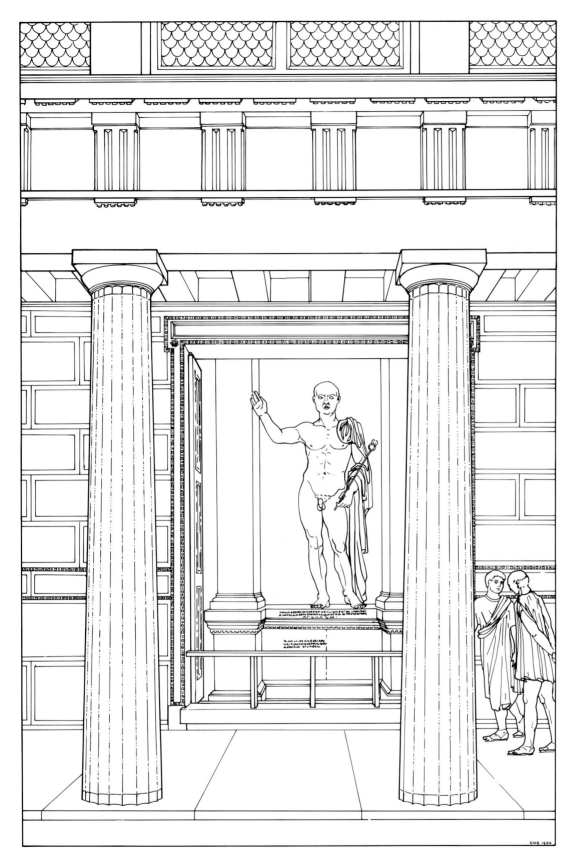

839 Reconstruction of the niche of C. Ofellius Ferus in the Agora of the
Italians on Delos, ca. 100. Ht. of statue, ca. 3 m. For the dedication
and signature, see T 160.

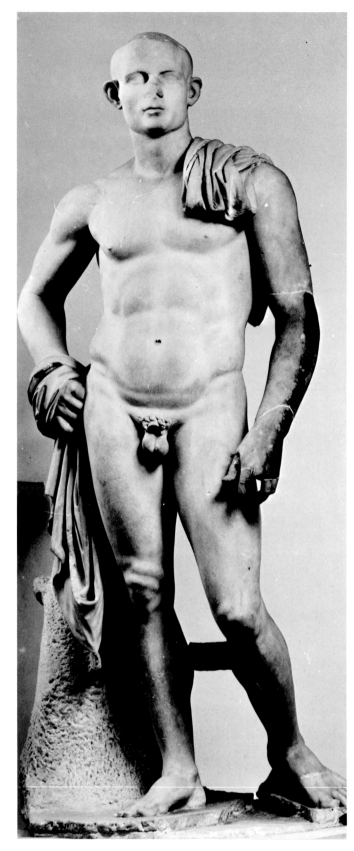

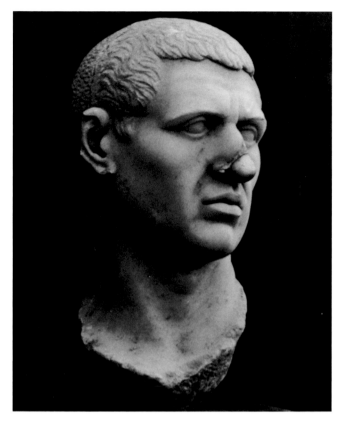

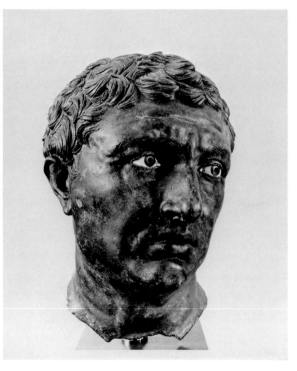

840 Colossal portrait statue from the House of the Diadoumenos on De-
los, ca. 100–88. Ht. 2.55 m. Athens. Unfinished.

841 Portrait from Delos, ca. 100–88. Ht. 49.2 cm.
842 "Worried Man" from Delos, ca. 100. Bronze, ht. 32.5 cm. Athens.

Delian Portraits
840–842

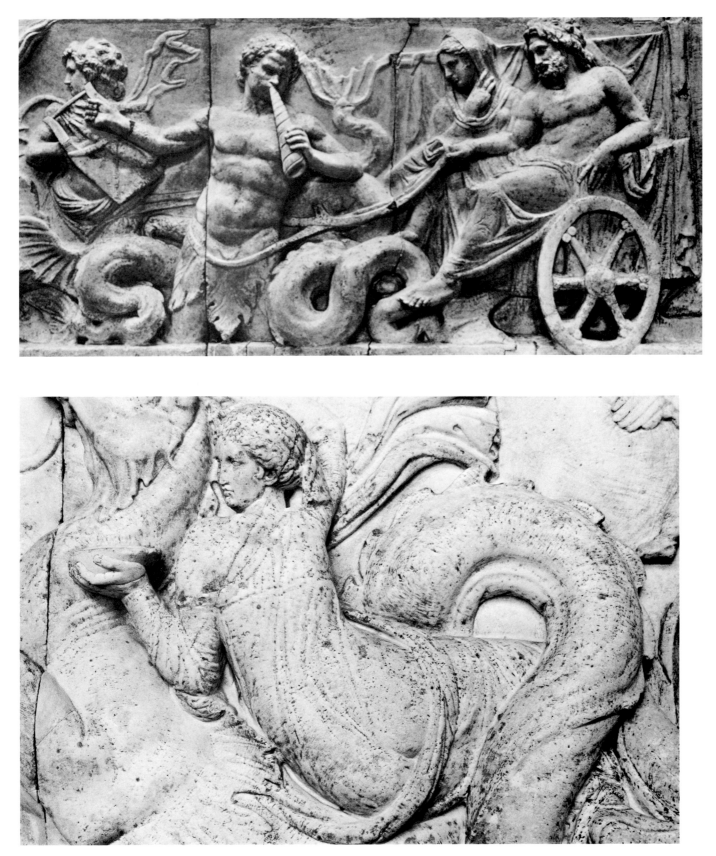

843 The "Altar of Domitius Ahenobarbus," from Rome, ca. 130–100. Marriage of Poseidon and Amphitrite. Ht. 1.52 m. Munich. Recut to fit the census slabs of figs. 845–846.

844 Detail from another slab of the "Altar," fig. 843: Nereid on hippocamp.

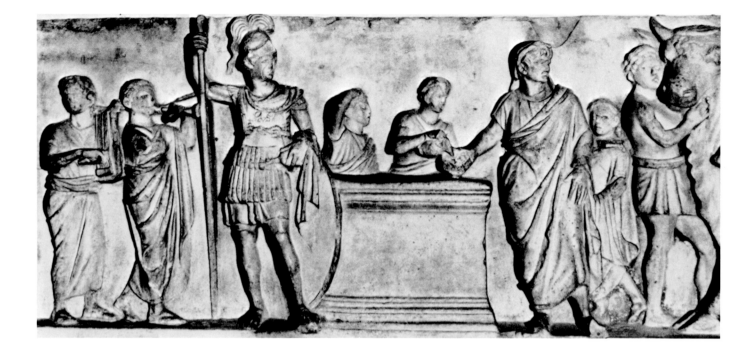

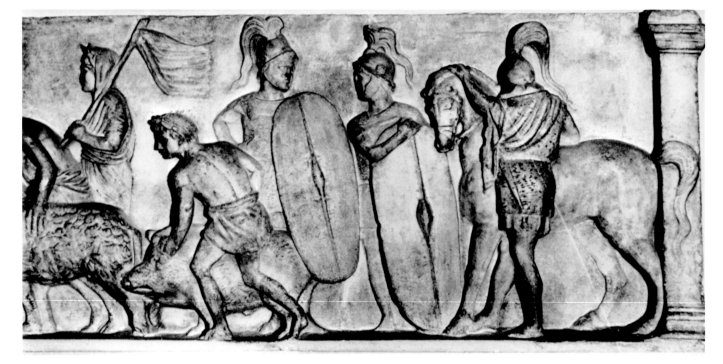

845–846 "Altar of Domitius Ahenobarbus," from Rome, ca. 100–70.
Census, *top,* and sacrifice, *bottom,* with Mars looking on. Ht. 1.52 m.
Paris.

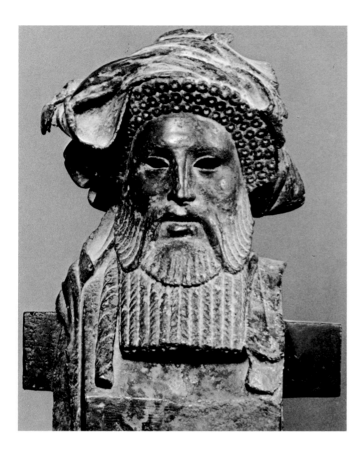

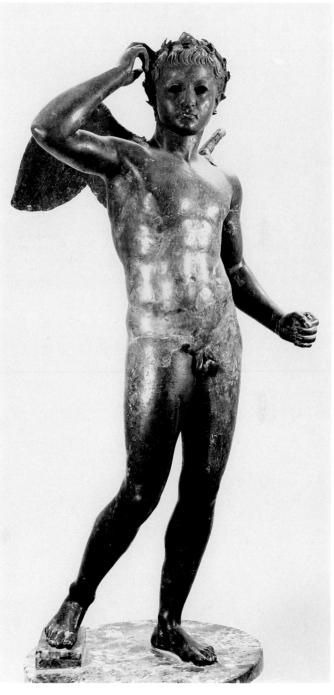

847 Herm signed by Boethos of Kalchedon, from the Mahdia wreck, ca. 130–100. Bronze, ht. 1 m. Tunis. Probably belongs with the winged youth, fig. 848.

848 Winged youth (probably Eros Enagonios), from the Mahdia wreck, ca. 130–100. Bronze, ht. 1.40 m. Tunis. Probably belongs with the herm, fig. 847.

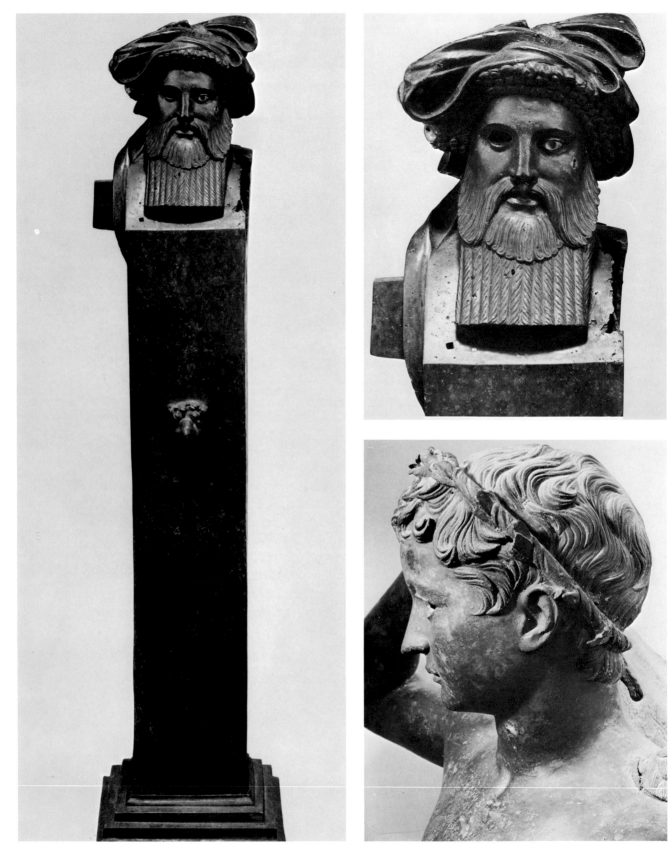

849–850 Another version of the herm (not from the same mold), fig. 847. First or second century AD. Bronze, ht. 1.04 m. Malibu.

851 Head of the youth, fig. 848.

A Copy of Boethos's Herm/The Mahdia Wreck
849–851

852 Grotesque dancer from the Mahdia wreck, ca. 130–100. Bronze, ht. 32 cm. Tunis.

853–854 Fragments of a krater from the Mahdia wreck, ca. 130–100. Dionysiac thiasos. Ht. of figures, 60 cm; of krater, 1.75 m. Tunis.

855 "Borghese" krater from Italy, ca. 100. Dionysiac thiasos. Ht. 1.71 m. Paris.

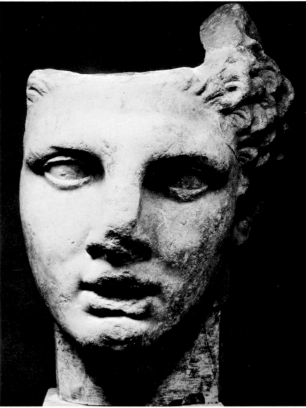

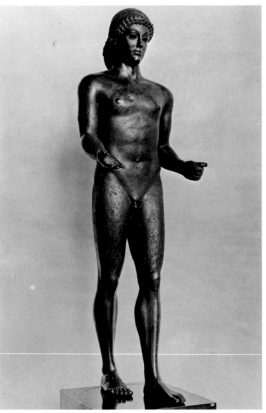

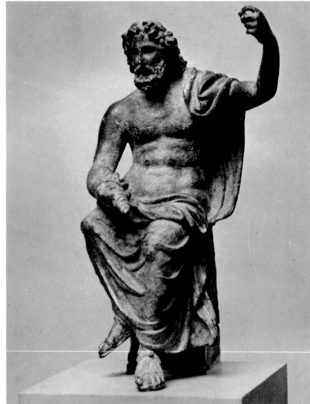

856 The "Belvedere torso" (Philoktetes?) by Apollonios, son of Nestor of Athens, ca. 50. Ht. 1.42 m. Rome.

857 Apollo from the sea off Piombino (Italy), ca. 50. Bronze, ht. 1.15 m. Paris. A dedication to Athena is inlaid into the left foot, and a lead strip found inside was signed by [M]enodo[tos of Tyre and . . .] phon of Rhodes.

858 Colossal head of Hercules from the Capitoline (Rome), ca. 150–125. Ht. 57 cm.

859 Roman statuette of Jupiter Capitolinus, after the original cult statue of ca. 80–69. Bronze, ht. 10.4 cm. New York.

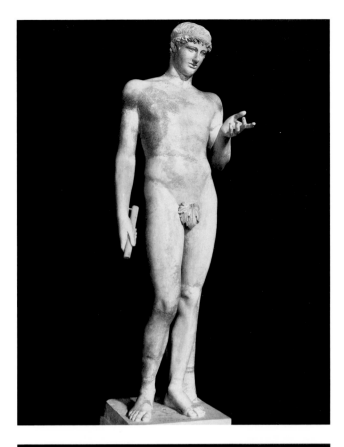

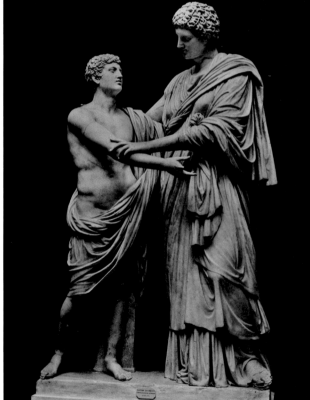

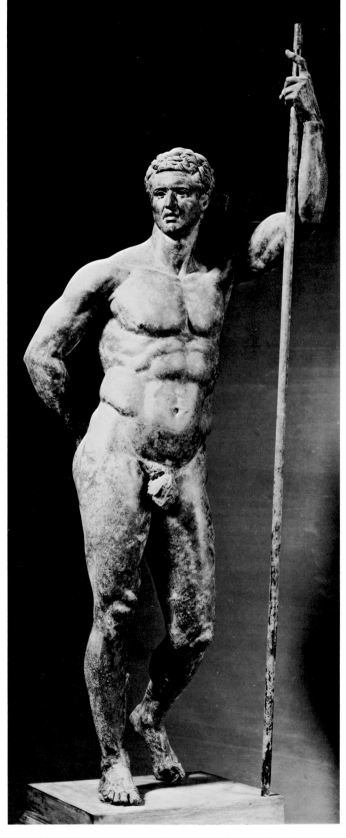

860 Athlete signed by Stephanos, pupil of Pasiteles, from Rome, ca. 50. Ht. 1.44 m. The top of the head, locks falling over the forehead, tip of the nose, right arm, left forearm, right foot, and most of the plinth are restored.

861 Orestes and Elektra signed by Menelaos, pupil of Stephanos, from Rome, ca. 30. Ht. 1.92 m. On the youth the tip of the nose, most of the right arm and several fingers of the hand, and on the woman the front part of the hair, the left forearm, and some of the fingers are restored; the drapery has been textured and the flesh smoothed.

862 Roman general ("Hellenistic ruler"), from Rome, ca. 150–125. Bronze, ht. 2.22 m.

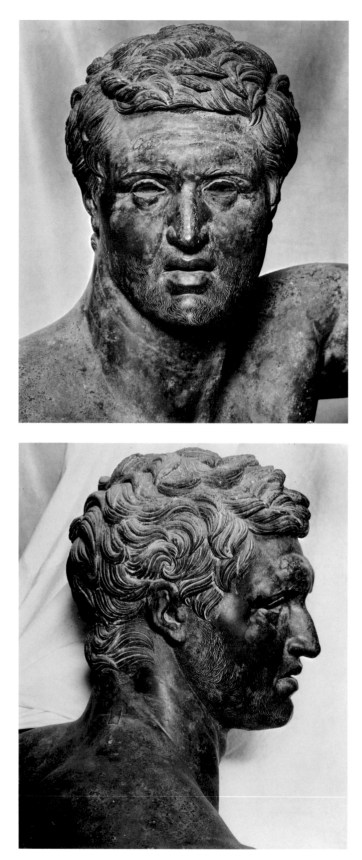

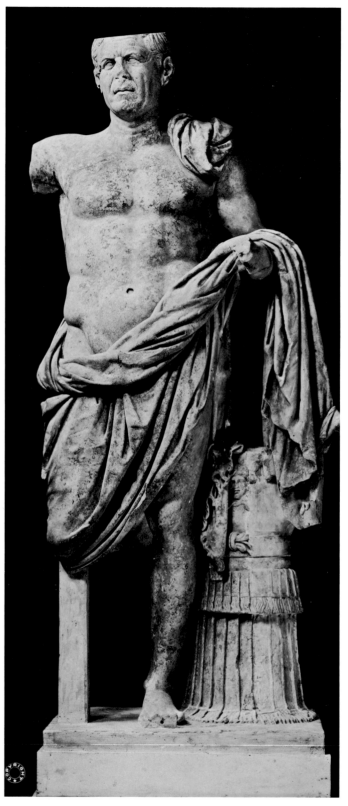

863–864 Head of the general, fig. 862.

865 Roman general from the temple of Hercules at Tivoli, ca. 100–50. Ht. 1.88 m. Rome. The right shoulder and the upper part of the support are restored.

866 The "Tower of the Winds" (Horologion of Andronikos), Athens, ca. 50, if not late second century BC. View of the winds Skiron (NW), Zephyros (W), and Lips (SW). Ht. of reliefs, 1.65 m.

867 Euros (SE wind), from the "Tower of the Winds," fig. 866.

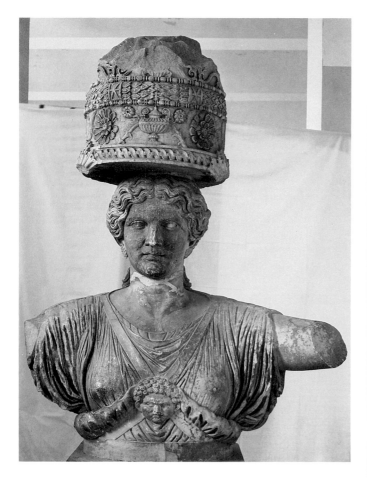

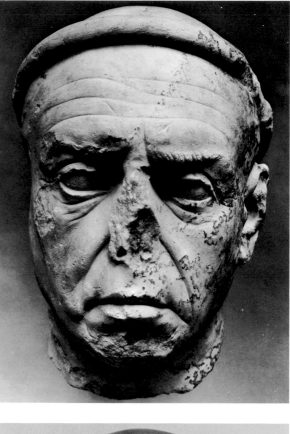

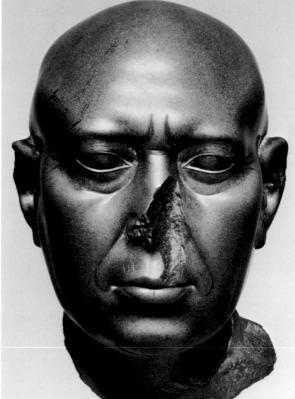

868 Caryatid from the Lesser Propylaia at Eleusis, after 54 to after 48.
 Ht. 2 m.

869 Priest, from the Athenian Agora, ca. 50. Ht. 29 cm.
870 Head of an Egyptian priest (the "Green head"), from Egypt, ca. 100–
 50. Green schist, ht. 21 cm. Berlin.

Attic Sculpture during the Roman Civil Wars
868–870

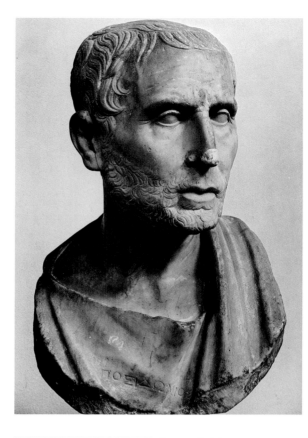

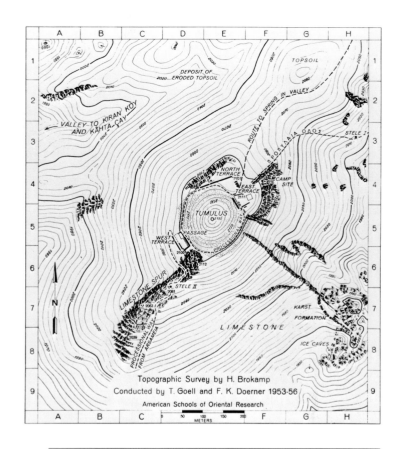

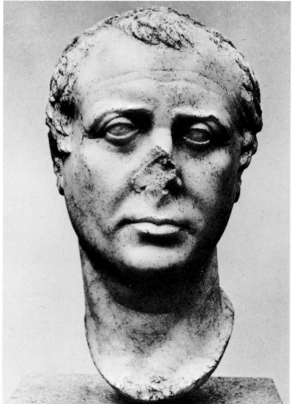

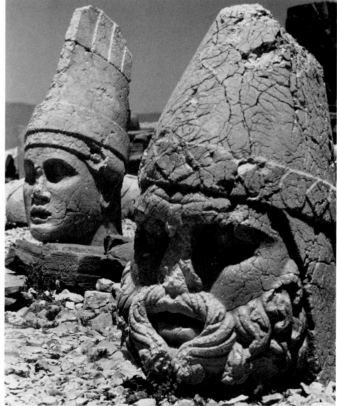

871 Bust of Poseidonios (Roman copy), ca. 75–50. Ht. 44 cm. Naples. The tip of the nose and most of the ears are restored.

872 Head probably of Diodoros Pasparos, from the "Marmorsaal" of his gymnasium at Pergamon, ca. 80–60. Ht. 44 cm. Bergama.

873 Plan of the Hierothesion of Antiochos I of Commagene at Nemrud Dagh (Eastern Turkey), ca. 50–35.

874 Hierothesion of Antiochos I of Commagene at Nemrud Dagh, ca. 50–35. Heads of Antiochos and Artagnes-Herakles-Ares on the west terrace. Limestone, ht. of heads, ca. 1.6 m.

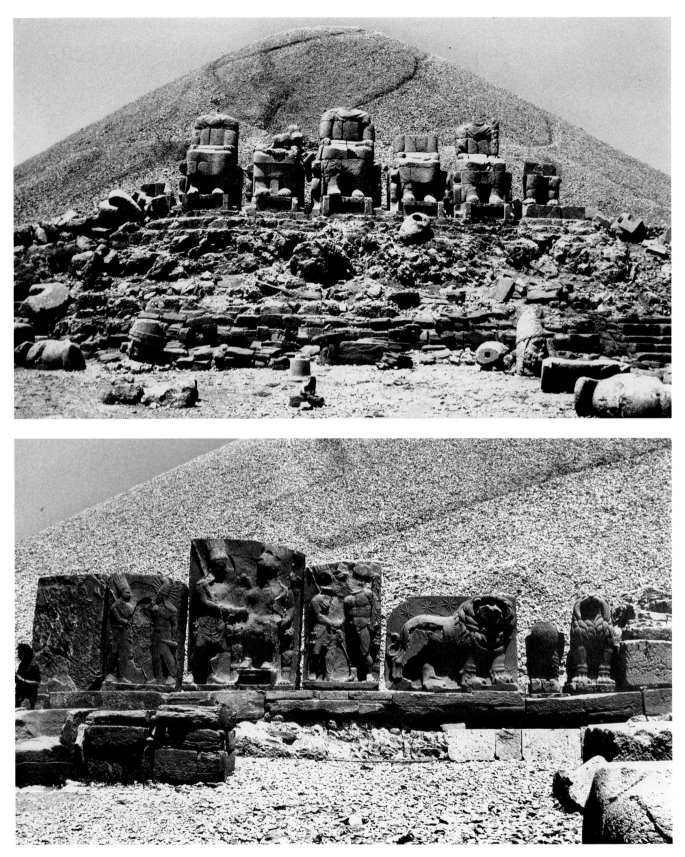

875–876 Hierothesion of Antiochos I of Commagene at Nemrud Dagh,
ca. 50–35. East terrace with (from left to right, flanked by eagles and
lions) Antiochos, Commagene, Zeus-Oromasdes, Apollo-Mithras-
Helios-Hermes, and Artagnes-Herakles-Ares; stelai showing Anti-
ochos with gods and heroes and lion-horoscope. Limestone; ht. of
figures, ca. 8 m; of stelai, ca. 2 m.

Antiochos I of Commagene
875–876

877 Hierothesion of Antiochos I of Commagene at Nemrud Dagh, ca. 50–35. Detail of lion-stele with horoscope of Antiochos. Limestone; ht. of stele, ca. 1.2 m.

878 Tetradrachm of Queen Kleopatra VII Thea of Egypt, possibly minted in Antioch, 42–30. Silver, d. 2.7 cm. Cambridge (England).

879 Queen Kleopatra VII Thea of Egypt, ca. 50–30. Ht. 30 cm. Rome. The nose is restored.

880 Octavian, from Italy, ca. 35–25. Ht. 37 cm. Rome. Part of the nose is restored, as are some small areas of the flesh surfaces; the bust is ancient, but does not belong.

Antiochos I of Commagene, Kleopatra VII of Egypt, and Octavian
877–880

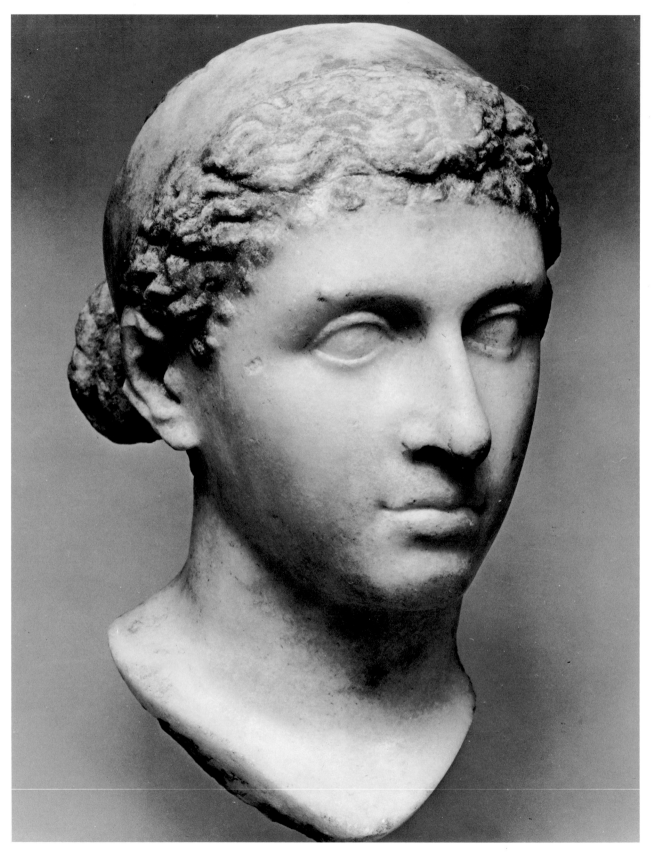

881 Queen Kleopatra VII Thea of Egypt, ca. 50–30. Ht. 29.5 cm. Berlin.

Queen Kleopatra VII of Egypt
881

Greek Sculpture
An Exploration

Andrew Stewart

Volume II: Plates

This is a magnificent and intellectually stimulating account of large-scale Greek sculpture from the Dark Ages to Augustus (c.1200–30 B.C.). Andrew Stewart not only describes and dates the sculpture and illustrates its most significant, interesting, and characteristic examples but also places it in its full social and political context. He focuses on who the sculptors were, how their workshops were run, who commissioned and supported their work, and what the political, cultural, and natural settings were. Stewart writes in his preface, "While I try to be careful to preserve the integrity of the artwork and to give due regard to the uniqueness of the creative act, I am nevertheless most comfortable when I contemplate the artist as a social being and his work as a barometer of society's concerns."

The book begins with an introduction to Greek art and culture, a thorough investigation of certain aspects of that culture as it relates to sculpture-making, and a discussion of five individual monuments of power and complexity that evolved according to different sets of circumstances. The second section presents a chronological history of Greek sculpture. The third part of the book analyzes primary evidence for the lives and achievements of almost 100 sculptors, including translated testimonia, attested works, and speculative attributions.

The book consists of two volumes, Text and Plates, and contains more than 900 high quality illustrations and reconstructions. Also included are a glossary of Greek and Latin terms and translations of ancient literary and epigraphical testimonia.